MW00851546

Whispers of the Ancients

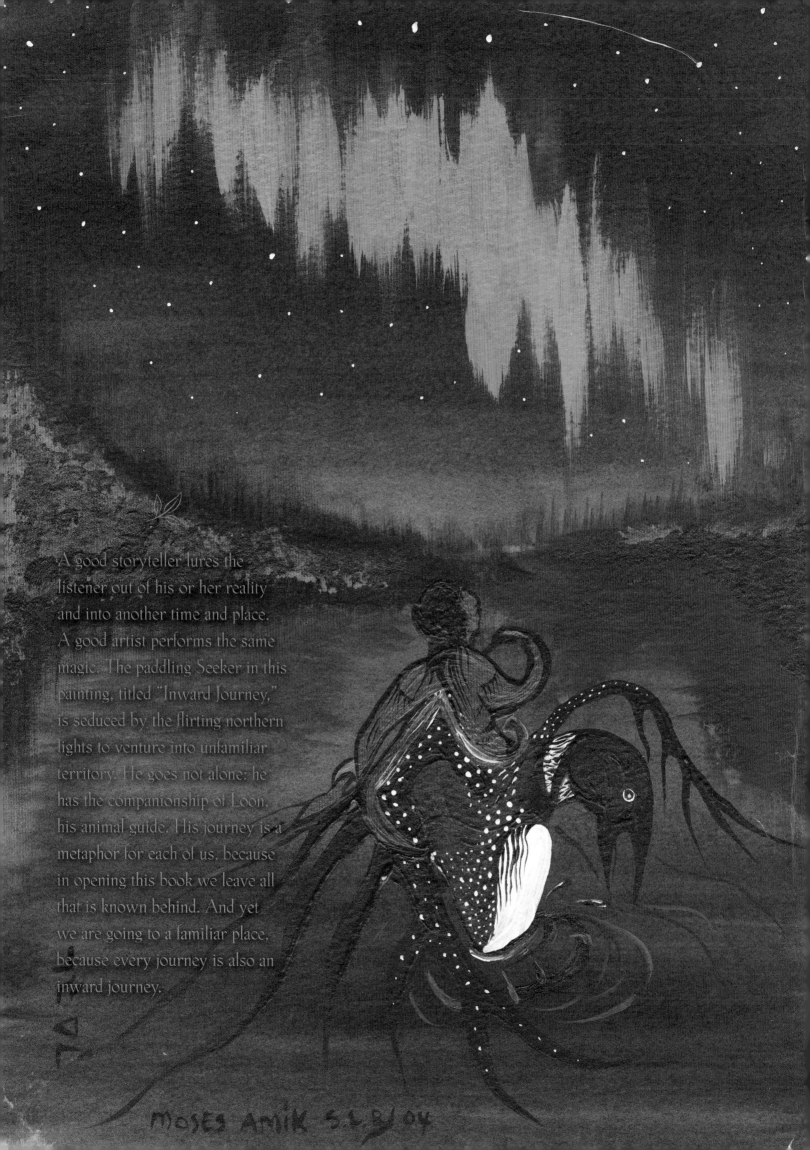

A good storyteller lures the
listener out of his or her reality
and into another time and place.
A good artist performs the same
magic. The paddling Seeker in this
painting, titled "Inward Journey,"
is seduced by the flirting northern
lights to venture into unfamiliar
territory. He goes not alone: he
has the companionship of Loon,
his animal guide. His journey is a
metaphor for each of us, because
in opening this book we leave all
that is known behind. And yet
we are going to a familiar place,
because every journey is also an
inward journey.

MOSES AMIK S.L.B/04

Whispers
of the
Ancients

Native Tales for Teaching and Healing in Our Time

by Tamarack Song and Moses (Amik) Beaver

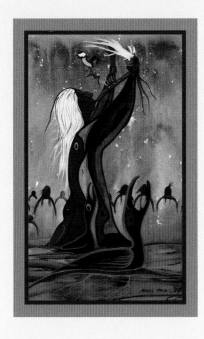

Cover Art

"Wha . . . what was that?" stammered Chickadee as she sprang
into the air and exposed the sound hole she had inadvertently
covered.

—From the story in this collection titled,
"How Flute Came to the People"

All author proceeds go to support the revival of traditional storytelling
and the indigenous cultures keeping the old stories alive.

Copyright © by the University of Michigan 2010
Illustrations copyright © 2010 Moses (Amik) Beaver
All rights reserved
Published in the United States of America by
The University of Michigan Press
Manufactured in Singapore
⊗ Printed on acid-free paper

2013 2012 2011 2010 4 3 2 1

No part of this publication may be reproduced, stored in a retrieval system,
or transmitted in any form or by any means, electronic, mechanical, or otherwise,
without the written permission of the publisher.

A CIP catalog record for this book is available from the British Library.

U.S. CIP data on file.

ISBN 978-0-472-07106-7 (cloth : alk. paper)
ISBN 978-0-472-05106-9 (pbk. : alk. paper)

Partial support for this book's illustrations came from the District School Board of Nibinamik.

To find out more about Tamarack's writings and activities of his extended family at the
Teaching Drum Outdoor School, see www.tamaracksong.org and www.teachingdrum.org

The land is not empty
the land is full of knowledge
full of story, full of goodness
full of energy, full of power
Earth is our mother
the land is not empty
There is the story I am telling you
special, sacred, important¹

−*Wandjuk Marika*
Australian Aborigine, 1900s

Contents

Acknowledgments

WHEN MOSES AND I FIRST ENVISIONED THIS collection, we did not realize how challenging it would be to convert oral tradition to print. Even though Moses, an artist renowned for his narrative pictures, and I, a word crafter, each possessed one of the core components of recorded story, at the same time we shared the same character flaw: a penchant for dreams that defied reality. Where the storyteller can illustrate with inflection and gesture, the writer struggles to infuse imagery into silent ink on cold paper. A storyteller is able to tailor the story for each new audience, whereas an artist's paint dries and the story lives on only as it was first told.

We held another trait in common: undying optimism. After we spent two years exploring the relationship of art and story, our collaboration began to gel and *Whispers of the Ancients* took form. With every turn of the page, Moses' animated paintings and vignettes meshed seamlessly with the text to help elicit the breathless feeling a storyteller can engender.

I cannot imagine a more congenial or dedicated coauthor than Moses. Whether I was his houseguest in Canada or we were engaged in one of our countless correspondences, he was always fully present and gave his creative best.

Fortunately for this book, Moses and I had exceptional cohorts whose views of reality were a bit more grounded than ours. Moses' friend, Karen Bester, worked with him in bringing the stories to life on canvas, as well as helping with logistical matters. My devoted mate, Lety Seibel, transcribed the text, advised and inspired, and maintained an undying belief in me and this project.

Special recognition goes to the members of the Ojibwe community who supported this book project. The District School Board of Nibinamik (Summer Beaver), Moses' band in northern Ontario, awarded him the grant that enabled him to coauthor this book. Two members of Wisconsin's Sokaogon Ojibwe band graciously assisted wtih Ojibwe terms and proper names: Vernadine G. Long (also known as Biiwaasinookwe or Stone-of-Light-that-Travels), a Bear clan Elder and Director of Cultural Preservation; along with Robert J. McGeshick Sr. (also called Anung, or Star), language instructor of the Bullhead clan.

If Moses and I were given the power to create our dream publisher, we'd be hard put to best the University of Michigan Press. They have treated our book with the conscientiousness of a caring midwife preparing for the birth of a child. We are deeply grateful for Senior Acquisitions Editor Ellen McCarthy who, enamored with *Whispers* from the onset, took it under her wing and competently guided it—and us—through the birthing process. Director Phil Pochoda's solid support, along with the faculty board's enthusiastic endorsement and the design and production departments' professionalism, made the whole experience a thorough pleasure.

Several others lent their valued talent and support to this endeavor. Katrina Joyner, our first-draft editor (and quite a storyteller herself), applied her innate feel for stories to help strike that elusive balance between readability and the unusual grammar usage that reflects the Native spirit of the stories. Editor Gloria Hendrickson, with help from Jessica Mansbacher, Susan Heatherfield, Glenn Helkenn, Jessica Leah Moss, Margaret Traylor, and Janet Parr, gathered the loose strands and wove them into the gilded word tapestry you now hold. The inspiration and creativity of graphics wizards Pat Bickner (A New Leaf Creative Services) and Russ Kuepper are responsible for the arresting book design.

Both Moses and I feel honored to have been involved with such caring and creative people as these. *'Chi meegwetch* (We are deeply grateful) to each of them for their part in crafting this book. There are many, many others who have played supporting roles, of whom we are also appreciative. Because this is intended to be a book of stories rather than a litany of accolades, we pray that our personal expressions of gratitude will suffice.

Were it not for the undying spirit of story, perhaps Moses would be painting landscapes and I would be writing math books. This spirit has been kept alive by people such as Rosendo Vargas and J. P. Harrington, who lived in the early part of the last century. At that time the Picuris Pueblo people of New Mexico were losing their stories as their children turned to radio and movies. Pueblo Elder Rosendo Vargas grew concerned and made a bold move: he left the Pueblo in 1926 and found J. P. Harrington, the man who would record the stories of his people. In response, the Elders banished Vargas for telling the stories outside the pueblo and not in the traditional storytelling way. (Any documentation of sacred aspects of culture was and still is considered sacrilegious by many Native people.) Rosendo Vargas died in exile of a broken heart.

Today, because of his vision and sacrifice, his people are emerging from cultural limbo. After a generation of silence, the children can again hear the old stories from the tapes and books which have kept alive the voices of the long-gone storytellers. We would like to express our deepest gratitude to the Rosendo Vargases of every culture who had the vision to foresee troubled times and the courage to save what they could, as well as to all the J. P. Harringtons who had the heart and wherewithal to help.[2]

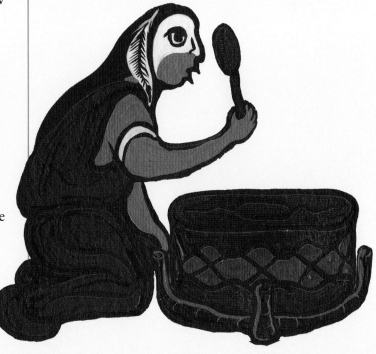

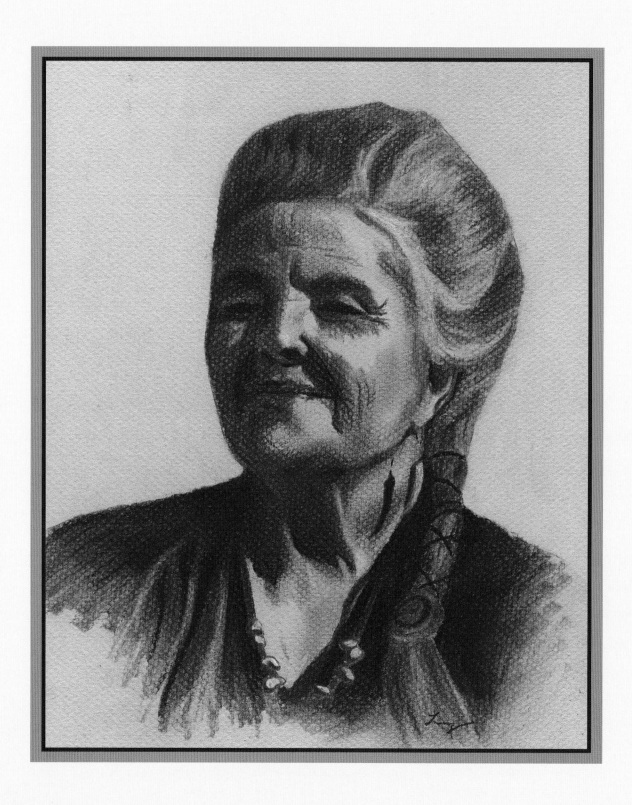

Dedication

In Honor of Keewaydinoquay

WERE IT NOT FOR THE SPORADIC flicker of firelight visible between the trees, I may not have found the campsite. A moonless night in a dense forest can be a very dark place. Once at the clearing, I leaned my pack against a tree and took a place on one of the logs circling the fire.

Across from me was an Elder with the flickering fire's glow shining upon her as though she were in a spotlight. Her dark skin was weathered; her long, white hair lay finely braided and tied with a buckskin cord. A colorful shawl shielded her from the chill of the Northwoods summer night. If she were Hawai'ian she would be called a *kahuna lapa'au* (healer);[3] however, at that moment she sounded more like a naturalist. She was explaining why moths are drawn to fire, only to spiral closer and closer to the flame until they fly right into it. "They think firelight is moonlight, which they use to navigate their way," she explained. "They'll fly toward the fire to get their bearings and then get confused because they don't know how to cope with a moon they can actually reach."

That was thirty years ago and the beginning of the magical world that the respected and well-known Ojibwe Elder Keewaydinoquay (Woman-of-the-Northwest-Wind) helped open for me. To wide-eyed me, she was a spellbinding storyteller; and at the same time her people knew her as their revered *Mashki-keekwe** (Medicine Woman).

Several months later I traveled to an elementary school in a distant city where Keewaydinoquay was invited to share her traditional stories. To the accompaniment of her hand drum, she told of the adventures of *zheengibis*, the silly grebe. Not only children, but parents and teachers, remained transfixed the entire time.

I remained transfixed. Keewaydinoquay became my Elder and guide. She blessed my pipe and helped me find my Native name. She invited me to her

*Ojibwe and other non-English terms are italicized and followed by their definitions.

wilderness island camp where she spent the summers. There, as well as at ceremonies, language classes, academic events (she was a college professor for a time), and her home, I would listen to her stories and ask for advice on how to walk the *Old Way** and follow my *Lifepath*. She explained that we were each asked to do more than an occasional island pilgrimage and ceremony if we were going to help restore balance to the Earth. "It needs to be lived, every day, the way it used to be," she would state in her direct yet gentle style.

I understood. I moved to the northern forest where her ancestors once dwelled, and I began living the way of her stories. The "Blessed Spirits," as she called them, were there to greet me, just as she said they would be. She spoke wistfully of coming to join us, even though she knew it was intended for her to stay behind. There were many in the cities who reached out for her guidance in their personal quests, and who also depended on the island to stay connected with their Native selves. For all of us she was the beloved *Nokomis* (Grandmother).

Were it not for Nokomis, this book might not have been written and some stories could have gone untold. "You have so much to share; you need to write so that it's not lost," I once advised her. She responded with a look that said, "Not me; perhaps you will be the one."

Now I am the writer, and I sometimes wish she had lived to see this book, which includes two of her previously unpublished stories: "Sisters of the Moon" and "The Grandfather and the Stone Canoe." When I recount them, I often hear her voice over mine, as though my words were merely an echo of hers. And yet I wonder whether or not my recounting would draw her approving smile. I can only hope she would embrace this effort as glowingly as she did some of my other writings, including my first book, *Journey to the Ancestral Self* (Station Hill Press, Barrytown, New York, 1994). When she declared it "a landmark work of its kind," I wonder if she knew what a needed boost in self-confidence she gave me.

I am honored to dedicate this book to the memory of Nokomis Keewaydinoquay and to the continuation of her teachings. In doing so, I choose to use the Hawai'ian word *Ho'ola'a*,[4] because it means both *to dedicate* and *to make sacred*. I believe sacred is all anything could be that has been touched by my dear Nokomis. ⋟

*Uncommon English terms are italicized and their definitions can be found in the glossary at the back of the book.

Preface
by Moses (Amik) Beaver

MY NAME IS NAJEKIAABE (Above-Looking-Down). My English name is Moses Amik (Beaver), and I am a full-blooded Ojibwe First Nation in this vast Anishnaabek territory.

I was born in traditional territory, at a time when we still lived off the land and dog teams were a vital means of transportation. I lived in a time without radio or television. Out in the bush, we communicated with others by writing letters on birch bark with charcoal, hanging them in the trees so that others knew where we were if they needed to find us. My uncle said that the bears could read these letters; he would write messages to these bears, asking them not to touch our food supply. It was funny, because it worked—the bears never seemed to mess up our camp. It was my uncle's way of showing me that the animals have intelligence, too.

My uncle taught me the ways of the land: how to track, trap, and hunt. When we were out, he and I had each other, and he would tell me his stories while we were living in the bush. One time we had an Elder and his son stay with us. We piled the wood high on the fire, and the Elder told stories all night. He started at eight in the evening and was still talking at five in the morning . . .

The stories of our Elders were not only a means of entertainment, they were lessons and teachings with a moral base—about making good choices in life— and were important in passing on our history to the younger generations. We learned about powerful medicine men; why animals looked and behaved the way they do; our strong connection to the land and the importance of respect-ing it. My mother used to tell me that everything on this Earth has its place and needs to be thought of in spirit. She always said the trees could talk; she would look at the birds gathering food all summer, hiding it in the trees. She explained that the trees talk to the birds, helping them find their food. She always said that if we listened closely enough, we could hear the trees, too . . .

When I was seven, we had to move to Lansdowne House so I could go to school. Some of my other relatives were forced into residential school and were gone as long as five years. I was fortunate enough not to have had that experi-ence. I still speak our language, I am connected to Mother Earth, I keep my hair long because it reminds me of who I am, and I have held onto my traditional spirituality.

As I grew up, many of us had already begun to lose our culture: missionaries had condemned our beliefs, and the older people were beginning to speak in

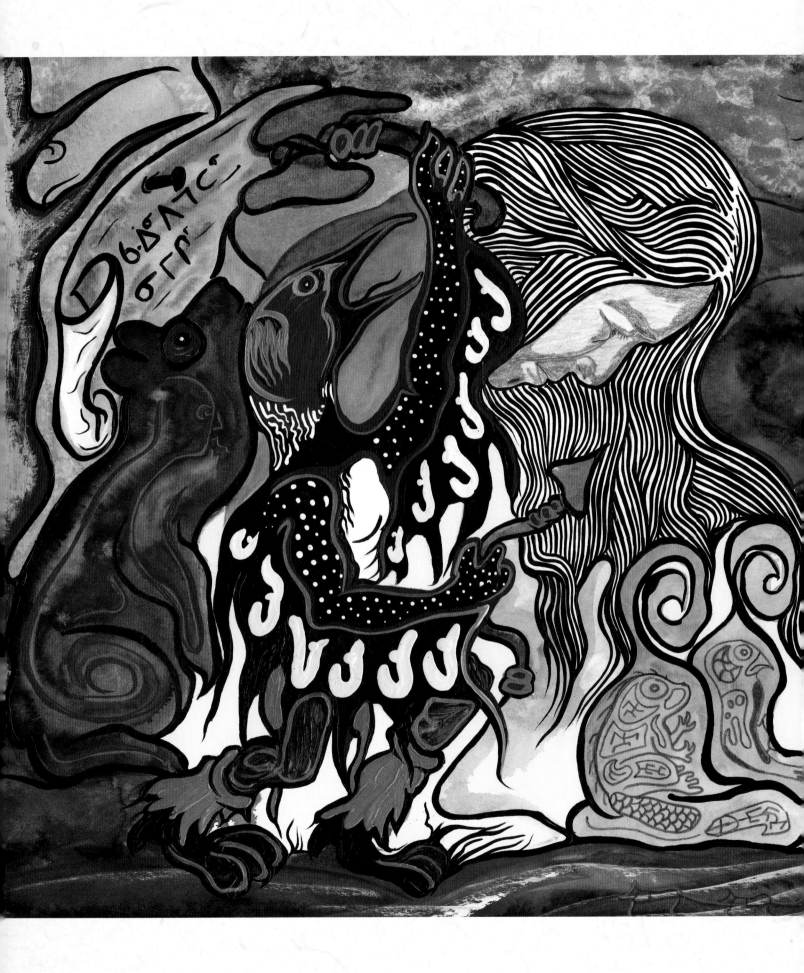

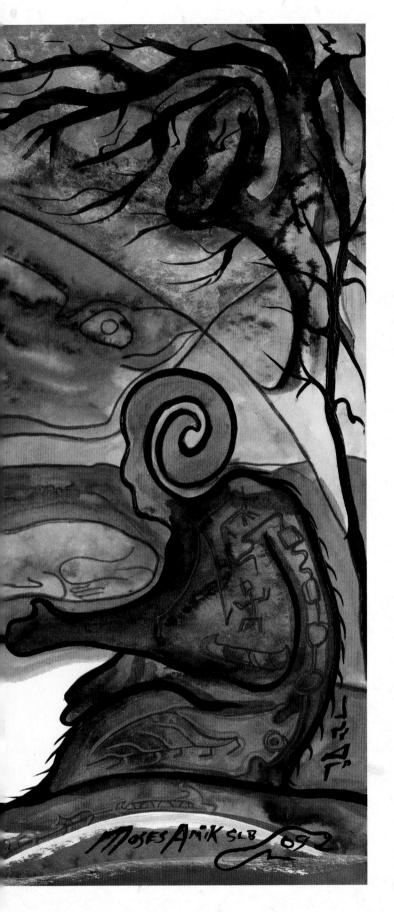

English. The difference between the loss of language and the loss of spirituality is that, because the missionaries learned our language in order to bring us their God, they were better able to push Christianity on us. Today, Christianity still has a huge influence and the language continues to disappear. The children these days cannot speak our language; they cannot listen to our Elders because they do not understand them. They cannot learn from the stories the way I did. Now many Elders are dying. When Elders die, their knowledge goes to the grave with them. It's a sad thing . . .

That's why this legend book is so important to my Nation: once the legends are written, they are permanent. The threat of the stories and history being lost is diminished; by writing them and painting them, we can preserve them. Kids these days are too much into computers, DVDs, and video games to think about the past and who we are, or where we came from. I am hopeful that the visual and textual form for these legends captures young readers' attention and interest.

I owe a lot of this to Tamarack Song. He found me through my website and we connected in Thunder Bay, where I was living at the time. The first time I met him, Tamarack put me at ease; he is intelligent, gentle, and soft spoken. We discussed my illustrations for the stories and he told me how important it was that they come from my perspective, without anyone telling me what to paint. That's what I really liked about it—he wanted me to show what I saw in the stories, to bring them to life in the most organic way possible.

This book is bringing back and keeping so much of what has been lost; it is like a heartbeat. Tamarack's gift to us is to write our stories; mine is to paint them. It felt so natural for me to illustrate them because they were already inside me, already a part of me. Tamarack's idea has been born into a written and visual communication that everybody can benefit from. This book is a perfect collaboration that speaks and illustrates many universal truths. It has been an honor to work with him.

Gitchi miigwetch (I am very thankful). ⟩

The Doorway to These Stories

STARLIGHT GLOWS OPALESCENT on the wind-polished snow, and ice-glazed branches crackle in the breeze. A perfect night to draw close to the fire. Pull your blankets up around you and let the children cuddle in your laps. The winter nights are long and the firewood is stacked high, so we have the time for listening. The drum will soon sound, to signal that the stories are about to begin.

I am Tamarack Song, Owl clan, and I feel privileged to sit in this circle around the sacred fire with you and my coauthor and Bear clan friend Moses Amik. Together we will listen to the indigenous stories of the people—our people—for the long-ago ancestors of each of us were Natives, and they all told the same stories. As the howl of one wolf to another brings spirit to the ageless story of the hunt, Moses will give body to the stories and I will lend them my voice, so that they may come to life.

These stories are my good friends. Some have traveled with me a long time on my journey, guiding me through love and lust for revenge, through elation and the pit of despair. At times they have brought comfort and at other times they have come to haunt me. When I refused to listen, they found ways to break through, shake me out of my slumber, and inspire my healing. With their help, I could again walk with honor and respect. They are the stories of my life.

The stories I have known the longest have been passed on to me by Elders of the Ojibwe and other traditional peoples. I am ever grateful for their keeping the old stories alive. More recent stories have come from friends like Moses, and from the storyline: the collective ancestral memory which is the caretaker of stories ever since the first was told. Hawai'ians call this memory *'ohana*,[5] and it is the single wellspring of our myriad cultures. This means we are all related; this means all stories are one story.

Like butter on bread, cultural context enriches and flavors a story. For the

stories in this collection that had no cultural context, Moses and I chose that of the Ojibwe. It is his indigenous culture, and I have become familiar with the culture from living in the traditional Ojibwe way and having Ojibwe neighbors, friends, and Elders.

A storyteller skips over the details that she assumes her audience already knows. Because of this, someone from another culture might not fully understand the story as it is typically told. For example, if you mentioned a guitar in conversation with your friends, you would not need to explain what it was; however, you would if your audience were Sng'oi Natives from the interior of Malaysia.

Cultures must continually adapt to a changing world or they will not survive, and the same is true of their stories: they must evolve or they become irrelevant and forgotten. This book, therefore, is not simply a retelling of Native legends, nor is it a collection of relics. It is the living expression of our world's cultures, traveling throughout time, story by story, on the wing of human voice.

It is in this tradition that I offer these stories. I transcribed them because many have gone previously unrecorded, and because in this era there are so few storytellers, along with considerable distance between storyteller and audience.

I have honored the storytelling tradition by maintaining the original form and spirit of each story, while at the same time crafting it to be both understandable to contemporary readers and relevant to their lives. In their originating cultures, stories usually have simple, informal titles, as there is little reason to elaborate when there is an already attentive audience familiar with the stories. Titles are used only to identify and introduce the stories, and I have maintained this custom.

There are those who prefer listening to stories rather than reading them, or who enjoy listening and reading simultaneously. I have recorded an audio version of *Whispers of the Ancients*.

As with the Elders who passed these tales on to me, I now give them to you with little comment beyond the traditional citing of their origins. My interpretation could interfere with the voices that wish to speak through and around the stories' words, and each of us will hear those voices differently. A legend will also speak a different voice each time it is heard, because we, rather than the legend, continually change and grow.

Stories are born to be told; without the renewing breath of the storyteller, they will die. We become the story, and hence the storyteller, when a story embraces our personal journey and we enact it. This story may have touched our heart because somewhere a playwright, a painter, or a storyteller was pouring his own heart into it. Each of us, in turn, may well do the same for others, as we are all storytellers.

The stories in this collection embody a quality of relationship that is becoming increasingly rare in this day of disposable goods and dispensable people. With Native people, everything, whether animate or inanimate, has life, and all life is equally cherished. To help empower that awareness, along with creating the feeling these stories would have if they were told in a Native language by a traditional storyteller, I have taken grammatical and spelling liberties that would give an English teacher the jitters! In the stories, the names of plants, animals, geographical features, and many other "inanimate objects" are capitalized, much as one would do with proper names. This practice is in keeping with the tradition established by Native storytellers and early transcribers of Native stories. Some objects are inanimate in general reference and not capitalized, as in *Old bowls leak*, while in specific reference they are animate and capitalized, as in *This Bowl is solid*.

Many languages, including most Native tongues, have non–gender-specific pronouns. The Algonquin *wiin* and the Hawai'ian *'oid*[6]

refer to both *he* and *she*. We English speakers are not so fortunate: we need to choose one or the other, and the common practice is to opt for *he*. To honor both genders in my writing, I alternate arbitrarily between *she* and *he*.

There is a liberal sprinkling of typical Native object-first sentences, as in the Gaelic *Tha eagal oirre*,[7] which translates literally as *Fear is on her,* as opposed to the subject-first *She is afraid.* Combined with the occasional use of passive-voiced verbs (*was paddled by* rather than the active-voiced *paddled*), these features of Native speech help place emphasis on the soul of the story rather than the characters. (Object-first order and passive voice also help create a calm storytelling rhythm.) As a sign of respect and humility, characters in several of the stories refer to themselves in the third rather than the first person, as in *This woman spoke to him* instead of *I spoke to him.* This form of address is typically used in formal settings such as counsels and ceremonies.

You may notice occasional inconsistencies in a few stories, such as the sudden, unexplained appearance or disappearance of a character, an odd change of scene, or an abrupt ending. Rather than being reflections of my storytelling ability, these quirks in traditional stories are intentional, to help pull listeners out of the rational world and open them to the possibility that things are not always as they seem. The power of the old stories lies in the fact that they come from a realm steeped in magic and unbounded by linear reality.

Other twists are of a more mischievous nature, with the storyteller trying to outwit his audience by disguising one irregularity in each story enough that only the most clever and alert will discover it. I honor this tradition by practicing it in most stories. (Hint: the illustrations are fair game also.)

Native words are woven throughout these stories, which helps maintain their traditional feel and, in some instances, conveys concepts that may be unfamiliar to the general reader or untranslatable to English. These terms also serve to slow the reader down and transport her to another realm of consciousness. Unless otherwise noted, these words are from the Lake Superior Ojibwe dialect of the Algonquian language. Ojibwe is the first language of coauthor Moses (Amik) Beaver; and being spoken by many of my Elders and friends, it has become my second tongue. Additionally, a number of the stories in this collection were given to me by Ojibwe Elders, so I have retained some of their language to help convey the stories' spirit.

Native words and phrases are italicized the first time they appear in each story and are followed by their parenthetical definitions, as with this example, *Mishomis* (Grandfather). Exceptions are complex terms, whose definitions can be found in the glossary of Ojibwe terms in the back of the book. (Uncommon English terms are italicized as well, and their definitions appear in their own glossary, which is also at the end the book.) Some terms have more than one definition; the appropriate one can be determined by context.

Students of language may be interested in knowing that most of the Ojibwe words are presented as I have learned them from my Elders and other Native speakers. Additionally, I consulted reference works in my library and others. I found these sources to be of particular merit: *A Dictionary of the Ojibway Language* by Frederic Baraga,[8] *Ojibway Language Course Outline* by Basil Johnston,[9] and *A Concise Dictionary of Minnesota Ojibwe* by Nichols and Nyholm.[10] Extensive or detailed inclusion of a second language—especially one as complex as Ojibwe—would interfere with the flow of these stories. I favor simplicity and readability over linguistic accuracy, so you will not have to take an Ojibwe language course before continuing. Whenever possible, I use shortened

versions of names and the basic singular forms of nouns, along with phonetic spellings for ease of pronunciation. An apostrophe between syllables indicates a glottal stop: the type of throat-pinched pause that occurs between the syllables of *uh-uh*, slang for *no*.

Those of you who wish to learn some of the Ojibwe language might start with the words in these stories, which are compiled in the glossary of Ojibwe terms in the back of the book. For more extensive study, I recommend the *Pimsleur Ojibwe Language Program* by Simon & Schuster Audio. It is completely aural, which gives it versatility, as well as being the most effective way to learn a language.

Some of these stories are straightforward parables; others go much deeper, raising questions that may take a lifetime to answer. Pay particular attention when a story stirs an emotion, or where it irritates you. These are your personal doorways to the teaching aspects of the story. They are the places within you where healing is required and where wisdom can find a place to rest.

Because these stories are allegorical, they have great power. When taken literally, they may not make as much sense; however, if you let yourself *become* the story, you may be surprised to discover which world you find is real and which is myth. Their magic—their potential—can then liberate you from the constructs of your everyday life.

Stories serve many roles. Because each of you is at a different place in your life, you may want to choose a story that speaks to you most strongly, rather than simply beginning with the first story in the book. To aid your selection, I have grouped stories according to theme in their own chapters, and each story's particular focus appears after its listing in the table of contents. While a chapter's stories form a continuum, each story is complete in itself.

The best way to hear a story is directly from a storyteller. If you retell these stories—and I strongly encourage you to do so—you may wish first to read the glossary to familiarize yourself with the terms and concepts in the stories. Then get to know the story itself, so that you can tell it in your own words, and always gear it to your audience. If you are reading from the book, paraphrase and add explanations as needed. Remember the power of pauses: they are one of the simplest and most effective storytelling techniques. Use them to create the feeling of passing time and to give space for assimilation and reflection. Just as important is verbal punctuation, which Keewaydinoquay, my dear Elder, taught me how to affect by using understatement, emphasis, and changing rhythm.

A good storyteller can breathe life into a story virtually anyplace. The rest of us need to choose a subdued location, free of interruption. I prefer a place where I can be at eye level with my audience and we can sit in a circle.

Our ancestors are honored when we come together in this way. They sit with us, as do those of the coming generations. Every time we share these ancient stories we help the ancestors reach across time and grace the future with their wisdom. An endless ritual that has been enacted for as long as we have been human, this way of listening joins us in the old way of sharing our gathered knowledge and the teachings that well from it.

For one reason or another, these stories have come to you now. I pray that they touch you with the same spirit that has always stirred me. And in the event that one does, embrace it like an old friend, because deep down you have known each other for a very long time.

Now, in the words of countless generations of Hawai'ian storytellers, I will say *Ha'ina mai ka puana*—Let the story be told.[11]

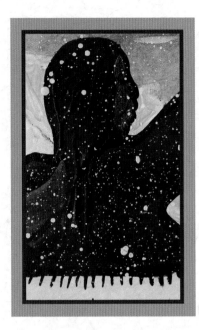

Introduction

A Story to Invoke All Stories

SEVERAL YEARS AGO, my mate Lety told me an old Mayan story about the bitter fruit of gossip. The tale has been passed down for generations in her family, who are Indians of Maya, Olmec, Mixtec, and Popoluca descent. I have since heard the same story (found in this book under the title "The Woman and the Talking Feathers") in places as seemingly unrelated to ancient Mesoamerica as Ireland, Billy Graham's pulpit,[12] and an old rabbinical story.[13]

Whispers of the Ancients is a collection of stories for all people, because they are known to people of all cultures and creeds. Eminent mythologist Joseph Campbell is renowned for his exhaustive work showing that stories past and present are based on themes common to the human experience.[14] Essentially the same stories can be found in nearly all of the world's diverse and far-flung cultures. Whether in a Bedouin tent, a Navajo hogan, or a movie theater, you'll hear stories of anger's curse and the trickster's wit, of creatures who stalk the night and demons who protect the enchanted farther places.

Swiss psychiatrist Carl Jung identified the source of these stories as the collective unconscious.[15] It is known as the Dreaming by Australian Aborigines[16] and as the universal mind in popular culture and some academic circles.[17]

In *Whispers of the Ancients* you'll find representations of the major universal story themes, including several never-before published versions, regional Ojibwe forms of origin stories, and a unique variant of the human origin story. Most story descriptions identify the story's universal theme.

A demonstration of the multicultural nature of the stories and the collaborative foundation of the book occurred in June of 2007 when the fifth and sixth graders of Ogden Community School in Thunder Bay, Ontario presented a stage version of "How Bear-Heart-Woman Brought Truth Back

to the People." The students, half of whom were Native, and half of whom were non-Native, performed the play six times to over 1000 people in Native and non-Native communities, along with a special presentation to a group of Ojibwe Elders. The play has received nothing but praise from Elders, the public, and the press.

Lila Cano, director of Community Arts and Heritage Education Project, which sponsored the play, summed up its spirit with these words: "[The tale] really spoke to me because I think it was a story that everybody needs to learn again—all cultures, all people." *Whispers* coauthor Moses (Amik) Beaver, who worked with the multiracial staff as the play's artistic director, had this to say in a post-performance interview: "To me, kids are like colors. When I teach, I see different kids all the time. There are a lot of colors in this world, [and they are] my inspiration."

There may be no more appropriate way to introduce a story collection than with a story. Here is a classic tale of the hero's journey—a story theme to invoke all stories. It takes place far to the North in a mystical place where the ice cracks like thunder and Bears* wear coats that look like thick white frost. Whale and Walrus play in the waves, while White Fox and Raven scavenge the beach.

There, in a snug stone-and-sod lodge on a rise overlooking the Water, lives an ageless Elder known as *Bezhig* (Paddles-Alone). Some say he lives by himself; however, he will tell you that he lives with the buffoons, the tricksters, and the heroes in his stories, and that they keep him good company.

On many a long winter's night, the ancient storyteller's family, who are of the White Bear *clan*, come to visit him and listen to his tales of

*In keeping with the Native tradition of showing respect for all life, the names of specific plant, animal, and mineral entities are capitalized.

the Long-ago. His voice travels like words on the Wind, because like the Wind it sails in from places unknown, fans the fires, and then travels on to find the future. This happens to be one of those storytelling nights, so let us join Bezhig in his lodge.

* * *

One day before your parents were born, I walked out to the edge of the ice in front of the family Lodge to spear some Fish. I was a young Man with mate and Children, we were nearly out of food, and I was anxious to try out a new lure I had just made. "It's a lazy day," I thought to myself when I reached the Water. "I'll take a nap and then I'll fish. I'm tired from trudging through the Snow; and besides, the Fish like to feed after the Water warms up from the midday Sun." I found a comfortable place to lie down, and the softly lapping Water soon lulled me to sleep.

"Where am I?" I gasped as I sprung to my feet and looked around frantically. When I fell asleep I was surrounded by a field of white, and now in every direction all I could see was blue—a Sea of blue and a Sky of blue—and I could not tell where one ended and the other began. This, and the tiny island of ice under my feet, rolling on the swells, caused me to sway so much that I no longer knew which way was up. I remember saying, "I feel dizzy . . ." and then everything went black.

"Oooh, my head," I moaned as I awoke. Struggling to get up on my knees, I reached up to find a gash across my forehead. I must have fainted and gone down face-first. Splattered with my blood, the jagged ice looked like the bloodstained teeth of some demon whose wide-open jaws I fell into.

"What sorcery is this that marooned me on this crumbling scrap of rotten ice?" I screamed up at the empty Sky. "Why didn't the Great

Mother Water boom and shake like She always does to warn her Children when She's about to shed her skin of ice? Why has She forsaken me? Could I have slept through her thundering voice?" I wondered. "Impossible! And yet here I am, caught like a tiny Fish in the jaws of a great hungry Whale."

I drifted all the next *Sun* and into the next. Not a Bird, not a Seal—nor even a Fish—swam by. Only Water and the Wind murmuring to the waves. My white Wolf-skin parka was warm and I had good sweet ice for Water, and yet I grew colder and colder because I had no food to stoke my inner Fire.

Early on the fourth morning I woke up, barely able to raise my head. My teeth clattered like shells rattling in a Basket. "I fear it is my time to die," I lamented. "If it were intended for me alone, I would be at peace; however, my Children have no food and my dear Mate will kill herself trying to find some. Her aged parents will steal away naked into the night so that their furs and foodshares might keep the Children alive longer. When our clan mates next come to visit, they'll find my family frozen to death, and they'll say, 'Bezhig is no good; he has abandoned them.'"

With no more need to live, I wailed to the setting Moon, then dragged my defeated flesh into a hollow in the ice and curled up. My last memory before I fell into a deep sleep was of an incessant Wind tearing at me and the ice around me. In my sleep I had the vague impression of a soft Snow falling and covering me like a warm fur.

Sometime in the night came a vision: Far in the distance I could see Great White Bear swimming from floe to

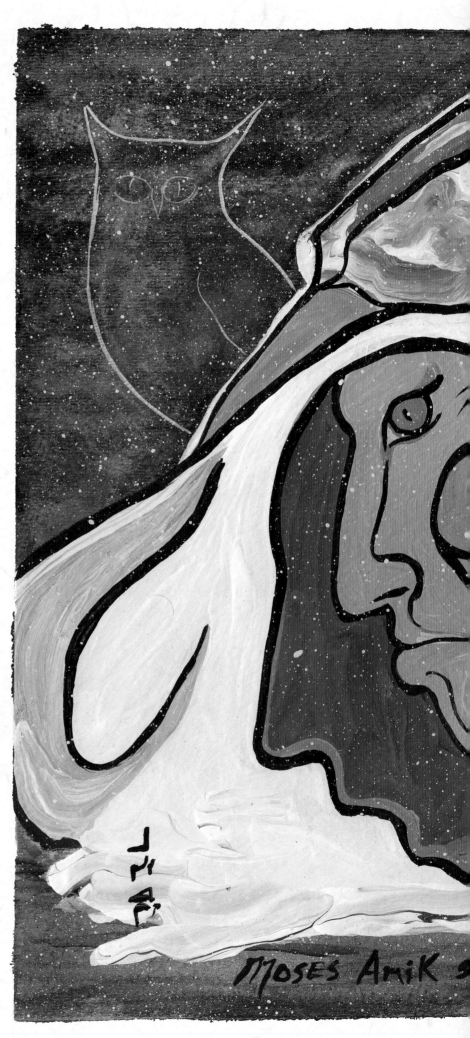

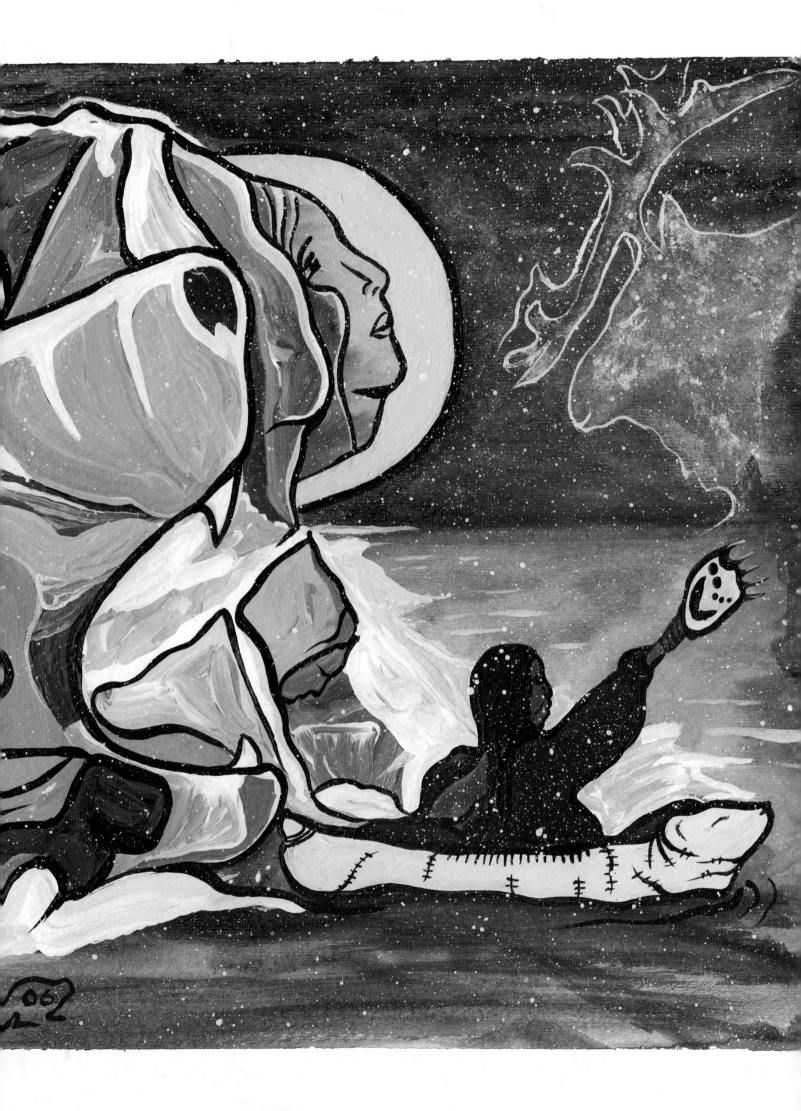

floe. For four Suns she swam, gradually coming closer and closer, until she finally reached the floe that carried me. She was so gaunt and weary that she was barely able to drag herself up onto the ice, where she immediately scouted for a place to collapse.

My resting place must have looked like a comfortable nest, as she lay on top of me and was soon fast asleep. Had she any idea what lay beneath her, I'm sure she would have first filled her belly!

"Wake up!" I hollered inwardly to my sleeping body, but it could not hear me. "You're a fool," I shouted, "you lay there feeling sorry for yourself while your family starves!" Still, my almost lifeless form would not move.

The Wind continued to howl above, and yet all I could hear under my heavy cover was a whisper. "Wait," I cautioned myself, "Listen … it's a voice …" It was an ancient voice, that of an Elder from my youth, saying just as he did so long ago: "Your bowl is half empty because your mind says it is. Listen to your heart and your bowl will become half full, and then you will be able to fill it the rest of the way."

My ocean of rage cascaded from me like Water down a rapids. There before me stood my clan: Children, Elders, Sisters, Brothers. I could not tell whether they were Bear or Human, I simply knew intuitively that they were both. Among them stood Caribou and Seal and Wolverine, and hovering overhead, Falcon and Owl. "My *Relations*," I whispered softly as tears filled my eyes, "I will live for love—I will live for you."

The strong, musky smell of wet fur tickled my nose and shook me awake. At the same time Great Bear started to stir. "Nooo!" I screamed as I came to fully realize what lay on top of me. "I will not die!" In a flash I had slipped my knife from its sheath, forced it up through the Snow, and plunged it into the heart of the Bear.

Life-giving blood gushed down through the Snow and into my mouth, and between chokes

I gulped it down. Immediately the Fire of life charged through me and I squeezed out from under the massive, limp body. Kneeling beside her, I opened my heart and it showered these words upon her: "Great Bear Spirit, this Man has walked into the icy jaws of death, and you have gifted him with a second life. His other life was for himself only, and he's glad that it has passed. His new life is for his People, and he's glad that it has come."

I then cut out White Bear's heart and held it in my hands as my tears washed over it. "You will live on within me," I spoke, "and your strength and passion to serve others will continue to nourish my People. In the tradition of those who have walked before me, your heart will now become mine."

I feasted upon the heart, wrapped myself in White Bear's pelt, and slept soundly through the night. And yet I only got physical rest, as I dreamed on and on about White Bear swimming, swimming, swimming, far out on an endless ocean. For many Suns, nothing appeared on the horizon, though she still seemed to know where she was going.

"Of course!" I blurted out as I woke up to first light, "White Bear is a great swimmer; surely she can take me back to my People, because . . . because . . . she is me—I am the White Bear!"

Right then I set myself to cleaning her broad curved ribs and lashing them together with sinew to form a framework. Over this I stretched her hide, tied it down, and soaked it with Bear oil to make it waterproof. From one of White Bear's broad front paws I fashioned a Paddle, and then I loaded the boat with meat and fat for my kin.

Before I pushed off, I bowed my head to the face of my tiny island of ice and forced these choked words: "Every time the ice thunders, this grateful Person will look out upon You, honored Mother Water, and his voice will rise in a Song

of Thanks-giving. When he didn't listen, he was shown how to listen. In dying, he has been given reason to live. When he despaired, he was given trust. In the alone of alone, he found a circle of love. The cursed Wind stole him away; the same Wind—the Blessing Wind—now whispers his way home."

* * *

My friend Nick Vander Puy is also like the Wind: he comes in from a far-off place with stories of things unknown. Recently he came to harvest wild rice with my family; we gave him food and he gave us stories. He had heard the story of Bezhig and White Bear from a man who lived with Bezhig's people, the Yup'ik, on the western coast of Alaska.

Storytellers, like the Wind, come softly and forcefully, announced and unannounced, invited and scorned. Take, for example, the story you were just given. How did it come to you? Did you

expect it? Do you have any idea how it might affect you? Are you aware that, like the Wind, these stories will travel through you and beyond you, because you are also a storyteller?

We are all storytellers, and life is our story. Whether or not you retell this tale of Bezhig, you will share the spirit of the story with those in your life, and you will pass this spirit on to the next generation. That is because you are part of the continuum that began even before our kind knew language, and the continuum will go on until the last person's final breath.

Whispers of the Ancients is a doorway to this continuum, where you can step into a world quite different from the one you perceive. It is a sacred place where plants have spirits and animals lead lives of purpose, just like humans, and where all of life interacts as peers.

Part I of this book is a celebration of the magic of story and the mystique of the storyteller. It brings you back to the time when listening to stories was considered a spiritual experience. Part II is a feast of some of the world's most evocative and soul-touching stories. So turn the page and listen now to the whispers of the Ancients. ❧

The Power of Story:
Where Stories Come from and Why We Tell Them

Introduction

Story Is Life

"THE UNIVERSE IS MADE OF STORIES, not atoms,"[18] poet Muriel Rukeyser once said. Whether it be the entire cosmos or a speck within it, stories hold their blueprint for existence, stories give them purpose, and stories are the web that binds them together. The life of our universe is one immense adventure story. Our Mother Planet's life is the story of evolution, the birth of our stars is the story of the Big Bang. These stories are essential to life, and that makes storytelling essential to the human experience.

"For Mongolians, a person who cannot play a *morin khour* [a traditional stringed instrument] or sing a song is not a human being,"[19]* says Oyun, a nomadic Mongolian storyteller. As individuals and as cultures, we need stories for survival and renewal. In 1870, a !Kung San (Bushman) in South Africa spoke such yearning from his jail cell: "I sit waiting for the time to come that I may listen to all the people's stories . . . I do merely listen . . . turn my ears backwards to the heels of my feet on which I wait, so that I can feel that a story is in the wind."[20]

More recently Shiro Kayano, a storyteller of the Ainu tribe of Hokkaido Island in northernmost Japan, voiced the cultural importance of stories in this way: "My father saved all of our family's extra money to buy a tape recorder. This was such an expensive thing for him to buy. I didn't understand then the importance of what he was doing. You see, with no written language, our people were superb storytellers. The stories contained all the wisdom of our people. My father has now recorded more than five hundred hours of Ainu stories that would have been lost."[21] (The minority Ainu were rapidly losing their stories due to Japan's official program for the extinction of the Ainu culture.)

Had those stories been lost, Ainu culture would have died. The people, yet needing story in order to survive, would have adopted the stories of the dominant culture. In effect, this would make them Japanese—the end result of the process we call assimilation.

Story is power. Ignored, it will kill. Honored, it will bring life. Let us take the example of Shiro Kayano's father and listen to our culture's storytellers to learn our stories. At the same time, let us find and embrace the storyteller within. Story and storyteller will then become one, and we will find that story is life and life is story. ✣

* All quotes are reproduced exactly as found in their original sources, with no attempt to conform them to contemporary rules of grammar and usage.

Chapter One
The Role of Stories

I'll break open the story and
tell you what is there. Then, like
the others that have fallen out onto
the sand, I will finish with it,
and the wind will take it away.[22]
— *Nisa, a !Kung San woman, 1969*

JUST LIKE THE WIND, a story can bring the chill of foreboding clouds or the warmth of a familiar essence. Its seductive touch might entice one on a *Journey of Discovery*. As with the wind, a story travels from one region to another, its origins often remaining wrapped in a veil of mystery. And as with the wind, a story has a voice of its own, no matter what its source or who is telling it.

This voice lures us away from the familiarities of our world so that we may come to know our innate selves. This experience is implied in many Native terms for *story*, such as the Gaelic *sgeul*[23] and the term *kukumi*,[24] once used by the now extinct Xam Bushmen of South Africa. Stories transport us to dreamscapes where we observe ourselves enacting the dramas of our lives. Think of a story as a play with nameless, faceless actors, where each person in the "audience" observes himself as the main character on the stage. From this vantage point, each of us can more easily find the reality within our own illusions and the trust within our own fears, along with the personal guidance intended for us.

THE GLOBAL STORY

Stories reflect universal themes common to the human experience. No matter what the continent, culture, era, or belief system, the same stories surface, as there is only one storytelling tradition. Variations in language, climate, and lifestyle are no more than ripples on the reservoir from which our stories flow. An Arctic Inuit legend of a boy on his first hunt differs little from the !Kung San legend that comes from the African Kalahari. Robin Hood, Zorro, and Han Solo are all the same person. Bugs Bunny was brought to us by African slaves in their ancient stories of Zomo, the trickster rabbit, who in America met his cousin Nanabozho, the legendary Native American trickster who would transform into a rabbit.[25]

Storytelling, whether it be in the guise of speech, dance, song, or symbolic art, is probably the oldest of teaching methods. The sharing of stories was undoubtedly a favorite pastime of our distant ancestors as they gathered around the fire. Their stories chronicled their history, amused their young, and instructed them in the ways of life. Ota K'te (Chief Luther Standing Bear), an Oglala Lakota who lived in the 1800s, expressed it in this way: "Long before the Indian was skillful enough to make musical instruments, he composed and sang songs in which he put the history of his tribe. He told of his wars, his ceremonies, and his travels. There were brave songs, medicine songs, war songs, songs of reverence to the Great Mystery, and love songs. Then the lodges had their songs which only lodge members sang. Even the individual had songs which he composed for himself alone . . . no matter what event in life the Indian faced—he sang."[26]

To this day, storytelling plays a central role in people's lives. We congregate in front of projection screens rather than gather around hearths, and the storyteller's voice reaches us indirectly through a speaker. Other stories come in the form of songs, books, plays, and prayers.

THE CORE FIRE

Friend and fellow storyteller Terry O'Brien recently shared with me a dream she had that vividly pictured the central role of stories in our lives: "I [Terry] stepped into a clearing and stumbled over a heap of bones. Looking around, I saw more bones, laid out like spokes of a wheel. Its hub was the charred remains of an ancient campfire.

"'These are the bones of the storytellers,' I exclaimed as I suddenly realized that the stories shared around the fire were so compelling that no one wanted to leave. Story after story, they listened, until one by one they fell into the sleep of no awakening."

"Perhaps it is a story," said Terry after she finished relating the dream, "a telling and retelling that is the hub of every circle."

WEARER OF MANY HATS

The role of stories ranges as far and wide as the spectrum of human life and culture. Some hand down a people's traditions and prophecies, others preserve knowledge of hunting, food preparation, and crafting skills. There are stories explaining the forces of nature such as storms, floods, and eclipses. Healing stories offer relationship and emotional guidance, and awareness-raising stories help people open to their greater potential as they learn to see with different eyes. Maps depicting travel and animal migration routes are sometimes conveyed in story form, as with this recollection of Ohiyesa's from his Santee Dakota boyhood in the1800s: "It is customary with the hunters and warriors to tell their stories of adventure most minutely, omitting no geographical and topographical details, so that the boy who has listened to such stories from babyhood can readily identify places he has never before seen. This kind of knowledge is simple, and, like the everyday

meal, it is properly digested and assimilated, and becomes a part of one's self."[27]

I place personal stories in a category of their own because of their importance to both the storyteller and her people. These recountings present the discoveries of journeys, along with lessons learned from the hunt and other personal life experiences. While reflecting upon a story before its telling (a typical exercise), the storyteller often gains new perspective. This is an invaluable gift because it is the pure wisdom-voice of the storyteller, unaffected by anyone's input. So uniquely precious is the gift that it would likely not be had if the story were not shared.

There are also those stories that seem to exist purely for the joy of it. Some academics would disagree, and yet my experience and the opinions of Natives, such as the following one from Netsit of the Siberian Yukaghir tribe, tell me that pure entertainment is valid enough reason for a story: "It is not always that we want a point in our stories, if only they are amusing.

It is only the white men that want a reason and an explanation of everything; and so our old men say that we should treat white men as children who always want their own way. If not, they become angry and scold."[28]

PROVERBS

Ralph Waldo Emerson once said that common sense is genius dressed in its working clothes[29]—an apt description for what we know as sayings, maxims, axioms, adages, and proverbs. Michael Patterson, a proverb collector, defines them as refined, popularly used tidbits of wisdom.[30] I describe them as stripped down teaching stories.

These mini teaching stories are so highly regarded in some cultures that there are now proverbs extolling the virtues of proverbs. The people of Sierra Leone say that proverbs are the daughters of experience,[31] and an American adage states that proverbs are short sentences based on long experience.[32] A favorite of mine is "A proverb often flashes light on regions where reason shines but dimly."[33]

Some proverbs, such as "Slow down and live," are so mundane and commonplace that one would hardly recognize them as proverbs. Others, like "A book can't be judged by its cover," are cliché and obvious. Many are direct and to the point (Practice makes perfect) and give good advice (A penny saved is a penny earned). They impart solid wisdom based on long experience. Still others can be metaphorical: "A rainbow only follows a storm."

Two wellsprings give us our proverbs: wisdom and common sense. Their waters often mix, as when salt-of-the-earth wit is admired and adopted by the learned, or when common people find value in the formal words of the wise.

However they are described, from wherever

they originate, and no matter who uses them, proverbs are valued in virtually all cultures. Some people, such as the Saami (Lapplanders) of northern Scandinavia, have a sacred word for them: *sananlasku*.[34] The New Zealand Maori show this reverence in their proverb "Hold fast to the axioms of your ancestors."[35]

Because proverbs don't have the substance of a typical story to make them memorable, many employ a clever twist or play on words. For example, this saying from the Damara tribe of South Africa, "He who wishes to seduce a !Kung San man's wife had best first grow eyes on his buttocks,"[36] would probably have been long forgotten had it been stated merely as, "If you are going to do something risky, first make sure you have it well planned."

In both traditional and contemporary cultures, proverbs are often used for guiding young people when there is not the time or circumstance for sharing a longer story. Proverbs can also be easily remembered and quickly recalled—a boon for a busy parent who must convey something in a hurry.

Proverbs are a good example of what all lasting stories have in common: they are entertaining and they are relevant. These core roles are essential, for therein lies their magic and their immortality.

The enduring life of a story is the person who becomes the story. Proverb, poem, mime, or movie, its spirit is the spirit of the one who fears or cries or laughs it. When a story is told with heart, a life is shared, and when a story is taken *to* heart, a life is renewed. ❧

MINI MESSAGING

The Japanese people are particularly fond of proverbs, which are employed in all types of communication to help keep it brief, to the point, and clearly stated. This is the likely reason for the huge popularity of cell phone instant messaging in Japan.[37] Here are several commonly used Japanese proverbs:

Depend on your walking stick, not on other people.

Difficulties make you a jewel.

You can't see the whole sky through a bamboo tube.

Sleeping people can't fall down.

Darkness reigns at the foot of the lighthouse.

Even monkeys fall out of trees.

Deceive the rich and powerful, but don't insult them.[38]

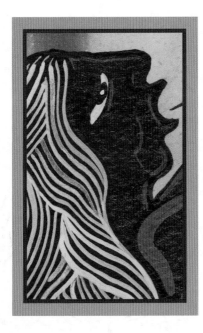

Chapter Two

The Soul of a Story

A STORY'S VOICE, OR SOUL, belongs to no one and everyone. The body of a story reflects the personality of the storyteller and the character of the culture, and like the storyteller and the culture, it is born and it will die. Not so with the soul, for like all souls, it is eternal.

We remember stories because they take care of us. Our stories are more important than food or weapons or clothing, because they give us the wherewithal and the wisdom to find nourishment, peace, and warmth. They are the conveyors of culture: they keep it alive and spread its consciousness and cumulative experience. They give culture a continuity that spans generations.

We also remember stories because they are ours to take care of. Each one has come to us for a reason. Lasting stories, pregnant with the best of a culture's awareness and wit, have been cradled in the hearts of generations of storytellers and honed to brilliance through countless retellings. They have stood the test of time and have earned the venerable title of legends. The Saami's word for legend, *muinaisrunous*,[39] is deeply infused with reverence.

Legends often begin as personal stories which strike a common chord, so they are remembered and retold. In time they may be adopted by the entire culture. When they persist through war and migration and all else that the ages might heap upon them, they become legends. These cultural treasures are a people's enduring friends and guardians.

Stories become legends the way people mature into Elders: by becoming doorways to the more profound aspects of life. As with an Elder, a legend's function is not to explain life's source or meaning but to involve us fully in its richness and experience. In this way, we can come to know life's mysteries ourselves, in our own time and way. It will then be our personal knowledge

rather than something we are repeating from someone else.

Some legends are a culture's diary, or a history book of sorts, in that they chronicle the life of the people. We call these stories *sagas*, *runes*, and *epic poems*. We consider them to be history and yet they differ fundamentally from our traditional history, which is a noun: a record of dates and events. Sagas and epic poems are verbs: recountings of experiences and awakenings.

I watch people who listen to these old stories; adult and child alike become entranced in childlike wonder. A good story never becomes outdated and a person never outgrows his thirst for one.

Stories embrace the enduring spirit of a traditional people. We who come from cultures preserved by written stories, which we call history, often have trouble understanding this. Because we take our stories to be a literal chronicling of past times and culture heroes, we tend to place the same expectation upon stories from the oral tradition. Even though both *story* and *history* come from the same Latin word *historia*, they differ in significant ways. History is a linear chronicling of what a rationally based culture values and critiques: things, places, and events. The old stories embody a different consciousness, a different way of perceiving the world, which we are about to explore.

LIVING THE STORY

Stories have life because they are about living people—you

and me. We are the stories' heroes and fools. "Sometimes I feel like the first being in one of our Indian legends,"[40] comments Lakota mystic John (Fire) Lame Deer. Story characters personify our aspirations and desired qualities. Often free of reward or sanction, the characters provide us with examples of behavior to emulate and avoid. We reenact their adventures, follies, and lessons as our life journeys parallel theirs. In doing so, we personalize and expand upon the story. This is our gift to the story for the blessings it has given us, and this is one of the ways the story stays relevant to the times.

This personal relationship with a story's characters is evidenced in the North Australian Yolnu Aborigine's term *wanarr*,[41] which means *culture hero*, as well as *ancestral and personal sacred objects*. *Baayama*[42] is another similar term from Australia's Gamilaraay Aborigines.

The characters of stories are often one dimensional. This is so that they can clearly symbolize singular aspects of the self. When we look at all of the characters together, these aspects of self merge and we find a dynamic, multidimensional persona in whose footsteps we can tread. A story works when we become the persona, and vice versa.

ANOTHER REALITY

To be relevant to our life and times, stories do not have to make rational sense. Stories seldom fail because they are too imaginative or unrealistic, but because they are not imaginative enough. A story needs to take us out of our present reality so that we can look back upon it and gain perspective. Therein lies

both the beauty and the power of story. By not being constricted to our personal or cultural understanding of reality, stories can bring us new worlds of awareness and possibility.

Because children of most modern cultures are indoctrinated early on with the supreme value of logic, some children react with scorn and disbelief when hearing a traditional story. And rightfully so, because according to the definition of a lie, traditional stories are full of them. Many adults not only accept these lies, but they like to dress them up with terms such as *culture hero* and *metaphor*. The paradox is that these lies give us the story's truth, and the more skillfully and attractively the lies are told, the stronger the truth.

Stories are like dreams in that they address the now. They resonate with where we are at and offer timely insight and guidance. At the same time, they connect us with times and people past, to help us realize that others before us have faced the same questions and challenges and have done the same silly things. In this way stories can help us to feel that we are not alone: that we are connected with the common human experience.

We all know stories and use them for the same purposes: to entertain, provoke, inspire, and transport. Because our stories are about real life, they have sanction to speak explicitly about all the textures of life, from bodily functions, sex and violence, to birth, growing pains, and death. In Native societies even the very young are familiar with these events because they occur openly and are viewed as natural parts of life. For this reason, "adult stories" are rare, and such stories might actually be used to help their children explore and understand life.

Recently a woman expressed to me her concern that her interest in traditional stories kept her dwelling in the past, thus interfering with her efforts to be more in the moment. I was fascinated by the question because I had

not considered it myself, so I jumped on the opportunity to explore it. Following is my reply:

My awareness of my world is limited by my sensory abilities. When I broaden my concept of self to include the life around me, I become this life and its experiences become mine. In this way, when I guide young people they give me the gift of seeing through their eyes and touching with their hands.

When what they experience runs parallel to the experience of my youth, I am taken back to that time, which allows me to relive the experience and grow anew from it. I can do so because I see life as a spiral rather than a progression. There is really nothing new under the sun, because as my life comes around upon itself, I revisit the places, experiences, and feelings of old. And yet each time I gain something new, something I hadn't noticed or been ready for the last time around.

Even though one day spirals in much the same way as the next, no two days are alike. The same is true of the spirals in my life. Each time the spiral comes around I am given a new skill, broader wisdom, and perhaps a deeper understanding of self. And always, a greater sense of relationship.

This is the way with stories. They recount the past and yet they are very much the present. And the future. When we hear them again and again, they will tell us nothing new. However, if we were to listen anew each time, we might well *hear* something new. Ancient times are now and will be again because past and future are only constructs of the mind. We are continually living our ancestral memories and we are continually enacting the lives of our children's children.

How often have you heard somebody say that they are hearing the same old story? Of course they are. At least as much as every day they are seeing the same old sunset.

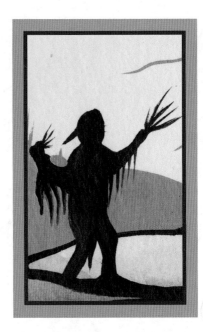

Chapter Three

The Body of a Story

A GOOD STORY IS LIKE GOOD FOOD: It is anticipated, savored, and nourishing. The same happens when the appetite is whetted by the storyteller. If she were Saami, she might begin with *Ennen vanhaan*,[43] or if she were a Gamilaraay Aborigine, it would be *Yilambu*,[44] both of which mean *In former times* or *In days of old*. Such invocations, which introduce stories all around the world, immediately take us to another place and time, freeing us of our present reality.

STORY AS METAPHOR

Like food, the experience of a story is different for each listener. This is because stories are metaphorical, which means that characters, images, and situations are representative of something outside the story. The metaphor of a relevant story will draw a parallel to the listener's life. For example, a butterfly emerging from a cocoon could be a metaphor for personal transformation, or a person crossing a mountain range might be a metaphor for one's life journey.

Metaphor works by creating distance between us and our experiences, allowing us to see ourselves with perspective. Metaphors give a story universality and immortality because they permit many different types of people who live in different times to relate to the story. Metaphor is the real voice of the story and the source of its power.

Within a metaphor are symbols: things simple and familiar used to represent things larger or more dimensional. For example, a raised hand could symbolize a greeting, and a flower might be a symbol of beauty. Symbols are both familiar doorways to help us enter the story and quick, clear, direct means of expression. They help both storyteller and listener keep focused on the spirit rather than the details of the story.

The Sasquatch (also known as Bigfoot, Yeti, Abominable Snowman), Loch Ness monster, and outer space alien all play the role of the Dragon, Thunderbird, and Windigo in older stories. The Loch Ness monster and the space alien are the symbols, the quest for the monster and the UFO abduction are the metaphors.

STARVING FOR ONENESS

We need to approach these stories metaphorically in order to gain their guidance; however, in this pragmatic age we are so starved for communion with something greater and wiser than ourselves that many of us want to believe that these stories are real. To this end, we work hard to authenticate them with hard evidence: video footage of Bigfoot, sonar soundings of the Loch Ness monster, photos of UFOs, and firsthand accounts of alien encounters.

In doing so, we steal the magic of our contemporary stories. We destroy the potential for the communion we are seeking by taking the metaphorical mystery—the doorway to communion—and making it part of our everyday, pragmatic reality. We take the story away from the storyteller and give it to the scientist and the journalist.

We go to the opposite extreme with our traditional stories. We feel estranged from them because we no longer view ourselves as being capable of enacting them. We are not in touch with our personal power, as are the characters in the legends, so we feel estranged from them. We ask ourselves how we could possibly assume such noble roles and achieve such grandiose feats.

Our response is to sanctify the legends by embracing them as relics of a revered, enchanted past. Rather than become the story, we hold it up as an example to inspire us. This transforms it from a companion voice guiding our walking to an elevated holy scripture from which we feel separate. Awestruck, we bow and submit.

We have gone from integration to subservience: rather than walk the guided path, we take a seat on the coach of compliance.

This idolizing of our legends starts when we are young. We are given Santa Claus and fairies (such as the Tooth Fairy, who leaves a small gift in exchange for a shed baby tooth) as belief systems rather than stories. When these early belief systems die, they leave hurting vacuums that yearn to be filled. Enter alien messengers, godlike religious figures, esoteric mysticism, and so on.

The yearning turns out to be insatiable. Some of us go from one belief system to another, and then another, leaving the exposed or worn out ones behind like old clothes. When we can no longer keep them elevated, we desanctify them, rationalizing them away as the preoccupations of the young and naïve (Santa Claus) or of the older and naïve (a fornicating "celibate" guru or a debunked prophecy).

This is everyday ego gymnastics. When we degrade the old, the new is elevated by default, which serves to romanticize the stone underfoot to the point that it transforms into the *Island of Truth*. The illusion created by this degrading–romanticizing ritual helps mask the realization that if the previous stone did not turn out to be the *Island of Truth*, the next one might not either. Aggrandizing the stone underfoot also keeps us from having to admit that all the stones are roughly the same, and that there are more stones ahead. This would be a disquieting awareness for someone who has been conditioned to believe in the *One True Island of Truth*.

We are encouraged to stand solidly upon the illusory stone of belief (the deified legend) by being instilled with fear of drowning in the river of our living story. Our choice is clear: stay dry and go through life dreaming about who we could be, or slide into the river and find out who we are.

At the end of a story, the traditional storyteller honors the ever-flowing river by conclud-

ing with something similar to a Hawai'ian story-teller's *Pîpî holo ka'ao* (The tale is spread around, the tale has fled)[45] or *Ha' ina' ia mai ana ka puna*[46] (Let the echo of our story be heard). This recognizes that the story has a life of its own and must fulfill its reason for being by continuing its journey to guide the people. When using a formal story conclusion such as one of the above, the storyteller acknowledges that the story is not his and gives it back to the storyline.

For me the terms *story* and *magic* are synonymous. A story that has no magic is merely talk. It has no power to carry us beyond our realities; it has no mirror so that we might see ourselves. Our dreams become merely curiosities, our imaginations only distractions. Magic is necessary because it is the only food we know of that feeds our souls. Without magic in our lives, we grow depressed. With magic, we fly with eagles and dance beauty into our days. When we are told stories with magic, we are given glimpses of the divine within. ✣

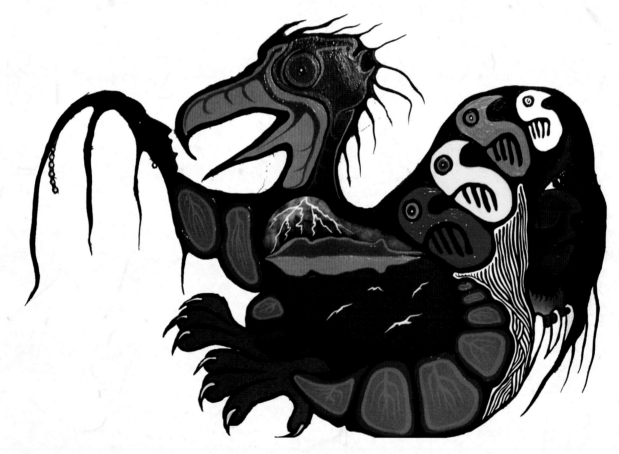

Chapter Four

Where Stories Come From

HOW IS IT THAT THE SAME STORY can be found in diverse and seemingly unrelated cultures, sometimes on opposite sides of the globe? And why are the same stories passed down from generation to generation for thousands of years? Each question has a different answer and yet they both address the same basic reason as to why stories exist: to perpetuate our human culture and give it continuity. The more rational intelligence and conscious memory a creature possesses, the more his culture is perpetuated by learning rather than instinct.

An example: I grew up with four Wolves who were orphaned so young they had not yet opened their eyes. They never saw another Wolf until they were adults and still they knew the ways of the Wolf: how to function as a pack, how to hunt, and how to raise young.

Some of our human culture is instinctual also, yet we learn most of it from example and through story. A Wolf raised by humans is still very much a Wolf, whereas a Human raised by Wolves becomes Wolflike. She will walk on all fours, growl and howl, and exhibit most of the other characteristic Wolf behaviors. It is because of the missing piece in her upbringing: story. Wolves carry most of their stories in their instinctual memories; we do not. This is why storytelling is essential to the perpetuation of human culture.

THE STORYLINE

The mystery of the same story being voiced by storytellers of every language has fascinated world travelers and story buffs ever since there have been world travelers and story buffs. Why is it that, as they discovered, most stories are universal? Over time, a number of theories have been put forth, which can be summed up as follows:

- A psychic connection exists among storytellers.
- Stories of an ancient, fallen civilization were scattered in the diaspora.

Both explanations suggest that most stories come from one wellspring common to the human experience. Neither possibility is taken seriously by the academic community. And yet reason dictates that if the same stories are found with various peoples, there must be some connection among them.

What might this connection be? We all come from the same mother, the Earth, and the same father, the Sky, so we must all be sisters and brothers. When the surface colorings and flavorings of belief, climate, and region are stripped away, we can see that all of us live essentially the same way, with the same basic values and needs, feelings and aspirations. With this perspective it is not hard to see that we all share essentially the same culture and history.

These common bonds and shared lifeways are core to the human experience and the continuum of human life. I believe they are so intrinsic to the human psyche that they are imprinted in our genes. In the ways that we are part of our surroundings, this shared soul has become part of the world we live in. It is echoed in the wind and etched in the landscape. Psychiatrist Carl Jung calls this the collective unconscious, and Australian Aborigines call it the songline, which they describe as the songs, stories, and ceremonies that connect in lines to form a web that lies over the Earth to guide our lives. Because *story* encompasses all of this, I favor the term *storyline*.

The storyline is the voice of the dimensionless, timeless place where all past, present, and future experience dwells. The ancestors and those yet to be born reside there. Think of it as the womb of all life and all creation, as the holder of all wisdom known and unknown.

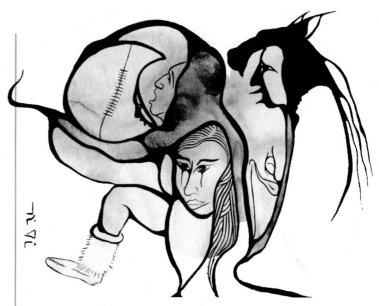

Each of us is one with the womb, whether or not we are conscious of it. Within each of us it resonates and touches everything we say and do.

There is no word-based language in the storyline. It is a pure state of communion where all is known and sensed and felt without having to be consciously heard or processed. A story comes to the storyline as a pure subconscious impression. The storyteller chooses the words to wrap around a story in order to make it a communal experience. Therein lies the storyteller's challenge—and her unique and essential gift to her people.

I seldom know when I am about to enter the storyline; it just seems to happen spontaneously and at the appropriate time. Were it not for the lingering feelings of communion and the stories I am sent back with, I do not think I would ever have had recollection of journeying into the storyline. Those rare and special times that I am blessed to remember usually occur during a ceremony or through a spontaneous flash of awareness.

What never ceases to instill in me the feelings of awe and reverence for the storyline is the fact that all people, whether deep in the Amazon, high in the Himalayas, or on a coral island in the South Sea, have access to the same storyline and the same stories. Equally inspiring

is the fact that stories somehow have a way of coming to us from the storyline when we most need them. Even if a story was forgotten because it was no longer relevant, it will—seemingly out of nowhere—resurface when it can again serve the people.

When a traditional storyteller narrates a story, neither she nor her audience experiences it as a standalone, self-contained event, as one might a song or movie. This is because the story is not an entity unto itself. The storyteller is dropping in on the storyline—the ongoing no-beginning, unending mother story—and narrating a piece of it. This piece could be any portion of the storyline the teller deems appropriate to share at the time. This portion does not have a prescribed beginning or end, because the storyline is a continuum that is not divided into set stories. The next time the storyteller recounts the same "story," it may begin sooner or later in the storyline, and it may end sooner or later. Reflecting this, the title may change as well.

Titles reflect the fact that stories are part of a continuum. We are accustomed to catchy titles designed to grab our attention; however, the traditional storyteller's "title" is more of a matter-of-fact introduction. It is merely intended to give us a clue as to what the upcoming story is about and to connect the listener with where it fits in the storyline. Here are some typical examples: "This is the story of how Rattlesnake got his fangs," or "Tonight I would like to tell you why we paddle a canoe rather than swim like Beaver." You will find more examples with the "titles" of some of the stories in this book.

CONNECTING WITH THE STORYLINE

Is it possible for a member of contemporary society to access the storyline? Many believe it is just Native peoples, or those who lived in pre-industrial times, who were able to enter the storyline. In speaking for American Natives, Sherman Alexie, a Coeur d'Alene Indian from Washington, says, "Every Indian has the blood of the tribal memory [storyline] circling his heart."[47]

In 1979 I had a personal conversation with Dolores La Chapelle, Elder of Native American–European descent and author of *Earth Festivals* (Finn Hill Arts, Silverton CO, 1976) and *Earth Wisdom* (Finn Hill, 1984). She told me we are all still intrinsically tribal people even though we may no longer know our tribal ways. This is because we are not enough generations removed from our tribal past to have genetically adapted to another lifeway, she explained. All peoples of all races were once "Indians" in that they lived as tribal hunter–gatherers. Anthropologist Marjorie Shostak in her book *Nisa, The Life and Words of a !Kung Woman* wrote that "The uniqueness of the Human species was patterned—and the Human personality was formed—in a gathering and hunting setting . . . People everywhere are, in a biological sense, fundamentally similar and have been so for tens of thousands of years."[48] Based on such references, along with my personal experience and that of others, I believe it is entirely possible for present-day people to enter the storyline.

The storyline differs enough from our modern concepts of time, relationship, and history, however, that it is often hard for some to access. And yet entering it is critical, because stepping aside from the familiar and embracing another reality helps one to gain perspective and understanding.

Let's take a walk to the edge of the storyline to illustrate. We will not be following a human trail, but that of a close kin, a woodland raptor known as Cooper's Hawk. From her perspective you might be able to better see yourself in the storyline. As you read the following narrative, think of Hawk as another human rather than a bird. Remember as well that the storyline carries the collective story of all life.

The primary, and perhaps the only, difference between Hawk's stories and ours is not in the stories themselves but in their telling. Hawk speaks in the primal language of the heart, which is the way most of life communicates. This common language is based on intuition, ancestral memory, and sensitivity to the energies that flow through and among all things. To this primal language, we humans have added our recent evolutionary acquisition of verbal speech.

This story takes place at my camp, a circle of bark wigwams out in the wilderness where several Seekers stay with me to learn the ways of the hunter–gatherer. We are sitting around the fire, having our evening meal. They are sharing with me their observations of the day. Henry, a young Canadian Métis (of Native–French ancestry), began to tell us about a Hawk who flew into camp while he was having lunch. When he paused his story to take a bite of food, I continued the story for him.

"Wait a minute," said Henry. "You weren't here; how did you know which direction she flew in from and that she landed on that branch in the dead fir tree and then flew off toward the meadow? Did you see her doing it in the past and then assume it was the same bird doing the same thing out of habit?"

"Yes and no," I replied. "I don't know that I've seen this particular Hawk before, but I know the species and I know that the bird was a female of the species."

"How could you possibly know that?"

"Because I fly in the shadow of the Hawk."

"What Hawk? You just said you may've never seen the bird before."

"A particular bird is just the present physical manifestation of the spirit of her kind. The physical forms of a bird will follow the track of the spirit of that bird, because body and spirit are one. When one physical form dies, another is born and picks up the track. She will shadow the bird before her, right to the same tree—often to the same branch. And then she'll fly off in the same direction as the bird before her. It doesn't matter that her predecessor had done these things days or even years ago."

"Is this something that parent teaches child?"

Realizing this question might be a doorway to greater understanding, I gave it some thought before responding:

It's not really taught, I began, at least not directly. The spirit of a bird is common to all the birds of her kind, so all of them share in the same spirit-way: the same manner of seeing and hearing, of acting and reacting. They all follow the same tradition of seeking food, building nests, and raising their young. And so it is with flying into a clearing and alighting upon a branch in a fir tree. Each bird, in her given time, is merely following the spirit-trail that was blazed and worn in by her predecessors.

This trail exists in two dimensions. It literally lies across the sky and leads to that branch and then over to the meadow. The track of the Hawk who flew the trail before her can be sensed by her. She does this by attuning to the song of the trail: the subtle echoes and repercussions left by her predecessor's passing through.

The trail also exists within the Hawk. It's instinctual, you might say; it's imprinted in her genetic memory. The trail is so much a part of a Hawk that the first Hawk to come upon the clearing after it was created by a windstorm knew exactly where the trail lay to fly in on, which branch to perch upon, and where the trail lay to leave the clearing.

In essence, the Hawk tuned into the web of guidance overlying the Earth: the storyline. There she found the story that would guide her,

just as it has guided many others of her kind on the trail to the meadow.

CLAN MEMORY

Complementing the storyline are stories that preserve and hand down a particular people's traditions, adventures, and accumulated knowledge. "The Indians did not have a written language, so the older people had to be encyclopedias of knowledge that could be passed from one generation to another,"[49] said Tokaluluta (Chief Red Fox), an Oglala Lakota from the era of Ohiyesa and Standing Bear. In the words of David B. Andersen, a Gwich'in Athabaskan from the Alaskan interior, "Thirty thousand years of legends have been passed on orally as teaching tools to maintain our existence on how we can live off this land. And how to maintain it is to make sure we do not disturb the resources."[50] Wandjuk Marika, an Australian Aborigine who lived in the last century, said "Since the dreamtime or dream land, we have followed the customs and laws that were made by the ancestors and we have kept sacred the special places."[51]

Some of these archival stories help make an individual's discoveries and teachings available to all of his people, as well as to those who will follow. Ketagustah, of the Cherokee people, acknowledged this in 1730 by saying, "When we shall have acquainted our people with what

we have seen, our children from generation to generation will always remember it."[53] In this way, the passing on of stories allows their Elders to live on through the perpetuation of their wisdom and guidance. This is the substance behind the saying, "The command of custom is great."[54]

Unlike the storyline, which is preserved in the greater consciousness, these stories are memorized and passed down from generation to generation.

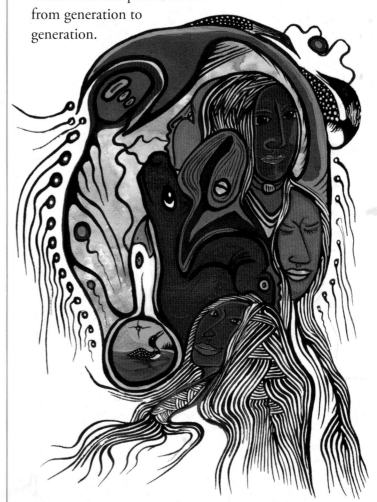

Some of my Elders call this *clan memory*. Because clan memory is based on people's experiences, it is fluid. I think of it as an ageless living body that evolves right along with its people. In order to keep the clan memory alive there needs to be a continuum—literally an unbroken line of storytellers. Just one generation without storytellers can virtually extinguish a clan memory.

TIMELESS STORIES, AGELESS WISDOM

"We have methods of transmitting from father to son an account of all these things. You will find the remembrance of them is faithfully preserved, and our succeeding generations are made acquainted with what has passed, that it may not be forgot as long as the earth remains."[52]

—Kanickhungo, Iroquois, 1700s

The storytellers are most often Elders because they, having known and lived the stories, remember them in their hearts and can tell them *with* heart. In the following two quotes, Wandjuk Marika describes how the clan memory is passed down in this way:

When I was young boy, my father, who was a very important man in Arnhem Land, started to teach me the beliefs and ways of my people, the Rirratjinu, the songs and dances and ceremonies, and he also passed on to me his skill at playing the . . . didgeridoo. My father knew all the designs or the stories of our ancestors and he showed me how to paint these. In this way I lernt from my father all the important things I need to know about life, about our history, our customs and our ceremonies.[55]

My father was painting and also he prepare for the ceremony, and also he was always with me to show me how to sneak in, how to hunt and keep an eye on me, and protecting me . . . from the danger, the crocodile. He show me where to catch him, how to sneak in behind him centrally on break-away (never to make noise, sneak up silently) where they are laying their eggs on dry land.[56]

In this day, very few of our Elders are storytellers. There is no longer room for them in our youth-oriented world where growing old has become shameful. And there is less and less interest in the ways of the people: the ways of the individual now dominate. This leaves us with no living repository for our clan memory. Were it not for books and audio–video media, much more of the world's clan knowledge would be lost than already is. The few dedicated writers and producers have become our storytellers, and their books, recordings, and videos have become our clan memory.

As with the storyline, preserving and passing down clan knowledge is not unique to the human experience. Many animals share their clan knowledge through stories, in much the same way that a mime will communicate by using the language beyond words. For example, honeybees dance to tell their hive mates where to find the nectar-laden flowers. Early in our evolutionary history, we also used dance,

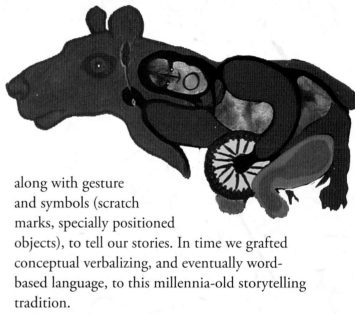

along with gesture and symbols (scratch marks, specially positioned objects), to tell our stories. In time we grafted conceptual verbalizing, and eventually word-based language, to this millennia-old storytelling tradition.

Clan memory acts in remarkably similar ways with the various social animals. Following is an example given to me by the Deer people.

* * *

About twenty paces ahead, two Deer—a yearling and her barren mother—cross the trail I am hiking. (Were the mother not barren, she would now be with a new fawn and would have already driven last year's fawn away.) This morning the two are following their usual path down the trail that crosses a large bog. In places the trail is so deeply worn that water stands in it year 'round. The bushes and small trees along the trail are distinctively shaped from years of pruning by browsing passersby. Eons of their scat has formed a rich compost that supports

unique trailside plant colonies.

The Deer are probably crossing the bog to feast on late-season violets that stay tender and succulent in the shade of the hillside maples. Then they will likely descend the far side of the hill to nap in a thick grove of balsam fir to escape midday's biting flies.

I would know them and their routine even had I not come back to this place for many years, because I knew their clan, their cousins, grandparents, and great-grandparents. If I were not to return for several years, I would still know the same of their children and grandchildren. The cycle of their lives and the pattern of their movements remains the same; the only difference is that one body replaces another as life begets life. The daughter literally walks in the footsteps of her mother and so will her daughter, the daughter of her daughter, and so on.

When they no longer wander this forest with me I will visit them in the cool hemlock grove where they go to die. Then I will come back to see them on this trail. Though the body of a Deer withers with death, it freshens with birth, as the spirit of Deer lives continually on and walks the unbroken cycle before me, across the bog and back again.

CLAN KNOWLEDGE

Many social animals have an intelligence that is centered not in each individual but in the group as a whole. "One head cannot hold all wisdom,"[57] say the African Masai. This collective intelligence benefits both the group and each member in ways that far surpass any single contribution. We see this phenomenon known by the proverb "The whole is greater than the sum of its parts," demonstrated in our brainstorming sessions and think tanks, and by a school of fish or a flock of birds moving together in choreographed synchronicity. These are examples of clan knowledge.

Clan memory is augmented by clan knowledge. Think of clan memory as the spring that brings nourishing water up to the people, and clan knowledge as the cup that brings the water to their thirsting lips. Clan knowledge is the personal insight and experiential knowledge needed to apply clan memory's ageless wisdom. The relationship is symbiotic, as clan memory is largely useless without clan knowledge, and clan knowledge flounders for purpose and guidance without clan memory.

I see clan knowledge being demonstrated in the daily routines of the two Deer who passed before me in the story above. For example, in the white season when their water sources are frozen up, their Elders take them down to the lake and show them how to paw through the snow to reach pooled water on the ice's surface. (The weight of the snow bears down on the ice, forcing water up between the cracks.) In this way, the Elders pass the story "How to Get Water" on to their grandchildren, who in their turn will pass it on to their grandchildren. And thus the story from the clan memory continues on as clan knowledge.

This is cumulative intelligence: each generation contributes to it. An individual might discover something new which—if it continues to work and contributes to the good of the whole, and if she is able to pass it on to others—becomes part of the body of clan knowledge. A Deer may come across an open spring and share the story of her finding with her clan members, who then come to use it. If the spring remains open and used, its whereabouts become part of the clan knowledge.

Clan knowledge is useful knowledge. If the spring were to dry up or start freezing over in the white season, knowledge of its use would be dropped from the clan memory because it would not be passed on to the next generation.

Just as with human oral histories, Deer clan

knowledge has a life of its own. In order for it to survive, it needs the generational dimension of the clan, including Elders, those in midlife, and the young. This is because the life of clan knowledge is like the continual unfolding of the seasons, where each is essential to the existence of the next. If ever there were a clan season missing, such as the young (the new bearers of the clan knowledge) dying of disease, or those in their middle years (the teachers) being decimated by overhunting, or the Elders (the Wisdomkeepers) dying before their time in a harsh winter, the clan knowledge might not be passed on and future generations could suffer.

This has already happened with human clan knowledge. When our hunter–gatherer ancestors were conquered by agricultural peoples, the Elders were silenced, parents were forced to work alien jobs, and the young were indoctrinated with the ways of the conquerors. The circle of the seasons of our clan was broken and our knowledge quickly died.

Yet there is hope: clan knowledge can be revived with knowledge from other clans. When a Deer migrates to a new area and joins another clan, she may share some of her old clan's stories. If they are useful, they will become part of the clan memory.

Those new to an area not inhabited by their kind face a unique challenge: they have no stories to help them. Imagine if Deer were being reintroduced to an area where they had been exterminated: they would not know where to find water in the white season, where to go to birth their fawns in safety, or what migration routes to take, along with other knowledge that makes life good for those who walk in the shadow of others of their kind. (This is one reason that many animal reintroductions fail, and why most humans who attempt to return to their Native ways also fail.)

When many of us hunt, we look for a big mature animal: a "trophy." Eliminating such an animal from the clan is erasing some of his clan's memory. He is in his prime—a survivor, a leader—and thus a sire of strong young and a teacher of the ways of the clan. Rather, let us hunt as does Wolf and take either the old who have already passed on the stories and can no longer lead or the young who do not yet know the stories and are too numerous for the clan to accommodate.

If we are going to continue ignoring the example of Brother Deer and Sister Wolf and keep removing our Elders from our communities, we ought to at least gather from them the precious clan knowledge they hold. We are not faring well without it.

WHAT IS MYTH?

"I am reminded of a time when a missionary undertook to instruct a group of our people in the truth of his holy religion. He told them of the creation of the earth in six days and of the fall of our first parents for eating an apple.

"My people were courteous and listened attentively; and after thanking the missionaries, one man related in his own turn, a very ancient tradition concerning the origin of maize. But the missionary plainly showed his disgust and disbelief, indignantly saying, 'what I delivered to you were sacred truths, but this that you tell me is mere fable and falsehood!'

"'My brother,' gravely replied the offended Indian, 'it seems that you have not been well grounded in the rules of civility. You saw that we, who practice these rules, believed your stories. Why, then, do you refuse to credit ours?'"[58]

—*Ohiyesa, Santee Dakota, 1800s*

FAIRYTALE OR FACT?

What we commonly call myths, fables, fairytales, and children's stories—especially when they come from other cultures—are often viewed by us as fiction. This can be disrespectful and demeaning to the people of those cultures because their stories are their clan memory. It is because of their stories that they have survived and can remember who they are. If the stories were fiction, they would not have served these people and would have been forgotten long ago. One person's myth can be another person's sacred ancestral legend. One person's children's story might be the next person's instructions on how to gather oysters.

As I was growing in this awareness, I started to take another look at what I once thought to be the imaginative inventions of isolated people needing to amuse their children on long winter

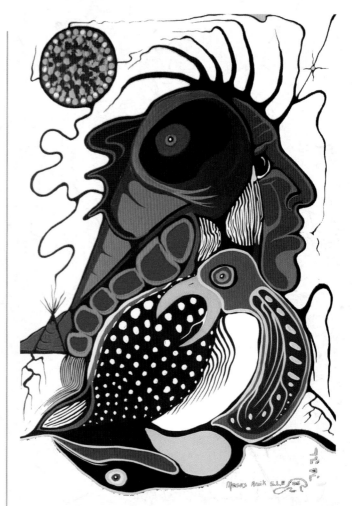

HOW TO LISTEN

As you rediscover these so-called children's stories and fairytales, I suggest that you listen to them with the attentiveness and respect that you would give an elder. In doing so you are placing your feet in the footsteps of your ancestors and regaining your clan memory. If you have trouble entering the story or feeling its spirit, envision yourself as one of the characters. Listening to the story rather than reading it could help as well.

nights. What I found was still living evidence of cultures whose only remaining traces I thought had to be sifted out of the soil by archaeologists! One of my first discoveries was that "Hush-a-bye baby on the tree top; when the wind blows the cradle will rock" was actually about the old Native cradleboard way of caring for babies.

The more I listened, the more I heard. A whole new way of learning was opening up

for me. From teachings in healing ways to gaining new foraging and hunting skills to instruction in shelter building and craftwork, the possibilities seemed limitless. I learned about clan relationships, animal guides, and ritual practices; I was given guidance sometimes as profound and relevant as if it were being spoken by my living Elders.

THE LITTLE PEOPLE

A particular class of "fairytales" came to fascinate me: those about the crafty, wizardly little people known as goblins, gnomes, elves, and woodsfaeries. The Saami call them *trulli*[59]—trolls. "Why are these stories so heavily laced with references to Native lifeway? And why do these forest sprites sound so much like Native people?" I would ask myself. "Of course!" I exclaimed one day in a flash of awareness,

"It's because these folks probably *were* Native people!"

That was my doorway. I then began seeing the stories as surviving clan memories of pre-agricultural ancestors. The stories seemed to be describing those who remained behind when we came out of the forest to take up farming and other civilized pursuits. The more civilized we became, the more the forest people appeared to us to be secretive, mysterious, and prankish. To us who had lost touch with our nonhuman relations, their natural ability to commune with the wild plants and animals seemed like a magical power. Their skill in moving stealthily and staying hidden in the shadows created the illusion of them drifting ethereally through the forest—of being invisible.

I researched the literature of a variety of cultures to see if I could find some historical substantiation for what the stories were telling me. Not surprisingly, I found ample evidence, along with some fascinating insights into the past. For example, I discovered why the *Menehune*, the little people of Hawai'ian legend who come out only at night, are reputed to have such magical powers.

Archaeological evidence points to the Native Hawai'ians settling the archipelago in two major migrations, the first arriving from the Marquesas Islands at around 400 AD.[60] In legend they are referred to as *Ka Po'e Kahiko*[61] or the Ancient People. They lived by the clan (extended family) system and had no chiefs.[62] The second wave came from Tahiti around 1200 AD and were called *Na Ali'i*[63] or Chiefs, because they conquered and ruled over the Ka Po'e Kahiko.

The warlike Na Ali'i were feared by the first people, who were peaceful and of a different culture, so many moved inland and kept a low profile. They became the legendary Menehune, living on in story after the two peoples had largely integrated. (The Na Ali'i became the ruling class and the Ka Po'e Kahiko, the commoners.)

The following is a more detailed description of how the mystique of the Menehune came to be. It is given by Kaili'ohe Kame'ekua, an Elderwoman who lived in the 1800s on the island of Moloka'i. The island became a holdout for the original culture because the overlords feared the seemingly

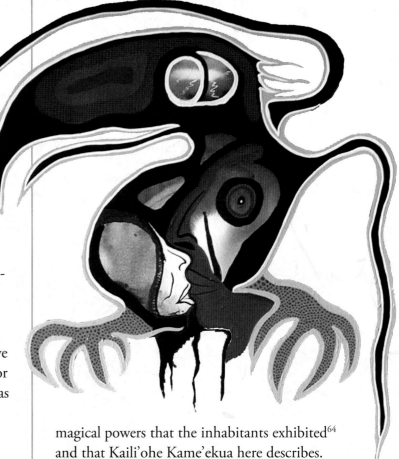

magical powers that the inhabitants exhibited[64] and that Kaili'ohe Kame'ekua here describes.

Legends and stories of the Menehune's great deeds came about because the *ali'i* (Tahitian conquerors) would give the order when they wanted a fishpond built, or a temple, or a ditch, and allowed a very short time for it to be done. The ali'i would order the *maoli* (indigenous residents) to do the job and then go off laughing. If the work was not accomplished in the given

time, all the people of that place would be slaughtered.

When such orders were given, the maoli or pre-ali'i came out of hiding—down from the mountains, from the caves—and they worked together as one person to accomplish the task. These jobs were done at night because during the day other work had to be done. When enough people were not available on one island, fireballs were sent up as a signal to the ancient ones on other islands that help was needed.

When the first rays of dawn began to show on the day, the project was to be completed. The boats were already gone, the people had returned to their caves in the mountains. There was no sign of anyone. Since the ali'i knew it was not possible for the people of that certain site to do the work by themselves, they thought the ghosts of their ancestors helped them. When they happened to see or hear people coming down from the mountains for such a project, they hid, for the burial places of the ancient ones were in the mountains. This is how the stories of the night marchers began. In those days, the ones who marched were flesh and blood. They would not bow to the rule of the bloodthirsty ali'i so they hid away, waiting for a time when the land would be at peace again.[65]

Kaili'ohe Kame'ekua goes on to give some hint as to the fate of the Menehune "Some families lived for several generations in the mountains before they knew things would not change back to the old ways ever again."[66] Based on evidence I have garnered from people of other cultures in similar plights, some of the Menehune may have been captured and enslaved, others probably committed suicide, and still others likely chose to join the conquerors—doubtless without shame, seduction,

or threats factoring into their "choice." Invariably some individuals chose to live on in their traditional way, realizing they had to keep their existence a tight secret in order to survive. Their continued existence could have spawned the legend of the Menehune.

Perhaps the greatest blessing of my research was that in getting to know these various elfin people, I came to realize that I was getting to know myself. I saw in myself and others viewed as their peculiar mannerisms and characteristics. I envisioned myself as I might be if I set myself free to dance my days as did they. I still feel comfort every time I realize that these storied people are my ancestors talking to me over what I once thought was an impassable bridge of time. They have come back to tell me what their life was like. Even more meaningful to me is that they are showing me what life could be like.✖

<div style="border:1px solid">

FINDING OUR PERSONAL PAST

Each of us is descended from an ethnic tradition (or traditions) that likely carries some memories of its origins. Ask your family Elders and other Elders of your culture for any stories they remember of the mischievous spirits of the wild places, including meadow, garden, and fencerow. Some of these creatures dwell in trees or in the water. Family and clan reunions are great places for story scavenging. Comb family archives for journals and unpublished writings and tap into library resources. Ethnic festivals are often good story sources, and a visit to your country or region of origin could land you a unique souvenir: a piece of yourself that your immigrant forebears inadvertently left behind.

</div>

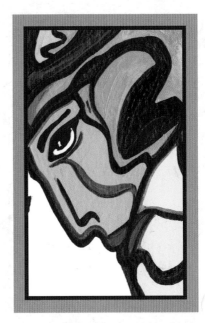

Chapter Five

The Role of the Storyteller

LISTENING TO A STORY becomes a transformative experience when a masterful storyteller draws out the child within us to dance in the greater consciousness. Why our child? Because he is our inquisitive, impetuous, changeable self—just the person to sashay through the world of a story.

Who are the masterful storytellers? "Bizindaw weweni gichi-anishinabeg (Listen to the Elders)" is guidance I have often been given and overheard being given to others. During the winter in a traditional Dakota camp, the children would gather in the lodge of a wise and gifted Elder storyteller.[67] Ohiyesa said that the storyteller's "skill in making the most of his material had built up a reputation which might extend even to neighboring villages. He was . . . an entertainer in demand at all social gatherings."[68]

Our Elders are storytellers wizened by time and given the knowing of experience. As the Ainu (the original inhabitants of Japan, who were Caucasian–Polynesian) would say, they know *upaskuma*[69]—how to tell the old stories. They embrace the memories and they have a well-worn path to the storyline. Now *that* is masterful.

The most cherished and accomplished storytellers for many of us have been our parents. I fondly remember being transfixed by my father's recounting of his childhood adventures and my mother's retelling of the stories she heard when she was a child. The ways of the world that mystify a child were clarified for me by those stories. The same was true for Tokaluluta (Chief Red Fox), who recalled that "From my mother's bedtime stories I . . . learned much of the folklore that had come down from ancient times. She told me stories about birds and animals that lived on the plains and in the forests, why the Great Creator gave wings to the birds, the fawn its spots; the goat, elk, buffalo, and antelope their horns, the wolf the strong claws and teeth, and the rabbit his speed."[70]

Some Native groups will have individuals who specialize in the telling of certain types of stories. These people are sometimes held in high esteem because they have committed a large body of stories to memory. Examples are genealogical and direction-finding storytellers. Other stories are under the stewardship of certain individuals because the stories are considered sacred. The drumkeeper of a clan may carry the story of the drum's origin, and only the drumkeeper will tell the story.

HONOR THE ANCESTORS

By memorizing and reciting a traditional people's oral history, storytellers play vital roles in honoring the ancestors. For example, a Hawai'ian *'aha* (gathering) "consisted of the flesh, or living family and the spirit family. That a person had passed from flesh did not make them less family. They were spoken of and to, remembered in *mele* (song, poem) and chant. At meals they were remembered before the family ate the food."[71]

—*Kaili'ohe Kame'ekua, 1800s*

The adept storyteller is also a story collector. One of her roles is to be on the lookout for new stories that will be of value to her people. The Irish have a proverb, "He who comes to you with a story brings two away from you."[72]

Another useful skill is to know how to choose the form of delivery that best suits the story and the storyteller's ability. She has the choice of four media: narrative, song, play, or dance. Oftentimes the medium is determined by the story's tradition. Even though many contemporary storytellers use various technologies to help tell their stories, those aids are merely the voice. The story is still being told in one of the four traditional media.

STORYTELLING PROTOCOL

Many stories have their season for telling. Those with certain animals as characters might be told only when those animals are hibernating or have migrated. This is done because distance helps give perspective—one of the storyteller's desired effects. Yet this will seldom be stated by the storyteller, because it could undermine her intent. More often I've heard a storyteller state, in typical Native tongue-in-cheek style, that her reason for not telling the story when the animals are around is so that they will not hear themselves being talked about. In the Northern Forest where I live, certain stories are told only when snow blankets the ground. The quiet, introspective mood of the season lends itself well to the soul-touching character of the stories.

In some traditions the learning of a story is considered a sacred undertaking and is approached in a formal customary way. In the Algonquin tradition, the person desiring to learn the story presents a *petition pouch* of *kinnikinick* (nowadays more often tobacco) to the storyteller, who is considered the keeper of the story. The pouch (sometimes followed by a gift) symbolizes a willingness to give in order to receive. After the story is learned, the new storyteller—now also considered a keeper of the story—might hold a feast in honor of the event and her story teacher.

The storyteller will begin each recounting by giving the story's lineage: where it originated and whom she learned it from. Sometimes this turns out to be a story in itself. I fondly remember one magical summer night on a wilderness island in Lake Michigan with my Elder, Keewaydinoquay. There was no sound but the chirping of frogs and the waves softly lapping the shoreline. So as not to disrupt the song of the night, we kept our silence. The Elderwoman looked up into the cold blackness and I followed her gaze. We feasted upon a plethora of stars that blazed like burning-white

diamonds. The brightest ones dangled so close to my reach that were it not for my knowing better I would have plucked several and pocketed them.

I glanced over at Keewaydinoquay; her transfixed expression told me that she was seeing much more than stars. As though she were talking to the heavens, she began to relate a childhood memory of her first hearing of the story about how the old man and his stone canoe came to live with the star people. She then stooped to one knee, reverently laid a handful of kinnikinick on the ground, and began the story (which is in this collection, titled "The Grandfather and the Stone Canoe").

If the person who gave the story is present, the storyteller will usually give him an offering and ask for permission to tell the story.

Louise Erdrich, a masterful storyteller of Ojibwe and European heritage, aptly refers to this custom in her book titled *Books and Islands in Ojibwe Country*, "Very traditional people are very careful about attribution. When a story begins there is a prefacing history of that story's origin that is as complicated as the Modern Language Association guidelines to form input notes."[74]

ARE YOU A STORYTELLER?

In most cultures, whether contemporary or traditional, the guardian–warrior, hunter, healer, and journeyer are all asked to share their stories. Not everybody has the opportunity to see them in action and virtually everyone is interested in how these servants of the people perform. Their stories are their way of sharing what they have gained from their adventures, and they are a way for young aspirants to learn about what calls them. An example of guardian–warrior storytelling comes from a recounting of 1800s Lakota life by Standing Bear: "At large social gatherings and council meetings the warriors all wore their various decorations, and everyone knew what deeds of bravery each man had performed by looking at the decorations. A lot of thrilling stories were told without any speechmaking. Also it was quite the custom at gatherings for the braves to relate their war exploits in action and in mimicry. This some of the warriors could do very dramatically."[75]

The best and most important stories are often those about unsuccessful ventures and embarrassing situations, because they attest

A STORYTELLING TRADITION

Karelia is a forested region of many lakes in eastern Finland and adjacent Russia that is home to an old culture of woodworkers and weavers. The Karelians have a storytelling tradition that is unique in Europe. Their epic poems, called *Kalevala*, are sung by two men who sit side by side on a bench holding hands. More can be learned about the Karelians and their stories in Alvin C. Currier's book titled *Karelia: The Song Singer's Land and the Land of Mary's Song.*[73]

to the humility and sense of purpose of the storyteller. And because they have much to teach. Everybody gains from the stories, including the storyteller. Being acknowledged for one's efforts often makes it easier to embrace the awareness that success can come from failure when we welcome it as a guide and let it show us where we need to focus and grow.

These stories naturally focus on the self, because they are about personal triumphs, defeats, and aspirations. In our society individuals often use this type of story to self-aggrandize. Unfortunately a great many of us lead isolated lives and have unfulfilled dreams, which makes us easy prey for ego peddlers. Such attempts would probably backfire in a close-knit Native society. When people know each other intimately, there is no one to dupe.

Not to be overlooked is the high entertainment value of personal adventure stories, whether they be contemporary or traditional, old or new. Many of the stories in this book are personal adventures, as are a good share of the stories we call books, movies, and television shows.

CHILDREN NEED STORYTELLERS

Storytelling is especially important to the development of children because they are biologically programmed to learn through stories. Children are also designed to give special attention to the words of someone with whom they have a trusting and loving connection. From the time when my son first showed interest in stories until he was about twelve years of age, I told him a story virtually every evening.

My stories were fantasies created on the spot, traditional legends from memory, and stories read from books. The source is often secondary; what is important is that we tell our children stories, period. The living storyteller is an endangered species in our culture. If more parents told stories, their children would grow

up with an appreciation for the oral tradition, and they would in turn pass it on to their children.

Equally important is that we choose our stories well. They are food for our children's imaginations, values, and psycho-emotional development. Children can comprehend material that is a couple of years ahead of what they can read or express. Such material holds their interest and keeps them growing.

CHILDREN AS STORYTELLERS

There is a separate culture embedded in ours that most of us are barely aware of. Most of us adults, that is. This phantom culture has its own judicial and educational systems, initiations, social events, and even sexual training, as well as its own stories and storytellers. It is the children's culture, and it comes alive mainly when adults are not present. Without it our young would have no option but to act like miniature adults.[76] Riddles, rhymes, singing games,[77] parodies, and jokes are their teaching stories, and their storytellers are usually the most world-wise and outgoing of their groups: older siblings or friends who pass down their own clan memories. For more on our children's culture and storytelling tradition, see *One Potato, Two Potato . . . The Secret Education of American Children* by Mary and Herbert Knapp and *Skipping Around the World: The Ritual Nature of Folk Rhymes* by Francelia Butler.

A DYING TRADE?

Instead of learning a song or story, most of us now listen to a recording or read a book. A machine holds the memory and gives the voice. "It took me so long to learn this song, and this thing has learned it at once without making

any mistakes!"[78] said a Siberian Gilyak woman storyteller in reaction to a tape recorder. This is a fitting metaphor for the virtual disappearance of the traditional storyteller. With the advent of modern technology, the craft has transformed itself to the point where it barely resembles its old roots.

This technology allows a scant few storytellers to reach immense audiences. The storyteller is a distant stranger, an image, and the audience is a homogeneous mass of nameless, faceless beings. The teller sits alone with one machine, and the listener sits alone with another machine. The same telling is heard over and over. Gone is the dynamic rapport between teller and listener, gone is the audience's lasting feeling of camaraderie from the shared experience.

And yet the ancient storytelling way survives. Many of us are responding to the yearning we feel deep within and initiating a revival of traditional storytelling. House concerts and storytelling festivals are becoming popular, and the traveling storyteller again finds waiting audiences. (See further reading section for a list of storytelling guilds and publications.)

SHARING STORIES FROM OTHER CULTURES

It is not uncommon for someone visiting the people of another culture to listen to one of their storytellers and be left wondering why he did not enjoy the stories as much as the Natives had. He was probably uninspired by the stories; to him they were bland and the narration was unanimated. If it is true that stories must be relevant and entertaining in order to survive, how is it that these stories could be so lackluster?

Much goes unnoticed to someone who is visiting from another culture. Gestures, double meanings, and inflections, along with cultural humor and unspoken cultural knowledge are all lost to the outsider. Imagine what *rock around*

the clock might mean to you if you come from a culture where *rock* means no more than a large stone and there are no clocks. Now envision stepping into a society where animals are literally referred to as people, which is the case in many Native cultures.

There can be a similar chasm around cultural symbolism. Someone who is not a Great Plains Native might not realize that when bison appear in a story they symbolize abundance, and one who is not familiar with the Mongolian horse people may not know that a golden eagle represents a successful hunt. Imagine not realizing that the rainbows referred to in a story are actually bad omens (true with some African peoples) or not knowing that the old women are desired as lovers by young men (a common practice with Australian Natives) and you will begin to realize how out of touch with a story a person can be.

The greater context from which the story was taken may be unknown. A culture's oral tradition—the stories of its legendary origins, journeys, heroes, and gathered teachings—gives meaning to a story in the same way that a person can be known by the company she keeps. What is sometimes construed as a story might not be intended to stand alone because it is merely a chapter in a saga. In such a case, an outsider could easily miss the unspoken *This is the continuing story of . . .* at the beginning and the *To be continued* at the end.

All of this must be surmounted by the storyteller if the listener is to have a chance at embracing the soul of the story. A number of the stories in this collection would likely have been hard for some of you to connect with if I had presented them just as I had learned them from the Elders. Their versions were considerably shorter than they appear here, so I did as would a typical storyteller: flesh out the parts of the story that would otherwise have gone un-narrated because they were already

familiar to the audience. This elaboration includes unfamiliar terms, symbols, and cultural behaviors. If my audience were already acquainted with the story and its cultural context, I would do the reverse and not recount this common knowledge.

There are similar differences between the oral and written versions of stories. Oral renditions are typically strong on narration, where written versions rely more on dialogue. Without the benefit of body language and the personality of voice, the storywriter turns to descriptive language.

When a storyteller is given a good story from another people, she may rewrite it to include the metaphors and symbols of her own people. In order to interpret the story correctly, she must know the metaphors and symbols of

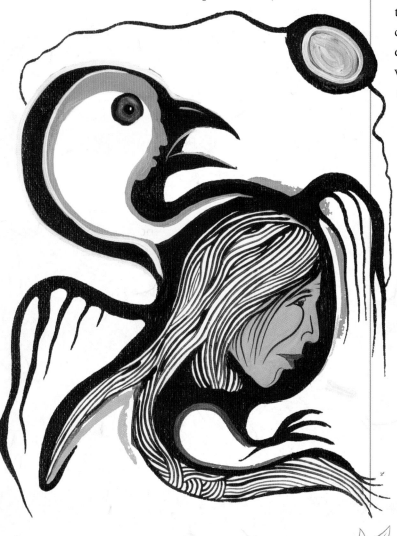

the culture of a story's origin. Many storytellers will study a culture, with the most dedicated immersing themselves in it.

Perhaps the ultimate challenge for a storyteller is to craft a body for the soul of a story she receives from the storyline. With no words or cultural context to build upon, she needs to know her audience as well as she knows herself.

I have found that most people from other cultures are interested in sharing their stories, particularly if I am willing to do the same. There are two criteria: respect their traditions and honor their traditions. Ainu storyteller Shiro Kayano says, "I believe that culture belongs to the whole world. To keep our Ainu culture isn't just for us or the Japanese—it enriches the world."[79]

When people from different cultures meet, they share stories. But why? Of course there is curiosity and entertainment value, and perhaps even cultural pride. There is another reason, to which Shiro's statement alludes: survival. The sharing of stories is essential, for without stories there would be no culture, and without the sharing of stories among cultures, there would not be the cross-pollination that keeps cultures vibrant. The role of the storyteller, then, is essential to the survival of a people.

This role broadens the definition of who is and who is not a storyteller. When you or I meet someone from another culture, we are our culture's emissaries, its storytellers. Our stories create bridges of understanding, of empathy. Perhaps if we were all to share more stories, we could pave a road to survival— to peace. ❧

Chapter Six

Learning through Stories

IT IS COMMONLY BELIEVED that our natural ways of learning are by experience and example; however, the popular saying, "Experience is the best teacher,"[80] makes no mention of example. In defense of the saying (a favorite of mine), greater perspective shows that experience and example can quite easily be seen as one and the same. Whether I learn from direct experience or follow the example of someone else who learns from direct experience, in essence I am learning from experience.

From personal perspective, it could be argued that experience and example are not the same, because someone else's example could not possibly affect me in the same way as experiencing it myself. This argument draws a line between self and other, which, as with all lines, creates a boundary. Boundaries impose limitations, which in this case relegate me to my own experience. This inhibits my learning, thus limiting my growth and potential.

When I move beyond the limitations of personal perspective, my definition of self can expand not only beyond my physical form, but also beyond my feeling, thinking, and sensing self. I can then eat food and recognize that it is more than just fodder: I literally become what I eat. In the same sense, I could feel oneness with my mate and child. Mayans honor this awareness when they greet each other with *In laakech*, which means *I am you*; to which one responds, *A laaken*, or *You are me*.[81] I can sense the deeper meaning in the honored proverb "Cry for the eye that has cried for you, and feel merciful for the heart that has felt for you,"[82] from the Gabra nomads of the Chalbi Desert in Kenya.

I find that all I once recognized as being separate and distinct *from* me is actually in relationship *with* me. This relationship is energy, shared energy, and its physical form is a manifestation of this energy. "In the Ainu

30

language, we have a word, 'Ureshipamoshiri,' which signifies our concept of the world as an interrelated community of all living things,"[83] says Ainu tribesman Giichi Nomura. Ota K'te's (Chief Luther Standing Bear) words reflect the same awareness: "The Indian has a friendly feeling toward all creatures. It is a feeling that he and all other things of earth are unified in nature."[84]

From this place of knowing, another person's experience is no longer example; it is my experience. And vice versa.

The same is true of story. As I listen to or read a story, I become a part of it, experiencing the life, adventures, and teachings of its characters. We are one and the same. The story is me, the story is life, and life is the story. Like facets of a crystal, all draw their light from a common source.

STORIES: NOT A MATTER OF FACT

Many of us, as modern people, have trouble accepting that life and story are one. We prefer to shatter the crystal and reassemble the slivers into two separate and distinct worlds: fact and story. Rather than one, this presents us with two ways of learning: fact based and story based.

Our contemporary world is based primarily on quantifiable entities: numbers, institutions, possessions—in essence, facts. It stands to reason, therefore, that the cornerstone of our educational system is fact-based learning. The natural world of a Native person, however, is one of flow: a continuum of ever-transforming energies and ever-evolving relationships. It is a living story, so naturally his education would be story based.

When facts are given as education, they lie cold on the heart. A fact is a slice of a moving experience, a glimpse of a process frozen in time. As such it does not exist in a living world; it is no more than an intellectual construct. To be given facts is to short circuit the heart-centered

natural learning process and then rewire it into the brain. This process is contrary to our nature, and it goes against nature itself.

As a result, we often struggle to relate facts to our own personal stories or to the stories of others. The facts that my grandfather was born in 1899, graduated from Such-And-Such School in 1918, and practiced such-and-such a profession, belonged to Such-And-Such Church and Lodge, and had such-and-such children, and then died in 1961—the usual biographical information—tell me virtually nothing of his real life story. What were his roots, his character and talents, his flaws and failures, his dreams and achievements? Where did he really learn what he knew? The facts alone present nothing about the person that I can relate to, no life story to compare with the stories of others. All I have are facts that I might compare with another person's facts. When we compare facts we are not able to gain from a shared experience because all we are doing is making statistical comparisons. When we call this story, we have forgotten what stories are.

And yet facts are part of life. When a fact has context as a component of a story, the fact is an aspect of a living experience, as opposed to the static, isolated glimpse a bare fact affords. When a fact appears alone, outside the context of its story, it is like a limb stripped to the bone. The flesh—the roundness, the color, the warmth—is all missing.

Facts give knowledge; stories impart wisdom. Facts keep us functioning and relating through rational mind. They feed the ego—the mind's best friend. Stories speak to the heart-of-hearts: that place within each of us where mind, feelings, senses, intuition, ego, and ancestral memories meet. The heart-of-hearts is our center, our place of balance and perspective, from which we are designed to function.

Our fact-based approach to learning is relatively new for our species; it likely came

about due to our adoption of agriculture. The structure and skills required to plant, grow, harvest, and store necessitated hierarchical organization and specialization: the class-and-craft system. This isolated us from each other, and the growing of food isolated us from our nonhuman relations and our natural foraging ways. In essence, we lost the direct connection with the rest of life, because we were no longer in communion.

This communion was a critical source of our stories, without which our qualified life became quantified. Rather than immersion in life's dynamic abundance, we came to know life as a menagerie of time blocks, facts, and figures. These segmented bite-size pieces were necessary in order to fit life into our new structured lifestyle.

Soon we were no longer able to trust in the natural flow of life to provide for us. We had simply lost touch with it. In response, we turned to storing and hoarding, and around it we evolved an entire philosophy of living. I call it the store-and-hoard mentality. It touches all aspects of life, causing us to be more private, mistrustful, and materialistic than our natural-living forebears.

This is the antithesis of the story way. Life is a river and stories are the river's flow. We are

> **A SCHOOL OF STORIES**
> "The stories . . . were all teachings and reminders."[85]
> —*Kaili'ohe Kame'ekua*
>
> "[The storyteller was] an honored school-master to the village children . . ."[86]
> —*Ohiyesa*

stealing the river by bottling and labeling it, and in doing so we leave life high and dry. Without the river to carry us, we cannot explore our horizons. Without the river's flow, the symbols and metaphors needed for our healing are not brought to us. We lose perspective and become narrow; we lose empathy and become self-absorbed.

And yet we need guidance. Without stories, our guidance comes in the form of lectures, and nobody likes a lecture. A story helps us find our own way, while a lecture tells us what to do. Our evolution was guided by stories. We were genetically programmed to learn from stories, and we languish when we go long without one. Story is life and life is story. When we hear a story we no longer merely exist; we become the story—we become alive. ✺

The Stories

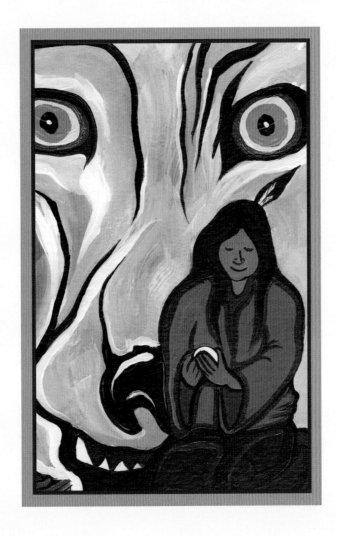

Chapter Seven

The Gifting Way

BECAUSE WE ARE SOCIAL CREATURES, our natural tendency is to be helpful, share what we have, and aid those in need. My Elders call this the *Gifting Way*: the state of abundance and personal fulfillment that comes, often seemingly without effort, from living the natural law that giving is receiving. A Native Person often gifts anonymously and customarily strives to give without expectation of anything in return. By living in a trusting environment where the feeling of relationship extends to all of life, the Native learns that when she is giving, she has already received. She knows from experience that when she gives of herself for the pure bliss of sharing, she keeps the doorway open to all the gifting that is intended for her.

At times it may appear to others that she has already received and is due to give, or that she has been greedy and taken many times over what she has given, or that she has been taken advantage of and received nothing in return. All of this is of little matter to her, as her life of gifting is her continual offering of gratitude for the privilege of living the Gifting Way.

A Native Child will come to the fullness of this realization with the help of stories such as those that follow. For those of us who have not had the opportunity to grow up in a Gifting Way culture, stories can be our guides to healing through the self-centered behavioral patterns that often keep us from experiencing the fullness of relationship.

How We Came to Wear the Skins and Furs of Animals

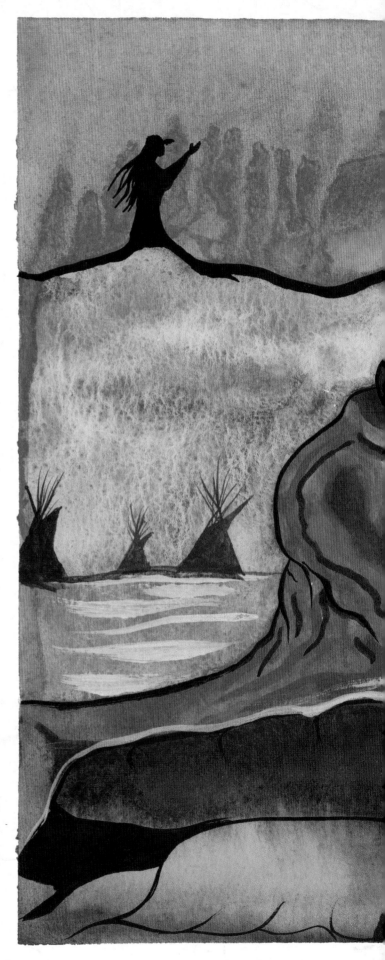

MY SISTERS AND BROTHERS, Children and Grandchildren, did you hear the Trees crackling in the cold on your way to my *Wigwam* (Lodge)? And the Stars, did they seem so crisp and bright that you could reach up and touch them? This, then, is one of those nights when the spirits of the Ancestors will come to tell their stories. However, when the Ancestors walked the Earth, they did not have the language we now know. They spoke in the way of Fox and Deer, so their stories will be far more ancient than words.

Come nearer the Fire on this chilly night, my dear kin, and watch the shadows dance upon the Wigwam walls, because there you'll begin to see the story of how we came to wear the hides of Animals. Let us listen now to the voice of our Ancestors.

In the beginning, life was good. The lush Savanna Grass of our Earth-Mother nourished an endless Sea of Four-Leggeds, from families of tall Long-Necks to herds of swift Horned-Ones to prides of the regal Maned-Cat. An abundance of sweet leaves and succulent tubers could be

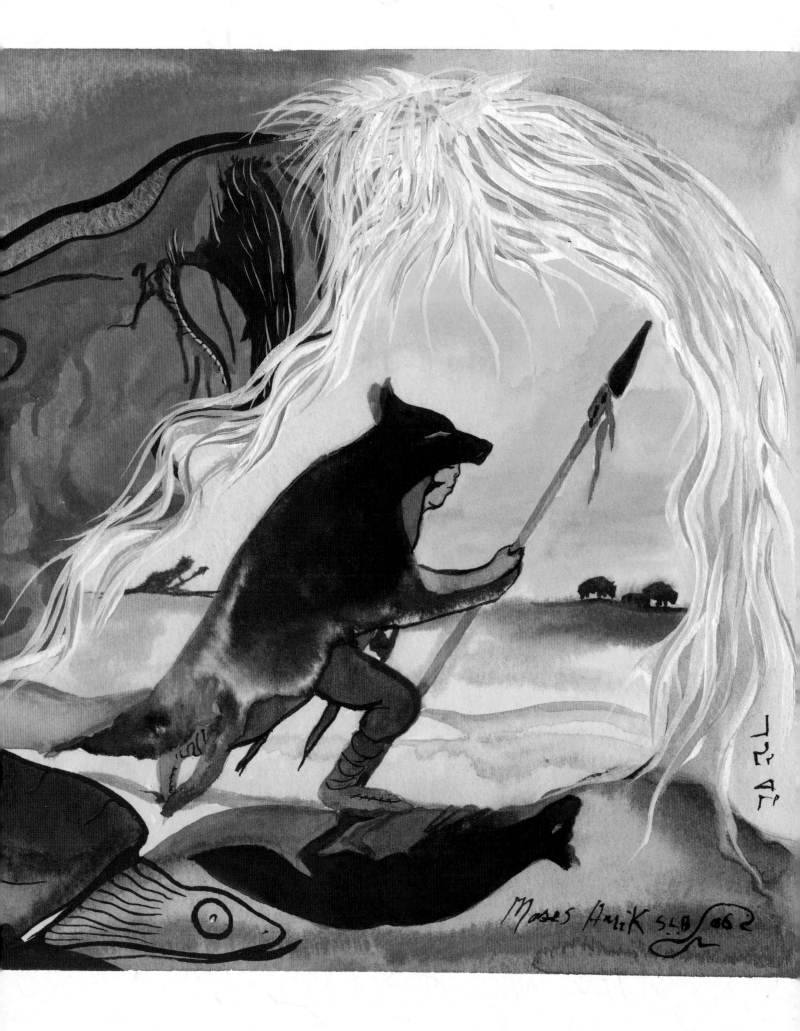

found among the Grasses. For many generations we thrived—until a hot Wind blew out of the North.

At first it came only now and then. We didn't notice that with each passing season it pushed upon us a little stronger and stayed a little longer. Only in time did we come to realize that the Grass grew ever shorter and not nearly as thick as we remembered it. The families of Four-Leggeds seemed to get smaller and smaller. From the Hilltops we'd watch them move away like leaves before the Wind.

Then came a time when the Scorching Wind no longer retreated. Plump roots that once nourished us shriveled like dead Snakes baked crisp in the Desert Sun. The juicy bark of shrubs turned so brittle that it crumbled to dust when we tried to harvest it. All we could find to sustain us were tiny Lizards and what little bitter Water we could squeeze from the Mud under the crusted bottoms of dried-up Water Holes.

We stayed alive, yet we were hardly living. Our Women no longer bore Children and our Elders, whom we called Silverhairs, couldn't find the strength to stand. We passed the *Suns* listlessly in the scant shade of naked Bushes. In time we forgot what life was like before the Merciless Wind. We *had* to forget, lest the memories drive us crazy.

One Sun, we awoke to a Wind coming out of the west. It felt cool and moist: welcome balm for our parched faces. When we breathed deeply, it soothed our dry throats. And most thrilling was that it carried with it the smell of life!

Wingeds we had never seen before were riding this Wind. Above

them drifted the oddest sight: what looked like white, rolling Hills. These feathery mounds brought smiles to our gaunt Silverhairs, who remembered the stories of a time when these same skies sprinkled sweet Water that turned the trampled, brown Grasses green and lush.

The air was so rich that it seemed to nourish us; we had energy to lift our heads and dream again of life. We turned our faces to the Wind and began walking. Many sleeps we journeyed, and just when it seemed that our fate was to wander endlessly in quest of an illusion, we saw before us a Pool of Water so magnificent it made us weep. "It reaches so far that it touches the sky," someone exclaimed.

Beneath its surface grew tall, green Grass; and instead of Four-Leggeds, we found creatures we called *Slow-Shells*. Like the Savanna Four-Leggeds, they grazed on the Grass and gave us rich meat. They had no bones to give us for tools, and yet we found that their hard shells made fine choppers and scrapers.

"Try this Grass," said one of our Women one Sun as she passed a dripping handful around the Hearth. "I watched the Slow-Shells feasting upon it and I thought I'd try some myself."

"It's sweet; is it good to eat?" we asked our Silverhairs. They smiled, and that evening we had a great Thanks-giving Feast.

Over the following Suns, we ate well and rested, and we soon regained our health and strength. Again, life was good for us.

For many generations, we lived by the Mother-Water, and gradually we became creatures of the Sea. We grew taller and more upright, so that we could wade farther out to forage. Our body hair thinned and our Women were given fat under their skins to help them stay warm in the Water. Our Women's head hair grew thick so that their Babes could better cling to it while out gathering with their Mothers. Men grew great rounds of

hair on their faces, much like our tawny Cat Brothers on the Savanna.

When we were in the Sea, often with only our heads above Water, we could no longer read each other's body language, so we found it difficult to communicate. New sounds began to form in our throats, and from them we crafted words. Like leaves along a twig, we strung them together, and soon we had language. For this gift we were most grateful, as now we had a new way to share the visions in our minds and the feelings in our hearts. Life grew even better for our People.

For many generations, we dwelled in peace and abundance. And then one Sun in the heat of the afternoon, someone asked, "When did it last Rain? It seems a long time since the white, floating Hills have gifted us."

"You're right," replied another, "and I noticed this morning that when I went to gather Slow-Shells, I had to walk farther than usual to reach the Water."

"Do you remember when our Lodges used to sit right beside the Mother-Water?" asked yet another. "Now they are far from the beach."

"We have more Rocks for climbing and diving," added the Children, "and Gulls and Seals like them too."

Even with the Children's playful presence, the Silverhairs' hearts weighed heavy. Ominous visions of the last bitter Suns on the Savanna filled their heads as they sat quietly under a relentless Sun.

That evening we sat around the Hearth without speaking; the melancholy mood of the Silverhairs had infected everyone. Well, almost everyone.

"Look, Water and Sky are no longer one!" screamed one of the Children as they all came racing down from a nearby Hill.

"How could that be?" we wondered. "The Little Ones must be playing a game."

Still, worry set in as we climbed the Hill to take a look for ourselves. There, where blue Sky and blue Water had always met, was a horizon of brown Mud and gray Rock. What we had thought was the never-ending Mother-Water was now only a Lake.

Before long it shrank to a small Lake, and then to a few shallow Ponds. When they dried up, we had to dig for precious Water, just as our legends told us our Ancestors did in the time before the Journey of Many Sleeps. We would dig in silence, haunted by the realization that we had somehow returned to that time. The Silverhairs had always told us that the Ancestors walked on within us, and now we felt it—now those stories were being fulfilled like an ancient prophecy.

We grew destitute and lost the will to live. Our Children grew so weak they could no longer cry, and Mothers had precious little milk for their Babes.

One morning, perhaps in search of the happiness of Suns gone by, a young Girl climbed the Hill where she and the others used to play. She looked out over the parched Land that was once the Mother-Water, and the sight of it burned her eyes. Having no tears left to soothe them, she turned away and looked inland.

A bloodcurdling "Aieeee!" rose from somewhere deep within her and echoed off of the barren Rocks on either side of our camp.

"What was that?" shouted everyone in the camp.

"Up there," pointed a Woman who saw the Girl atop the Hill, frantically waving her arms. Those of us who could scrambled up the Hill and looked to where the Girl was pointing. There in the far distance where we were accustomed to seeing the gray skeletons of long-dead Trees silhouetted against a dry and dusty Sky, was an endless Sea of green!

"It must be a vision," someone said.

"Maybe we're just in a dream," mused another. Whatever it was didn't matter because, as if in a trance, we all started walking toward the alluring horizon.

Whispers of the Ancients

Within a Sun our feet touched the first
Grass, which was short and bristly. But it was
alive! Another Sun's Journey brought Greenery
that was knee high, and the next Sun we waded
through waist-high Grasses that rippled in the
breeze like the waves that once rolled upon
the Sea.

On the eve of the fourth Sun, we reached
a grove of Trees in a lush valley. The Silverhairs
said, "Let's rest here and have a Feast in honor
of our Earth-Mother, who showers us with
the blessings of the Gifting Way." Women
gathered tender Herbs that grew among the
Grasses, Men netted the Six-Leggeds who were
creeping, jumping, and flying everywhere, and
the Children even found small Slow-Shells in
the moist turf. We slept well that night, and our
dreams told us we had returned to *Balance*.

Soon we were discovering bounty of
every kind to nourish us: great herds of Four-
Leggeds, Wingeds' eggs and young, and fruits
and nuts from the Trees and Bushes. Even with
the incredible abundance of foods that Earth-
Mother laid before us, what we cherished most
was Her sweet Water flowing in the Rivers and
filling our Water Holes. Both experience and
clan memory told us that good Water, more than
anything, would help us grow strong once more.

That it did, and again we had reason to
smile.

Even though the Savanna was new to us,
we were soon saying to each other, "It feels as
though we've always been here." Perhaps that's
because we had word-paintings of this place
given to us by our Silverhairs ever since our
earliest memories. Along with that, we found
that life in the Sea of Land Grass wasn't so
different from life in the Sea of Water Grass.

There was one difference that stood out.
Stories of the Long Ago described a People who
were like us and yet not like us: we were taller and
fleeter of foot, we used more words and less ges-
turing, we seemed more curious and adaptable.

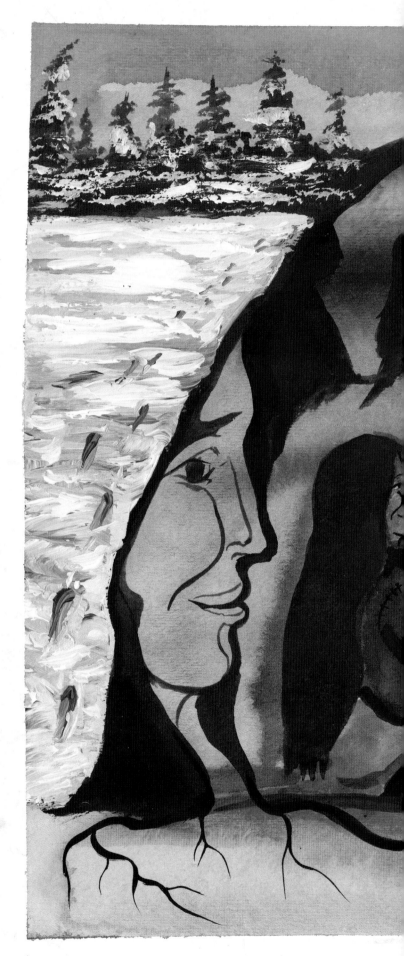

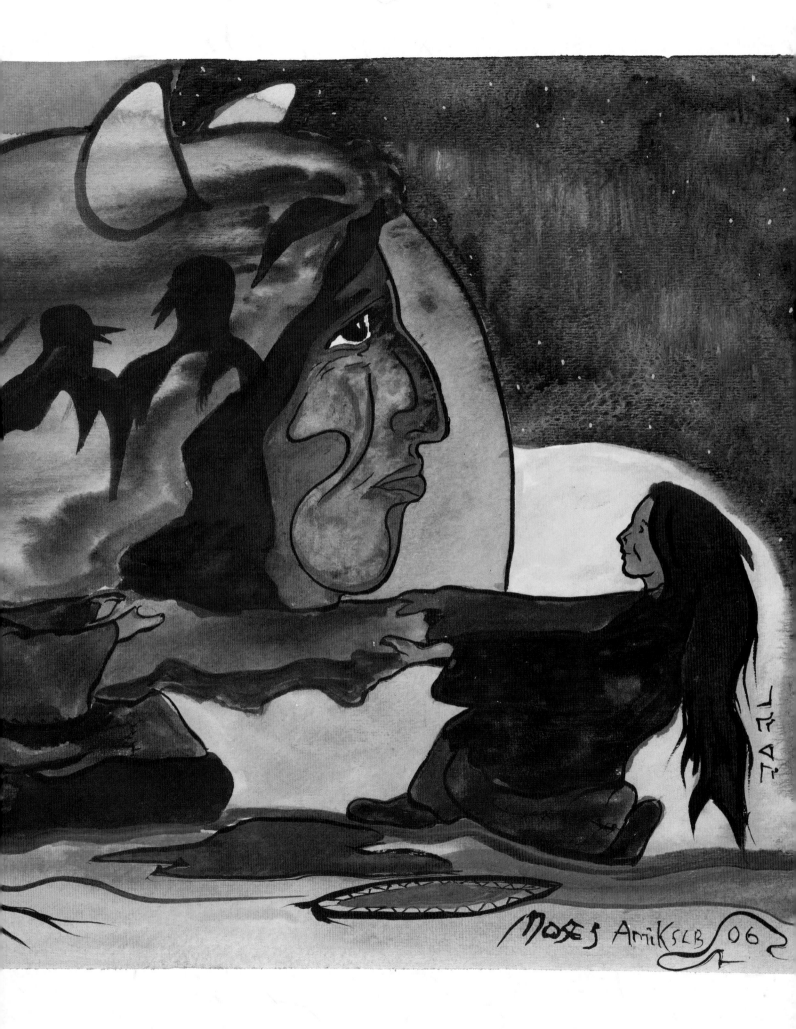

This gave us a yearning to explore new places and try new ways of doing things. Having many and strong Children, we soon spread over the Savanna, forming new *clans* as we went. Before long, we found ourselves venturing beyond the Savanna, to places where our stories and clan memories could not help us adapt. And yet because of the new kind of People we had become, we adapted to the new surroundings and thrived.

In time, we came to a place of strange and wondrous Plants and Animals. There were pointed Trees that reached high into the Sky, with short, bristly spines for leaves and cones filled with tasty seeds. In places, these Trees were so thick and endless that we could walk under them for most of a Sun and hardly see the Sky. Flowers of every color carpeted the light-filled openings. Some of the Four-Leggeds had horns that branched like Trees, and they lived together in twos and threes rather than in great uncountable herds like the Four-Leggeds of the Savanna. The smaller *Relations* had fur more lush and long than any we had ever seen. "Why would they want to carry such heavy coats?" we wondered.

As strange as this new Land was, we did adjust and we were blessed again by the Gifting Way. However, it did not last long. The Suns grew shorter and the deepening chill of the nights forced us to sleep huddled under the shelter of low-hanging branches.

One morning we awoke to a cold, white dust that the North-Wind-Blower was drifting over us with a shrill, howling breath. He made us shiver so hard that our teeth rattled. Our body fat, which kept us warm in the Mother

Sea, wasn't nearly enough to make a difference here. Babes turned blue, and we lost feeling in our hands and feet. Stiff and numb from the cold, we could do nothing but squat together in desperate silence. Again we felt the presence of our long-ago forlorn Ancestors, crowded under a scrawny Tree to escape the Great Dry Heat.

"This old Man asks that you listen," said one of our revered Silverhairs in a barely audible voice. We huddled around him so that we could hear, and he continued in a solemn tone.

In a dream last night, I was taken on a Journey to the Savanna, back to the time when I was a young hunter. We became the Four-Leggeds by adopting their spirits and draping their skins over our bodies. When we did so, they accepted us as their own. As Humans, we became invisible to them, and we also became invisible to those hunting us.

I was deeply honored to become a Four-Legged; however, I grew so hot wearing their skin that sweat poured down my face and stung my eyes. And then I awoke, realizing I was here in your midst. Immediately an awareness came to me: perhaps the Four-Leggeds will gift us their warmth! If so, we could wear their robes and roam as comfortably as they do in this frosty-white world.

"*That* is why the small Four-Leggeds have such thick coats," exclaimed someone. We wrapped what furs we had around us, and right away we felt warm.

"Our Animal Relations have gifted us our welcome; it now feels as though we belong," said a woman cradling a nursling. Even though we welcomed the words, they were not needed, as her tears and smile spoke eloquently for her.

At first the robes were warm and comfortable; however, when they dried, they turned stiff and wrapped poorly around our bodies. When we moved

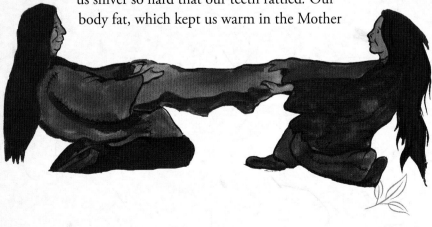

around, they would chafe our skin. Yet in time they softened, especially where they absorbed oil from our skin and were stretched from wear.

Once during a Feast in honor of the successful Hunt for the Wooly-Tusked-Ones, two Women lay before us a fur of the One-Who-Howls.

"Feel of it," they said. "Wrap it around you."

When we passed it around, we found it so soft that it was as though the One-Who-Howls had just gifted it.

"How could this be?" we exclaimed.

"We noticed that skins soften naturally from being worn," replied the Women, "however, it took so long. We thought we'd try rubbing oil into one and stretching it by hand, to see if we could speed up the process."

Joy overcame us as we realized the gift that these Women had brought us. They beamed in the glow of our gratitude.

Soon we were experimenting with different oils and pelts. We found that the lush furs of our smaller kin worked well to keep our heads and hands warm, and that when we removed the hair from larger skins, they made soft and comfortable Summer clothing, as well as footwear. Because oil was so cherished as a heat-producing food, as well as for preserving and

waterproofing, we looked for substitutes. Bone marrow and brain turned out to work well, along with eggs of all kinds: Frog, Fish, Turtle, and Bird.

With this new skill, we could dance in the icy breath of the North-Wind-Blower and continue venturing northward. The Relations welcomed us and we found the Land to our liking.

Aho (I have spoken).

* * *

The Ancestors now leave us to return to their home among the Stars. As you go back to your Wigwams for the night, look up and you'll see shimmering sheets of light rippling across the Star-speckled Sky. Those are the Ancestors dancing their sprightly way to their Wigwams. They are happy we invited them this evening and listened to their story.

Before entering your Wigwams, perhaps you would pause for a moment and give honor to the Snow underfoot. It is North-Wind-Blower's gift to Earth-Mother: a thick, soft blanket to keep all Her Children warm. It is also the deathly white sheet that inspired our Ancestors to learn fur tanning so that we could live in comfort in our beloved Northcountry.

Origin

I DREAMED THIS original story to show how our traditional crafts, together with our ancestral memories, might have developed in conjunction with our evolution as a species.

The story came to life as does a stew. Here is the recipe:

To a large pot half full of traditional lifeway stock, add
½ cup paleolinguistics
3 medium sized anthropological discoveries

1½ cups hide-tanning experience
1 dollop each of
 —marine biology
 —botany
 —zoology
1 tablespoon climatology

Spice liberally with an unorthodox view of human evolution.

Simmer for a long time over a medium flame of imagination. Serve hot.

Medicine Spear

A GIFT GROWS STALE if it's not, in turn, gifted to another. In fact, it can become as un-gifting as a mad *Zheesheegwe* (Rattlesnake) in your lap. And that is why *this Person*, called *Nee-kana Ma'eengan* (Brother-to-Wolf), *Gookookoo ween dodem* (Owl *clan*), wishes to give you the story of one of the great blessings from his life's Journey. That you would keep this old wanderer company on this long night is an honor to him. By allowing him to relive the adventures of his youth, you help him honor those who have guided and gifted him. He speaks it to you now only as he remembers it, for it was a long time ago and time has its own way of choosing what to keep and what to release.

Many, many turns of the seasons ago, I wandered through the Land of the *Zhawanomi* (People of the South). Their Forest was alive with great Elder *Zhingwak* (Pines) clinging to rocky outcrops and tall *Anaganashk* (Ferns) fanning in the Wind. *Migizi* (Eagles) soared overhead as *Makwa* (Bears) feasted on fruit in the sunny clearings.

One morning I heard the faint voice of Water over Rock. The sound drew me to a tumbling River nestled between tall, ashen shoulders of polished Granite. Sensing the presence of someone of my kind, I crept catlike to the River's bank and peered cautiously through the bordering Sedges.

In the riffles between the boulders stood an Elder *Mashkikeekwe* (Medicine Woman). Her

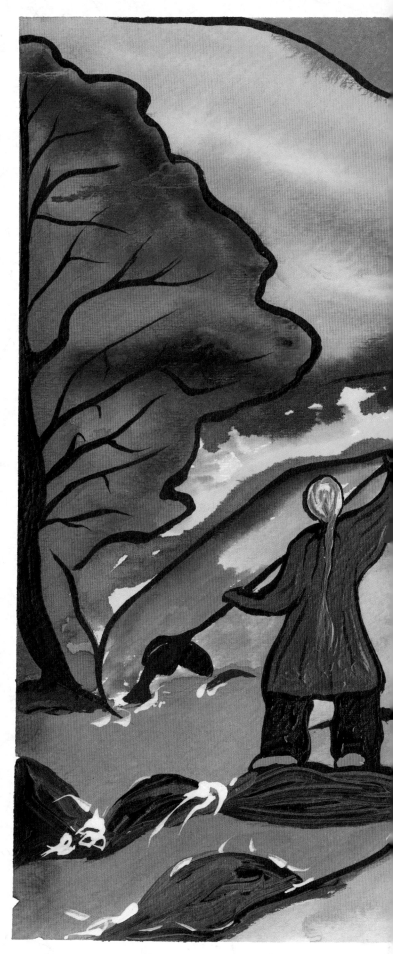

44

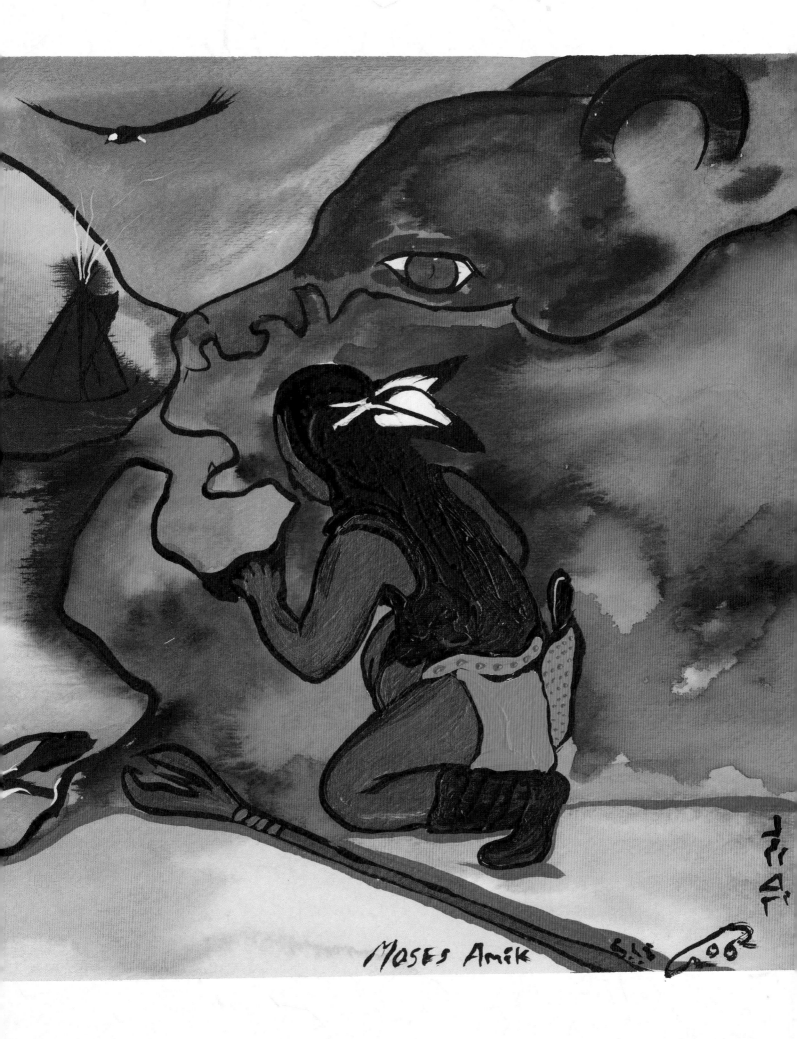

Moses Amik

grizzled skin spoke of her kinship with the ancient *Gizhik* (Cedars) that leaned over the Water. The way she braided her Cloud-white hair told me that her eyes had seen much, and that she was of powerful *Medicine*. Her surefootedness and agility over the slick Rocks while wielding an *Anit* (Fish Spear) belied her slight build and great age.

My gaze backtracked her wet footprints upstream to a Gorge. On its bald top stood drying racks filled with Geegoon (Fish) fillets glistening in the sunlight. Behind the racks, Rock gave way to Forest; and there tucked just under the Trees was a modest *Wigwam* (Lodge).

I watched her *Makak* (Basket) fill quickly from the steady stream of fat Geegoon she plucked out of the tumbling Waters. "How does she do it?" I blurted aloud. I studied her technique, watched which Pools she chose—I sought *any* clue as to how she was doing what I knew to be impossible. From what I saw, I'm sure the Children of my clan could be better spearers than her. Every time her Anit pierced the Water—no matter where or how hard she thrust it—up came a Geegoon.

"Wait . . . what's that figure carved on top of Anit? It looks like . . . it *is* . . . *Geeshkimansi* (Kingfisher)! No wonder Geegoon come to her like Bees to a Flower—she has a *Gichi-Anit* (Medicine Spear)!"

Of all the Animal *Relations*, Geeshkimansi is the greatest catcher of Geegoon, and she is guardian and teacher to those who wish to practice her craft. She is a good omen: when she's nearby, chances are good that someone will learn more about fishing and come home with many Geegoon.

In no time Mashkikeekwe was ready to climb the bald Rock to prepare her day's catch for drying. As she turned to step out of the Water, the hair on the back of my neck bristled. She knew I had been there the whole time—I could feel it! Even though her back had been turned to me and I had remained deep in the shadows

behind a screen of Sedge, she knew. With a look that pierced my veil, she caught my gaze and motioned for me to come.

My first impulse was to back into the Forest and run, yet something held me to this Woman's gaze. I felt like a predator discovered by a quarry who was surprisingly smarter, faster, and stronger than was he.

Stepping out of my hiding place, I came forth with the humility and shame of a Child caught eavesdropping. She said nothing and gave no reaction—not even the slightest change of expression. All she did was glance down at her Makak. I took the cue, hoisted it to my shoulder, and followed her.

We cleaned Geegoon in silence, with me being lost in wonderment over Gichi-Anit.

After a meal of dried Geegoon and *Zesab* (Nettles) it was time for me to leave. As I rose, the Mashkikeekwe asked if there was anything I needed for my trip. Her question was innocent enough, and yet I detected an undertone of deeper inquiry.

"*Nokomis* (Grandmother)," I replied, "before I came upon you I was content. Being trained in the ways of my People, I could well take care of myself and provide for my kin. Now I distrust myself, and I can think of nothing but your Gichi-Anit. If I had it, I'd never doubt my ability to feed our Elders, Women, and Children as long as I walked this life."

Without hesitation she handed me Gichi-Anit. "Young Seeker," she said, "yours is an honorable vision. May you and this Medicine be Brothers." She bade me blessings on my travels, and I turned north to continue on my Journey.

Four Suns later, I stood before the Wigwam of the Mashkikeekwe. "Nokomis," I began, "this Person is troubled. Gichi-Anit is like no other, and I thought it would provide me with what I sought on my Journey. However, when I returned to my People with Gichi-Anit, I realized that you have something of much more

value, something that would serve my People with far greater honor. I respectfully ask that you take back this sacred Medicine. Instead, I humbly beg to be gifted with that which allowed you to selflessly gift Gichi-Anit. With that, I could walk in *Balance*."

In response, I was given a hint of a smile and a gesture inviting me to sit at the Hearth, where she had already prepared food for two. We feasted in silence, just as we had during our first meal together.

When we finished, she pointed to a corner of the Wigwam and said, "You shall place your pack there beside the *Mshibishi* (Cougar) fur. That is where you'll sleep."

"Sleep? I had planned on returning with all haste to my People," I replied.

"If you're to learn the ways of selfless gifting, you'll need to spend your nights on that fur," she responded.

For a moment I froze, not able to grasp what she seemed to be offering. The Mashkikeekwe waited until I caught my breath and then spoke these words: "Four *Moons* ago when the Snows lay deep over the Land, *Gekek* (Hawk) spoke to me in a dream. 'A Seeker of the *Geewaedinoni* (People-of-the-North) will come to you,' he said, 'in quest of what he *thinks* he needs. He will leave, only to return on the dusk of the fourth Sun, this time ready to receive what is intended

him. *Gagagi* (Raven) will tell you when he draws near. Go, then, immediately to the River for Fish. Geegoon Spirit will give again of his clan, in order that this Man may learn how to give to his.'"

Mashkikeekwe would trade Anits with me while we were spearing, and whether or not she had Gichi-Anit, Geegoon would still come to her in abundance. At first I could spear Geegoon only when using Gichi-Anit. In time, as I felt my own Medicine more and more, I began getting Geegoon regularly with my own Anit. "I don't teach you," she'd say teasingly, "and yet you grow so wise."

I stayed to serve Nokomis for four whole turns of the seasons. On our last night together, she told me, "Some need the illusion of receiving Medicine in order to find their own. Like you, they may have to seek outside themselves in order to discover what is already within."

On the trek back home to my clan, I had time to ponder: I was so sure that the woman mystic had something I wanted—no, needed— and she gave me nothing but myself! Ha, what a fool I was to covet something so close to me that I couldn't see it! To this Sun, a smile warms me when my memories take me back to that long-ago time. And to this Sun, I am in awe of the wise Mashkikeekwe who did not need eyes to see or words to teach.

Aho (I have spoken).

ORIGIN

KEEWAYDINOQUAY, a Mashkikeekwe of the Ojibwe People and my honored Elder, was fond of saying,

> Blessings and Balance
> Balance and Blessings
> For from Balance
> Comes all Blessings

The utter simplicity and directness of this sutra hindered my hearing of its voice for a long time. To open myself to the teaching, I needed a story; and I suspected there were others who

might need the same. I wanted one that smelled like the Winds and flowed like the Waters of both Keewaydinoquay's and my own homeland. The story needed to honor the spirits of this land, because they were the source of the teaching. "Medicine Spear" is my variation of the "Blessings and Balance" story that is known in various forms by virtually all Peoples.

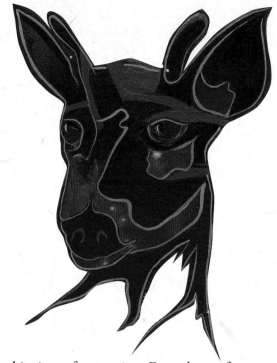

The Circle Way

OVER ON *MANIDOGAMI* (Mystery Lake), the next Lake over from ours, is the camp of our relatives of *Wagosh dodem* (Fox *clan*). There *Jeeman Meekanakwe* (Canoe-Trail-Woman), or *Kanakwe* for short, lives with her two Children. The Girl is known simply as Little One because she has not yet received her name. She's still in her *Dikinagan* (Cradleboard), which is where our Babes spend most of their first turn of the seasons. Her Brother, around five Winters of age, has been named *Makade Gegek* (Black-Hawk). This is his Child-name, given him in his first Winter by an Elder. When he comes of age, he will seek his own name on his *DreamQuest*

For almost a full turn of the seasons, Kanakwe has been mourning the loss of her Mate. A dead Tree had fallen on him in the night while camping by the rapids where he had gone to spear *Geegoon* (Fish). We used to joke about the old, rotting hulks being widowmakers. Not any more.

Perhaps Kanakwe will join with her Sister and Sister's Mate at their Hearth, as is our custom. That would go well for the Children, because they already call their Mother's Sister "Mother" and her Mate "Father." It's yet too soon to know whether this will happen, or whether Kanakwe might be intended to have a different Mate. These things will reveal themselves when her time of mourning is over.

All of a clan's Children are raised in common by the adults, so it's normal for adults to refer to any Child as "my Child." This is especially helpful for Kanakwe and her Children during this time of mourning. Even those of neighboring clans such as ours are lending a hand. It's given us an opportunity to honor our relationship with the other clans, as well as to acknowledge that what we're given is not just for us but for all the *Relations*.

A young hunter from our camp, which is *Mang* dodem (Loon clan), had such a chance last night. He, who is called *Makwa Neebashka* (Night-Traveling-Bear), was out spearing Geegoon on Manidogami. In the light of his Birch-bark torch, he saw two sets of glowing eyes along the shoreline. As he drew closer, a pair of *Wawashkeshi* (Deer) Fawns appeared out of the dark. One was bright and alert: ears perked, eyes staring inquisitively into the light. The other held her head low and hobbled as she took a step toward her sibling.

"I fear the worst," said Neebashka to himself as his *Jeeman* (Canoe) drifted toward the pair. He knew that frisky Fawns will sometimes show more daring than wisdom in leaping over a downed Tree. Occasionally one will fall short and get tangled in the branches. In panic she'll thrash around trying to free herself, sometimes breaking a leg.

"It is so," sighed Neebashka as he drew near enough to get a clear view. The back leg of the injured one dangled by mere threads of skin and sinew. As her Brother wandered down the

48

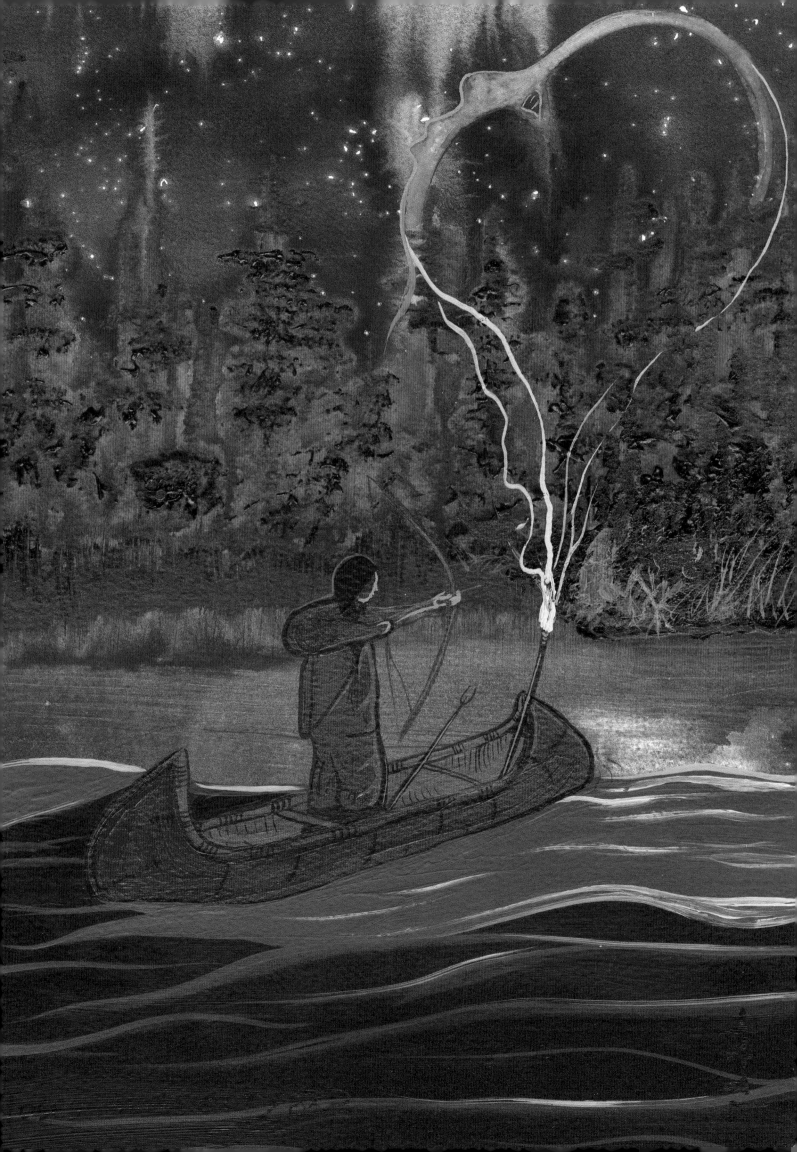

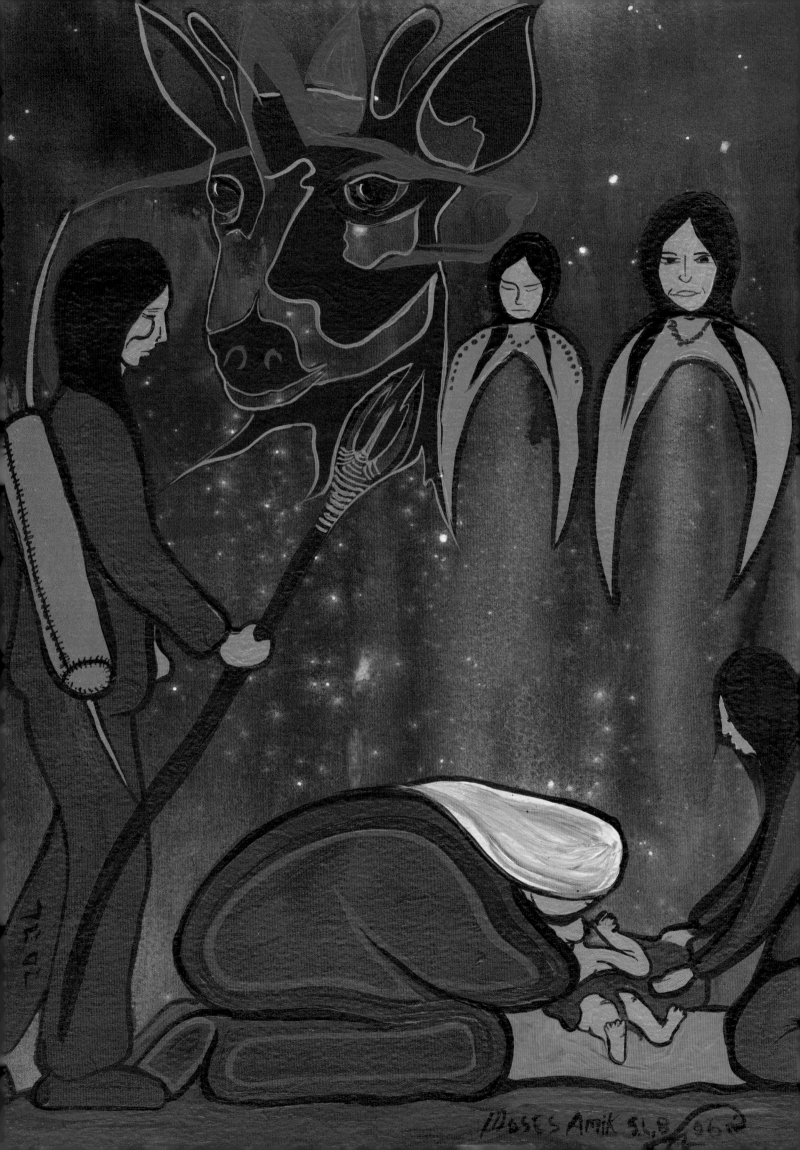

beach, she stood there alone, preparing for her *Passing-over*. She knew she was intended to serve *Bimadiziwen* (*Circle of Life*), for in this way she would live on, joining in spirit with whoever would feast upon her flesh, wear her hide, or make tools of her bones.

A lump formed in the Man's throat as his Jeeman quietly drew near the frail Animal. He chose an Arrow and shot it off the hip, so fast that there was no chance for the Fawn to react. With reverence he picked up the frail body and paddled to the camp of Wagosh dodem on the far shore of the Lake.

There on the beach, he found a clean piece of Birch bark. In its center he placed the Fawn's heart: a gift to bring clearness of heart to the grieving Kanakwe. On either side of the heart he laid tender strips of the choicest meat, to give Little One and Makade Gegek strength of muscle. "The Fawn will live on," Neebashka said as he followed the footpath up the beach and crept quietly into camp.

"I am blessed," he thought to himself when he saw that the central Hearth *Shkode* (Fire) was out and that everyone had retired to their *Wigwams* (Lodges). With the stealth of a stalker, he stole over to the Wigwam of Kanakwe and slipped the Birch-bark tray under the door flap.

It was late when Neebashka reached the shoreline below his camp, and he was looking forward to a peaceful rest with his Mate and Children. "What is this?" he wondered as he walked into camp and saw almost everyone gathered around a large Shkode. The mood was hushed: something serious had happened.

He approached cautiously, keenly observing with each step. From his *Minisino* (Guardian–Warrior) training, he had learned not to rush into the center of activity. Closer to Shkode, he saw *Nodeni Waba-nunkwe* (Woman-of-the-White-Wind), their revered *Mashkikeekwe* (Medicine Woman), hunched over something on the ground.

Before he could make out what it was, he knew it to be his infant Daughter. All the signs told him so: his Mate assisting Nunkwe, his Brother tending Shkode, and his Mother sitting with the other Children (who were asleep on a Bear rug).

"It cannot be," said Neebashka as he felt his knees weaken. And yet, in the way of the Minisino, he remained centered. Approaching the vigil, he kept a respectful distance from the activity, as he trusted the skill of their Mashkikeekwe.

"Your Daughter was out of her Dikinagan this afternoon, exploring the area near the Hearth," said Waseyakwe (Bright-Sky-Woman), one of Neebashka's clan Sisters. "At the evening meal we noticed her breathing was shallow, and yet she seemed otherwise alright. There was no congestion, no fever, and she seemed to have no pain. After the meal her breathing grew ever more shallow, and we called for Nunkwe."

Neebashka was impatient to know all that had happened, and yet he kept respectfully silent as Waseyakwe spoke. "Nunkwe took one look at the Babe, immediately disrobed her, and asked two nearby Women to bring cold Moss from the Bog."

Neebashka knew that Women were chosen because they had natural resonance with Earth energy, and that's why they're usually the gatherers of medicinals.

Waseyakwe continued, "She packed your Daughter in the Moss, replacing it through the evening as it lost its chill.

"Before long," Waseyakwe said, "the Babe's body turned blue and her face looked as though it was afire. Her breathing grew more and more shallow until we couldn't tell if she was breathing at all."

Seeing that Neebashka was growing agitated, Waseyakwe paused and placed her hand on his knee to reassure him. She then spoke on, "It looked as though she was about to die. Covering

the Babe's mouth and nose with her own mouth, Nunkwe began to breathe into her.

"Our Mashkikeekwe has been tending to your Child steadily. Only now, as you walked up from the beach, has she taken pause."

"Look," someone whispered, "she's taking breaths on her own!"

Nunkwe stripped off the Moss and began vigorously rubbing the tiny body. "Build up Shkode," she said insistently, "we need warmth." At the same time she motioned for two of her apprentices to come and help massage the infant. Within moments—right before our eyes—the nursling turned from blue to pink and her breathing grew deep and steady.

The next morning, as the Little One slept contentedly in her Dikinagan, the tired but elated Mashkikeekwe called everyone together.

This old Woman has never before seen what befell our Nursling, she began, and yet as soon as I set eyes on the Babe, a healing story came forth from the *clan memory* to guide me. It was passed on to me by my *Nokomis* (Grandmother) when I was a young Girl apprenticed to her. In the evening she would tell me stories of healings, and I'd ask her to retell them, over and over, until I fell asleep. And then I'd dream of them.

One of my favorites was about a young Boy who ate a mushroom that robbed him of his breath. 'This happened in the time of our distant Ancestors,' I remember Nokomis saying, 'and yet the story lives on in our clan memory. Perhaps on some future Sun, the story will guide you in a healing.' This intrigued me all the more, and I listened intently to every detail.

Last night was like the story-dreams I had as a Child. The story of the young Boy came alive before me, and I knew just what to do. We were to cool the dear Babe's body, to force what spark of life she held on to into her head. Without breath there is no life, so as long as she was under the Mushroom's spell, she needed help breathing. Once she could take a breath on her own, it was time to use massage to warm her and help the blood flow through her reawakening body. If we did not, her heart may have stopped from the shock of having to do too much too soon.

Nunkwe paused and took a deep, slow breath. That was the easy part, she said in a subdued voice. Before I touched her, I needed to determine whether or not it was time for her *Passing-over*, for if it was, keeping her alive would have interfered with her *Lifepath*. A voice told me that she had not yet received her name, so it was intended that she live on and be a blessing to her People.

Neebashka wasn't there to hear these words. He had stolen quietly away and gone down to the Water's edge, where he stood looking out in the direction of the next Lake over.

ORIGIN

A SHORT WHILE AGO, my Mate Lety was writing an essay on the *Gifting Way*: how Natives share because they believe in abundance, as opposed to the scarcity consciousness that drives modern economies. She asked if I would contribute an example of the Gifting Way. I closed my eyes and this story, in simple form, was given to me by the storyline.

Recently when I was in a heightened state of awareness in the *Madodiswan* (Sweat Lodge), the story came back. This time it had life and characters: it was being enacted before me on the very shores of the neighboring Lakes.

Chapter Eight

Self-Discovery

THE MBUTI (CONGOLESE PYGMIES) consider themselves Mbuti because of their nomadic hunter–gatherer way of life. If one of them were to join a farming village, his new lifestyle would be so alien to his kin that they would no longer consider him Mbuti. Nor would he identify himself as Mbuti. Their identity is profoundly rooted in how and where they live, rather than on blood relationship or culture of origin. In the words of an Elder named Moke, "The Forest is our home; when we leave the forest, or when the forest dies, we shall die. We are the people of the forest."[87]

Many of us base our ethnic identities on the country (or countries) of our Ancestors' origin, even thought we may never have traveled there and know little or nothing of its language and culture. We have an abstract connection with the past rather than a current relationship with a living culture.

Cultural traditions are important, as they give us ways to deal with everyday emotions such as anger and jealousy, along with ways to take responsibility for our own actions rather than feeling victimized or blaming others. When we have no functioning cultural identity, we lack the traditional tools to help us with these daily affairs of life.

Cultures will preserve and transmit these tools through stories. A storyteller will often choose one story specifically for someone in her audience. She knows that the story will gift the others also, because in a community the actions of one touch all. The following stories are examples of the repertoire of insight and guidance a storyteller in a living culture has at her disposal.

Two Hungry Bears

OUR PEOPLE HAVE A SAYING that when all is quiet under a blanket of Snow, *Makwa* (Bears) wake up. Now these are not ordinary Makwa who hibernate when the Snow lies deep. No, I'm talking about the Makwa who wait to come out *during* the White Season, when the nights are long and cold and virtually all of life is snug asleep in warm, sheltered places. On nights like this, only the far-off call of *Ma'eengan* (Wolf) or *Gookookoo* (Owl) remind us that anything at all might still be moving about.

On one such night, a young Boy named *Nigig Inzow* (Otter-Tail) sat up late by himself. His family was long asleep, snuggled into a pile of plush furs, and yet his fretful mind would not let him join them. He could find nothing to do but stare at his faint shadow, which was cast on the wall by the pale, yellow glow of the fading *Shkode* (Fire) in the center of the Lodge.

He was a carefree Child, always clear in what he thought and felt. Only now, as he approached his tenth Winter, his life began spinning in a confusing web of feelings. Tonight he stared at the wall as though searching for something in his silhouette that he couldn't find inside himself.

The wailing chorus of nearby Ma'eengan shook Inzow out of his trance. As the howls trailed off to rejoin the stillness, Inzow's eyes opened wide in a sudden realization: "I'll go and see *Mishomis* (Grandfather)! He is wise like a Mountain; perhaps he can help."

It was all Inzow could do not to awaken his family. He quickly tended Shkode, snatched his *Wagosh* (Fox) fur robe, and darted out the door. Even before he got the robe fully wrapped around him, he was across the clearing and entering Mishomis's Lodge.

"It is very late and you are awake, Honored Mishomis," Inzow said in a surprised voice as he entered the cozy Lodge. The Elder was not only up but he was building up Shkode, as though he were expecting someone.

"Mishomis is also opposite the door: the place for greeting visitors," thought Inzow. "Perhaps the doorway was drafty and he wanted to sit where it was warmest." Out of respect, Inzow kept his confusion to himself and sat in the traditional place for Children: to the left of the door, from where they could easily run errands for their Elders—or as they saw it, scoot out quickly to play.

"Honored Mishomis," spoke Inzow straight away, "*this Boy's* belly is being torn apart; it feels like two hungry Makwa battling each other. Often they fight in his dreams; and sometimes even in the day when he feels impatient or sad, they wake up and claw at each other."

Mishomis looked intently into Shkode. "I know them well," he replied. "They live inside me also. And perhaps inside everybody. One is the Makwa of *Balance*, who comes when we trust in the *Gifting Way*; the other is Makwa out of Balance, who comes when we trust in ourselves."

Mishomis said no more. He stirred the coals, and they both sat in silence.

After a while the Boy spoke: "Mishomis, can you tell me which one will win?"

"The one you feed, my Child."

"How would I feed the Makwa of Balance? I want him to grow strong!"

"With your heart," was his Mishomis's simple reply.

Before another voice was heard, Shkode had burned down to deep orange embers, casting just enough light into the blackness to mark the features of their faces.

"But Mishomis, they're both me—if I don't feed one, I don't feed myself."

"Yes, my Child. You are wise beyond the turns of the seasons you've been blessed to know. In truth there is only one Makwa. Just as Cloud and Sun come together to make the day, the two fighting Makwa join to help us see both the dark and the light. Go now to be with your family under the sleeping robe, my dear Grandson, so that your two Makwa might find their place of rest within you. Together they will guide you through love and battle as you walk this Journey of Life, and they will help you find vision in blindness."

"Mishomis, you speak in riddles," Inzow said with a lightened heart. "And yet they bring me comfort. Sometimes I understand the wisdom of your smile better than the wisdom of your words. *Meegwetch* (Thank you) dear Father of my Father. I shall carry your smile into my dreams."

ORIGIN

GOOD STORIES HAVE A WAY of traveling. I find the same ones not only in the expected places where there is a history of cultural exchange, but also in diverse and isolated cultures around the world. The original version of this story came to me from the Cherokee people by way of my Irish–American friend Patty Miller, who received it from her sister in England.

In the original story from Patty, the two Animals were Ma'eengan (Wolves). I chose Makwa instead, to break from civilized culture's false *vicious Wolf* stereotype.

Also, in the original story, the Ma'eengan remained two and opposed to each other. That fit for the Cherokee because they are agriculturalists, who typically draw a line between domestic and wild, cultivated and untended. When this line exists in a culture, it usually cuts through the People of the culture as well. Life gets divided between the polarities of good and evil and becomes an eternal struggle between the two. This division is allegorized by the two Ma'eengan in the Cherokee version of the story.

With hunting–gathering Peoples, the line between good and evil, as between domestic and wild, is not so well defined. While living in intimate relationship with all of life, Native People find little reason to categorize. This was probably reflected in the original "Two Hungry Bears" when it was a hunter–gatherer story, and my intent in revising the story was to restore it to something approximating the original.

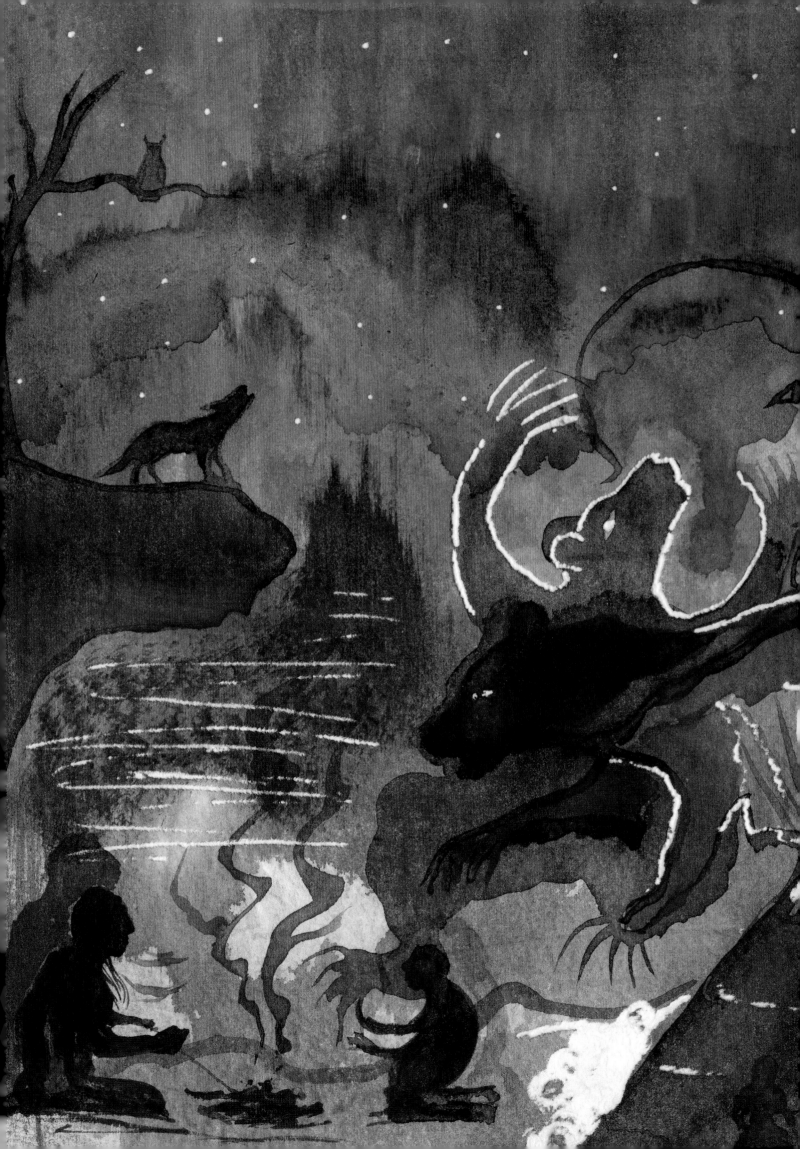

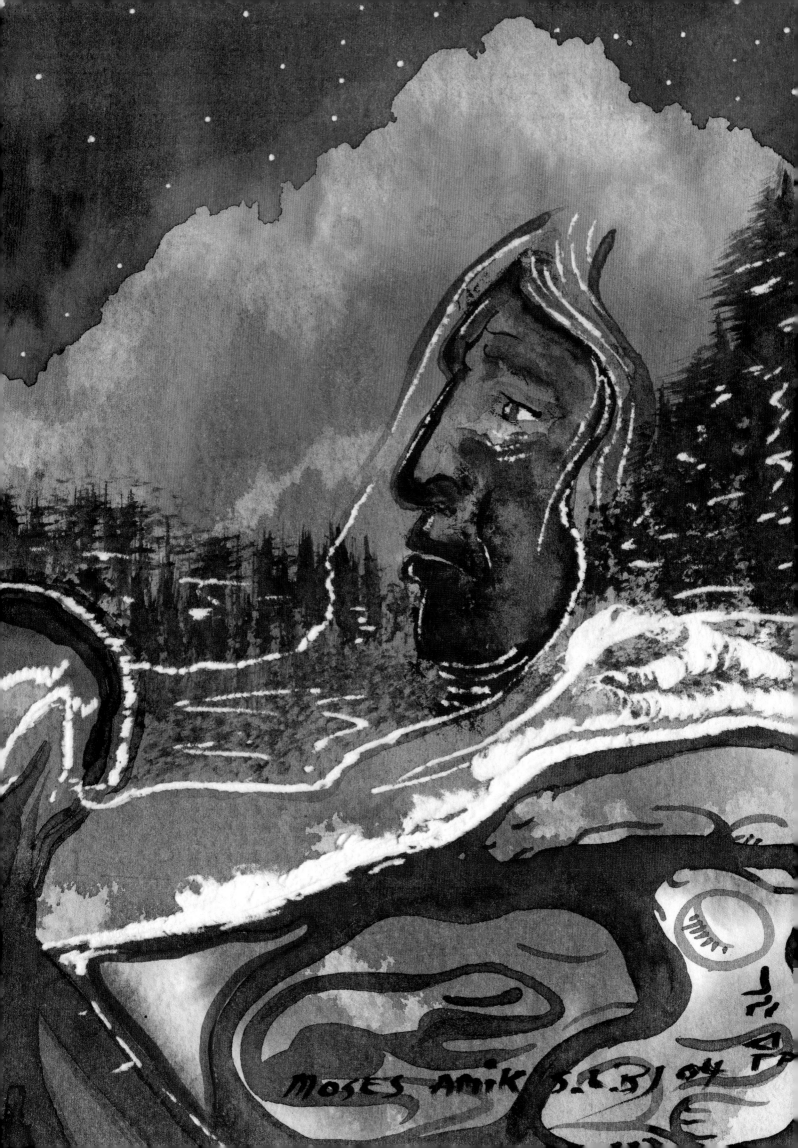

How Bear-Heart-Woman Brought Truth Back to the People

IN THE TIME OF THE FIRST PEOPLE, everything that was spoken was truth. Whether it was the sound of *Nodin* (Wind), the chatter of *Ajidamo* (Squirrel), or the word of the *Anishinabe* (Human), it was the voice of truth. These truths arose as naturally as a whim and flowed as freely and clearly as a Mountain Stream. They were all the truth of *nongom* (the moment), and each Person had his own truth, because there was only nongom and only truth could dwell there.

This was the way of all life. Each Person of the Leafed ones, the Furred ones, the Rock ones, and all of the other *Relations*, dwelled together in a glorious web of sharing. It was as though they were dancing, each in their own way, to their own music. And yet there was a synchronicity to their movements: there was giving and receiving, there was honor and respect, there was good life and good Death. There was *Balance*: a natural state of harmony with self and all life.

The Ojibwe People call this personal truth *debwewin*, which literally means *voice of the heart*. "A Person's center is the heart," the Elders

MOSES AM

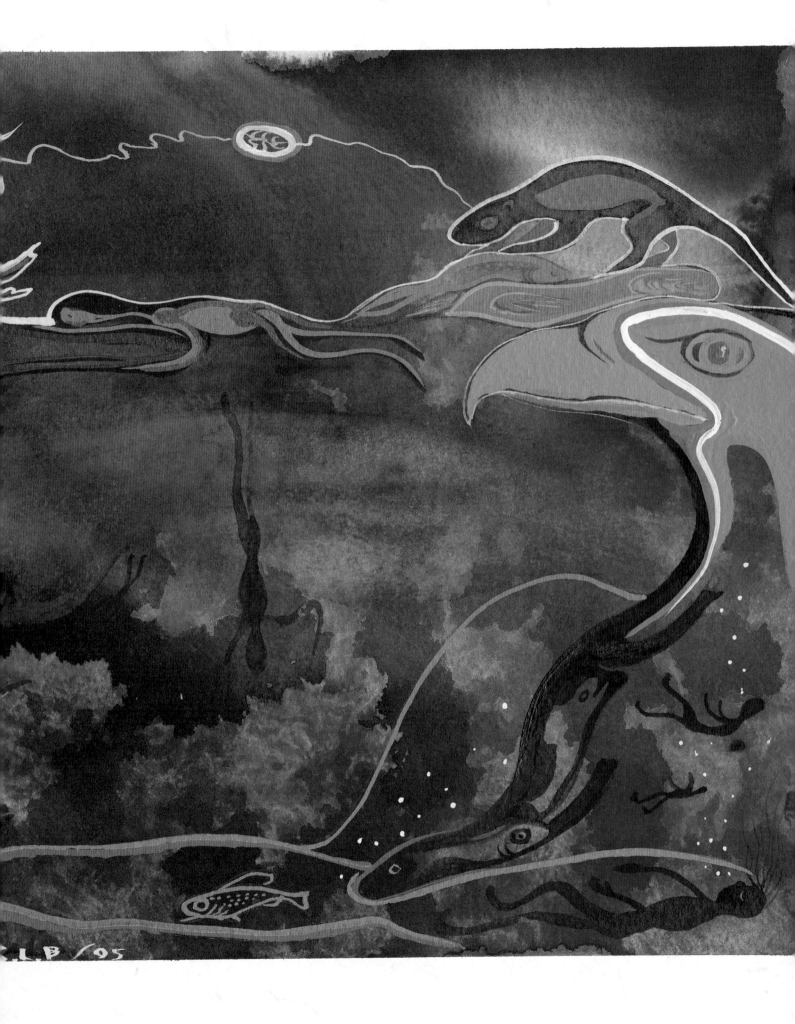

say. "It's where senses, intuition, feelings, mind, and ancestral memories come together to form one's personal truth."

Once in that long-ago time, the People began to wonder what it would be like if they left nongom and wandered into the past or future. Before long they were brooding over old wounds, unfulfilled expectations, and fears of what might come.

"What if the next White Season brings deep *Goon* (Snow)?" some would ask.

"And what if *Geegoon* (Fish) don't come up our Stream to spawn when Goon melts?" said others.

The People grew confused. When they dwelled on the past, old feelings clouded nongom; when they dwelled in the future, the voices of worry overpowered the voices of intuition. Gradually they lost touch with their debwewin.

"What are we to do?" they lamented one after the other.

"Let's go to our Sister and Brother Relations," suggested a young Man named *Anakwad Agidaki* (Cloud-on-the-Hill). "They've been ever kind to us when we've sought their guidance."

Sometimes these Relations would give guidance in a dream or by leaving a sign. More often, guidance was given through their example, which the Anishinabe regarded as a great teacher. No matter how it came, it was cherished because it was debwewin.

The People would wait patiently for the Relations to speak their debwewin. Preparing themselves by developing awareness skills, the People could better recognize and be attuned to what was given.

To empower this awareness, the People would usually place an *Offering* of sacred *Kinnikinick* (an aromatic herbal blend), on the Bosom of their cherished Earth-Mother. However, now they were too confused to trust, too desperate to wait. Without debwewin to guide them, they were no longer walking in

Balance. Forgetting how to dance with the turnings of the seasons, they were too often either hot and burning or wet and shivering. They fought among themselves, because they spoke from their heads, with the passion of desperation, rather than from their hearts, with the passion of truth.

For *Moon* after Moon, they wallowed in this pathetic state, gradually forgetting their traditional ways of food gathering, hide tanning, and childcare. Freezing nights and screaming bellies drove them to find something— anything—that might relieve their misery.

They went to Forest and Lake and Cliffside to ask their Relations for help. Only this time they didn't go to quietly fast and wait for a voice—they went to beg and plead. They were *sure* they knew what they needed: "We are hungry—we need food," they implored. "We are cold—we need dry wood. We are fighting among ourselves—we need weapons."

Some of them went to *Nigig* (Otter), who lived in the Lake. "Nigig," they whimpered, "we are starving; will you help us?"

"Who are these creatures who look like my Two-Legged Brothers but act as though there is no Honor Way?" wondered Nigig. "They don't introduce themselves, nor do they bring an Offering." Nigig stayed out from the shore, a safe distance from them.

And yet he had a home in his heart for his Two-Legged kin. "In the *Suns* when you dwelled in Balance with our Earth-Mother and all the Relations, we learned from each other," he said. "We haven't spoken our truths to each other for a while now, and I see how wretched you have become. Perhaps my example will help you find food." Nigig dove down into the cold depths of the Lake.

"Where is Nigig?" someone asked. "He's been down there a long time; what if something happened to him?" A mix of fear and concern was etched on every face, but it was *not* for

Nigig. They were beyond empathy; their hunger left them room only for self-concern.

"Aaaahhh!" exclaimed everyone when Nigig finally did break the surface. He caught his breath and pulled himself up on a floating log. The Water droplets on his sleek, dark coat sparkled like beads of sunshine. And yet the People hardly noticed: they were focused only on the golden Trout in his mouth. He gave Thanks to Trout Spirit for the gift of food and then quietly and reverently feasted.

"That's what we'll do also," the People emphatically stated. "Nigig is fat and we are thin. We shall hunt in the depths of the Lake, like Nigig, and then we too shall be fat!" They wasted no time stripping down and diving into the black depths where the gilded Trout lurked.

One by one the Humans surfaced, choking and gasping for air. They crawled up on the beach and collapsed. "The Trout swam so fast that I couldn't grab even one," one of the divers sputtered. "The Water's sooo cold—I feel more miserable than ever," another grumbled.

They looked around at each other, taking stock of their predicament, and noticed that several of their kin were missing.

"Aieeee!" A great wail rose spontaneously from the People and echoed across the Water. "Why did the Lake take my Child?" screamed frantic Mothers as they pounded their breasts and tore at their hair. Those who lost Children and Mates would now have to sleep alone. That evening, they burnt off their hair and blackened their faces with charcoal.

"You tricked us: either you're a *Contrary* or you do not speak truth," they cursed Nigig. "We will turn our backs to you and find a *real* speaker of truth among the *other* Relations."

"But who?" they asked each other.

"How about *Makwa* (Bear)?" "No, I think it should be *Wagosh* (Fox)." "That's ridiculous; *Amik* (Beaver) is the one!" Arguing got them nowhere: they began to threaten and shove. Fists

flew. Raging cries pierced the air as blood and bruises disfigured faces. Shredded clothing and handfuls of torn-out hair littered the ground.

As vicious as it was, it didn't last long, for they had little strength. While they sat there catching their breaths and smarting from their wounds, an agitated young Man known as *Shkodewan Enig* (Ant-on-Fire) jumped up and proclaimed, "We're a miserable lot—we have no food and we hurt ourselves when we try to get some. Our speech is no longer sacred, and when we try to talk, we abuse ourselves even more. I'm finished with this *clan*; I must take care of *me* and protect myself from *you*. I'm going to *Migizi* (Eagle), the Mighty Lone Hunter, and she'll tell me how to stand strong and take care of myself."

Another Person joined in agreement.

"You're both fools," *Midasso Dibik* (Ten-Nights) spat out. "I'll go to *Zhashagi* (Heron), who stands alone in the Marsh and stabs all the Geegoon he wants with his spear. He'll show me how to grow fat while you all starve!"

"What silliness!" someone else said. "*I* will go to *Minensagawanzh* (Thorn-Apple Tree). She stands alone in the Meadow, lush and laden with fruit, because her nasty spikes won't let anyone get close to her. With you cowards, I am miserable; I am no more than bones and hide— I'll learn how to stand alone

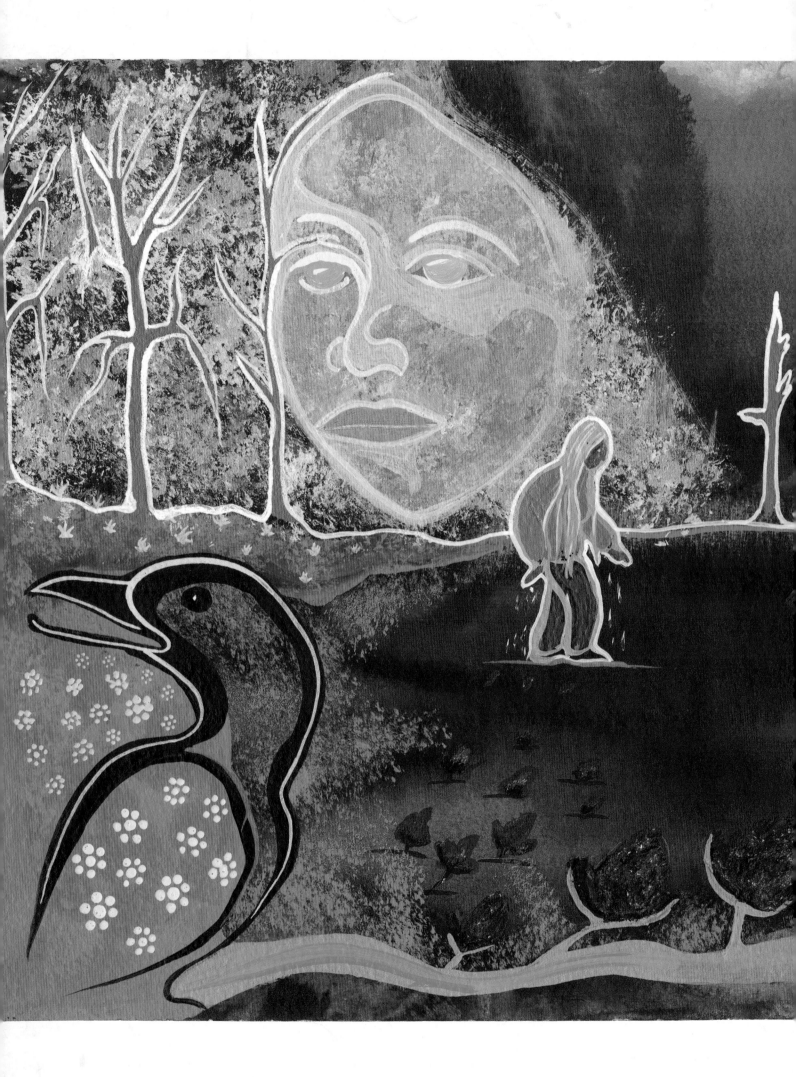

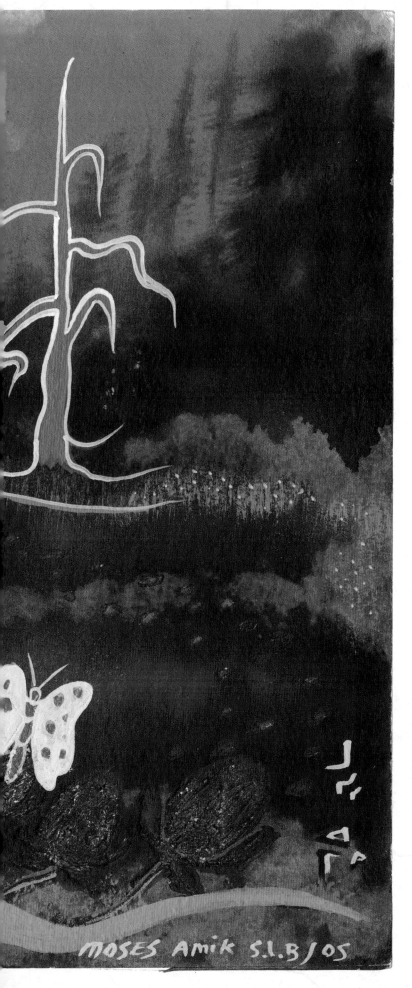

MOSES AMIK S.I.B / 05

and be invincible like her!"

Without looking back, they each set out in separate directions to learn the way of the Relation whom they were sure would help them. Before long, there were People wandering alone throughout the Land, practicing all that they had learned.

Or thought they learned.

When someone who carried a Zhashagi beak spear came across someone with a Migizi claw knife, a clash was almost certain. Being embittered and mistrustful, they fell easily into fighting. Only now, it cost them more than a bit of blood and hair. The power of Makwa or *Ma'eengan* (Wolf) in the hands of someone who was out of Balance only magnified the imbalance. What a grisly lot they were!

They needed truth, and since they could no longer hear their own, they were only trying to find something that worked. However, another's truth wouldn't fit for them—it couldn't fit— because each Person's truth is strictly his own.

No more did anyone serve the clan and honor the Relations. Virtually everyone had become self-possessed and greedy. The *Gifting Way* never gave enough: their lust for more was insatiable. They craved more food than they could eat, they coveted a bigger Lodge than they could ever fill, they demanded more wood than they would ever burn. If something didn't come easy, they would plunder it with the help of their new fang and claw weapons.

Not all of the People found ways to survive. One small Girl had lost her Mother, and now she wandered alone, deep in the Forest. Her swollen belly burned from ceaseless hunger. Only by eating Bugs and chewing on leaves, along with finding shelter under uprooted Trees was she able to survive at all.

She no longer knew herself, because she no longer knew her People. Her *Hoop of Relations* was broken. The song of a Bird, the touch of the Sun—and even one's own name—mean nothing

when one no longer dwells within the Hoop. And so it was with this Child.

One gray and rainy afternoon, she crawled under a Bush and found no reason to move further. For four Suns she huddled there. Neither thirst nor cold—not even the relentless biting Flies—brought any response. And then, right behind her "Snap!" went a twig. Instinctively she clenched her eyes and curled up even tighter. The next thing she knew, she was being comfortingly embraced in furry-warm arms, and she dropped off into a deep and peaceful sleep.

"There, there, *Abinozhee* (Little One)," was the kind voice she heard when she opened her eyes. "You are safe. I am *Ode'imin Makwakwe* (Bear-Heart-Woman); just call me Odekwe, because you and I are Sisters. Your Forest kin asked me to find you. They told me you're the only one left of your kind who has a sense of heart."

Odekwe brought the Girl to a Meadow laced with Flowers and Butterflies. Birdsong drifted from nearby Trees and Fawns frolicked in the lush Grasses. The two feasted on ripe berries and the succulent shoots of Fern and Violet. They gathered Clams and Duck eggs along the clear-water Stream that meandered through the Meadow, and they swam in the Healing Waters of the Beaver Pond. In only a short while, roundness returned to the younger Sister's cheeks, and her hair again glistened like the coat of Amik.

One morning, a serious look tinged with sadness came over Odekwe's face. She was filled with words that asked to be spoken, and yet they came hard. Here is what she said:

It is now time for us to part and for you to return to your People. For too long they've been looking for debwewin outside themselves, and you have been chosen as the one to guide them back. In youth the voice of the heart is strong, and that's why this

great honor has been bestowed upon you. Like you, those of my kind, Makwa, have not lost their heartvoices. This is why I've been handed the privilege of giving you the Heart Teachings to take back to your People.

We'll spend this coming Moon here in the Meadow, listening to the voices of our Feathered, and Scaled, and Leafed Relations who dwell here. They're all Heartspeakers, for debwewin is all they know. After a Moon of Heartspeaking with them, you'll be ready to gift the Heart Teachings back to your People. It'll be a joyous Sun for them, for they'll again be able to embrace their speech as sacred."

"You speak words of beauty, Older Sister," the Girl responded, "and I wish to carry the spirit of your words to my People. Only they will not listen to me." Tears trickled down her face.

"I will give you a sign to take to them," said Odekwe. "They'll know the sign because it will speak to their hearts." With a piece of broken Clam shell, Odekwe cut her own left hand, which is called the giving hand, because it's the one closest to the heart. Walking through the Meadow, she left a trail of blood droplets in the form of a Circle, because the Elders instruct that heart energy flows in a circular way.

"What's this?" said the Child as she looked down at the crimson beads on the Grass. Where they had been, there were now small red hearts. They were juicy and smelled luscious, so she tasted one and found it pleasing. Wherever her elder Sister's blood had fallen, she now saw these new berries growing.

"They shall be known as *Ode'imin* (Strawberry)," said Odekwe. "They bring a teaching: they are red and shaped like a heart, and they're sweet and inviting, as is the voice of heart. Notice how they live gently and close upon the Bosom of the Mother, just as we are intended to do."

Odekwe looked sharp into the young Girl's eyes and solemnly spoke these words:

This Woman asks if her younger Sister will gather a Basket of Ode'imin and share it with her People. When they see you with a laden Basket, they'll approach you in hunger. Be not afraid: let them take some Ode'imin. Bring them to this Meadow, so that they might gather more. Like begets like: while eating Heartberries, their shriveled hearts will swell and they'll begin to feel communion with other hearts. Because you'll have renewed that which opens one heart to another, the *Circle Way* will be restored, and you will no longer be alone.

From this Sun on, until the very last sunset, this Moon will be remembered as the time of your People's reawakening. It shall be called *Ode'imin Geezis* (Heartberry Moon), and it shall be the first Moon of the Green Season. It'll be a time of new beginnings for all the Plant and Animal Relations. Ode'imin will be the first fruit of the season, to remind everyone of this time of misery and the teaching that brought it to a close.

There is one thing your People must do in order to continue receiving the blessings of Ode'imin: when the first fruit ripen, hold a Feast in honor of those who walked in this time. Before you eat, place an Offering of the season's first Ode'imin on a specially made Shkode. The sweet smoke that rises will touch the spirits of those who died in this time, and they will be pleased. They'll listen with misty eyes as your storyteller recounts the legend of how Ode'imin brought heartspeaking back to the People.

The Teaching is now complete, and it is time for this Woman to honor her courageous Sister with a gift. You shall be known as *Ode'iminikwe* (Heartberry Woman). Every time your People say "Ode'imin," they will be honoring you. And every time they eat Ode'imin, they'll reenact perhaps the greatest Journey they have ever taken: the way back to their hearts.
Aho (I have spoken).

ORIGIN

SEVERAL YEARS AGO, I needed a story to illustrate the power and value of heartspeaking (also called truthspeaking) for a book I was writing. Immediately a story of courage from the life of my old friend and spirit-sister, Ode Makwa, came to mind. It resonated with archetypes already familiar to me from Ojibwe stories: a people who had lost their way, a mystic who yet possessed what the People had lost, and a noble young Person who became the savior of her People.

Ode Makwa's life story melded so naturally with these archetypes that "How Bear-Heart-Woman Brought Truth Back to the People" virtually created itself. In honor of Ode Makwa I dedicate this story.

How Flute Came to the People

ANEEN (GREETINGS) TO YOU of the Human People. I am the one you call *Bapase* (Woodpecker), of the Winged People, and I wish to tell you a story of the kinship of your People and mine. Let me take you back to the time when only the Wingeds could paint melodies across the Sky. On the dawn of every *Sun*, we would do so in gratitude for our many blessings. We watched you Give Thanks as well, with *Opwagan* (Pipe), and yet we could see that there was an unspoken yearning in your hearts.

Gijiganaeshi (Chickadee), whom we know simply as Giji, is not so shy as some of us. She would sometimes alight on your Opwagan while you were Giving Thanks. One Sun, she told us that Opwagan had spoken to her, saying, "We feel the same yearning as the Humans, because we have only breath: no sweet voice like yours to help the Humans free the song of their hearts."

We Wingeds were saddened by this news, so we called a great council to see how we might serve in finding your song voice. We came together in Circle in the arching branches of a great *Gizhik* (Cedar). Even then she was your most sacred Tree, and you called her *Nokomis* (Grandmother). She gifted you with *Medicine* for your skin and with the tea that kept you healthy when there was no fruit during the

Deep-Snow *Moon*s. Her wood was used for *Jeeman* (Canoe), *Nagan* (Bowl), *Dikinagan* (Cradleboard), and Opwagan making; you used her bark for tinder, cordage, and weaving.

"Who shall guide our council?" we asked ourselves.

"Perhaps it ought to be me," responded *Migizi* (Eagle). "Humans smile and nod gratefully when I fly overhead, saying I'm a good omen." Standing boldly on an upper branch and glistening in the midday Sun, Migizi certainly did hold a commanding presence.

"I think *I* would be the best to guide," stated *Deendeesi* (Blue Jay). "My voice is strong and they're used to seeing me around their camp."

"Let it be me," said *Nenookasi* (Hummingbird), "for I am sweet and small like the voice of Human Children."

Soon all of the Wingeds were talking at once:

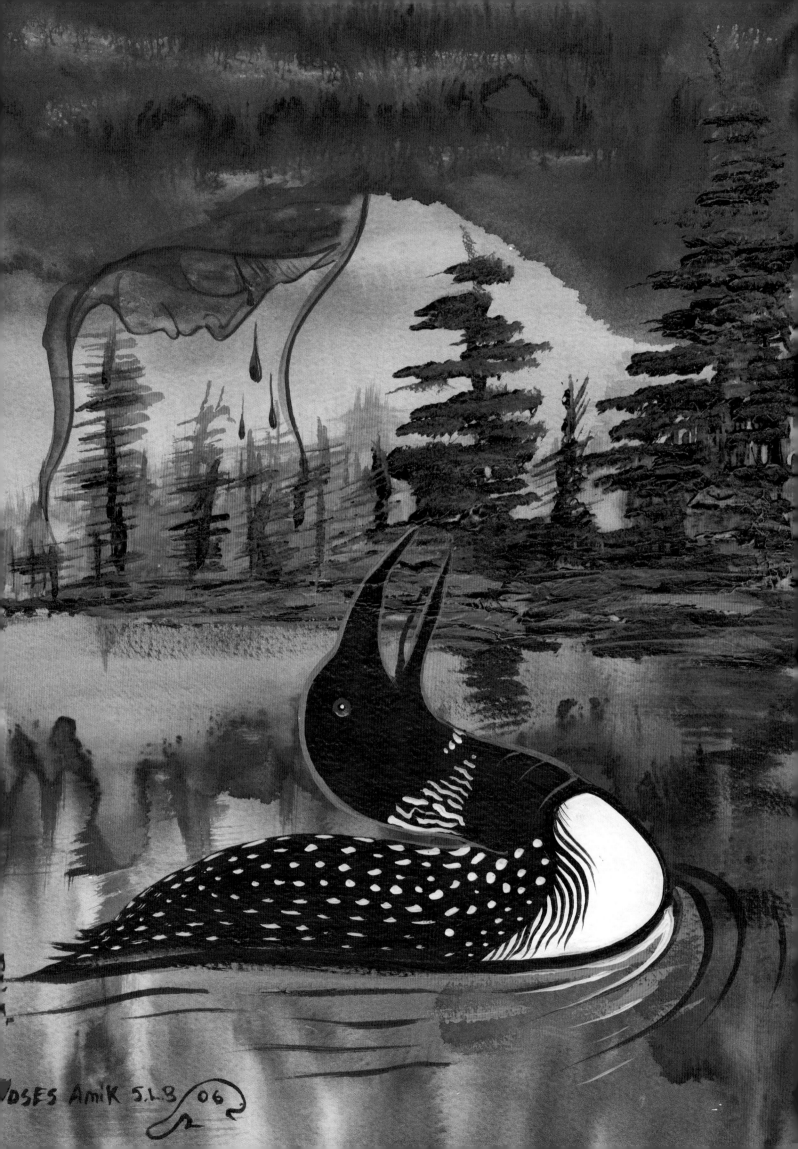

Moses Amik 5.28/06

"I should guide." "No, me!" "Why not me?"

When the ruckus was at its loudest, a dark shadow crept over us, one by one. "What . . . what could that be? There's not a Cloud in the Sky!" exclaimed the excitable Deendeesi. We looked up and there on the highest branch, the lookout perch, *Gagagi* (Raven) was slowly spreading her great black wings. As her shadow touched us, we each realized that we were speaking in pride and not in giving.

In shame we looked down, only to notice *Mang* (Loon) sitting on the golden needle blanket beside Nokomis's trunk. (Mang couldn't perch because her feet were made only for swimming.) Having not yet spoken, she knew that now was her time. These are her words as I remember them. "*This Sister* of the Wingeds respectfully asks that she may share what she knows of our Human kin. When I'm resting on the night Waters, I'll sometimes hear the sighing of a Human who has come to be alone with his heavy heart. The Water from his eyes will fall upon the Lake and come to touch me, and I will feel his grief and wail in mournful voice. My family will often join in, along with Brother *Ma'eengan* (Wolf), who sends our lament deep into the Forest. It seems to help the Human find peace, perhaps because—at least for the moment—his heart has found a voice."

After Mang had spoken, it was clear that she was the one to guide our council. Her words reminded us of why she was one of the more common *dodems* (Animal guides) for Humans. She asked that we all be *Smudged*, after which she called the council to begin.

Just then, a Wind gathered in the treetops and a plaintive song like Mang's filled the air. "How could this be?" we all asked ourselves. "Mang is below us, and yet we hear her voice in our midst."

"Has one of my Sisters found a way to roost in the Tree?" asked Mang, as confused as the others.

We listened more closely. The song seemed to be coming from a deep scar in the trunk, the kind made by a furious *Animikee* (Thunderbird) when he hurls a great Fire-bolt earthward. Hanging from the scar was a long splinter of wood with several holes down its length, which looked as though they were made by a fellow Bapase.

"Does anyone know how this song can be when there is no one to sing it?" asked Mang.

There was only silence until the Wind picked up and again swayed the splinter.

"Incredible!" exclaimed Deendeesi.

"How can it be?" asked Nenookasi.

"Only we Wingeds can sing; it must be a spirit," said Migizi.

The Wind stilled, and for some reason so did all the other sounds of the Forest. "Hush," whispered Gagagi, "and I'll watch for whatever it is that lurks nearby." A sudden chill caused me to tremble, and I could see that others were nervous and on their guard.

"Granddaughter Mang," came in a voice as ancient as the Forest himself. "This old Woman asks if she might have the honor of speaking with her Grandchildren."

We dared not look around: the voice vibrated the very branches upon which we sat. All Mang could do in response was nod.

"My beloved Wingeds," continued the voice, "this one, who is stiff and hollowed with age, is warmed by your presence in the folds of her branching arms. She shares your compassion for the ones who have no heartsong. What sings is this splinter of her flesh, which is empowered by mighty Animikee and crafted by skillful Bapase. Might she be allowed to gift this Song Stick to the Humans?"

"Meegwetch (Thank you) dear Nokomis," replied Mang. "You honor us all with your sharing. Now who will offer to carry word of Nokomis's gift to the Humans?"

"I can speak to them in the night," offered *Gookookoo* (Owl).

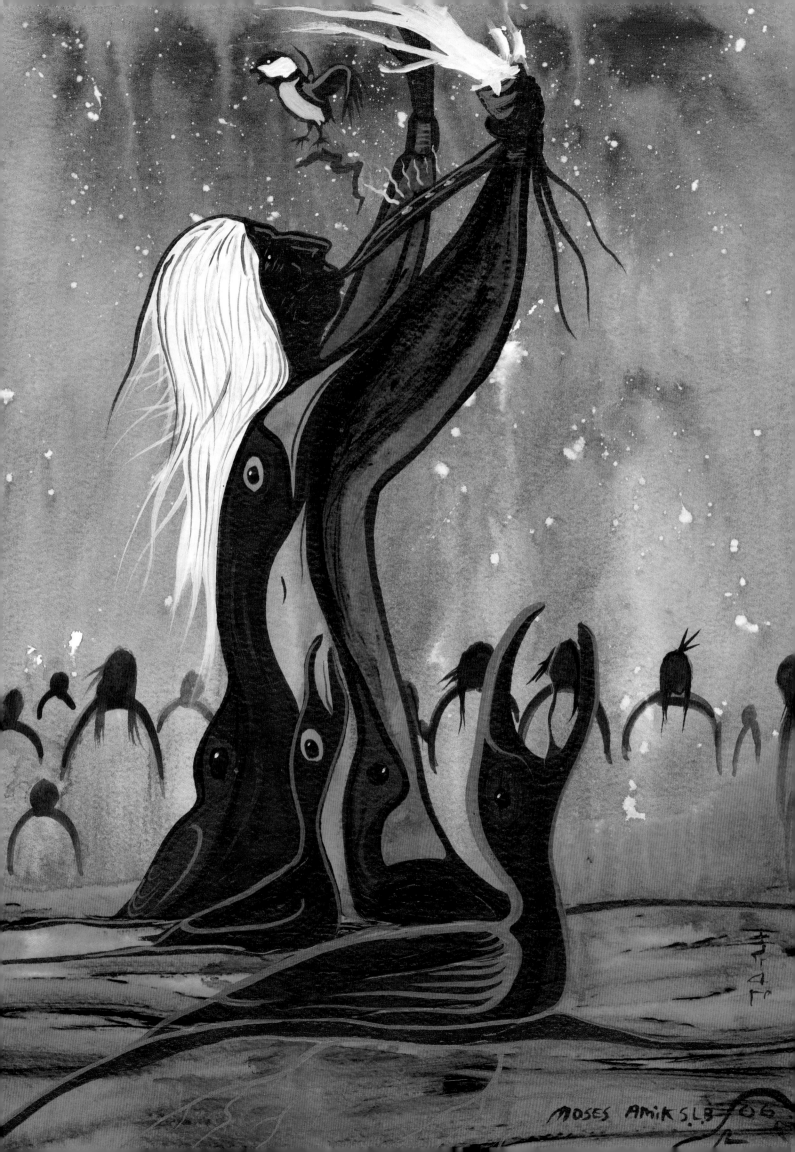

"And I'd like to talk to them by day," added *Opitchee* (Thrush).

Everyone agreed.

"The council is now concluded," stated Mang. "Let us gather in the arms of Nokomis on the next full Moon, to hear how Gookookoo and Opitchee fared on their mission."

On behalf of all assembled, Mang laid a Thanks-giving *Offering* of *Kinnikinick* (an aromatic herbal blend) before their revered Nokomis-Gizhik.

In the time before the full Moon, we all listened and watched, hoping you Humans would hear the message from Nokomis. We heard Gookookoo tell you in the night and we heard Opitchee repeat it in the day, and yet we continued to hear only Mang and Ma'eengan voice the laments of your hearts. We watched you come to Nokomis for wood; however, you did not make Song Sticks with it. Every Sun we hoped would be the one in which you'd listen, and every Sun our hope withered more.

The full Moon arrived and we came together in council. Again Migizi was the first to speak—this time with some humility: "Perhaps the Humans will listen to me, as they already turn their eyes up to me."

"Because I make such a noise hammering on Trees, the Humans could hardly ignore my voice," suggested one of my Bapase Brothers.

Giji then spoke, "I am close with Humans. I sometimes perch upon the Bowl of Opwagan during ceremony, and they let me

pick scraps of meat from the bones while they eat. They are kind of heart and nearly always greet me with smiles. And yet they may not listen to me any more than they did Gookookoo or Opitchee. The Humans have been without heartsong for so long that they might've forgotten our language."

There was silence after Giji spoke, and all grew quiet in the Forest. This time we were not afraid. "Humans already walk with Opwagan," spoke Nokomis, "so perhaps they'll listen to Opwagan. His Stem is made from my wood and it looks much like my splinter that sings in the Wind. If there were holes in the Stem like those in my splinter, perhaps Opwagan would also sing. When Humans draw Wind into Opwagan, he might then pour forth the song of their hearts."

"Let us consider the words of our wise Nokomis," suggested Mang.

"How would we make these song holes in the Stem of Opwagan?" asked Gookookoo.

"If we tried, the Humans might think we were destroying Opwagan," said Gagagi.

"We couldn't even *get* to Opwagan," added Deendeesi, "because the Humans treat him with great respect and keep him safely stored away,"

"We must try somehow," lamented Opitchee. "There *has* to be a way we can help our Human kin."

We all agreed, only no one else spoke up. It seemed we were out of ideas.

"I would like to craft the song holes," I, Bapase, offered. "However, I'm large and noisy, so I'd surely not be welcome in

their Lodge. Hopefully we'll find someone who can serve."

"Listen," whispered Giji. We all paid close attention and from a little hole in the Tree trunk came a tiny voice, "Your Brother *Moasay* (Woodgrub) asks if he may speak. I would be honored to craft the song holes, and I'm small enough that I could enter the Lodge without being seen."

"*Aya* (Yes)!" we all exclaimed. "Brother, you are so small and yet you have the courage of *Makwa* (Bear). You are a true Minisino (Guardian–Warrior)." However, it didn't take long before we realized that a sightless, defenseless being with neither legs nor wings had no real chance of reaching the Lodge of the Humans, much less finding Opwagan. "Meegwetch for your most noble offer," said Mang with an overtone of sadness. "It seems as though there's no way we can help our Human kin."

"This Person has felt hope and despair several times," said Giji, "and yet the inspiring words of Nokomis keep coming back to her. If it's intended that we serve our Human kin, then there *is* a way. I know the Lodge where Opwagan rests. The Humans welcome me there; I believe that upon my back I can carry Moasay to Opwagan."

And so it happened. Moasay was so small that he wasn't even noticed by the Humans. He crawled into the Bowl and down the stem, chewing out sound holes as he went. When he came out through the mouthpiece, he hopped back onto waiting Giji and they returned jubilantly to a resounding "Hurrah" from all of us Wingeds.

A few Suns later, the Humans assembled for an Opwagan Ceremony. "Look in the Trees all around us," said the Elder *Makizinens* (Small-Moccasin). "It looks like all of our Winged Relations in their rainbow-feathered splendor have come to join us in ceremony. There must be big Medicine afoot."

For a sacred flame to light Opwagan, a special *Shkode* (Fire) was started by a young apprentice. He held a flaming stick of Gizhik to the Bowl and Makizinens drew the breath of life into Opwagan. The Kinnikinick crackled and a rich, white smoke curled upward. Makizinens faced East, the direction of new beginnings, and sent a billow of smoke in East's honor. The Elder then turned *sunwise* and in the same manner honored South's gift of nourishment, and then West's gift of wisdom, and lastly North's gift of introspection. He continued on to the East to complete the *Circle of Life*.

"I don't hear Opwagan's voice," whispered Moasay in Giji's ear. "What went wrong?" I wondered the same thing, and I'm sure the rest of the Wingeds did also. "Didn't Moasay and Giji tell us that all went well on their mission?" I asked myself. "Were all our efforts wasted; will the poor Humans not be gifted with heartsong after all?"

I could see that Giji, standing beside me, was very troubled. Of all the Birds, it was she who felt closest to the Humans, and she visited them often. She sometimes perched on Opwagan during ceremony. "The Humans call it a good omen," she would tell us.

In a flash she was gliding down toward the Humans. The instant she set foot upon Opwagan, a song so birdlike and yet so otherworldly rose with the smoke.

"Wha . . . what was that?" stammered Giji as she sprang into the air and exposed the sound hole her foot had inadvertently covered.

"What *is* that?" murmured the Humans. That is, all the Humans but Makizinens.

My People, he began, our Winged Sisters and Brothers have just graced us with the most profound of gifts. From where Sun-Father now stands, we will walk on with the sweet voice of this new Opwagan, which we will call *Bibigwan* (Flute). In honor of Giji,

let us carve her likeness out of Gizhik, so that Giji may ever perch upon the sound hole of Bibigwan.

"Aho (The ceremony is now finished),"* exclaimed Makizinens. And everyone, including us Wingeds, replied with a resounding "Aho."

And that's how your Bibigwan came to be. We of the Wingeds remember this story whenever we hear Bibigwan giving voice to your deep agony and pining love. Do keep in mind that you are especially blessed when Mang and Ma'eengan sing with you, for then your longing soars into Sky-Father's boundless expanse and returns as soothing melody.

We see that you often craft Bibigwan from lightning-struck Nokomis-Gizhik. She wishes you to know that she is honored when her Grandchildren so remember her gifting. We Wingeds feel equally honored when our likenesses grace your sound holes, and when the images of Mang or Ma'eengan are carved into the end openings. Gagagi is pleased that her lesson in humility is remembered in your tradition of playing Bibigwan not out of pride but alone in the quiet of the night. This is where love best finds its voice, and where the heart feels safest to cry.

ORIGIN

A NUMBER OF WINTERS AGO, a young Man stopped in to see me on his way home from a nearby reservation, where he played his Bibigwan at the wake of a respected Elder. My visitor was known to some as "pretty boy" because of his vanity. I could see how he earned the nickname, and at the same time I realized that his conceit came from his struggle with the emptiness he felt on his lonely Journey to find himself.

He was very proud of his Flute. I asked how she came to be and as he told me the story, I watched his self-absorption melt away. He was relating the age-old saga of a Person discovering and coming into relationship with a personal Medicine Object. This archetypal story, luxuriantly rich with symbol and metaphor, forms the skeleton of "How Flute Came to the People." I fleshed it out by adding morsels of Flute and Animal folklore from my Elders and from my own experience. As the story was told and re-told, its personality developed, and now it has a life of its own. This is one of the ways traditional stories live on and remain relevant to the times.

The Rattle Who Stole Personal Power

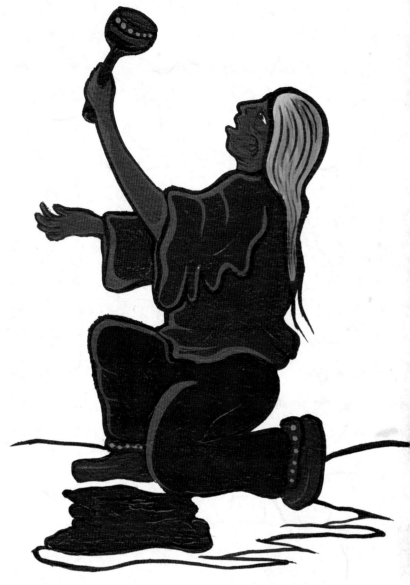

NOKOMIS (GRANDMOTHER) was boiling young Spruce cones over an open *Shkode* (Fire). The extracted indigo would be used to dye fishnets so they'd be camouflaged in the Water. As she added a few sticks to Shkode, a familiar shadow appeared before her. "Nokomis, may I speak with you?" asked *Namegos Mokibi* (Trout-Rising) in a respectful voice.

"Of course," the Elder replied. She gestured for the Girl, almost a Woman, to sit down beside her. "My Son's radiant Daughter always has a place at the Hearth of this proud old Nokomis."

Keeping focused on her task, Nokomis gave time for Nameg to choose the right words. "On the first *Sun* of this *Moon*," the girl began, "I was at the River fishing when something sparkled in the shallows and drew me toward it. Even before I touched it, I could feel its energy. When I opened my hand, I expected to see a rare and beautiful Pebble; instead, I found myself looking into the eye of *Ma'eengan* (Wolf)! Nokomis, I fell to my knees and could not move. Never, never have I seen anything like it."

"That must be some potent *Medicine*," responded the Elderwoman. "What happened next?"

"My tears of gratefulness fell into the River along with my *Offering* of *Kinnikinick* (an aromatic herbal blend); then I conducted a *Smudging Ceremony* to prepare myself for whatever was intended. I called him *Minwab* (Sees-Much) and carried him wherever I went in a special pouch I made to wear around my neck. As is our way, I kept the pouch concealed to keep from boasting about my Personal Medicine."

"Nokomis, whenever I had a question, he'd give me an answer. Whenever I slept with him under my pillow, he would calm me." Her last words quivered on her lips as she laid her head on the Elderwoman's lap. Sweetly-smoked buckskin brushed the Girl's cheek as the touch of a wizened hand calmed her.

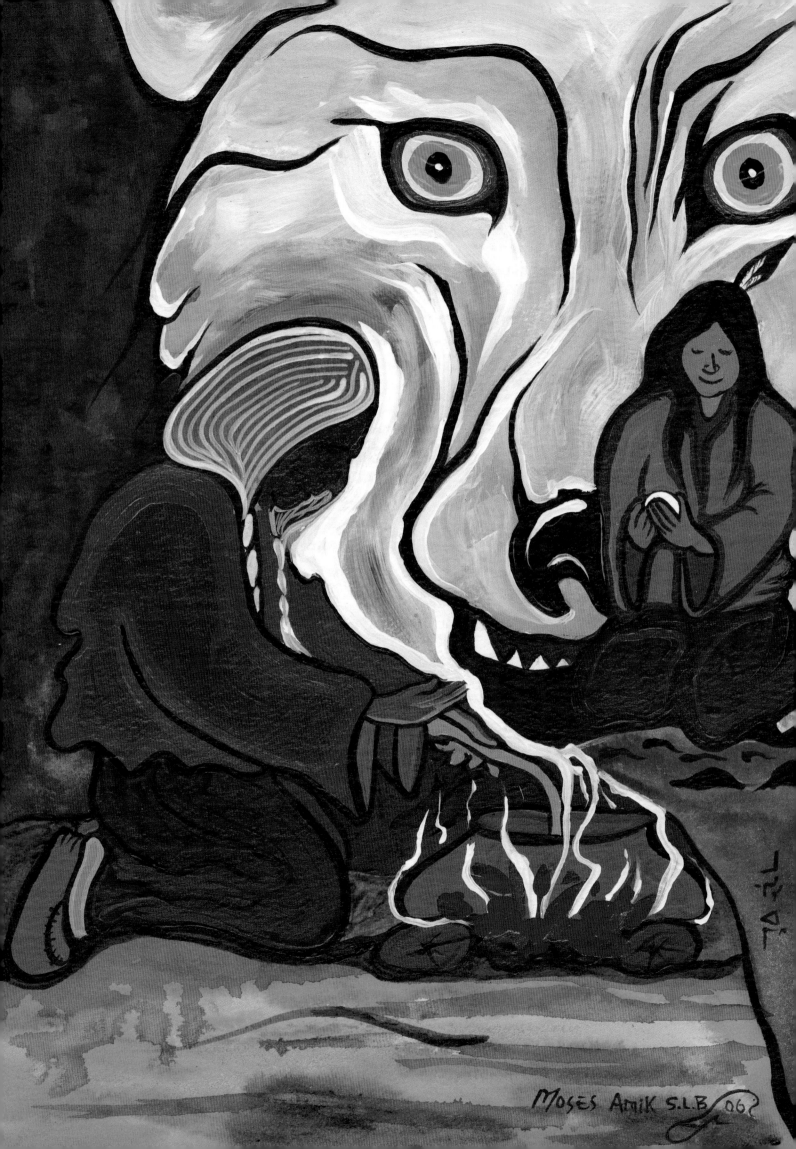

MOSES AMIK S.L.B 06

"And then yesterday I lost Minwab," she continued. "If I don't find him, I'll be lost; and I won't have his gifts to share with my People. I have failed them, Nokomis—what shall I do?"

The Elder brushed her silver braids back over her shoulders, removed the pot of cones from Shkode, and took Nameg's hands in hers. "My dear Grandchild," she began, "I will tell you a story. There was once a *Mashkikeekwe* (Medicine Woman) called *Miskwadesi Bimwagan* (Turtle-Who-Is-Wounded) who was revered by all of her People. They affectionately called her Miskwa. She brought healing to many, and her example inspired the Young to walk with honor.

"Miskwa had Medicine Helpers: sacred objects in her keeping who worked with her at ceremonies and healings. She was the keeper of her *clan*'s cherished *Medicine Bundle*, who glowed with the power of a rainbow because of the brightly colored Bird skins from which he was made. Miskwa also carried a sacred *Opwagan* (Pipe), who she took long ago to have blessed by the distant *Red Pipestone People*. In her hair she wore a Raven-black *Meegwan* (Feather) gifted her by the great *Animikee* (Thunderbird) who lived in the far Mountains.

"The People came to believe that Miskwa's Medicine Helpers had great power. In particular they revered *Zheesheegwan* (Rattle), who was passed down to her from an esteemed Mashkikeekwe of long ago, and whose memory still lived with the People. Zheesheegwan was made from the shell of a Miskwadesi. If you listened closely when he rattled, you could sometimes hear him telling stories of the healings he had witnessed.

"One day Miskwa petitioned a Man of her clan named *Zeekapidan* (He-Who-Drinks-Quickly) to be the keeper of the ancient Zheesheegwan. Miskwa felt that Zeekapidan, the new leader for the *Sweat Lodge Ceremony*, could use Zheesheegwan's help.

"'Why did Miskwa not give Zheesheegwan to my Brother instead of Zeekapidan?' sneered a Woman named Madwe (One-Making-Noise).

"Hearing this from Madwe, her Sister Amikwag (Many-Beaver) added, 'I hope *I* get one of her Medicine Helpers when she *Passes-over*.'

"A chorus of voices joined in, 'Why is she giving away her power?' 'Isn't she supposed to keep what is entrusted to her?' 'She'll no longer be able to help us!' For many *Suns* the talk buzzed around camp.

"'Why can't they see that they covet what they already have?' Miskwa thought to herself. 'My heart is heavy for them in their turmoil; I will prepare *Petition Sticks* and send a runner to give one to each Person in our camp and the camps of our nearby kin.'

"On the evening that was inscribed on the Petition Stick, everyone met at the ceremonial grounds in the woodland clearing near Miskwa's camp. 'Why have we been asked to come?' they said to each other. 'We have been told nothing; we come only because it's our tradition to honor a petition.'

"'My People,' began Miskwa, 'I am honored by your presence. *Meegwetch* (Thank you) for joining me this evening. Please come closer and sit in Circle with me around the ceremonial Shkode. Remember to leave an opening on the eastern side of the Circle, so that clarity and new beginnings, the gifts of the East, may enter and enrich us.'

"She laid a small fur before her and placed upon it a number of bundles that were wrapped in the finest golden-smoked buckskin. Unwrapping one bundle, she held up what was inside for everyone to see. It was her Opwagan.

"She lit Opwagan and caused his breath to swirl downward in honor of Earth-Mother, upward in honor of Sky-Father, and then to each of the Four Directions. She then blew Opwagan's breath in a Circle to honor her People.

"Without a word, she cleaned Opwagan's

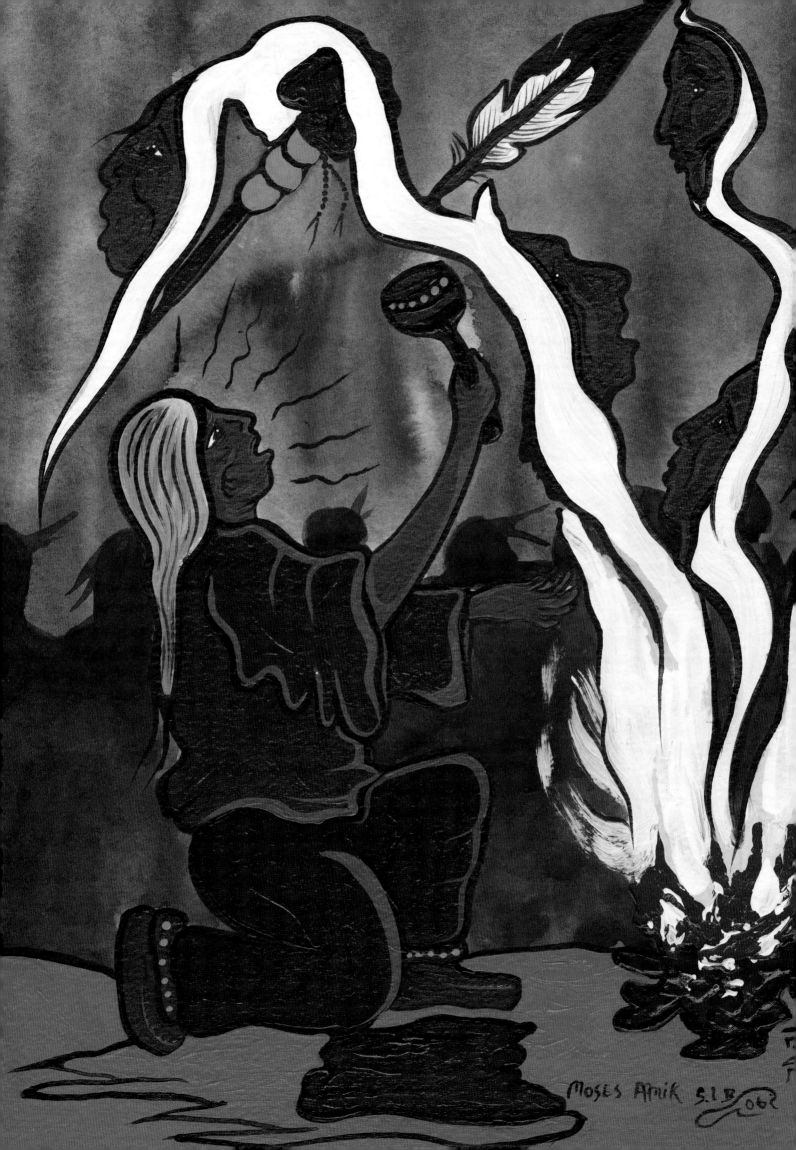

Bowl and reverently held him in outstretched arms, as though she were formally gifting him to her People. She then lowered Opwagan, and as though it were an afterthought, she tossed him into Shkode.

"'What?' exclaimed nearly everyone at once. 'Was that one of those tricks-of-sleight?' some wondered. 'A strange new ceremony?' suggested others.

"A few thought the old Woman was losing her senses. And yet they quieted and kept their places in the Circle, as respect for their Elders ran strong.

"Miskwa sighed, and again without speaking, carefully unwrapped another bundle. There lay her great brown and white Meegwan from the wing of Animikee. With Meegwan, the Mashkikeekwe walked *sunwise* around the Circle and fanned each Person with purifying air. She then held Meegwan up high and turned to face the Mountain home of Animikee. 'Kaaeeee!' she shrieked.

"A distant 'Kaaeeee' returned from the Mountains.

"She lowered Meegwan and unceremoniously tossed him into the flames.

"Into the night she continued until all sacred objects were released to Shkode. The only interruption all night was a collective gasp every time Shkode consumed another Medicine Helper.

"'My Children and Grandchildren,' she said as she stepped back from Shkode and wiped the sweat from her face. 'Sun-Father is about to rise and *this weary Woman* is honored that you've come to join her for this *Giveaway*. She is grateful to have her clan here in this Circle helping her.'

"With renewed energy, she continued:

Everything is given a time to live, and then it returns to *Aki* (Earth), *Nibi* (Water), *Nesewin* (Air), and Shkode. And so it was with these sacred Medicine Companions. They were not mine; I was merely their caretaker. This night was their time to return to

their parents. I've felt both honored and humbled by being allowed to walk so many turns of the seasons with the Medicine Helpers.

I wish to ask each of you if I look or sound any different now than when Opwagan or Meegwan walked with me. I *feel* the same as before, and at the same time I feel richer for having less. The less I have to care for, the more I can care for you. And as you know, when we move camp, less is easier to carry than more.

"The laughter that followed was a welcome release. When all quieted, the Elder continued, 'Long ago when our venerable Mashkikeekwe, Gichi Gigizhebkwe (Early-Morning-Woman) presented me with Zheesheegwan, she said, "The power you were given to serve your People was already with you when you were born. Remember that power dwells in the heart, not in things. Aho (I have spoken)."'

"Respected *Mishomis* (Grandfather) Gidiskwam (On-Top-of-the-Ice) rose to speak on behalf of the Circle. These were his words:

We are relieved that we can again see you, our revered Mashkikeekwe, for who you are. When your Medicine Helpers became our envy, we gave our power to them and we became their slaves. This night we have learned that our Lodges may burn down and our moccasins might rot from our feet, and yet we will remain happy, because we will still have strength of heart. *Meegwetch* (We are grateful) to you for this most valued of gifts. Aho.

"'Aho' echoed around the Circle, and the Giveaway was completed. The clan held a great Feast in honor of their Mashkikeekwe, Miskwa. In the years that followed, she went on to perform many healings. That was a long time ago, and she is still warmly remembered in story for that night when she gave her greatest gift of healing to her People."

Having finished the story, Nokomis stirred

the embers and added some wood, and then put the pot of cones back on to boil. Nameg remained silent for a long time, staring into the orange flames dancing before the black pot.

"Honored Elder," she finally spoke, "I will cherish the story of Miskwa's Giveaway always, for it has shown me that in losing I have only gained. Yes, I have lost nothing. Minwab is still

with me, because he was already with me when I found him.

"Dearest Nokomis of mine, I am honored to be your Grandchild and I feel most blessed to be touched by your gifting heart. My greatest wish in this life is that I be able to know and share my heart half as well as you do yours."

ORIGIN

LONG AGO A RATTLE was gifted me by a Man of my *dodem* (clan), Owl, who was from a lineage of Maygar shamans. He taught me about the necessary shared regard for sacred objects, which the Ainu (the original inhabitants of Japan, who are Caucasian–Polynesian) call *iyoykir*.[88] Collective regard is an intrinsic part of the definition of iyoykir.

Recently I talked with a young Man who was convinced that if he could have a certain possession, everything in his life would fall into place. He obviously did not have the Ainu awareness of nonpossession that goes along with every *iyoykir*. Neither did he have an Elder like Australian Aborigine Wandjuk Marika to tell him, "Some *Yolnu* (Aborigines) have *mind* medicine (personal power) and also there's the magic, because the magic is come from the land, not from tree or bush."[89]

The young Man also did not know the personality of *amana*[90] and *pule-o-o*[91] (Hawai'ian for personal power and great personal power). He was caught up in an illusion without being able to see it, so he was struggling to understand how ashes could bring riches.

I told him about a teaching that Keewaydinoquay (my beloved Elder to whom I dedicate this book) gave me when I was young: that I could tell someone was a true Medicine Person if he could just as easily throw the accoutrements of his craft into the Fire as keep them. She said that a true Medicine Person would rather burn

the tokens of his craft than have what they symbolize be diminished or tarnished. Someone who fears this trial by Fire might be merely a magician creating illusions with the tricks of his trade.

"The Rattle Who Stole Personal Power" is for the young Man who came to me with his confusion, and I am deeply grateful to him for inspiring the story.

The day after I recorded this story, I received the following e-mail from a Woman. "I dream infrequently; however, when I do I sometimes see wolf eyes. Usually they come when I'm dozing off or just waking. Is there any significance to this? Why do I see only the eyes? I know wolf is a teacher, so I'm wondering what he is trying to teach me, what I'm supposed to be seeing."

If I called receiving this when I did a coincidence, *I* would not have been seeing much.

I wish to here honor the family of Wolves I was blessed to live with when I was a young man, for without their guidance I may have struggled throughout my life with looking and never being able to see. Honor goes also to my Owl dodem Brother who gifted me the Rattle, as he placed something of value before me that took more than eyes to see.

78

How to Live with a Wolverine

THERE IS A CREATURE so fearsome that some People cringe at the mere mention of his name. Seldom has someone met him who has not limped away with injury, and many are lucky to be spared their very lives. Every now and then, however, there's a Person not even as fortunate as that: he becomes enslaved to the creature. Is this a bloodthirsty beast who haunts a faraway wilderness? Or might he live closer than that—dangerously close? Let me tell you a story about him, and let's see how long it takes you to recognize him.

There once was a young Girl, *Migwazhawa* (Blue-Feather), who was nicknamed Migwa. She was being harassed by a *Gweengwa'age* (Wolverine). "He came around," Migwa confided in her friend *Zhabowe* (Women-Singing-Together), "because my younger Brother *Matawan* (River-Becomes-Lake) could dive deeper than I could."

"What does Gweengwa have to do with diving?" asked Zhabowe.

"He has *everything* to do with diving," Migwa replied indignantly. "Why should my *little* Brother be able to do something better than me?"

Now Gweengwa is not so big an Animal, and he prefers sleeping to almost anything else. In fact, he'd probably sleep his life away—*if* he were never disturbed.

It's only when he is awakened that he's called by his other name: *Zhigag Makwa* (Skunk-Bear).

This is because he not only looks like a cross between Zhigag and Makwa, but because he can be as vile as an irritated Zhigag and at the same time as ill tempered as a wounded Makwa. He'll claw at your gut, and—if you let him—he'll eventually devour you. From the inside out.

Fortunately, Gweengwa is a sound sleeper. Actually, this is *most* fortunate, because there are as many Gweengwa in this world as there are People: we each have one.

If Gweengwa is so fond of sleeping, you might wonder why he was roused inside of Migwa every time Matawan would bring beautiful Stones up from the bottom of the Lake. "I can't reach the bottom," she would lament, "and I'm *better* than him at most things. Why should everyone admire those silly pebbles he pulls out of the gooey muck, anyway?"

"But I don't want to feel this way," Migwa would think at other times when Gweengwa was not clawing at her insides. "I'll ask Father for help."

Migwa's Father, *Epitanimak* (Speed-of-the-Wind), was a good hunter and an honored *Minisino* (Guardian–Warrior) of his People. He was actually her Father's Brother, yet she called him "Father," and he enjoyed helping to parent Migwa, because it was the *Gifting Way.*

"Father," said Migwa, "Gweengwa has awakened inside me. He has sprayed my eyes with his putrid musk, and he chews away at my

79

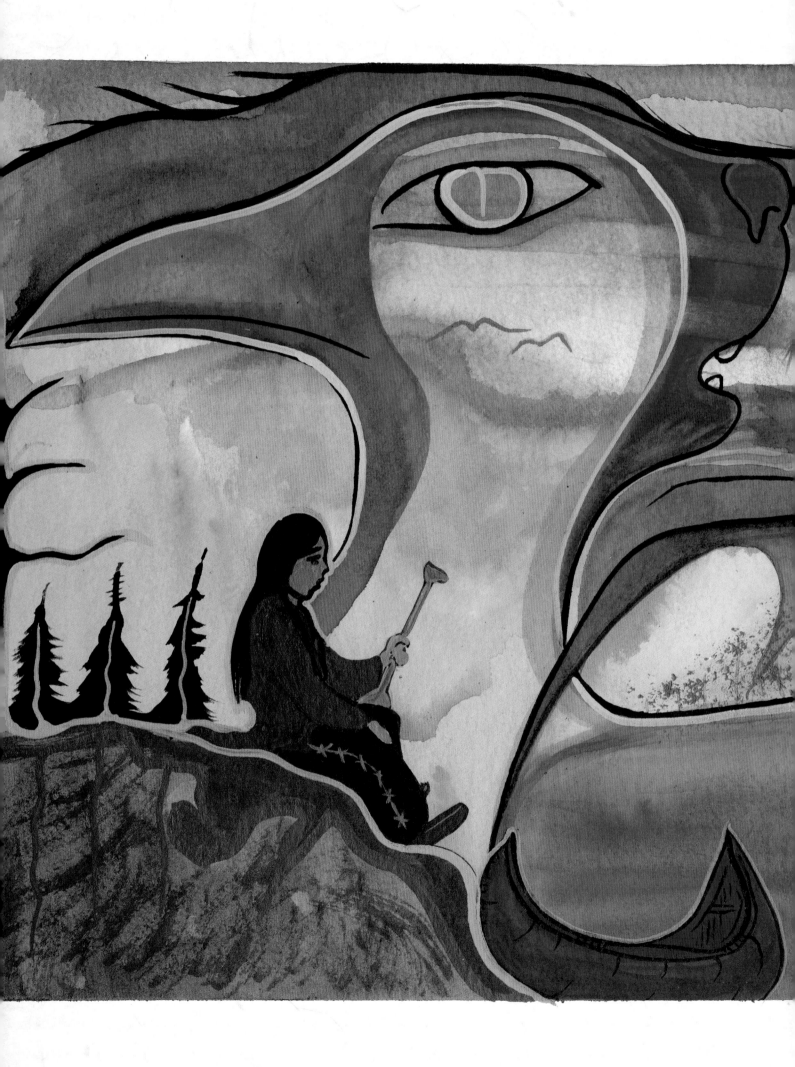

heart. I say vile things to my Brother that I do not mean, and then when Gweengwa falls back asleep, I am ashamed. What can I do?"

"Daughter," responded Epitanimak as he motioned for her to sit beside him. "*This Person* would like to tell you a story from his childhood. When I began my apprenticeship to become a Minisino, I wanted to prove myself, so I would compare myself to others. Often I didn't think I matched up, and I'd get frustrated. Gweengwa would be roused in me—just as in you—and he would growl and churn my stomach. I didn't see others struggling the way I was, so I pretended that I was okay. And yet before I knew it, Gweengwa had consumed me."

"Oh no, Father; what happened to you?" Migwa exclaimed.

"I would go and sit by the Beaver Pond," he replied. "There Lily pads lay calmly upon the Water and Dragonflies dashed about catching Insects. As I looked out over the Pond, I'd watch Mother Beaver showing her Cubs the choicest new spring buds, and Ducks teaching their chicks how to hide in the Rushes when Hawk flew overhead. My Daughter, before I realized it, I felt like myself again. Only I didn't want to go back to the training camp."

"Why not?" asked Migwa.

"Everything on that Pond seemed to have its place and purpose," continued Epitanimak. "I saw the young Duck and Beaver apprentices learning together and having fun doing it. I wanted to stay there and train with them.

"As did you, I went to my Father for counsel. He was called *Zoonginjee* (Strong-Hand), as he was wise in the ways of things."

"Yes, even we Children respect *Mishomis* (Grandfather) Zoonginjee's wisdom. What did he tell you?"

He did not give me an answer. Instead he said, 'Become the Lily, become the Beaver. Then you will know what they know.'

I respectfully accepted his words, even though I didn't know how I was supposed to

become the Beaver. I went back to the Pond and floated among the Lily pads and swam underwater with the Fish.

All of a sudden something came over me and I blurted out 'Father Zoonginjee!' even though he wasn't there to hear me. 'I got it: I am the Ducklings! Even though they are being trained here and I am being trained at camp, there is no difference! If we are to be Minisinos, we need to serve wherever we are. If I can feel enough at peace to let my Gweengwa sleep here on the Pond, I'm sure I can do it with my fellow apprentices as well.'

Migwa listened with great interest to Father Epitanimak. "I am grateful that you shared this story with me," she responded, "only I don't want to be kind to Gweengwa. He's nothing but an angry, smelly Bear! And he's much stronger than me: he wears me down so that I dive even worse than usual."

"My Child, do you remember the teaching of the Gifting Way?"

"I do, my Father: that giving is receiving . . . Oh, of course!" she exclaimed in a flash of awareness. "Gweengwa is stronger than me for a reason: he gives—he gives by clawing at me—to try to stop me from clawing at others with my anger. He is my own *Medicine*, which I must receive in order to know how someone else feels when I give it to them. Father, I don't want to hurt People, not even someone as annoying as my baby Brother."

They both had a good laugh at that.

"I am honored," added the Girl, "to walk with the ornery little Gweengwa. I welcome his presence, because I'd rather feel the hurt than hurt someone else."

"Migwa," responded Epitanimak in a kindly voice, "you are wise for your years. I am honored to have you for my Daughter. Now go and have fun diving with your Brother."

ORIGIN

BEING A CREATURE of the Far North and shy of civilization, Wolverine is not a well-known animal. He is the size of your average Dog, which makes him the largest land-dwelling member of the Weasel family; however, he has none of the sinuous grace of his Mink and Martin cousins: he looks and walks more like a Bear. Nor does he have their hunting prowess: he lives mainly on the scavenged remains of other Animals' kills.[92]

What he does have is a trademark temperament: pugnacious, ferocious, fearless, voracious. Called Devil Bear, Mountain Devil, and Glutton, he is noted for breaking into food stores and swiping trappers' catches. He can stuff himself until he can hardly walk, and he is able to go for long periods without any food. The folklore surrounding this creature claims him to be the nastiest, pound-for-pound strongest carnivore alive, able to drive packs of Wolves from their kills and drag off Animals three times his size.

For some of the same reasons, he has garnered the respect of many Native People as a *Contrary* and *dodemic* figure, and he has landed roles in a number of traditional stories. He was my only choice for this story.

Not long ago, I wanted to illustrate the self-destructive nature of retained anger for a book I was writing, and Wolverine's ways immediately came to mind as the most fitting metaphor. The form of the story is as old as stories themselves: it was given to me by the storyline. I merely chose appropriate symbols to bring the story to life.

The inspiration came from my clan Sister *Gegekwe* (Hawk-Woman), who has wrestled long and hard with the tempestuous little Bear. Gegekwe also gave me the insight for this story by helping me become Wolverine for a while. I came to know firsthand his emotions and motivations. This telling of "How to Live with a Wolverine" is in Gegekwe's honor.

Chapter Nine

Winter Stories

"THE TIME FOR TELLING INDIAN STORIES is in the evening: best of all around a glowing wood fire on the long nights of Winter,"[93] said Ohiyesa, an 1800s Santee Dakota who was brought up in the traditional way. He went on to say that "since the subjects lie half in the shadow of mystery, they have to be taken up at night, the proper realm of mysticism . . . There was usually some old man whose gifts as a storyteller and keeper of wisdom spread his fame far beyond the limits of his immediate family. In his home at the time of the Winter camp, the children of the band were accustomed to gather."[94]

Along with the rest of Winter life, we find ourselves moving more slowly and being more single of focus. The quiet brought by the insulating blanket of Snow encourages us to be less extroverted and more reflective. We naturally have more interest in matters of spirit, and in our dreams and inner feelings. This is when our Native Ancestors traditionally explored their personal and cultural roots that led back to the source of all things. Stories were—and still are—the primary ritual for this Journey.

A special group of stories is reserved for this time. According to my esteemed Elder Kamgabwikwe (Woman-From-Across-the-Water), who lives in Canada on the north shore of Georgian Bay, these stories are traditionally told only when Snow lies on the ground. The energy is then right for the deeper voices of these stories to be heard. They seem to explore the mysteries of creation, where in actuality they are metaphors for the mysteries of our own creation.

These are among the oldest of stories, and because they explore the very spirit of life, they are considered sacred by the Native People of my area. My Elders' term for these traditional stories is *adizookanag*.

The following are several of my favorites. I suggest that you honor the custom of telling them in the Wintertime (or when Plants are dormant, if you do not live in Snow country), both out of respect for the people the stories came from and because the stories are more poignant in their season.

How Birch Got His Thunderbirds

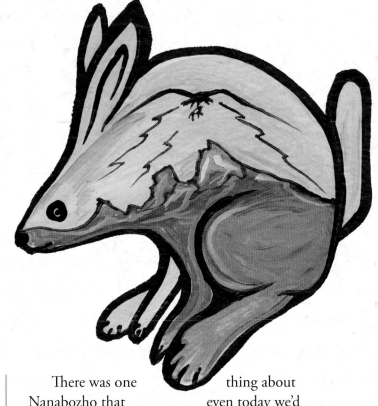

THIS STORY IS FROM A DISTANT TIME, and yet *Bimadiziwen (Circle of Life)* was much as it is today. There were Hills covered with Birds and Flowers, and the Waters teamed with *Geegoon* (Fish). All the other Furred, Scaled, and Shelled People were there. Only one of the *Relations* was missing: Humans.

Nanabozho (First-Man) was the first of our kind to appear and behold the splendor of Bimadiziwen. He lived with his *Nokomis* (Grandmother) in a bark *Wigwam* (Lodge) on the shore of *Gichigami* (the great inland Sea known also as Lake Superior).

A good and dutiful Grandchild was Nanabozho. He'd gather *Shkode* (Fire) wood for Nokomis, help pick berries, and trap the *Wabooz* (Hares) who lived in the thickets.

Yet Nanabozho was not a typical Boy. We would probably think him to be half spirit and half mortal, because he possessed tremendous abilities and strengths. He could run nearly the whole *Sun*, from dawn till dusk; he could swim in the coldest of Waters; and he knew what the birds were saying in their songs. Because these abilities were nothing unusual for the People of that time, neither he nor Nokomis thought this to be anything special.

There was one thing about Nanabozho that even today we'd recognize as being typical of many Boys: he had a lust for the Hunt. Having such skills and abilities as he did, he was a good hunter. As soon as he was done gathering Shkode wood in the morning, he'd grab his Bow and Arrow and go out stalking through the Forests and Bogs in quest of game. And yet only occasionally did he shoot an Animal to bring home for Nokomis, because there were but two of them and they did not need much food.

It was the spirit of the Hunt that thrilled Nanabozho the most. He reveled in drifting invisibly through the Trees, not as a Boy but as the shadow of an Animal. His Brother and Sister Animals felt comfortable with him and did not run away, because he didn't separate himself from them. He belonged: he was movement within the greater movement. He became the Deer and the Grouse, thinking as they did and feeling as they felt. When he did so, they also became him. This, for Nanabozho, *was* the Hunt.

Nanabozho could provide everything that he and his Grandmother desired. Except for one thing: the great *Namay* (Sturgeon). Her fat

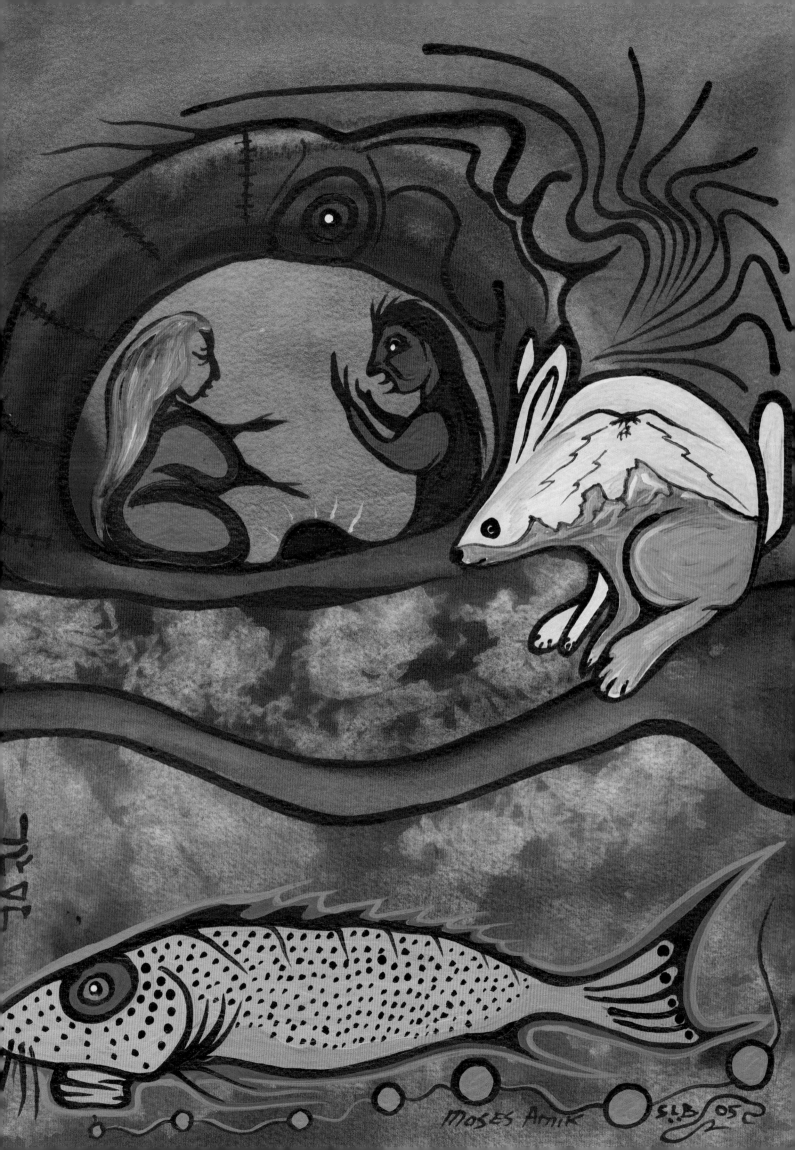

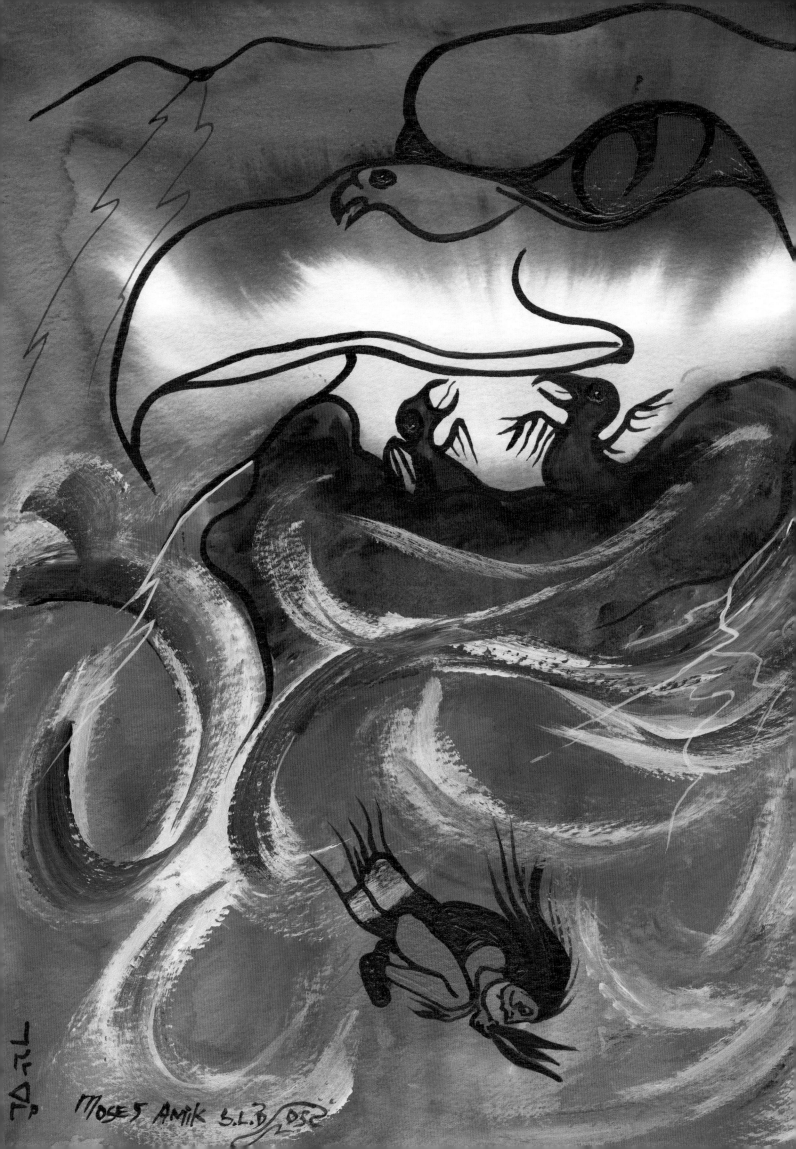

Moses Amik

made the finest oil, and her strong, sinuous skin tanned into a leather of no equal.

"I'm not yet strong nor skilled enough to hunt the monster Geegoon, Namay," Nanabozho would say. "After all, she is the chief *Minisino* (Guardian–Warrior) of Gichigami and all who live in her Waters. She wears tough, bony plates of armor, and she has *Medicine* that I cannot begin to fathom. On top of that, she lives in the frigid depths, among the huge boulders that I can just barely make out when the Water is clear and the light is just right."

"Nokomis," Nanabozho asked one morning after breakfast, "I know that I'm much too small to even think of yet hunting the honored Minisino of our Water Relations. I've heard stories of her strength and cunning, and I'll need to grow in these ways myself before I'm a match for her. And yet I'm curious. I do not believe that any normal Spear or Arrow would serve on such a quest. What would a Person need in order to hunt our great Sister Namay?"

"Hmmm . . ." thought Nokomis to herself, "I know that Nanabozho's trying to trick me into giving information that he's not ready for. I think I'll play along anyway, because I trust in my Grandson, and because I know that everything has its reason."

"Grandson," she replied, "you are wise to realize that you're not yet ready to hunt the Powerful One who lurks in the dark underworld of Gichigami, for she has gifts that are surely greater than yours. If you were to seek her out, she'd likely steal your breath away and lay you down cold and still, to forever be in the black abyss where she lurks. Perhaps on one coming Sun you will have the Minisino presence that would charm Namay into honoring us with her gifts."

Nanabozho could hardly contain his excitement, but he knew he needed to or Nokomis wouldn't continue her story. Masquerading one's intent is a stalking skill he was quite good at.

"You are right, Nokomis," he calmly stated.

"I am nowhere near ready. Perhaps in time I will be. If that time does come, I will consider it a great honor to hunt the Minisino of Gichigami for you. Let's say there was someone of more age and strength than me; what would *that* Person need in order to bring the great and cunning Geegoon up onto the beach?"

Nokomis had trouble holding back her smile as she watched Nanabozho trying so hard to trick her. Taking on a very serious air, she continued, "I will tell you what that Person would have to do, but only so that you'll know it when and if your time comes. An Arrow fletched with a tail Feather of mighty *Animikee* (Thunderbird) is the one and only thing that has the power to blaze through the Water and find the heart of that Monster who guards the underwater graveyard."

"*Meegwetch* (Thank you) kind Nokomis," said Nanabozho. "I will hold on to your words until such time as I might need them." He then excused himself and told his Grandmother that he was going out for the morning to hunt, which is what he typically did if there was nothing else for him to do.

It took all of his willpower to keep from shouting for joy! "What a clever Minisino I am," he proudly stated to himself. "It is our way to be about our business without anyone knowing what we're up to."

As soon as he entered the thicket above the beach, he hid his Bow and Arrow in a hollow log and scrambled up to the highest point on the Cliff overlooking the Lake. He chose an open place on the bare Rock where he could easily be seen, and then he *shapeshifted* into a furry *Waboosons* (Bunny) and hopped around to draw attention to himself.

Meanwhile, high in the Cloud nest of the giant Animikee, the fast-growing chicks were hungry again. In fact, there was hardly a time when they were *not* hungry, which kept their parents constantly on the Hunt to feed them.

As the pair prepared to fly off, Mother said to Father, "Be careful, my dear Mate. I've heard that Nanabozho is about, and you know what a clever trickster he is."

"I'll be on the alert," he replied. "That mischievous Human has pulled so many pranks that I've lost count!"

He took off in the direction of the sunset to hunt over the great Bogs, while she flew toward the sunrise to circle over the seaside Cliffs. Immediately her keen eyes spotted a furry little bundle right out in the open.

"What a great playmate for my babies," she thought, and she swooped down to grab him.

When her Mate returned to the nest and saw the Waboosons, his eyes grew big.

"Are you sure this isn't the deceitful Nanabozho?" he whispered to his Mate.

"How could something this fair possibly be Nanabozho?" she whispered back, and yet she was beginning to feel a bit uneasy herself. The youngsters were having so much fun with their new playmate that the parents could only hope that he was what he appeared to be.

As is the way with raising Children, Father and Mother had little time to entertain their doubt. They knew that the youngsters would soon be clamoring for food, so off again they went to hunt.

The parents were no sooner out of sight than Nanabozho shapeshifted back to Human form, plucked a handful of tail Feathers from the little Animikee, and jumped out of the nest.

The piercing screeches of the Children spun their parents around and brought them racing back as fast as their mighty wings could carry them. Their keen eyes immediately caught sight of Nanabozho tumbling earthward with a bunch of precious Feathers.

"I knew it!" exclaimed Father. "That conniving, miserable excuse for a Human will never see another sunrise!"

"What have I done?" lamented his Mate.

"How can he be so wicked?"

The Clouds grew dark and heavy, the Wind thundered through their wings, and jagged spears of anger flashed from their blood-red eyes. They dove to intercept the plunderer, creating a whirlwind which shrieked so fiercely that every creature from horizon to horizon cowered in fright.

Nanabozho saw them coming and a fear like he had never known ripped through his entire being. He tucked into a tight ball so that he'd fall faster. Crashing through the treetops, he hit the ground with a hard thump. Amazingly, because he was possessed of such great power, he was only a bit scratched and bruised. He hopped right up, shook his head, and took off with all the speed he could muster.

"I must get to the deep Forest, where the ancient Tree Elders will protect me," was his desperate thought as his body strained like it never had before. He knew the avengers would be fast upon him, so he dared not take the time to look back. He didn't have to: right away he could hear a mad howl plunging down toward him.

Thunderbolts crashed all around the panic-stricken Boy, shattering Trees to splinters and bursting them instantly into flame.

The searing breath of the enraged parents scorched his back as out of the corner of his eye he caught sight of razor-sharp talons about to clench him.

"I must do something *now*," flashed in Nanabozho's mind, "or I'll be skewered like a chunk of meat and fed to the young Animikee!" Immediately in front of him was a hollow *Weegwas* (Birch) log—he dove head first into it.

The log rolled and tumbled as the giant Animikee unleashed another round of fury. "Rraaahh!" they screamed as they flapped their wings and created a mighty hurricane, which sent the log smashing against boulders. From their boiling-red eyes they shot crackling shafts of white-hot flame at the log. They stomped and

bellowed so mightily that boulders rolled down from the Hilltops and Trees came smashing down upon the frightened Boy's fragile-looking refuge. And yet it somehow refused to crumble.

After a while, the great War Birds had spent their rage and came to realize the futility of their efforts. They looked at each other in silent agreement and spoke these words:

Nanabozho, we honor you for your courage and cunning. You have proven yourself as a Minisino. We understand the good use for which you desire our Children's Feathers; they are rightfully yours. With our blessing, go and fulfill your calling.

The boy was too shocked and stunned to respond. He just lay there in the log, catching his breath and listening.

You were wise, continued the giant Birds, in taking refuge beneath the bark which not even we Animikee can tear asunder. So that all who follow may remember this great clash and your feat of valor, the charred battle scars on the bark of this log which protected you will appear on every Weegwas from this Sun forward. The scars will be in the shape of the flying Animikee so that everyone, for all time, will know that the gifts which you bring to your People have been tested and honed in battle with Animikee: Minisino of the Sky Realm.

From this Sun onward, the Animikee and the Weegwas *clans* will be kin. In the way we serve the Relations as Minisinos of the Sky Realm, the Weegwas clan will serve the Relations of the Earth realm. Weegwas will be the Minisino of Earth shelters: Animals will build nests and hollow dens behind the bark, and Humans will use the bark to cover their Wigwams, which will stay dry when our roughhousing shakes Rain out of the Clouds.

Your kind will also make *Jeeman* (Canoes), Baskets, and bug-proof storage boxes from the bark. And as a final gift, we have asked Weegwas to protect you from harm if you seek refuge under his branches when our blazing eyes spit Shkode earthward.

In honor of Weegwas's serving, we respectfully ask that you call him *Mishomis-Weegwas* (Grandfather-Birch).

We now return to our Sky Realm to care for our young. *Geegawabamin* (We are related and will remain so until we meet again), young Minisino.

Nanabozho stood proud as he watched the regal pair soar high into the heavens. He took a handful of *Kinnikinick* (an aromatic herbal blend) from his pouch, held it for a moment of reverent reflection, and then threw it skyward

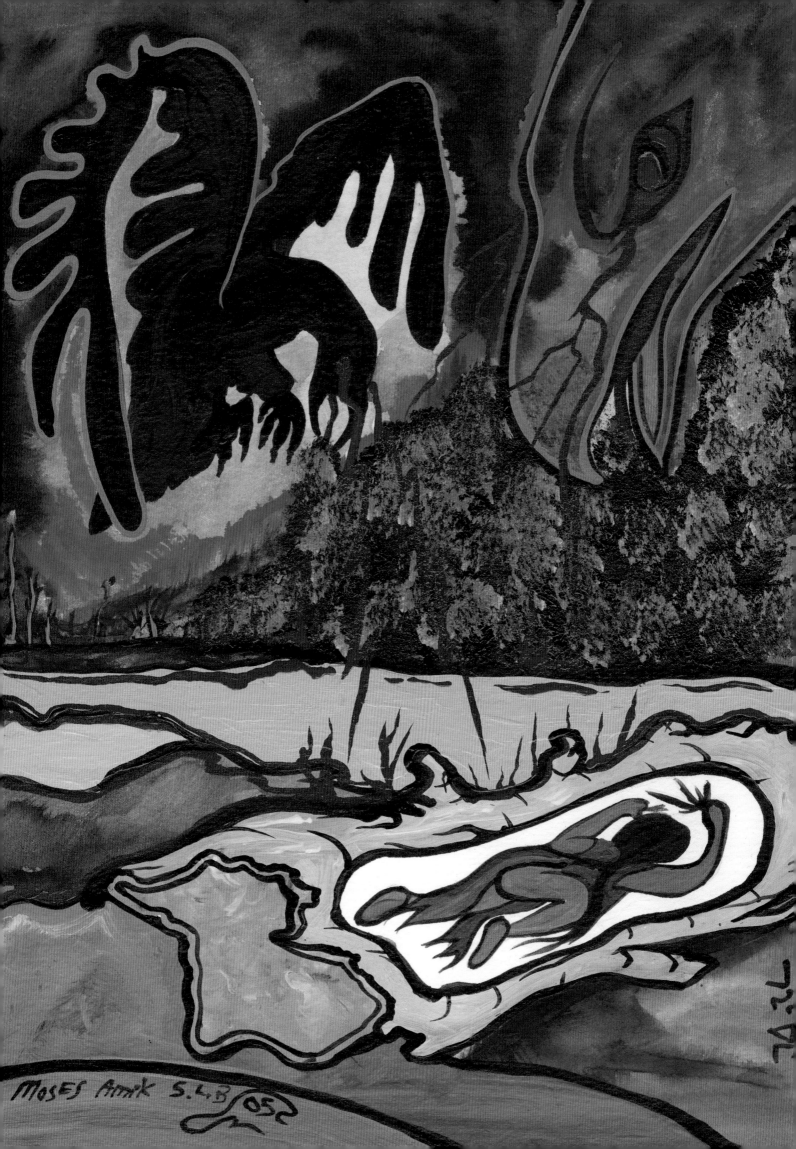

Moses Amik S.L.B 05

in honor of the magnificent Animikee clan. He then took another handful and stood humbly before the battle-scarred log that saved his life. Lighting the Kinnikinick and using an Animikee Feather to fan the smoke, he *Smudged* the log as a ritual expression of deepest honoring.

With Feathers in hand and a heart filled with growing passion to serve, he joyfully returned to the bark Wigwam on the shore of Gichigami. There his beloved Nokomis was waiting for him and greeted him with a knowing smile. Nanabozho gifted her with a bundle of Weegwas, and tears fell from her eyes as she read the story etched in the bark. And then she said, "Your newfound strength and deepening wisdom are helping you mature into the Minisino Way that is your calling."

Nanabozho faithfully served Nokomis for the rest of her Suns, and then he went on to prepare the way for the coming of the first Humans. He welcomed them to the *Gifting Way* and helped them find their *Balance* within the Circle of Relations.

ORIGIN

THE PRINCIPAL RANGE of the Paper Birch *(Betula alba)* is the upper Great Lakes area east to the Atlantic, which roughly coincides with the homeland of the Algonquin Peoples (the Ojibwe, Ottawa, Potawatomi, Cree and others). "How Birch got His Thunderbirds" is my favorite Algonquin legend honoring the profound relationship these Peoples have with this Tree.

This type of kinship is paralleled in other cultures, such as the Lakota. Standing Bear recalls this memory from his childhood in the 1800s, "When a thunderstorm came up, some woman of the household would get the bag of cedar leaves and throw a handful on the coals of the fire. In a moment or so the tipi would be filled with the sweet smell of the cedar smoke … the cedar tree protected the Sioux (Lakota) people and their tipis from lightning."[95]

My memory is sometimes like an old phonograph record: it plays pretty well until the needle hits a scratch, and then it skips. Apparently there must be a scratch just before my recording of where I learned this story. A version appears in an out-of-print bilingual book in my library, titled *Ojibwa Texts* by Samuel Jones (Cambridge University Press, 1917), and I have another version in a collection titled *The Adventures of Nanabush: Ojibway Indian Stories* compiled by Emerson and David Coatsworth.[96]

This is a classic Nanabozho story, as it shows several facets of his complex personality: mischievous, faithful, reverent, compassionate, and brave. I like telling the story because it does a beautiful job of personifying the complexities inherent in relationship. One of the gifts I received from this story is Nanabozho's example of what it is to be a fully actualized being. He is the archetypal Human, and also the Ojibwe Adam, or First Man, who prepares the way for the coming of the Humans. My dear Elder Kamgabwikwe says that Nanabozho (whom she calls "Nanabush" and who is also known as Wenabozho, Manabosho, and other variations) is the spirit of the Woods. She is saying that the spirit of Nanabozho is also our spirit, because our nature is nature—we cannot be separated from our Relations, our Ancestors, our biology.

91

How Winter Came to Be Five Moons

WHEN *WEGIMIND-AKI* (Earth-Mother) was young, she gave the Plant and Animal *Relations* only one season: Summer. Back then it was called the Green Season, which was nearly always mild and sunny, with Flowers in bloom, Birds raising their young, and Fawns frolicking in the Meadows. The Wind would sometimes blow and it would Rain, just as it does in the *Suns* of our time; however, the Rain was warm and brief and the Clouds would soon drift away.

Nanabozho (First-Man) was very appreciative of all the gifts of Wegimind-Aki, including the Green Season. And yet he tired of its sameness: the constant warmth and endless green. He thought that with some break in the season, he as well as the other Relations might appreciate it all the more, because it would then be fresh and new every time it returned.

"I shall make a new season!" decided Nanabozho, who got more excited the more he thought about it.

The very next Sun, the leaves began transforming themselves with vibrant colors that rivaled those of the sunset. The air turned refreshingly cool and the evenings sprinkled the Grasses with frosty crystals that changed the landscape into a fantasy world of sparkling brilliance when the rising Sun showered his light upon it. The leaves would eventually drift down and transform the landscape again, this time into a soft, warmly-colored, spicy-smelling carpet.

"This is spectacular!" exclaimed Nanabozho.

"We are fascinated with this new season of splendor," remarked the Relations. "You have gifted us all, kind Brother; *gitchi meegwetch* (we are very grateful). We like the break from building nests, having young, and growing new leaves and branches. We now have time to wander and get to know our other Relations."

"Let us call this the Falling-Leaves *Moon*," they suggested to Nanabozho. "We will look forward to it every time it comes."

Even though everyone was immensely pleased with the new season, Nanabozho grew agitated. He'd walk for Suns through the fallen leaves, which had now turned brown and crunchy, and he would stare up at the naked Tree branches, trying to figure out why he felt so out of sorts.

"Something is just not right," he said to himself on the morning of one Sun. "Everybody

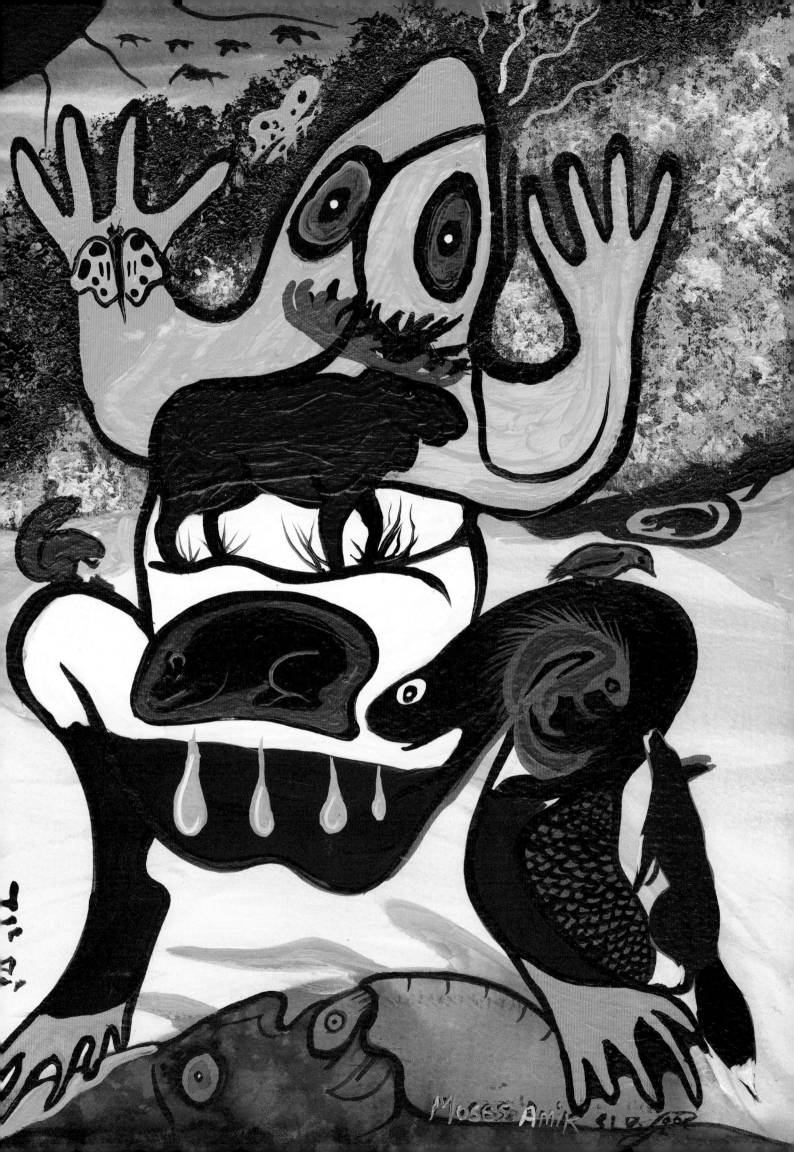

works so hard during the Green Season to raise their young, grow Flowers, and bear fruit. Now, in the time of the falling leaves, the Plants go to sleep. But the Animals do the opposite: *Ajidamo* (Squirrel) runs around gathering and storing nuts and *Makwa* (Bear) wanders wide to find anything that will help her grow a layer of fat. I don't understand . . ."

On one particularly cold morning, Nanabozho was up before the dawn: he could not sleep. He went for a walk in the Woods, which he often did when he was troubled. Ahead of him in a clearing he saw a little Pond.

"Come and sit beside me," Pond said, "and we shall talk." Back in those Suns, everything was alive and everything could speak, so Nanabozho wasn't surprised to hear Pond inviting him over for a visit. In fact, he was quite pleased to have something to take his mind off of his worries. He found a log near the edge of the Pond and sat down to make himself comfortable.

As he waited to see what Pond had to say, he was distracted by all the Birds flying overhead: large and small, some singly and some flocked together. Bats passed over also, and even Milkweed Butterflies.

"I've never seen such a thing!" he exclaimed. "They're all flying in the direction of *Zhawanong* (South)." When he glanced into the Water, he saw *Omakakee* (Frog) and *Miskwadesi* (Turtle) digging into the Mud. "They must be hungry and looking for Worms on this brisk morning," he thought to himself.

Nanabozho watched them a long time, expecting that they would be swimming around to look for food; only they just kept digging deeper and deeper until they disappeared completely.

After a while, Nanabozho's seat started to feel uncomfortable, so he rolled the log over to find a less bumpy side. In doing so, he exposed a sleeping *Agongos* (Chipmunk).

"I'm sorry for disturbing you, Sister," he said. "You've found a warm, safe place to spend the night and I've awakened you before you're ready to greet the Sun."

Except Agongos did not awaken.

"Rise and shine, Little Sister; it's daylight even deep in the Cedar swamp." Nanabozho called out again, and still Agongos would not stir.

"You're in a deep, deep sleep, Tiny Sister," softly spoke Nanabozho. "I can see that you don't want to be awakened." He carefully rolled the log back over her so that she could continue sleeping in peace.

"I'm more confused than ever," said Nanabozho as he buried his face in his hands. Tears trickled through his fingers and dripped down onto the cold ground. "The leaves turn beautiful colors," he murmured, "but then they go limp and drab and fall off. The Birds take a break from raising their young and gather in happy flocks, only to fly away and not return. Agongos retreats into a deep sleep, and I see now that Omakakee and Miskwadesi have done the same."

For the rest of the morning, he brooded. And then, as though stung by *Amoo* (Bee), he jumped up and screamed out, "I've got it! *Meegwetch* (Thank you), wise Pond, for speaking to me. Everybody wants—no, needs—time for rest and renewal before the return of the busy Green Season. I will make a season just for sleep, and it shall be called the White Season. The Water will become solid over the Pond, so that Omakakee and Miskwadesi will not be disturbed. Instead of Rain, the Clouds will gift fluffy white flakes to make a warm blanket that will shelter all the sleeping Relations.

"With the warm Winds of the returning Green Season, the hard Water and the white blanket will melt away, and this shall be the sign for the Plants and Animals to wake up. The Birds and Butterflies can ride the Wind on their way back from Zhawanong. It'll be a celebration—an explosion of new life!"

At last Nanabozho felt at peace: he had taken care of the needs of all the Relations by making a full turn of the seasons. There was just one question that remained to be answered: How long should the White Season be?

"I wish to serve my beloved Relations by using my gifts to bring them blessings," said Nanabozho. "However, I am not wise in the ways of all who walk, fly, swim, and sway in the Wind. I need help in deciding how many Moons of White Season would be best for everybody. Ah, I know what to do: I shall call a great *Talking Circle* so that all of us can decide together!" And that's just what he did.

Mooz (Moose), being the Elder of the Forest, was first to speak. She solemnly held the *Talking Stick* before her and took time to form her thoughts, because she knew her words, being the first, would set the tone for all the others.

"I am made for the White Season," said Mooz. "My coat is thick and keeps me warm in the most growling of Winds. Perhaps we could count the hairs of my coat and that would be how many Moons the White Season will last."

Mooz passed the Talking Stick on to the next Person, and that Person passed it on to the next, in *sunwise* fashion, until everyone had a chance to speak. No one could come up with a better idea than Mooz's, so they all began counting the hairs of her great, luxurious coat. Relations of all shapes and sizes: Insects, Birds, Fishes—and even the tall Grasses who tickled Mooz's belly—joined in the count. Mooz was a Person of great size, so there was room for everybody

somewhere on, around, or under her.

It didn't take long, however, for everyone to realize that if the White Season were to last as many Moons as the number of Mooz's hairs, there might never be another Green Season. The Relations said "Meegwetch" to Mooz and returned to the Talking Circle to see if they might come up with another idea.

Amik (Beaver), because of her cleverness in dam and Lodge building, was highly respected among the Forest Relations and everyone was anxious to hear what she had to say. "My tail is broad and covered with scales," she began, "which, I am sure, are far fewer than the hairs on Mooz's coat. Perhaps we can count the scales, and that could be the length of our White Season."

Nods of approval were seen all around the Circle. Even though the Talking Stick would go completely around the Circle so that each Person would have a chance to make a suggestion, it was already clear that everyone wanted to try Amik's.

Sure enough, as the Talking Stick went around, each Person said, "*Eya* (Yes), Amik speaks with wisdom. Let us count her scales."

When the Talking Stick was laid down by the last Person, *Deendeesi* (Blue Jay), *Wagosh* (Fox), and *Gag* (Porcupine) stepped forward and offered to count.

"What is taking so much time?" People began saying after a while. They were growing restless from waiting much longer than they thought would be necessary. Gag, Deendeesi, and Wagosh were only about halfway down the tail when Nanabozho felt

the need to address the Circle. "It does seem that the Moons would be many fewer if they were the number of Amik's scales rather than Mooz's hairs, and yet it appears that we would still either starve or freeze before the White Season was over. As grateful as we are for your kind suggestion, Amik, *this Person* proposes we search for another way."

Everyone agreed and the Talking Stick was again passed.

All of the Forest Relations create a big Circle, so it took a long time for the Talking Stick to make a complete round. By the time it reached Omakakee, folks were growing tired and frustrated. It was late and People were getting hungry; many were yawning and finding it hard to pay attention. When they saw it was Omakakee's turn to speak, they got even more distracted. After all, it was just little Omakakee and all she did was sit by the Pond, Sun after Sun after Sun, and eat Bugs.

Omakakee felt it an honor to speak. She held the Talking Stick respectfully before her, cleared her throat, and spoke these words: "My Relations, the White Season will be very important for my kind because our blood runs as warm or as cold as the air around us. When it turns cold, we must seek warmth and shelter in the depths of the Pond. There we will live in comfort and

security. It can only be for so long, however, because our stored energy will eventually run out. Perhaps the same is true for some of you. As well, we who have been given the gift of the deep sleep might wish to awaken at the proper time so that we may join with the returning Bird and Plant People. We could then together bear our young and give honor to the kind Green Season."

Omakakee then held up her hand and said, "This Person respectfully suggests that the White Season be as many Moons as there are fingers on her hand."

Snickers broke out around the Circle and People rolled their eyes.

"Why would a nobody like her even bother to make a suggestion?"

"What a ridiculous idea; does she really think we'd take it seriously?"

"I think Omakakee should stick with what she does best: croaking."

"My honored Relations," Nanabozho interrupted, "who among us has spoken a greater wisdom than Omakakee, that they can rightly belittle her?"

Embarrassed and humbled, everyone quieted and listened to the words of Nanabozho. "This Person has heard the words of Omakakee," Nanabozho continued, "and feels that she speaks with great vision. He suggests that by the number of Omakakee's fingers we count the Moons of the White Season."

With some deliberation, it became apparent to everyone that the White Season was intended to last five Moons. A great sigh of relief rose up from all assembled.

"This evening let us hold a great Feast in honor of Omakakee!" everyone cried out.

She was given the place of honor, and she was the first to be served her meal after the Elders. Many rose to speak in praise of her great wisdom, and after the Feast, an *Honor Dance* was held and *Honor Songs* were chanted in her name.

As the evening drew to a close, Nanabozho stood up to speak:

Omakakee, you are a great orator. We who have been blessed with the gift of your words would, in return, like to gift you and your kind with the voice of song. Each of your kind will have a different song, so that together you will form a chorus to sweeten the night. From this Sun onward, when the fifth Moon of the White Season draws to a close, the Omakakee People will have the honor of rising in song to announce that *Geewaedinong* (North-Wind-Blower) has returned to his Lodge in the North and *Zhawanong* (Warm-Breeze-Bringer) is coming to melt the white blanket.

"This Person is deeply grateful for the honor you have bestowed upon her People," responded Omakakee. "She wishes you to know that she's learned much this Sun about courage and speaking her truth. Meegwetch to all of you."

"We have learned as well," said Mooz, who spoke on behalf of all the other Relations, "When we hear you sing, Omakakee, we will be reminded of the lesson you've given us: that the least of us is the greatest and the greatest is the least. We'll not again so easily forget that we are all Children of the same Mother, and that we are all one with *Bimadiziwen* (*Circle of Life*). Without all of us dwelling together in *Balance*, none of us would be. Together we have found the Balance of the seasons, and now with your teaching we will be able to return to Balance among ourselves."

And so it came to be. From that Sun onward, the Omakakee have heralded the return of every Green Season, and all the Furred and Finned and Scaled and Rooted have learned again how to live well together.

ORIGIN

I HAVE CHOSEN to carry this legend in part because it shows the wise, benevolent side of Nanabozho. As a metaphor for each of our lives, a culture hero needs to display a many-faceted personality. If he does not, he will be merely an entertaining mythical character with little relevance to real-life people who have seemingly-contradictory aspects to their personalities.

Another reason for my fondness of this legend is that, even though it comes from a long-ago time, it eloquently addresses the turmoil we have created in this day by imagining we are the greatest of creatures. What might be possible if we humbled ourselves by honoring those we considered to be the least of creatures?

"How Winter Came to Be Five Moons" appears to be an almost-forgotten legend, which makes me all the more enamored of it. Often having felt almost forgotten myself, I have developed a soft spot for the rare and endangered. This story's rarity is attested to by the fact that my archival collection does not contain any version of it.

I can no longer recall the elder who long ago gave me "How Winter Came to the Five Moons." I am grateful to that Person, whoever he or she might have been, because living with this story has given me a piece of myself.

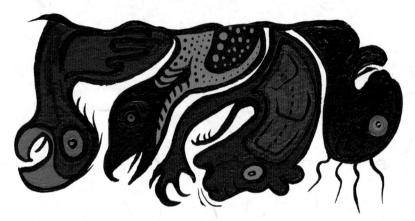

How the Four Directions Came to Be

IN THE LONG-AGO, all of the Human *People* lived on *Dibik Geezis* (the Moon). Green was the color of Dibik Geezis, because she was covered with lush Forests of towering Tree People, who were laced with long-trailing Vines. The Humans lived well there, as the Trees gifted them with fat nuts and rich seeds, and the Vines bore the sweetest of fruits. Ever mild was the climate, so there was no need for clothing or even shelter.

On Dibik Geezis there lived a young Woman named *Geegoozens* (Little-Fish), who took great pleasure in climbing high in the Trees and swinging on the Vines. Sometimes she'd go an entire *Sun* without her feet ever touching the ground, which brought her the admiration of all the People.

There was another Woman, known as *Giwashkwe* (Makes-Dizzy), and like Geegoozens she was young and beautiful. She enjoyed walking under the Trees and doing no more than watching the shadows dance upon the Forest floor.

And yet Giwashkwe was not always happy, as she was very jealous of Gigoozens. Giwashkwe wanted to be like her: adventurous and having fun sailing with the breeze through the treetops. Only Giwashkwe was afraid of heights, so she couldn't be like Gigoozens, no matter how

hard she tried. Still, all she could think of was Gigoozens, Gigoozens, Gigoozens. Wherever Giwashkwe went, it seemed as though Gigoozens was there, frolicking above her.

"I may not be like Gigoozens," she thought one Sun, "yet maybe I can do the next best thing. I'm easily as alluring; I bet I could have her Mate, *Bibigwe* (Flute-Player). *I* would be on the ground with him, not flying off somewhere on my own. Yes, luring him away from Gigoozens would give me great happiness—her happiness." The more she thought about it, the more sinister grew her smile.

In the next Suns, Giwashkwe found it easy to ignore Gigoozens' antics because she was busy working on a plan. "It must be foolproof," she told herself, "because I will have only one chance . . ."

"Gigoozens, my dear friend," called out Giwashkwe one morning, "I'd like to swing with you in the Trees. You look so beautiful with your hair blowing in the breeze and glistening like *Gagagi's* (Raven's) ebony Feathers! I wish to feel what it's like to have the Wind against my cheeks and tugging at my arms as if they were the windswept limbs of a Tree!"

"Really," responded Gigoozens, "I'm surprised, and at the same time I'm delighted you would want to fly with me. I don't mind being alone in the canopy, and yet there are times when I wish to share it with someone."

Even more important to Gigoozens was that she had been worried about Giwashkwe and thought that spending time with her might help

98

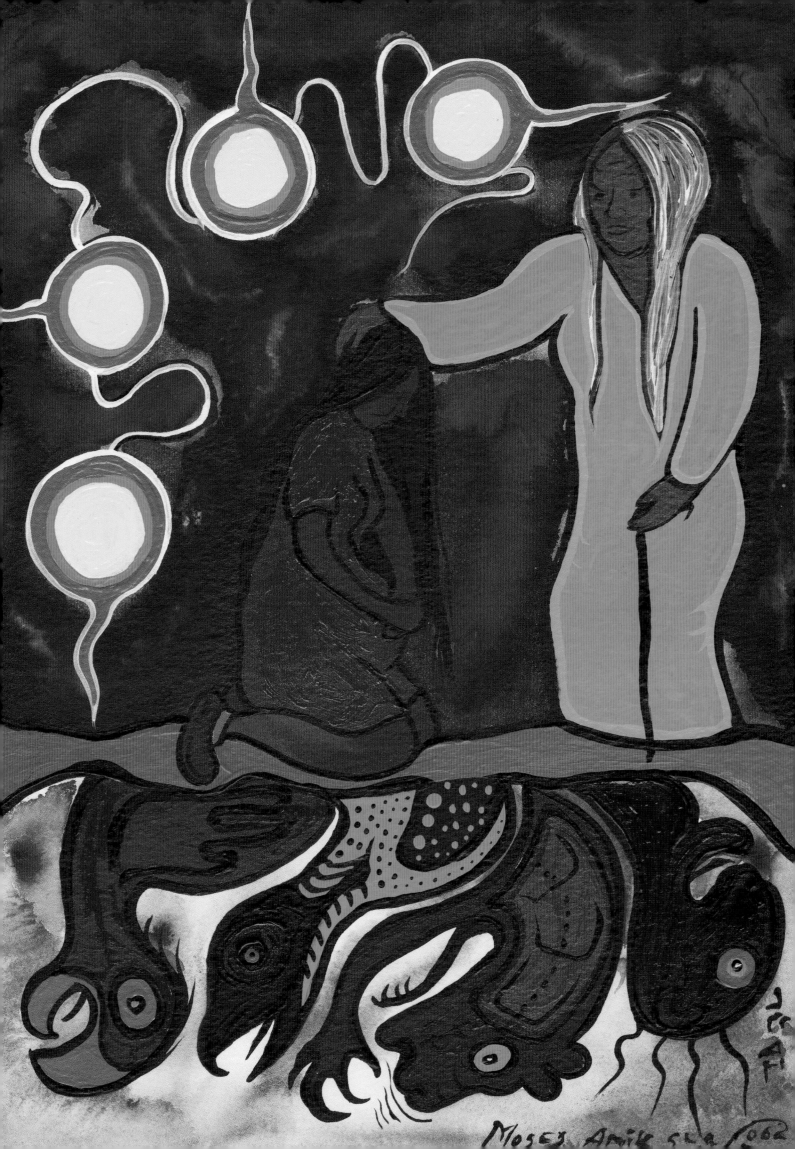

cheer her up. How could being together in the Forest heights with *Memengwa* (Butterflies) and *Nenookasi* (Hummingbirds) be anything but uplifting?

"You swing first, Gigoozens," said Giwashkwe in a cheery tone. "I'd like to see how high you can go, so that I might learn from your example."

Gigoozens found a Vine hanging from the tallest Tree and said to Giwashkwe, "Give me a push every time I swing by, and each time I'll go higher and higher!"

Giwashkwe was only too glad to oblige, and in no time Gigoozens could see over the treetops. She had never been that high before! There was nothing but Trees—big beautiful Trees—as far as her eyes could see.

Envy-driven Giwashkwe kept pushing, and Gigoozens kept going higher—so high that when she looked down, Giwashkwe appeared no bigger than a Pebble.

On the next swing, however, Gigoozens did not come down. Giwashkwe had cut the Vine and Gigoozens kept going up and up, higher and higher above the Trees. She looked back, only to see the Trees growing smaller and smaller, until her beloved green Forest home was only a tiny spot far, far away. And she, terrified and alone, kept drifting off into cold, silent-black space.

"Ha! Now I can be happy—I don't have to put up with that *Woman* anymore," chuckled Giwashkwe as she slid her knife back into its sheath. "And I have her precious Bibigwe all to myself." Other than a Vine stub, which she tucked out of sight into some brush, there was no evidence of wrongdoing. "No one will ever know what happened," smirked Giwashkwe.

Gigoozens, on the other hand, was squinting to make out the emerald globe she was rapidly tumbling toward. "What *is* that?" she exclaimed wide-eyed. "It looks a lot like Dibik Geezis, but . . . but it can't be: it's in the opposite direction, and much, much bigger!" She barely caught her breath before she stammered, "I . . . I'm falling . . .

too fast . . ." And then she fainted.

". . . ooooh . . ." Gigoozens moaned as she woke with a throbbing headache. She sat for a while with her eyes closed, feeling the bump on her head and bruises that seemed to be all over her body. Before long she noticed that the air was laced with sweet and spicy essences, enticing her to open her eyes. "What an amazing place!" she proclaimed. "There are Flower People of all colors—everywhere—and the Grass People carpet the ground with the richest green!" She was so taken that she nearly forgot her pain.

Nor did she at first realize there were no Tree People. Without branches to nest in, there could be no Feathered Ones, and with no trunk hollows or roots to burrow under, neither could there be Furred Ones. Deserts, Oceans, and Mountains did not exist, so everything looked much the same no matter where one might ramble. With no particular place to go to or come back from, there was no need for East, South, West, or North.

"I think we're the only Human People in this Land," said Gigoozens to her Mother, *Mizhakwe* (Good-Weather-Woman), after a Sun of wandering. "In fact, I think we're the only Animal *Relations* of any kind. It's so quiet wherever I go, and yet I don't miss others, because on Dibik Geezis I spent most of my Suns alone anyway."

"Yes, this is a strange Land in many ways," said Mizhakwe, "and at the same time She is most kind and beautiful. She cares for us; She is our *Wegimind-Aki* (Earth-Mother)."

Mizhakwe and Gigoozens were drawn to the bank of the small Stream that meandered through the Meadow, and there they built a *Wigwam* (Lodge).

When they woke up the next morning, Mizhakwe said, "My Daughter, last night the Plant and Rock People came to visit me in my *dreamtime*. They told me they would like to gift us with food, cordage fiber, and tools, and they showed me from whom we could make Baskets

and Bowls. I asked them the ways of the seasons and where we might find the sweetest Water. They instructed me on these things—and more, and I will share it all with you in its time.

"'Now you know the ways to dwell in honor and respect on Wegimind-Aki,' the Rock and Plant People said as they left. 'We would like to welcome you as our new *Relation*; this evening we shall have a great Feast in your honor.'"

Gigoozens acted as though she didn't hear Mizhakwe mention the Rock and Plant Peoples' Feast invitation. Instead the Daughter said, "There must be more, Mother, for as sweet and warm as is our new Mother Home, at times I feel an ominous force lurking about. I believe it was intended that I come here, and that Giwashkwe's scheme to get rid of me served this purpose."

"You're right, my Daughter; there is more to tell you. The Plant and Rock People gave me a warning to pass on to you and asked that you listen well. 'When she squats to relieve herself,' they said, 'she can not face where the Sun sets, for if she does, a great catastrophe will befall her.'"

The warning was so dire that day and night it haunted both Mother and Daughter. Mizhakwe was especially concerned; every morning she would implore Gigoozens to be very careful.

Gigoozens heeded her Mother's words. And then one Sun when she was out picking *Meenan* (Blueberries), she felt an urgent need to relieve herself. "I can't tell where Sun sets," she bemoaned, "because Clouds have come in to block my Sun-Father's watchful gaze. And this thick Fog . . . it has swallowed all landmarks. And yet I can wait no longer!"

Just as she was about to lift her wrap, a chilling breeze jerked it high above her waist. She felt something enter her: something piercing and alien. Her wrap then slapped down as quickly as

it was yanked up, the Fog lifted, and sunshine flooded through the opening Clouds. All had returned to normal. Or so it seemed.

Gigoozens was left with a chill that not even Sun-Father could take away, and a sickness began to grow in her stomach. She tried to go back to picking Meenan, but the pain became gut-wrenching. Nothing she could do gave her any relief. "I must run home," she said. "I'll feel safe in the Wigwam and my good Mother will know what to do." She dropped her Basket, Meenan spilling everywhere, and ran as though a *Windigo* (Demon) was about to pounce upon her.

"Mother . . . I . . . it . . . " sputtered Gigoozens as she burst into the Lodge.

"I know," said Mizhakwe, who was sitting with her back to the door. Gigoozens, not hearing what her Mother said, went ahead blurting out what had happened. With the last words of her story, Mizhakwe turned to reveal her tear-streaked face.

"I saw the weather change and felt the cold pass by me," Mizhakwe said in a barely-audible voice. "I knew it was the terrible thing that the Rock and Plant People had forewarned. I called to warn you—I shouted as loud as I could—but you were too far away to hear. I ran for you but got turned around in the Fog. By the time it lifted I knew it was too late."

In the days that followed, Gigoozens grew ever more sickly. Mizhakwe, even with the help of the Herb People to expel the vile presence, could not alter the path her Daughter was destined to walk. There were Suns when Gigoozens could not eat, and Suns when she couldn't so much as get up on her knees. The more her belly swelled, the more whatever was inside burned and thrashed to get out. It drew all of her energy and left her nothing but constant misery.

"It's a parasite, Mother—I've become a host to some aberration from another world." Tears tracked down her cheeks, and she could not stop them. "There's no use in my wailing in misery,"

she said, "for nothing can be done. *This Person* has been called to serve, and it's for the good of our People, so I will continue walking this Journey."

No matter how noble her Daughter's destiny, Mizhakwe could find not a single shred of acceptance. All she could do was languish over the pitiful Child's suffering.

As the time of deliverance neared, much arguing and fighting could be heard inside Gigoozens' belly.

"*I* am the first to be born!"

"No, *I* am first!"

"Move aside, both of you—*I* want to be first!"

The tussling built to such a frenzy that Mizhakwe had to tie her Daughter down repeatedly to keep her from running madly into the night.

In the deep of one such black, black night, Gigoozens was shocked awake by a pain that tore through her entire body. "Rraaahh!" she moaned—so bitterly that it caused the Flowers in the Meadow to wilt. The whirlwind trapped inside of her shook her body, tore at her ribs, and exploded with such violence that not a trace of Gigoozens could be found.

Standing in her place were four snarling Children. Elated to be free of their forced closeness, they each immediately fled to the far corners of the Sky—as far away from each other as they could possibly get.

And that's where they stayed. As they grew, they each gained the teachings of their given paths. In their Elder years they became the wizened and benevolent *Minisino* (Guardians) of the Sky Realms. *Wabanong* (Morning-Light), who dwelled in the East, had discovered how to see things in their fullness; *Zhawanong* (Greening-Mother-Wind), whose home was the South, had found the way to live from the heart; *Neengabee'an* (Sunset-Vision), who lived in the West, had become a master at listening in all directions; *Geewaedinong* (Cold-Wind-Blower), whose place was the North, had learned the skills of introspection.

To this very day, these four knowing Keepers of the Sky Realms can be found dwelling in what we call the Four Directions: East, South, West, and North. From there they watch over us and are ever ready to share the teachings they've gained from their life Journeys.

ORIGIN

OVER THE YEARS, I have been blessed to hear some of the same stories from different storytellers. This has given me the opportunity to compare storytelling styles and techniques. Many of the best storytellers would not change the wording to fit their audiences as much as they would vary inflection and gesture. For example, say "The Sun is hot," emphasizing the word "Sun" while pointing up to it, and then repeat the sentence emphasizing "hot" and wiping your brow.

"How the Four Directions Came to Be" needs a storyteller who knows how to use words

and body language in this way. Because it is a story of such power, I retell it only when there is proper need for it and an engendering place for the telling.

The sudden and unexplained appearance of Gigoozens' Mother is an example of how the events in a traditional story will often defy logic and seem magical.

There is no particular Person I can credit for gifting me this traditional Algonquin legend, as I learned it over time from many storytellers. I wish to honor all of those who are keeping this very important teaching story alive.

How Helldiver Got Her Name

NANABOZHO (FIRST-MAN) enjoyed getting up before first light and walking quietly along the *Wawashkeshi* (Deer) trails to watch all of the night *Relations* going home to sleep and the day Relations awakening. He'd go past the Pond of *Amik* (Beaver) and see her swimming back from her night's work on her new dam.

"*Aneen* (Greetings) Nanabozho," Amik would call out. "I'm ready for a nap; perhaps we can go for a swim together this evening when I get up."

"That would suit me fine," Nanabozho would usually answer, as he was quite fond of Water and spending time with his Relations who lived there.

He'd often see *Michigeegwane* (Osprey) on his walk. She'd usually be catching first light atop the big *Zhingwak* (White Pine) on the edge of the Bog. It was in this Elder Tree that she had her nest. Nanabozho liked to watch her stretch her wings before she glided off to catch a Fish for her young's breakfast. In the clearing a little farther down the trail, Wawashkeshi and her two fast-growing Fawns would be browsing contentedly before their morning nap. If there was anything they liked better and more often

than eating, it was napping! Nanabozho would very quietly slip by so as not to disturb them. Down at the lakeshore, he'd look out to see *Obodashkwanishee* (Dragonflies), warmed and energized by the rising Sun, snatching Insects from over the Water. *Agwadashi* (Sunfish) would be rising from below to slurp Bugs off of the surface. "Don't their tough skins get stuck between your teeth?" Nanabozho would tease.

On this particular morning, Nanabozho was hungry. "I was up early and I've walked quite a distance in this chilly air," he said to himself. "One of those *Zheesheeb* (Ducks) swimming around out on the Lake would sure taste good right about now."

Unfortunately for Nanabozho, the Zheesheeb were quite a distance out, and it was unlikely they'd come in much closer. You see, they were very wary when Nanabozho was around, because he was well known as a *trickster*, and his antics were often the ruin of anyone who came near.

"Hmm . . ." thought Nanabozho, "I need a way to lure them in closer so that I might grab one."

Being a trickster, he didn't take long to come up with a plan. He built a *Wigwam* (Lodge) on the beach, started a *Shkode* (Fire) outside the doorway, and sat down to drum and chant. It

103

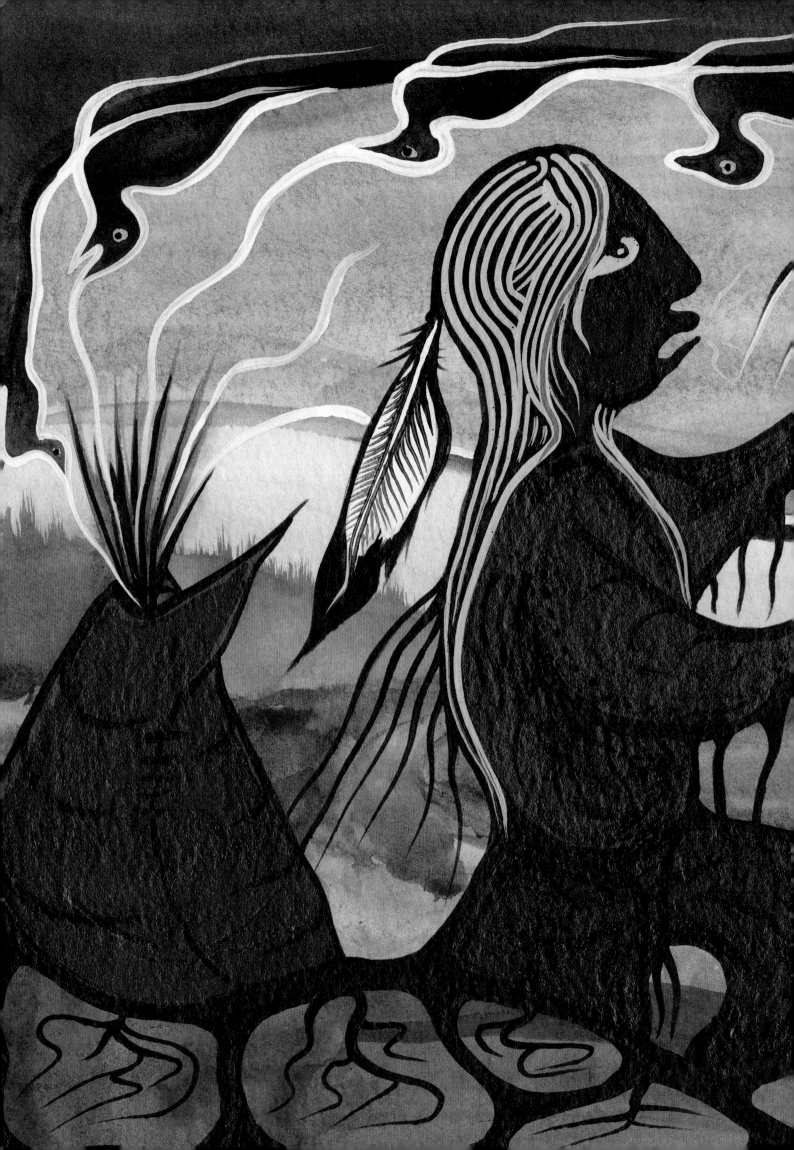

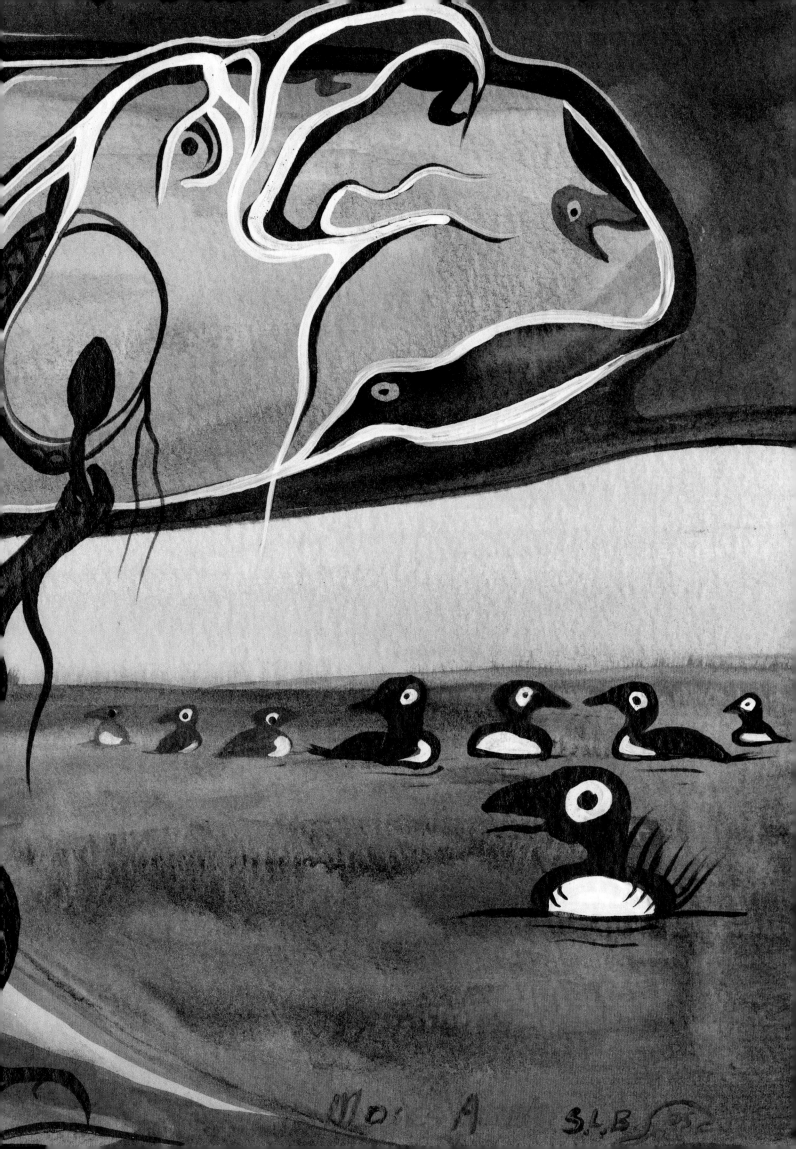

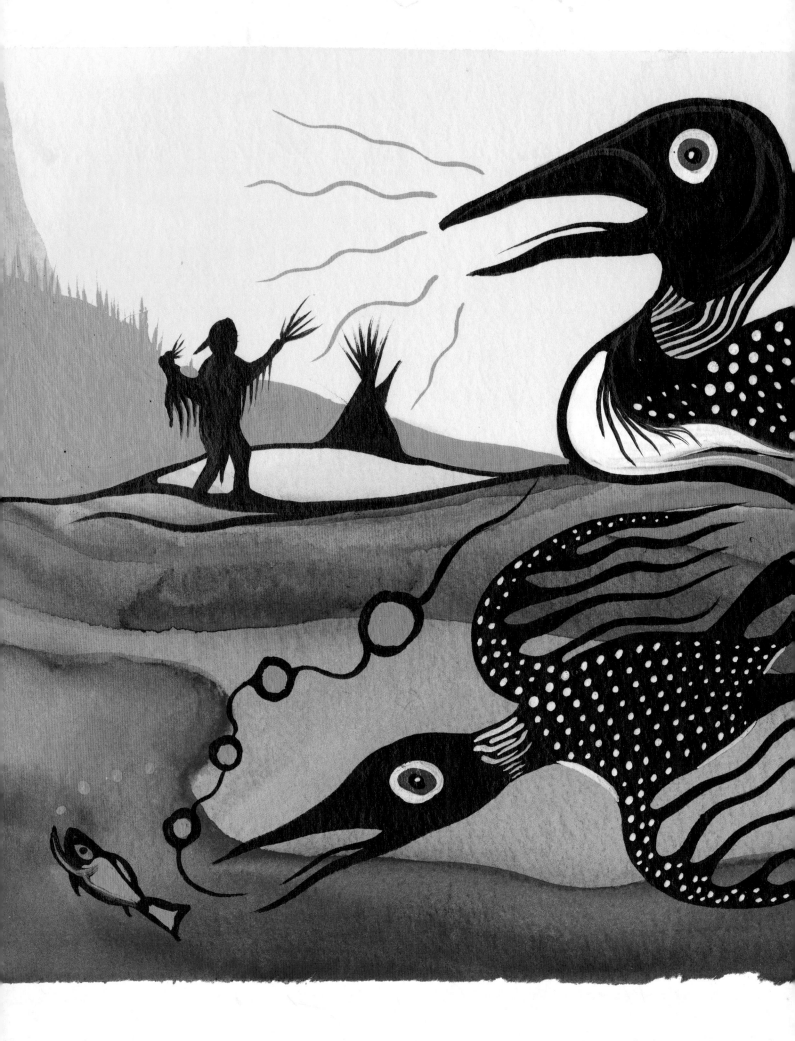

was a very enticing setting, as all of the Relations greatly enjoyed getting together to dance and hear the traditional songs.

And yet Nanabozho knew he would need some special songs to lure the ever-vigilant Zheesheeb. "I'll drum some of those I just learned when visiting my kin of the *Odawa* tribe in the east," he thought, "and I'll raise my voice so that the songs carry out over the Water."

"It's working!" said Nanabozho as he peeked out of the corner of his eye. The Zheesheeb were swimming to the rhythm of the Drum and couldn't help but join in the chant. Try as they did to stay out on the Lake, they gradually moved in closer and closer to Land. Still they would come only so far.

"My arm grows tired and my throat is getting sore," thought Nanabozho after a while. "If I'm going to eat, I'll have to gain their trust so that they'll come right up on shore—and soon."

"*Nakana* (My Relations)," he said soothingly, "It is intended that we dance and chant together in the *Circle Way*, and *this Person* believes that he's doing it alone. He can't make a Circle by himself. He wishes that you, his beloved Water Sisters and Brothers, would come and join him. Together, then, we could dance around Shkode and send our voices up as one in praise of *Bimadiziwen (Circle of Life)*."

It was a rousing speech. Nanabozho, being a very good hunter and stalker, was a master of deception.

"Perhaps we were wrong about Nanabozho," the Zheesheeb said to each other. "After all, he *is* our Brother and he *is* inviting us to come together in the Sacred Circle, which we have always honored."

"I impress even myself sometimes," Nanabozho whispered to himself. Not wanting to look overly pleased that they were coming closer, he went back to drumming.

Before long, he caught a glimpse of a couple of the Zheesheeb cautiously venturing up on

the beach. When the others saw that it was safe, they followed. Before long they were all dancing in rapture around Shkode with Nanabozho.

Shadows lengthened over the beach as afternoon turned to evening, and Nanabozho was growing ever more tired and hungry. "Friends," he began, "I'm having the time of my life and I don't want to quit. You honor me by coming together with me in dance, and you are good singers—the best I've had the privilege of joining with in a long time—so I would like to play an *Honor Song* for you. I have saved a special song which I brought back from our Odawa kin. Only my fingers grow numb in this cold and it's hard for me to hold on to a drumstick. I ask if you will join me in this Wigwam. There's a warm Shkode inside, with a thick stew simmering upon it."

The Zheesheeb were flattered by Nanabozho's praise and were having such a good time that they could think of nothing better than to dance and feast into the night in the comfort of Nanabozho's Wigwam.

"I must ask one thing of you," added Nanabozho, "that you blindfold yourselves. When I learned this song, I was told that it wouldn't have any *Medicine* if someone looked at the drummer."

"Of course, Nanabozho," said the Zheesheeb, as they no longer had reason to doubt him. They let him blindfold them and they entered the Wigwam with him.

Right away as Nanabozho began to drum and sing, the Zheesheeb realized the song truly did have power. They danced and danced in wild abandon.

Like most of Nanabozho's statements, the one about the thick stew was also not true; however, the stew was *getting* thick. As the Zheesheeb danced by Nanabozho, he'd grab them one by one and throw them in the stew pot.

"What is happening?" asked one of the Zheesheeb. "The voices of my Sisters and

Brothers grow weaker and weaker."

Nanabozho didn't realize that one more Zheesheeb in the pot meant one less voice in the song. Fortunately for Nanabozho, he was not only a trickster but a clever trickster. "Do not worry, my friend," he said soothingly. "Keep on dancing. It's only that some of your kin's voices have grown hoarse."

This contented the remaining Zheesheeb, with the exception of the last one in line, because he no longer heard anyone coming up behind him. He pulled off his blindfold, only to discover that half of his siblings were missing. "Aaaahhh!" he screamed in terror. "Run for your lives—Nanabozho has deceived us again!"

They scrambled in a mad frenzy to get out of the Wigwam, tipping over the stew pot and kicking hot coals everywhere.

Nanabozho was so hungry that he had wanted *all* of the Zheesheeb; however, now the remaining ones were racing down the beach to the Water!

"You *will not* escape me," he shouted as he picked up a hot coal and threw it at them. A glowing ember lodged in one of the Zheesheeb's eyes, and a chunk of hurled firewood hit another squarely in the back, injuring her spine and legs. Another Zheesheeb dove into the Water just as Nanabozho was certain he had her in his clutches. All he ended up with was a handful of wet tail Feathers.

"Graaahhh!" raged a dripping-wet Nanabozho as he stood there watching the last escapee paddle off to the safety of deep Water. "You've made a fool of me, so I'll now make *you* look foolish. I will not give you back your tail— in fact, none of your kind will *ever* have tails. And if you try to walk on Land again, you will limp and hobble so slowly that any Child will be able to catch you. From this *Sun* on, because you've raised hell with me, you and your kind shall be known only as Helldivers!" And so it was.

Today they're also known as *Mang* (Loon),

and their red eyes are a constant reminder to all the Relations of the lesson Mang learned from Nanabozho about how the truth often dwells beneath the words.

But this is not yet the end of the story. The Zheesheeb who was hit by the chunk of wood found that a misshapen back, crippled feet, and lack of tail Feathers made for excellent underwater swimming. She could now quickly dive to escape danger, and she had no trouble catching Fish to feed her young. Returning to where the forlorn Nanabozho stood in the shallows—and being careful to keep a safe distance—she said, "At first this Person thought you crippled her and that she might die. She felt sorry for herself and cursed your mother for having you. Now she realizes that you have given her a gift. You truly are a great trickster! *Chi Meegwetch* (Much gratitude) for the magnificent blessing you have bestowed upon her and her kind."

"You have turned my curses into gifts," replied Nanabozho after a moment's reflection. "I honor you for this, as you've helped me come to know the greater purpose of my trickster ways."

Helldiver has gifted us as well, especially those of us who would look upon her—or anyone else—with pity. With their example as inspiration, might we also find the beauty within travesty.

ORIGIN

NEARLY ONE HUNDRED YEARS ago, in a small cabin on the Red Lake Ojibwe Reservation in northern Minnesota, two venerable Elders named *Eskwegabaw* (Who-Stands-Last-in-the-Row) and *Debegizig* (The-Light-that-Spreads-All-Over), recounted the legend of Helldiver. The old friends took turns jumping in and out of the story, correcting and embellishing each other's contributions as they went along. Josselin De Jong, a German linguist, was present at the telling. He subsequently published the legend, just as it was told in the Ojibwe language, in a book titled *Original Odzibwe Texts*.

A diligent search turned up an aged copy of the book, which I was allowed to borrow only briefly, and which I photocopied, as it was long out of print and I could not find a copy for sale.

The reverence I feel for this book is actually for Debegizig and Eskwegabaw, who live on in its pages. On special occasions I will open it and they will recount my favorite version of the story of Nanabozho and Helldiver.

The Nanabozho legends are rich in trickster lessons. I am particularly drawn to "How Helldiver Got Her Name" because it gives a lucid example of the redeeming value of the trickster archetype.

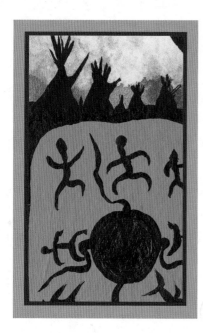

Chapter Ten

The Guardian-Warrior Path

PROTECTOR, SCOUT, EMISSARY, negotiator, provider, mentor: these and more are the roles of the Guardian-Warrior. In a real sense, we are all Guardians because we each, in our own way, are called upon to serve our People. Every one of us is born with a special gift, or talent, which we are to develop, in order that we might use it for the good of others.

"Our People," in the Native sense, includes the Plant People, Fish People, Rock People, and in fact all else that exists. To a Native, these People are Relations: all Sisters and Brothers with a common Mother, Earth, and the same Father, Sky. From this perspective, it is not hard to see how so much of what we do is in the service of our People. I share the next stories as examples of how we can serve our Relations, and of how we can groom and enlist our unique talents for this service.

Owl Eyes Saves Her People

ANEEN (GREETINGS) and welcome to the *Minisino* (Guardian–Warrior) training camp. Earlier this *Sun*, your hair was burnt and your face was blackened with charcoal: a ritual breaking away from your self-centered life and past involvements. Tomorrow your life will be your People's, and their well-being will be your focus. Tonight you may rest, as the coming dawn will begin your training with your Elder Minisino Sisters and Brothers. Now, as the night *Shkode* (Fire) begins to wane, *this Person* would like to gift you a story that you can take with you into your dreamtime. There your dreamself might give you the spirit of the story, so that when you awake, your spirit will be dancing with the spirit of the Minisino.

Come with me now as we journey back to the time when all the People lived as one. The Leggeds and Wingeds and Finned would lodge and hunt and eat together. In that time there was a *Two-Legged* hunter named *Eshkawanak* (Spike-Horn). He got his name from his preference for making arrowheads from the tips of antlers. There was also a hunter of the Four-Leggeds, a *Ma'eengan* (Wolf) named *Keenzhig-Gookookoo* (Owl-Eyes). She was called Keenzhig for short, and she was given her name because she had the gift of sensing things that lay beyond normal sight.

Eshkawanak and Keenzhig had been friends for a long time. Some of their earliest memories were of sitting together around Shkode in the Winter *Wigwam* (Lodge) and listening to the Elders' stories of a Land they had heard about long ago when they were Children. This Land was rumored to be over the Mountains, and strange Trees and Animals were supposed to dwell there.

"Do you remember the Elders telling us how big some of those creatures grew?" asked Keenzhig. "Much larger than anything we know!"

"I sure do," responded Eshkawanak. "I especially recall the hairy Bearlike creature they called *Misabe* (Giant). The old storytellers would describe him in frightful detail to try to scare us, and they did! I'd dream of him and wake up screaming."

"I think we all did," added Keenzhig. "Just going out in the dark was a scary ordeal after a story like that. And yet as we grew up, we seemed to forget about the spooky parts and be drawn more to the magic of a faraway place."

Even though Keenzhig and Eshkawanak were now young adults, they—as is typical of Natives—never lost their Childlike sense of adventure and curiosity for the unknown. It was no surprise to anyone when one Sun in the *Moon* of the Freezing Over (November), the

two young hunters decided to go to that storied Land in quest of Winter meat for their camp.

Excitement ran high in the pair as they crossed the high pass and prepared to descend into the far valley. Around the evening campfire, they would retell the stories they knew so well—the stories that lured them on this adventure.

As they followed the Elk trail over the last ridge and into the forested valley below, their eyes grew wide with wonder. Ancient Trees towered above them as they walked amidst the massive columns of their trunks. "I have to sit down," exclaimed Eshkawanak. "This is so overwhelming—I am in rapture! All I can do is look up at the lofty treetops; it's as though they're reaching for the Clouds."

"At last we're here," added Keenzhig, "actually experiencing what we had for so long only heard about. It's just as the Elders said: anyone fortunate enough to find their way to this place couldn't help but feel connected to *Bimadiziwen (Circle of Life)*."

A moment later, Keenzhig began to feel uneasy. "Something lurks nearby," she cautiously whispered. "There is danger . . . I sense it—I can *feel* it."

Her words sent a chill crawling up Eshkawanak's spine. For some reason, he was drawn to look up at the immense Tree they were sitting under. "Look," he said to his companion, "these great cracks in the Tree, they must be from lightning."

Keenzhig's gaze followed his. "I . . . don't . . . think . . . so . . . ," she stammered in a voice barely audible. "I . . . believe . . . they are . . . claw marks."

Just then the Tree rumbled, as though it was trying to contain a seething Volcano. "What . . . what ever was that?" stuttered a trembling Eshkawanak. "The Tree sounds alive!"

The once-courageous pair looked at each other in wide-eyed fright. In one great wave, all the moments of those childhood stories of

Misabe, and all the terrifying nightmares that followed, came rushing back. They had only one overwhelming desire: to be away from this ghostly place and back home with friendly People gathered around a warm Shkode. One glance at each other was all it took. "Let's go!" they shouted in unison, and they were on their feet and flying down the trail before they could catch a breath.

They didn't get far, however, before a roar like thunder hit them with the force of a crashing wave. They froze in their tracks. As if in suspended animation, they couldn't think, they couldn't feel, they couldn't even turn their heads. They had entered a new realm of fear: terror!

Not a Bird dared peep, not even the breeze dared shake a leaf. It was a silence like this valley had never known.

It could have been an eternity or it could have been a moment—Eshkawanak had no idea—before he came to realize that he was yet alive. "That came from the belly of the Tree we were just sitting under," he said in a barely audible whisper. "The claw marks, the rumble, the roar . . . it can only be one thing!" Terror escalated to panic, and in a flash the two were dashing out of the Forest and back up the Elk trail they had just descended.

It was too late. They weren't fast enough; they *couldn't be* fast enough. Fierce snorting and wild crashing rang in their ears like they were inside a brutally beaten Drum. Fear of Death bored into their hearts, and visions of their loved ones flashed before them.

"We don't have time to escape—we'll be lucky to have another breath," wheezed Keenzhig between gasps. Crossing over the Mountains was a hard Journey of four Suns, and they realized that even with the help of the *Spirit Wind*, along with traveling all night, it would take a full Sun just to get over the Mountains.

"Run ahead," shouted Keenzhig. "I'll hold the Terrible One off so you can get a head start,

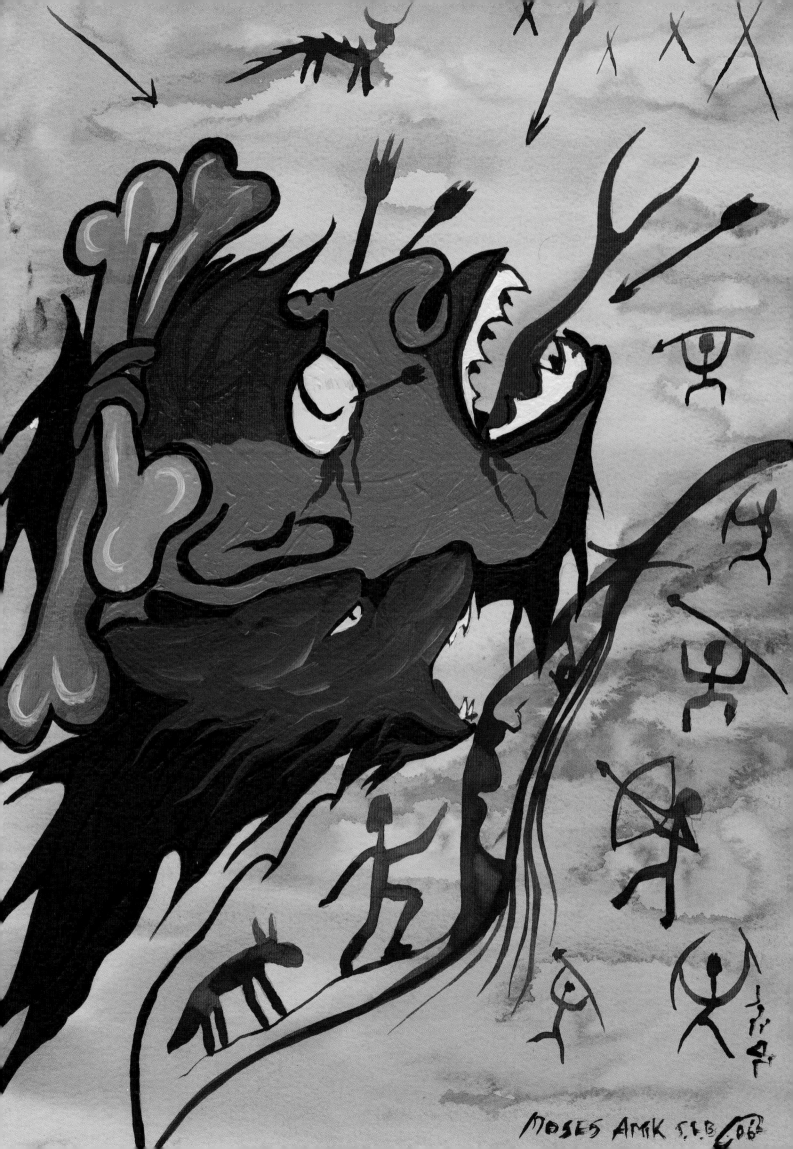

and then I'll catch up with you."

This made sense to both of them, because Keenzhig, being a Four-Legged, was the faster runner. Her reflexes were quick and she was swift of foot, which made her also a good fighter. At the same time, they knew from the sound of the cyclone rapidly gaining on them that Keenzhig would stand little chance of slowing the creature down.

"No," retorted Eshkawanak, "We will stand and face Misabe together."

As noble as this sounded, Keenzhig knew that two would fare hardly better than one against such a demon. She slowed down, shouted ahead to her companion, "Run, run on the Spirit Wind!" and spun around to face their nemesis.

Not the wildest nightmare could have prepared Keenzhig for what met her eyes. She'd have bolted without thinking if she weren't too petrified to move. Thanks to her training, she embraced her fear and transformed into a lightning bolt, dashing in to chomp at Misabe's shins. An instant before his wickedly long claws shredded her, she'd dodge out of reach. Had her Ma'eengan kin been there, they would surely have been impressed by the incredible stand she made against the mass of flesh and fury that towered above her.

"I can't keep this up," Keenzhig realized. The brute had stamina that she couldn't match, and she had to take tremendous leaps in order to avoid his reach.

One time she didn't spring back quite fast or far enough and a claw ripped across her back. "Aieeee," she yelped as she tumbled backward and rolled off into the brush. She lay there still as Death, hoping the ill-tempered beast would let her be.

Misabe took a couple of heaving breaths to renew his energy and rumbled up the trail for Eshkawanak, the new focus of his rage.

The gash shot pain throughout Keenzhig's body, and yet when she turned to look at the wound, she saw that it was not so deep. "I must get up," she told herself. "Eshkawanak needs me."

Being faster than the lumbering Misabe, Keenzhig had no trouble racing ahead of him. This time she met him more on her own terms, jumping on his back from an overhanging ledge. Tearing at his shoulders, neck, and cheeks, she whipped him into a frenzy that spun him around and sent her hurling into the face of the ledge. Bones cracked and she screamed so loudly that Eshkawanak heard it and felt his heart jump up into his throat.

This time the Raging Monster didn't miss a step. An earth-shaking roar transformed his hurt to rage, which fed his pounding feet as he continued to barrel down upon the Human.

Nor did the valiant Ma'eengan stop for an instant, even though her crushed chest made every bound and every breath feel like jagged Spears tearing into her. "Eshkawanak, I'm coming!" she howled as she leaped ahead of the foul-smelling demon to catch up with her Brother.

She found him gasping for breath and barely able to hobble along. Numbed by despair, she couldn't find anything to say. "If I can't somehow, some way, stop the barbarian," thought Keenzhig, not only will Eshkawanak and I be slain, but our entire People will be torn limb from limb and thrown about like so many snapped-off branches in a Wind storm."

In a flash of clarity, Keenzhig knew what she had to do. The Minisino is a master of illusion, trained to take what she has and create whatever she needs. There was a sharp bend in the trail just a few paces back, where Keenzhig waited for her third battle.

"Rraaahh!" right in his face with hackles raised, fangs bared, and a growl that sounded as though it came from the bowels of the underworld, Keenzhig flew out of nowhere into the massive Animal's face. To him, she appeared three times her size and ten times her fury. Rearing up, he tumbled backwards, pawing

wildly at the air in an effort to keep his balance. He crashed onto his back; and Keenzhig, without looking back, flew up the trail before the dumbfounded hulk could figure out what happened.

"I've nothing but a few breaths, a few heartbeats, left," thought Keenzhig. She was burning with pain and soaked in blood, and her sight would fade in and out. Nothing but pure spirit kept her moving. When she caught up with Eshkawanak, she couldn't even get out one ragged word between her frantic pants for air.

Pitying his ravaged comrade, Eshkawanak somehow found the strength to shout, "This time I will stand with you!"

An overwhelming sense of gratitude and admiration brought wetness to Keenzhig's fading eyes. And yet it didn't distract her. She knew the Minisino way; she knew what she was being called to do. Summoning up that last reserve of energy that every creature has, she straightened herself and felt her body swell with strength and resolve. She caught her breath enough to force out these raspy words: "Truehearted friend, we are now close to home. Misabe grows tired and weak; I'll stall him this last time so that you can make it to our People and warn them of his coming. The Elders, Women, and Children can run to safety while the Minisino bring Mighty Misabe down. I'll then race to join you in vanquishing him!"

"You alone have already performed a feat that no two of us could have done," Eshkawanak replied. "If you go back and face the Fierce Misabe, I fear I will never see you again. And I am sure that I can't go on. My legs have no feeling and my lungs scream as though they were afire. Let us lay here and offer ourselves to the mighty defender of his mystical Land, for he

has earned the Feast of our flesh and the power of our spirits."

Keenzhig responded in a solemn voice, "To offer ourselves to Misabe is to also offer our People to him. We are Minisino, the protectors of our People. As long as we breathe, it is our privilege and our imperative to serve them. Eshkawanak, hear me well. In honor of our fellowship, and for the love of our People, I ask that you go down to the Pond below us and do as you've seen me do: stir up the bottom to make the Water murky, and then drink. Our tiny Plant and Animal Relations who live in the muck will give you the strength to reach our People."

Eshkawanak got to camp just in time to call out the Minisino to meet Misabe as he came barging and bellowing into the camp clearing. He was a repulsive sight: bloody foam drooling from his mouth and running down his chest, shreds of blood and dirt-caked skin flopping from his head and shoulders, open wounds buzzing with Flies. Anyone unfortunate enough to be near him would've gagged on his putrid breath and retched at the vile-smelling spit he sprayed in their faces.

"Hurry, up to the Hills!" shouted the Minisino. Women turned white and Children shrieked—it was the scariest of stories come alive. In a mad but ordered frenzy, the Women ushered Young and Old out of camp, while the Minisino, like *Amoo* (Wasps), swarmed around the creature. They deftly moved in and out, stinging him from all sides. With each new jab the creature would spin around, only to be jabbed again from behind before he could lunge forward. At the same time, a rain of Arrows and Stones pelted down upon him.

First one eye, and then the other, was

pierced with lances. The brute raked his face with his paws, at the same time tripping on his own entrails dangling from his ripped-open gut. In agony he rolled and thrashed, flattening Wigwams like they were so many flimsy Baskets. Lashing out blindly, he spent the last of his rage hurling a barrage of firewood and dirt in every direction. Everyone backed out of harm's way and left him to bleed out the last of his venom.

The once-thundering Monster lay on his side and heaved a long sigh, followed by a shriek of such savage violence that those fleeing the scene were petrified in their tracks. And then all was still.

That evening after the People came back down from the Hills, the Elders announced, "Tomorrow let us hold an Honor Feast for Misabe, the fearless Minisino of the magical Land over the Mountains. His flesh will empower all who partake of it. In the same breath, we must with heavy heart tell you that Keenzhig will not return. We will remember her through all time as a champion of our People, for without her we would no longer be."

At the Feast, one of Misabe's furious black claws was presented to each of those who battled him. To Eshkawanak went his heart, which he ate on behalf of Keenzhig in fulfillment of the traditional ritual honoring a renowned and vanquished adversary.

"Grand Misabe is like no other," said Eshkawanak. "He has given this Person and his People what the lives of any ten enemies could not. Misabe's heart will now live on in this Person; and although he carries it, it is yours, and in honor of Keenzhig he will use its power in your service. *Aho* (I have spoken)."

The skull was buried in the center of the Ceremonial Circle, to honor their new kinship with the Misabe *clan*. A lush robe was made of the pelt, which the Elders wrapped around themselves in the long dark nights of the White Season when they told stories of a far-off Land where one couldn't help but feel Bimadiziwen.

And Keenzhig: to this day she is honored in story. When those who dream of serving as Minisino in their coming turns of the seasons hear the legend of her feat, they'll hunger for the privilege of walking in her footsteps.

ORIGIN

MY STORYTELLER FRIEND Johnny Rock first told me the tale of Owl Eyes. He believed that it came originally from a California People who were of the acorn-gathering culture. I liked the story because it was potent with Guardian–Warrior spirit and it resonated with my own calling to the Guardian Way. The story felt so familiar to me that if Johnny had not given me its origin, I would have taken it to be Ojibwe.

Story can bring worlds together that once seemed too far away to know each other. My wish is that this story be a bridge between the popular image of the Warrior and the Native Guardian Way as it is actually lived. The Warrior archetype perpetrated by many Hollywood

movies is not faulty for its inaccuracy as much as for its emphasis on ego and conflict. I added elements to "Owl Eyes Saves Her People" in order to portray some of the often lesser-highlighted qualities of the Guardian.

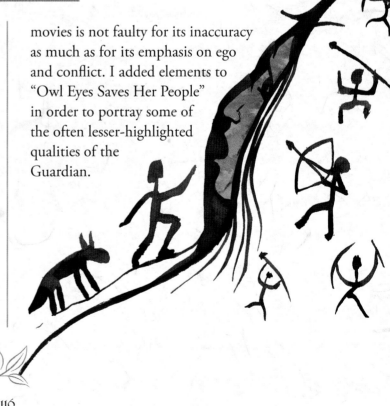

How Chant Came to the People

"IT IS A GOOD *SUN* to start a long Journey," said the *Ma'eengan* (Wolf) known as *Gichinodin* (Great-Storm-Coming) when he awoke. His silver-black coat shone in the morning Sun as though it were frosted with mist. So that everyone would know he was a chief of the Ma'eengan People, he walked with his hackles raised and his tail held high.

Anxious to begin his travels, Gichinodin immediately set out on the narrow trail that wove through a grove of stately *Weegwas* (Birch). Beside the trail flowed a Brook that hummed through Rushes and chortled over mossy Rocks. Even though he felt the heaviness of the grave Journey he was undertaking, he was uplifted by the unspeakable beauty that surrounded him.

"I sense someone coming up the trail toward me," he said to himself. "*Aneen Awema* (Greetings my Sister)," he said as he stepped aside so the Woman could pass. "*This Person* is called Gichinodin and he is on a Journey that will take him far away to an unknown Land. His heart is warmed as he travels through this beautiful Land where you live."

"This Woman is honored to know you, Gichinodin," replied the Woman. "Her name is *Eeshibag* (New-Leaf); she comes to the Stream to fetch hides from the Water, where she placed them last night to soften for tanning. She welcomes you to this Land. In these recent Suns, we've seldom had the gift of Ma'eengan among us; what gives us the honor?"

"I am now the last of my kind," replied Gichinodin. "Without my Sisters and Brothers to run with through the Forest and feast on sweet venison, I am no longer Ma'eengan. The spirit of our kind dwells not separately in each of us, but in all of us as one, so I am nothing unto myself. I am but a single pitiful Person; I can neither carry nor honor the spirit of Ma'eengan alone, so on this Sun shall be my Passing-over."

"This is hard for me to believe," responded Eeshibag, "as I heard you chanting your *Song* from far up the trail, and it echoed without end like *Mang* (Loons) calling to each other from one Lake to another. As I left my camp and started up the trail, your Song inspired me with the glory of the Wind and the River of your spirit. I know your chanting was welcomed this morning by all the *Relations*: the Six-Leggeds and Four-Leggeds and Two-Leggeds, because we all joined with you in a great chorus celebrating *Bimadiziwen* (Circle of Life). Your song is vital to that spirit."

Having said that, Eeshibag felt more relaxed and was able to pause and reflect.

She then added these words, "And you, Brother Ma'eengan, you stand before this Woman tall and strong, and your eyes burn with the Fire of life. Had you not spoken of it, I couldn't imagine this to be your last Sun."

"That it is *my* last Sun is not important," kindly replied the silverhaired one. "It is the last Sun of Ma'eengan. By walking this Forest one final time and chanting our Song as though this Sun were our first, I am honoring the era my kind has been given here on the Mother's lush

117

Bosom. I chant now because for us there is no tomorrow. The Land from which I come has been raped and all of my kin have been killed. I know now that I've been spared only for this moment, that I might bring this message to the one who has been chosen to receive it. This Person who now stands before her respectfully asks if she will listen, and then carry the words to all of the *Anishinabe* (Humans). My life will then be complete."

"This Person's heart is heavy," lamented Eeshibag, "because it bears the sadness of all the Relations. At the same time, she hears your request and would consider it an honor to do as you ask."

A faraway look came over Gichinodin's eyes, and he spoke these words:

Ma'eengan and Anishinabe were the first of the Relations to walk on the Bosom of *Aki* (Earth). We camped and hunted together, we feasted and told stories together. That changed when the other Relations came to live here on Aki with us. At the great Welcoming Ceremony we held in their honor, *Amoo* (Bumblebee) came forward to speak for them, and this is what she said: 'It is intended that you, Anishinabe and Ma'eengan, now begin keeping separate camps. You have different paths to walk. At the same time, you are to remain Sisters and Brothers, helping and looking out for each other, and learning from each other's examples. As goes the fate and fortune of one of you, so goes the fate and fortune of the other. *Aho* (I have spoken).'

The prophecy of Amoo now comes to pass, continued Gichinodin. Ma'eengan has met his fate, and he has come to warn you of yours.

"Noble Brother," replied the Woman, "your words burn like fiery coals upon my chest." Her lip quivered, and still she continued as best she could.

Without you, we will suffer. We are given meat and clothing by the *Wawashkeshi* (Deer)

People, and you are their *Minisino* (Guardian–Warrior): you keep them healthy by taking their sick and old. Since the time of our first Ancestors, you, the Great Hunter, have trained us in the ways of the Hunt. We will be drowned in a deep sadness when your shadow no longer crosses our trail.

Because I do not wish that upon my People, I will not believe that Ma'eengan has met his final fate. You, a noble chief of the Ma'eengan, still stand here before me; and your kin the Anishinabe will stand with you, for we are Minisino!

At the same time, I wish to respect your desire to leave your loneliness, so I take from before you any selfish wish I may have to keep you here. And yet if I were to let you go, I would also be giving up on my kind, because our fates are one. I can't do that—it is not the Minisino way. So this Person respectfully asks that you would honor the Anishinabe with one last request: that you allow us to carry your Song. For if the Song of Ma'eengan survives, the spirit of Ma'eengan will live on.

We the Anishinabe are with you as are the Stars with the night. We will bring honor to the Minisino way: we will dedicate our lives and the lives of our Children to the *Seventh Generation* to healing the Greed that so savagely plunders our beloved Aki. Endless camps of Tree People shall again cover the Hillsides, and the Hooved and Winged, in uncountable numbers, will come back to blanket the Plains and blacken the skies. And then, my lonely Brother, your kind may again dwell among us.

"This Person is deeply touched by your words," responded the last Ma'eengan. "They speak the love of your kind for all of Life. You are truly a Sister of Ma'eengan. Still it seems there is no way for the song of Ma'eengan to survive. I am afraid that, in spite of your noble intent, we are destined to leave Bimadiziwen for all time."

Again a deep sadness overtook Gichinodin. He bowed his head and his once-lofty tail hung

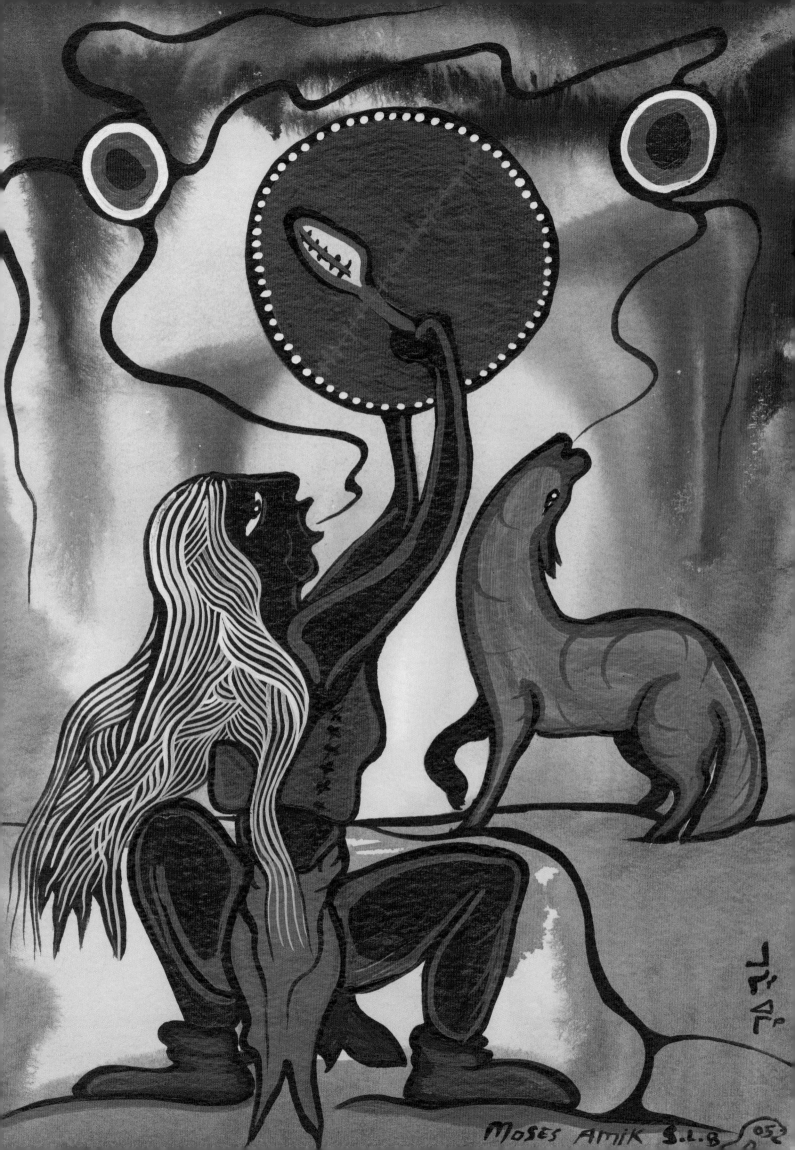

MOSES AMIK S.L.B. '05

limp. All of a sudden he looked very old.

The Woman Minisino looked caringly upon her Brother, and at the same time she did not soften. In the tradition of her kind, she presented Ma'eengan with a *Petition Pouch*, symbolically decorated with ornate *Gag* (Porcupine) quill work. She accompanied the Pouch with these words:

Since Ma'eengan and Anishinabe have parted ways, we have had no Song. In the Suns when our two camps were one, the Drum of the Anishinabe was our collective heartbeat, and the Song of Ma'eengan was our collective chant. It's a lonely rhythm that now rises from our Drum, and our hearts have cried because there has been no voice to chant in Thanks-giving.

This Person respectfully asks, again, if you would entrust us with your Song. We would carry it with honor, chanting it to the Seven Realms: East, South, West, North, Below, Above, and Within. We'd keep Wawashkeshi strong, just as you have. In this way, *Balance* could be maintained among the Relations, and we might all be able to continue dwelling in the Lodge of your most beautiful Song's blessings.

The lone Ma'eengan walked down to the Stream, where he stood on the bank and looked out over the Water. A long time passed, and when he came back, he said in clear voice, "Honored Sister, you speak from a place of wisdom that is greater than my narrow truth. On behalf of Ma'eengan Spirit, this Person wishes you to know that we would be honored to have you carry our Song."

At that, he raised his head and his eyes beamed as they once did when he ran blissfully with his *clan*. "In the beginning," he continued, "your kind and mine walked together. I see now that there may truly be a Sun when we come back together to drum and chant and hunt. Courageous Anishinabe, you have served my Journey—our Journey. My Sun, and the Sun of Ma'eengan, is now complete."

"When all of the Anishinabe chant your Song in ceremony," exclaimed an overjoyed Eeshibag, "you will know that it is safe to return. My Minisino spirit now hungers to begin restoring the Balance, so that we might chant you back into being. I say 'Farewell,' dear Brother; however, it's only 'Farewell' for now. Soon we will be running together like the Wind and stalking Wawashkeshi as in the Suns of old!"

Gichinodin, on behalf of his kind, and Eeshibag, on behalf of her kind, drummed and chanted together one last time. And then they parted, each to fulfill their destinies.

ORIGIN

AT POWWOWS and Native activist gatherings, I have listened to the Elders recount the prophecy that the fate of Ma'eengan portends the fate of the Anishinabe. Having lived with a Ma'eengan pack, I was privileged to first hear the prophecy directly from Ma'eengan. I remember feeling my face flush the first time I heard the foretelling from an Anishinabe. "There are other Humans who know and understand!" I all but screamed out. In that moment, a great piece of loneliness left me.

Some parts of the story that wrap around the prophecy were given to me by the storyline, the continuum from which all our stories come.

While putting the finishing touches on this book, I was gifted Lakota bowmaker and historian Joseph Marshall III's book, *On Behalf of the Wolf and the First Peoples*.[97] There on the first page was "How Chant Came to the People," only it came to Joseph in a dream over half a century ago, when he was six years of age. What a lucid confirmation of the storyline!

How Animal Guides Came to Be

IN THE LONG-AGO TIME, the *Two-Leggeds* and the other Animals were not separate from one another. They were all People together— *Makwa* (Bear) People, *Namay* (Sturgeon) People, *Bapakine* (Grasshopper) People, and Two-Legged People. They could all understand each other's talk, and they all lived together in *Balance* on the Mother's Bosom.

Back then, the Two-Leggeds did not know how to keep *Shkode* (Fire). Living on the Savanna, where Sun-Father's warmth was graciously given in all seasons, they had no need for Shkode. And yet they heard stories of a very different Land: the vast realm of *Geewaedinong* (North-Wind-Blower), where great herds of shaggy Animals wandered beneath towering Cliffs of ice. The Two-Leggeds could only visit the region on their Dream Journeys, because Sun-Father would often leave the area in cold and darkness, which would quickly freeze them to Death.

One morning, their Silverhair (Elder) awakened and immediately called the *clan* together for a *Talking Circle*. This is what he spoke:

Last night in a dream, I journeyed to the Land of Geewaedinong. There I found a clan of Two-Leggeds like us, and I sat in Circle with them, just as we are here. There was a small ring of Stones in the center of their Circle, and trapped in the ring was a Shkode!

When he'd start to die, the People would feed him sticks. He needed to eat in the same way as our lightning-started Shkode race over the Savanna to find more and more brush to consume. Only this Shkode didn't try to jump over the Stones to get more food; he seemed content with just what was brought to him!

They roasted their meat over Shkode, and it tasted as good as the Animals we find burned by our Savanna Shkode. The difference was that they could have roast meat any time they wanted. "Even more strange was that they gave honor to their Shkode in the same way we honor Sun-Father. 'Who *are* these People,' I wondered. When I looked around, I saw that they were us: they were you and me!

Aho (I have spoken).

Hardly anyone noted that *they* were the People in the dream; they were more fascinated with trapping Shkode in a Stone Circle. "Will you teach us?" they asked of their Silverhair.

"The air is warm and the Water is sweet," he replied. "The *Gifting Way* provides well for us; why would we not want to just let Shkode run free upon the Grasses?"

The People could tell their Silverhair felt uneasy about trapping Shkode, and yet he

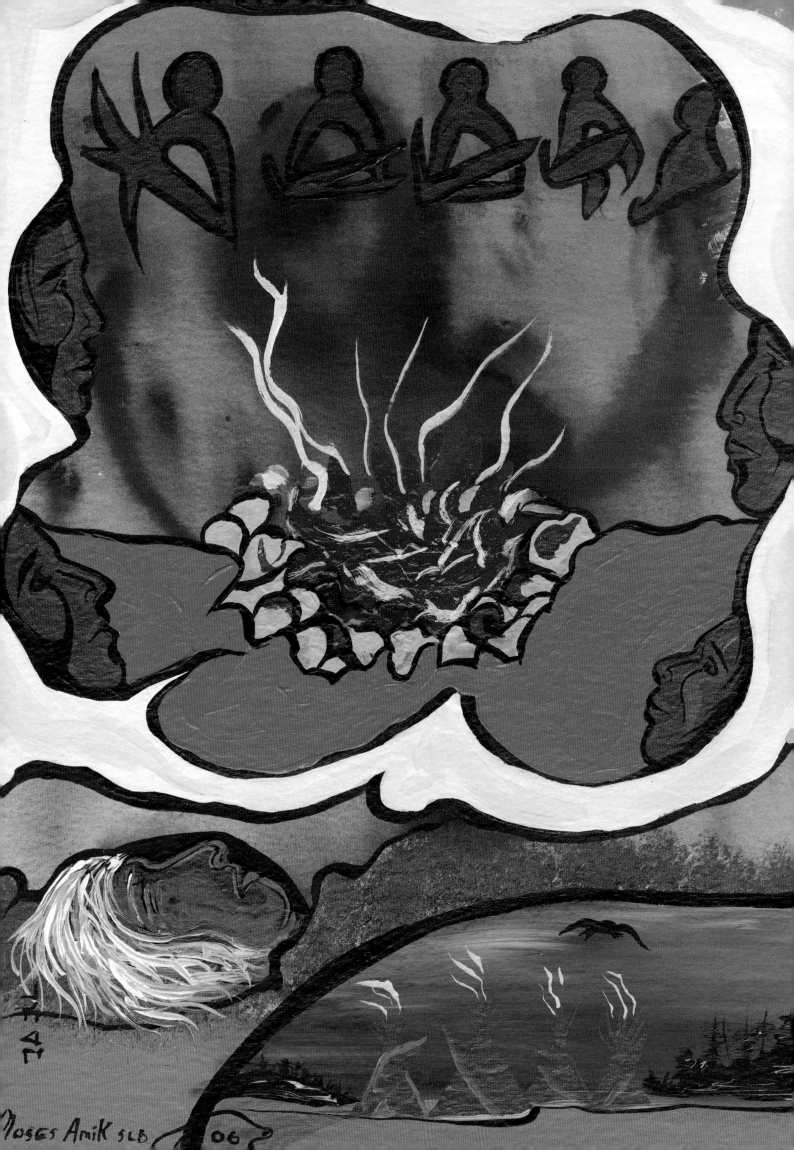

Moses Amik SLB '06

showed them how, because he cared for them. However, every time he tried to make a Stone trap, *Animikee* (Thunder Beings) would grow angry and bellow.

The Silverhair's clan saw the fury of Animikee not as a warning, but as a sign of hope. They would give *Offerings* of *Kinnikinick* (an aromatic herbal blend) to empower their desire for Animikee to grow angry enough to hurl down a blazing Arrow and ignite the Savanna. They would then have a Shkode to trap. They were obsessed—they wanted Shkode in a Stone Circle, just like in their Silverhair's dream.

In time this came to pass, and the People grew to learn the moods and gifts of Shkode. With his help, they grew more clever in making tools and storing food, and his warmth allowed them to gradually spread northward, into the Land of Geewaedinong.

Gagagi (Raven) was a *Minisino* (Guardian) of Geewaedinong. On a scouting flight late in one *Sun*, she came upon one of the Two-Leggeds' new camps. In the past she had spotted only the occasional Two-Legged, who she figured was probably on his *Journey of Discovery*. These interlopers would usually leave when the Rains turned cold, which gave fair warning for the coming Snows. Those who lingered too long would never return.

Gagagi sensed that these new Two-Leggeds were the same as those she had seen over the turns of the seasons, and yet they were different. They came in groups, they had new cunning, new tools—and they kept a trapped Shkode in the center of their Circle.

"Shkode is sacred and wild, like Water and Wind," thought Gagagi, "He is the Child of Sun-Father, sent to bring renewal to Geewaedinong. Why do they hold him slave and make him do their bidding? I must tell all the *Relations* what I have seen!"

The alarm call of Gagagi echoed through the Forest, followed by her request for all the Animal clans to come together in council.

The summons was picked up by *Andeg* (Crow), *Deendeesi* (Blue Jay), and *Ajidamo* (Squirrel), and spread by them to the far reaches of the Northland. In no time, all of the Relations heard the call, and each clan sent a representative. They came together in a great Circle upon a Blueberry Meadow.

Because Gagagi called the council, she was first to speak: "Honored Relations: *this one* who hovers before you requested we come together that you may be told of our Two-Legged kin who are coming to join us in our *Bimadiziwen* (*Circle of Life*). Knowing the Two-Leggeds from their past wanderings into our realm, this Person who speaks for the clan of Gagagi suggests that we welcome our new kin. Let us help them so they'll find comfort here, for in giving shall we also receive. *Aho* (I have spoken)."

"Yeah! Great! Wonderful!" they all cheered. Each in turn then spoke before the assembled as to what his or her clan could share with the Two-Leggeds. *Zheesheeb* (Duck) offered her rich eggs, *Migizi* (Eagle) suggested his sacred Feathers, *Wagosh* (Fox) pointed out her warm fur, and so on until every clan had presented its gift. They then planned for a great Feast to welcome the new People to the Northcountry.

With arrangements completed, Gagagi again addressed the Circle. "This Person originally called us all to council that we may celebrate the coming of the Two-Leggeds. She now realizes that we may have more to gift them. In honor and respect they come to this Land, yet I have seen that they have the power to take more than they give, more than they need. They've been given a gift of touch that extends beyond the reach of their hands. It allows them to kill from a distance, to crush Rock, and to fell large Trees. Perhaps one Sun some of them will step out of Balance and misuse these abilities. Aho."

Silence fell over the Meadow, as they had no experience with matters of such deep concern. After much reflection, *Wawashkeshi* (Deer) ventured to speak, "This Person respectfully

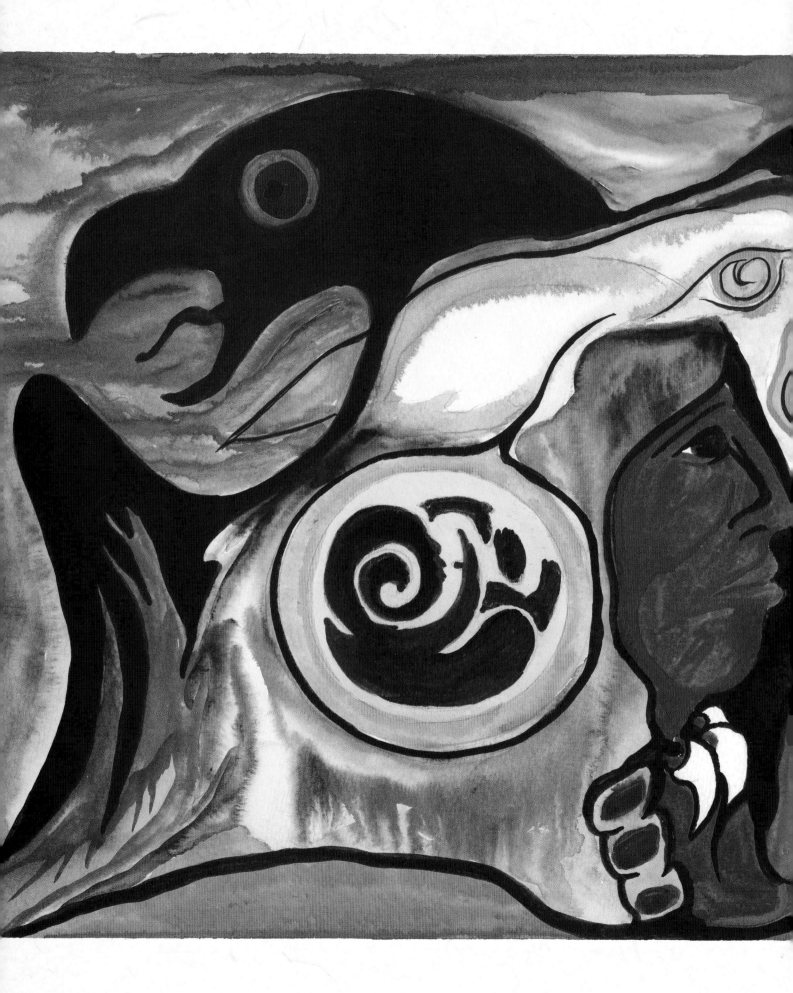

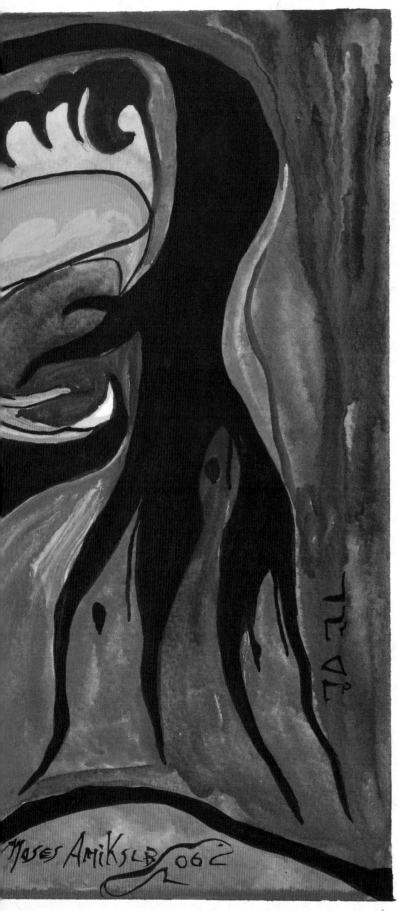

suggests that we, who do not have such capacity for imbalance, offer to guide the Two-Leggeds in their walking. Perhaps we could help them stay in Balance."

That gave *Bizhiw* (Lynx) an idea. "Each of us might choose an *Anishinabe* (Human) with whom we feel kinship and adopt him into our clan. When he is born, we could join our spirit with his, and then we and the Anishinabe could walk our lives together. He and we would be of shared heart and awareness, so we'd be right there to guide him in times of imbalance. We could revel with him in times of joy. He would be seeped in the blessings of our talents, and we in his."

Nods and murmurs of approval were heard around the Circle.

"Let us be careful," suggested *Wabizi* (Swan), "so that when they're walking in Balance or when they have lessons to learn, we remain silent, invisible. They, as with us, need to listen as much as possible to their own voices and make their own mistakes, in their own time and way."

Again there was obvious agreement.

"How might we each serve the Two-Leggeds?" asked *Amoo* (Bumblebee).

"Speaking on behalf of this Person's clan," began Gagagi, "we would be honored to perform as guides for their Minisinos. We already act as messenger and lookout for all of you by announcing the arrival of visitors and reporting on the movements of other Animals, so it would be natural for us to join with the Two-Legged Minisinos."

Everyone appreciated Gagagi's offer, as they all knew and trusted in the keen eyes of her clan.

Following Gagagi, *Makwa* (Bear) spoke. "This Person's clan is Minisino of the *Medicine* Plants; we could join with the Two-Leggeds whose gift is to walk with the Rooteds."

Enigoons (Ant), who sat next in the Circle, said, "Those of our clan are known for the ability to carry many times our weight. Having learned how to walk respectfully with strength, we could

perhaps guide those who are physically strong."

"We are ever on the move," said *Gijiganaeshi* (Chickadee). "Our wings beat almost as fast as those of *Nenookasi* (Hummingbird). This is because we're nearly always looking for food, and when not actually eating, we act as lookouts for the rest of our band while they eat. It seems as though we could guide the Two-Leggeds who are of high energy like us."

This continued for the entire afternoon, until all of the Feathered and Furred and Scaled had spoken. Many of the leafed and Rock People offered their guidance as well, because all of the Northcountry residents considered it an honor to serve their new friends.

In the days leading up to the Great Feast, the entire Forest emptied, as everyone left their homes for Blueberry Meadow.

Gagagi was asked by the clans to open the Feast by formally welcoming the Two-Leggeds to Geewaedinong and describing to them what each clan would like to gift them.

One of the Anishinabe's revered Silverhairs stepped forward to respond:

We are deeply touched by our new neighbors' offers to guide us on our *Lifepath*s. This is a profound gift, as we've come to realize that our new abilities give us the potential to do great harm. A heavy burden this has become for us to carry, and because of it we want to be very careful to walk gently upon this magnificent Land to which you have just welcomed us. Our last wish would be to harm any of you, our beloved kin.

At the same time, we have not been without hope. One of our young Women was told in a dream that the Sun would come when we would again clearly hear the *Song* of Balance. On that Sun we were to join closely with others whom we did not yet know, and we would then walk our lives in a whole new way. That Sun is today; the prophecy has been fulfilled.

The Silverhair continued: We are

especially concerned about this gift of Shkode, which is yet so new to us that we don't have the memories to help us walk in Balance with him. In our hands he can destroy much more than he gives. It's a blessing that Shkode himself has given us some help: The *Sweat Lodge Ceremony* takes us back to the womb so that we may be reborn and begin life with new clarity. It's been very helpful especially to our Men. The *Smudging Ceremony* cleanses us of self-preoccupation and the accumulated sludge of emotion. Yet we've felt a discomfort deep within ourselves that these gifts of Shkode did not touch.

This is why we regard what you bring us this Sun as a profound gift—it makes us whole again. Here you present us with the grandest of Feasts, and it is we who should be spreading a Thanks-giving Banquet before you! We are humbled by your sharing of self, and we will be ever grateful.

"The pleasure is ours to serve," spoke Gagagi on behalf of all the Geewaedinong Relations. "In giving do we receive, and you have brought us the opportunity to give."

A smile as broad as the Meadow spread over everybody's face as they reveled in feelings of mutual gratitude and appreciation. The Great Feast went on until the evening of the fourth Sun, because four was a sacred number in the realm of Geewaedinong. The tradition was that everything had to be eaten in order for an honoring to be completed, and considering the vast amount of food there was, the Feast *had* to last as long as it did.

And yet no matter what the tradition, there was much to learn about each other, and everyone was so filled with the joy of sharing that even four Suns was barely enough.

As the last of the luscious fare was being served, the Elder Silverhair stood up and voiced these closing words:

In order that we not forget this most sacred of events in the story of the Anishinabe, we will hold Honor Feasts for you, our esteemed guides, every turn of the seasons for as long as we shall walk upon our Mother's Bosom. *Mikinak* (Snapping Turtle), your Honor Feast will be the *Moon* of the Melting Ice when you rise from the Pond muck to rejoin us after your long slumber; *Gookookoo* (Owl), yours will take place when the first ice covers the Waters to herald the coming of the White Season, and when the ice breaks up to mark the beginning of the Green Season; *Zagime* (Mosquito), yours will be early in the Green Season when the young *Obodashkwanishee* (Dragonflies) emerging from the Water are feasting upon you.

Every year on a White Season's long evening, when the Snows lay deep and we're snug in our Lodges and gathered around the sacred Shkode, our storyteller will recount the legend of how we met our guides. In this way the *Seventh Generation* will know of this Sun, and of how to continue the honoring of your esteemed place in the lives of the Anishinabe.

You and we are now of shared spirit, which makes our relationship closer than that of Mates, or even of Mother and Child. With each and every breath of our lives, you are with us. We wish to call you by a special name: *dodem*, which in our language means *my heart*. From here on, whenever you hear 'dodem,' you will know that you are being embraced as closely as our own hearts.

ORIGIN

WHILE WRITING A CHAPTER on dodemic relationship for another book, I came to realize that it was starting to sound like a technical manual. I was missing my goal, which was to give a *feel* for who an Animal or Plant guide is to a Native Person. Readers had to be immersed in dodemic culture in order to gain an organic sense of dodemic relationship. Perhaps then they would be able to hear the voices of their own dodems. I needed a story.

I did not know a story that would work, so I journeyed to the storyline and was given "How Animal Guides Came to Be." It felt immediately appropriate, as it resonated with both my personal experience and that of other Natives. Ota K'te (Chief Luther Standing Bear), an Oglala Lakota raised in the traditional Buffalo-hunting Horse culture of the 1800s said, "Our legends tell of the time when bird and animal life communicated with man."[98] The 1800s recounting of a Cherokee legend is similar enough to "How Animal Guides Came to Be" that it appears they both came from the same place in the storyline. Interestingly, the Cherokee legend speaks only of how the Plant People stepped forward to guide Humans. Here is a line from the transcription: "Each tree, shrub, and herb, down even to the grasses and mosses, agreed to furnish a remedy for one of the diseases named and each said: 'I shall appear to help man when he calls upon me in his need.'"[99]

127

How the Peace Drum Came to the People

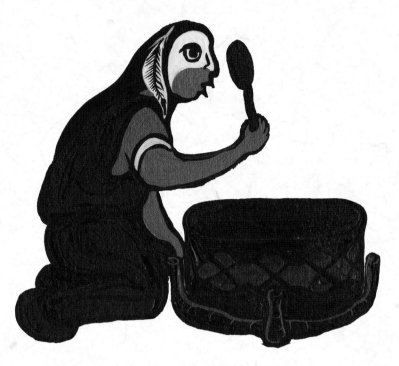

WHEN I WAS YOUNG, our venerable Old Ones would tell us stories about how *Bizhiki* (Buffalo) ran free over the Prairie. As the Elder storyteller spoke, I had visions of brown hump-shouldered Animals, as abundant as the Prairie Flowers, moving in endless waves upon a Sea of Grass. This was a time of plenty and contentment for our People—we lived what we called the *Gifting Way*. Brother Bizhiki kindly provided for all our needs: skin and fur for shelter and clothing, sweet meat and rich fat for nourishment, and bones and teeth for tools. We never had to worry about feeding our Children or providing comfort for the Old Ones.

The life of our People has changed since then—so much that it is as though we are a different People. The Old Ones said it began one morning when an Elder called *Ozeesigobikwe* (She-Who-Holds-the-Willow) woke up agitated from a dream. She called her camp together to share the message the dream gifted her. Everyone came, for back then this was the tradition. She spoke these words:

My kin, *this Person* must tell you about the time from which she has just returned. She

was here in this valley, right beside our River; however, she barely recognized it. Bizhiki was no more, and the howl of *Ma'eengan* (Wolf) no longer pierced the night. And yet the most striking change was a new People who had come to the valley. Our People called them *Agasode* (No-Hearts).

They came bearing gifts. The first was ravaging disease, which reached us even before they arrived. Once they settled in, they gave us another gift: new food. Even when it filled our bellies, even when we had ample stores for the Snow *Moons*, we starved. How did they expect this paste that had no color and no life to give us color and life? Their third gift was goods—goods of all kinds. They could be piled high upon one another, with no room for anything else, and still we'd want more. We could be living in peace and yet we were not content.

It was not the diseases of the Agasode that did this to us, because we were strong in spirit and we rose again. Nor was it their great weapons that forced their "gifts" upon us, because even though our bodies fell, our spirit lived on, and we returned. It was the

Agasode's Greed that conquered us.

My dream continued and I watched the Greed infect us. First it killed our ability to reason, and then it stilled our hearts. It blinded us to the misery we were causing: we couldn't hear those who were crying out in pain. We grew numb to everything except what fed our Greed. It was an addiction that made us crazy when we fed it and crazy when we didn't. It took only a few Winters for the Greed to conquer us.

The *Gifting Way* that we had known all of our *Suns* as a People had become the Way of Scarcity. The continual waves of abundance that once came flooding over our Hills were replaced with the bottomless pit of gluttony.

There my dream ended and only a voice went on: 'We implore you to be aware, for you will see the first signs in your lifetime. Care for your Sister, Ma'eengan, for if she is strong, you are strong. Like you, she follows and hunts Brother Bizhiki. When his place in the *Circle of Prairie Life* is taken over by a frail, dull-witted Grass-eater who must be watched over by Agasode, a noisy trash scavenger who follows Agasode around like a shadow will take the place of Ma'eengan. You will be given two choices: either go the way of Ma'eengan or live in the shadow of Agasode and feast on his leavings.'

Aho (I have spoken), concluded Ozeesigobikwe.

And so it came to pass. The Old Ones told us that the Greed first sent scouts, followed by the occasional missionary or trader. "We come to help you, to bring you the goodness of our way," they would say, and then they would leave to find others who they thought needed help. They were Men of good heart, and yet they wore the blinders of the Greed.

Not long after these first few Agasode left—just as foretold in Ozeesigobikwe's terrible dream—the Greed rumbled over the Prairie like Bizhiki once did. No longer were the Greed-mongers content with our souls and our furs, they now wanted to use our Women and take our Children. Soon not even that contented them—they wanted to strip us of our way of life.

The Old Ones went on to tell us stories about how we rose in defense of all we knew, of how we fought for our Sister Ma'eengan. "Why would you want to die for a sneaky, dirty, wild Dog?" they would ask those of us they captured. We remained silent, knowing they would not understand.

There's one story from those dire times that I'd now like to share with you. Ma'eengan was in trouble, and our War Chiefs went to the Mothers and ask for help from their Sons. Four times they came to *Ishpa'anakwadkwe* (Rising-Cloud-Woman); four times she gave them a Son.

And then they came again.

"This Person is honored that she might have the privilege of again serving her People," replied Ishpa. "She has Given Birth to four Sons and they have each become brave *Minisinos* (Guardian-Warriors) of our People and of our Way. Four times she has watched one of her Sons go to battle, and four times she has watched them come back. Each one was laid at her feet, in order that she might prepare him for the Scaffold of the Dead. And each time, her sole consolation was that the Scaffold stood high on a Hill overlooking the sweet Mother Prairie who gave her Son life. Now she must tell you that she has no more Sons, no more of her flesh and blood to give."

Soon another wave of Greed came storming over the Hills and down upon the camp, and there were few Minisinos left to defend it. Lodges were set ablaze, Women were carried off, and Children and Dogs were hacked to Death. Many of the Old Ones were spared, perhaps because they were no threat. Neither were they seen as having value. All that seemed to matter

to the Greedmongers was that which would feed their Greed.

In the middle of it all, Ishpa heard a voice that called, "Come to the Mother-Water." She ran through the mayhem and dove into the River, hiding under some Lily pads. Grabbing a hollow Reed to breathe through, she lay there for four Suns.

At the end of the fourth Sun, all was quiet but for the wails of the mourners. Scaffolds covered the Hilltop like Flies upon a carcass, and the wounded lay about in silent misery. With charcoal-scored faces and clothing ripped in grief, the Old Ones sat on the bank staring blankly out over the River.

There before them, a Woman rose up from under the Water. They were not startled; it was as though they had been waiting for someone. "Is that . . . ? No, it can't be! But it must!" they exclaimed to each other. Before the battle, her hair had been black as *Gagagi* (Raven); it was now the color of the Clouds that rolled over the Prairie. And her eyes, her deep-dark eyes, had a faraway look that spoke of something otherworldly.

They helped Ishpa out of the Water and lay her on the warm sand. As soon as she recovered enough to sit up, she addressed the Old Ones:

My Honored Elders, this Person feels like she has been gone for a long, long time. She has changed—our world has changed—and she was told that we must change with it. She is just returned from the Land of the Ancestors. They asked that we remember the prophecy of Ozeesigobikwe that we had heard retold long ago by the Old Ones in the Storytelling Lodge.

'Sister Ma'eengan is gone,' the Ancestors said to me. 'You can't stop the Greed. It will be there throughout your lifetime, and it will be there even in the time of your Children's Children to the *Seventh Generation*. If you

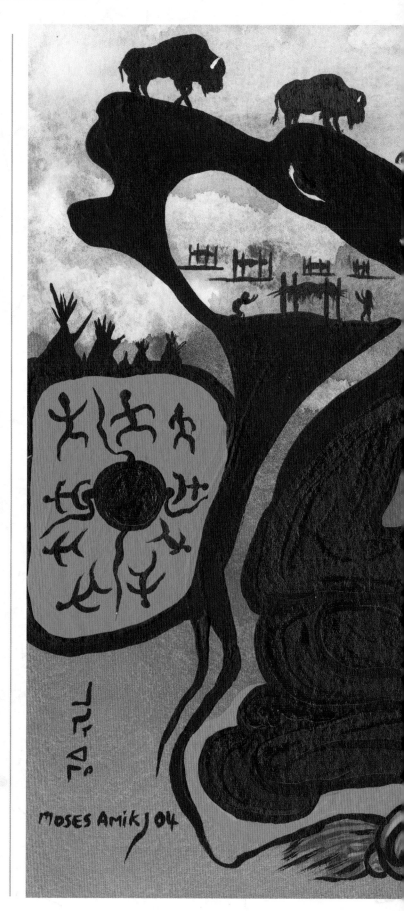

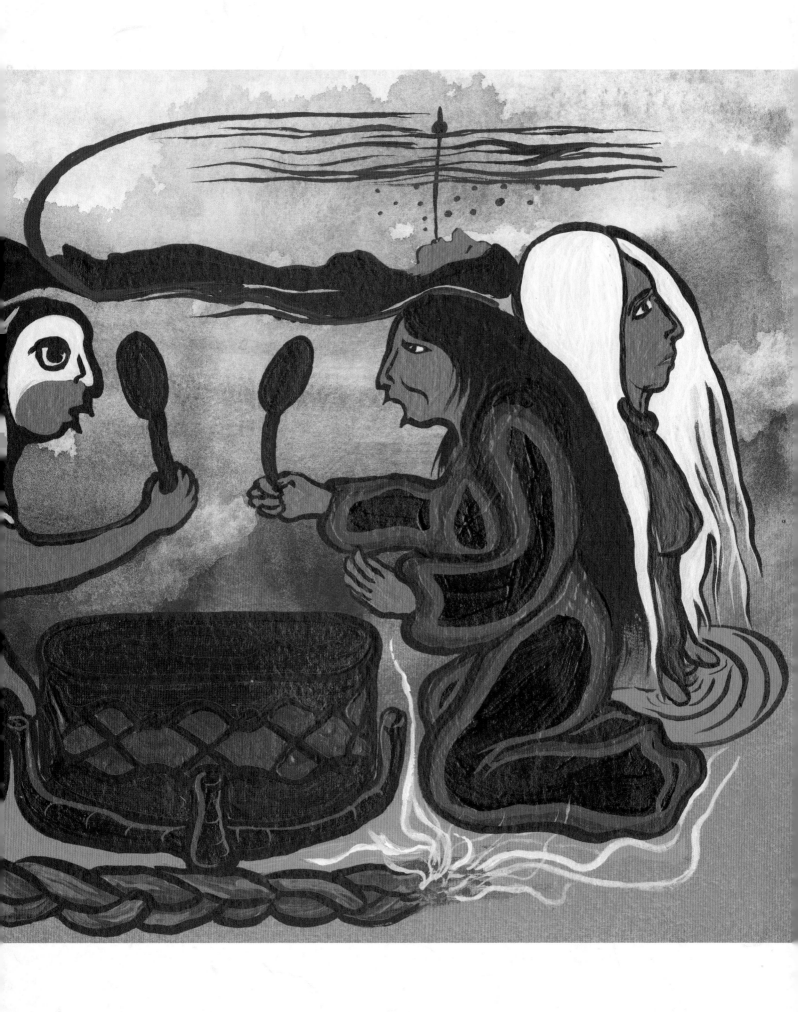

continue to meet the Greed with Greed for the *Old Way*, you will follow Ma'eengan and perish as a People. The harder you resist, the more you will become what you resist. If you were to let the waves of Greed pass over you like Wind over Grass, you could rise again like Grass after a storm. There would then be Bizhiki People to greet Brother Bizhiki when he returns.'

This made no sense to me, because we have always defended ourselves. My four Sons died courageously while protecting the People. This is our way: the way of the Minisino. My confusion turned into a Storm Cloud which furrowed my brow.

I feared that my anger might have dishonored the Ancient Ones, and yet all I saw in their eyes was kindness and understanding. They responded with this example: 'Imagine if we were to build a dam to stop the flow of a River. A great wall of Water would build up behind our dam and it would eventually burst, with the Water gushing through in an angry rage, destroying everything before it. Such is the way with Greed. You cannot stop it, you cannot destroy it, yet it can destroy you. When force is met with force, there are no winners.'

I listened to the truth of the Ancients, and I understood, because it sang to my heart.

On the second Sun, the Ancients began teaching me how to make a Drum. 'Embrace the image of this Drum,' they said, 'and follow her making closely, so that you'll remember. Pass all of this on to your Old Ones, and they will know what to do.'

We first prepared by *Smudging* ourselves. And then we readied the hide of a young Bizhiki who stepped forward to give herself to the Drum. Next we cut a section from the great hollow trunk of a fallen Elder Cottonwood.

"We do not make Drums from the great Cottonwoods," interrupted an Elderwoman who was listening to Ishpa. "A Drum that large would have to be played by many at once."

"Yes, Grandmother." replied Ishpa. "As different as this Drum was from our Drums, it yet felt as though it was going to be for our People. We gathered the materials in our Traditional Way, by giving *Offering*s and expressing our gratitude to our Bizhiki and Cottonwood Relations. And then we blessed Drum in ceremony, first by setting him upon an Elder Drum, and then by playing the two side-by-side."

The Elderwoman nodded in acknowledgment, and Ishpa continued her sharing:

After the Drum Blessing, the Ancients said, 'The Drum is to be called Peacebringer, and she wishes to dwell in the center of your camp. When the next great wave of Greed comes down over the Hills, ask your Minisino to grab drumsticks instead of weapons, and then run to Peacebringer and play the old chants. The Minisino are the ones to play Peacebringer because it is they who fight. Around them, the Women and Children shall gather and dance. When the Agasode descend upon you, they will meet no resistance. Finding the whole camp gathered around Peacebringer, they'll see that you are no threat to their ways, and they will leave you alone.'

The Ancestors then asked that after we've made our Peacebringer, we make another and gift it to the camp up the River. As the Ancestors showed me, we are to show their Women how to prepare the Bizhiki hides for drumheads and their Men how to fashion the great Drum bodies from the Elder Trees. In turn these Drummakers will do the same for the next camp. 'In this way,' the Ancients said, 'Peacebringer will come to all the People and help them survive to carry on the Old Way.'

'Some of the Agasode's Children and Elders,' the Ancient Ones went on, 'will hear the song of their hearts and come to you. Welcome them and invite them to join you around Peacebringer. Together you can keep the Old Ways alive; together you can drum and dance *Bimadiziwen* (*Circle of Life*) back to *Balance*.

And these were the Ancestor's final words: 'Greed knows only Greed, not Balance, so it must rape and plunder to survive. When there is nothing left to ravish, it will turn on its own kind and devour itself. The Mother Prairie will then grow lush, with Ma'eengan Pups rolling in the Grass and *Gekek* (Hawks) soaring on the Wind. And your People, along with Sister Ma'eengan, will once again follow Bizhiki, as has been your way since the dawn of time.'

Aho.

ORIGIN

THE WOLF-HUMAN RELATIONSHIP story that began in "How Chant Came to the People" is continued in this legend. It was given to me along with the honor of being drumkeeper for a community in which I lived. We received our Peacebringer from *Menominee* (Wild Rice People) Drum Chief Wallace Pyawasit.

Peacebringer came first to the Dakota (Sioux) sometime in the 1800s. At that time the Great Plains Natives (Cheyenne, Dakota, Comanche, and others) were not only deep in conflict with the Greedmongers, they were also at war with each other and with the Forest Natives (mainly Ojibwe) to the east. Everyone was being pushed together by encroaching civilization.

From the Land of the Dakota, Peacebringer and her message spread from people to people in all directions. Religious societies have evolved around Peacebringer, some of which survive to this day. Peacebringer is the precursor of the Powwow Social Drum.

Along the way, a tradition evolved in which people would abstain from alcohol and other mood-altering substances for a time prior to drumming Peacebringer. The period of abstinence varies with tribe or group.

In this day, another tradition is evolving: that Women as well as Men may drum Peacebringer. The sexes are warring between themselves, and neither are at peace with Earth-Mother, so both need to sit together around Peacebringer and again feel The Mother's— and each others'— heartbeats.

133

Chapter Eleven

Seeing through Different Eyes

MANY OF US ARE COMING TO SEE that by not realizing the full extent of our Human intelligence, we are placing limitations on our relationship with our world. We have put great stock primarily in our rational capacity, and to some degree our five senses, whereas Native People also rely heavily upon intuition, instinct, feelings, dreams, and Ancestral memories. These largely dismissed aspects of Human intelligence could provide additional and invaluable input for navigating our complex world, as well as serving to bring us back into balance with it.

Adding further to our limitations is the fact that we do not effectively use our senses. Sight dominates, giving us around eighty-five percent of our sensory input, with hearing providing most of the remainder. We limit ourselves even further by filtering out anything that does not make rational sense.

Recently, we have added another dimension to this dilemma: virtual reality. More and more our relationship with our world narrows as we funnel it through television screens, computer monitors, audio speakers, cell phones, and iPods. In this image-based world, fully functioning senses would be distractive, as would—of all things—the natural world. The upshot is that in order to experience life virtually, we end up shutting down a major part of our human selves, along with isolating ourselves from real life.

Stories can help us reawaken, both to our fully actualized selves and our *Circle of Life*. Our Native Ancestors shared special stories with their young, to encourage the development not only of their five senses, but to help them see in the fullest sense of the word: intuitively, instinctively, subconsciously, and ancestrally. For this chapter I have selected five stories that, were we raised in a Native culture, are the type our storytellers would have used to help us see through different eyes.

How a Boy Learned to Hunt

THE *ESHKIBOD* (Raw-Meat-Eaters) are familiar to most of us, as they are renowned for their swift kayaks, igloos, and uncanny ability to hunt the shifting ice for *Askik* (Seals). Their little-known cousins, the *Adikanesi* (Caribou People), live inland and have quite a different lifeway. They are *Adik* (Caribou) hunters and have developed a deep relationship with these Four-Leggeds. The Tundra Herbs, which cannot be eaten by the Adikanesi, are relished by Adik, who in turn gift the Plants to the Adikanesi in the form of nourishing flesh. The Adikanesi return the gift by challenging Adik in the Hunt. Only the swiftest and cleverest survive, and they pass their superior traits on to the young. Were Adik not hunted, they would soon overpopulate the Tundra, stripping it of greenery. Only one fate could follow: agonizing Death from disease and starvation in the bitter cold of a long, black Winter.

When an Adikanesi Hunt is successful, Thanks is given to Adik Spirit: the life force common to all Adik. A finger is nothing without the hand, and so it is with an individual Adik. As the hand gives the finger its life and purpose, so Adik Spirit gives life and purpose to each Adik. When one dies, her body nourishes the *Relations* and her spirit lives on in the spirit of all Adik.

I'd like to tell you the story of how an almost-grown Boy of the Adikanesi called Dewe'iganans (Little-Drum) found his way into adulthood. He had recently quested for his *Lifedream* and was anxious to begin living it. His dream told him that he was to be a hunter and bring the gifts of Adik, meat, bone, sinew, and pelt, to his People. Serving them in this way was to give him a deep sense of fulfillment; however, when he returned from his quest, he said to himself, "I don't know where to begin. Hunting for *Bine* (Grouse) and *Wabooz* (Hare) around camp is one thing, but venturing far out on the Tundra and tracking the mighty herds of Adik is quite another! I know that part of becoming a Man is finding my own way along my given path, and yet I'm already lost before I begin."

Making a small *Shkode* (Fire) for himself, Dewe'ig sat and stared into it. Most of the *Sun* passed, and just as Sun-Father was about to touch the horizon, Dewe'ig jumped up and shouted, "I've got it! My Uncle *Geemoodapi* (Laughs-Inside) is the greatest hunter of the Adikanesi; I will go to him and learn the way of the Hunt."

Dewe'ig spoke of his Uncle with some pride and not too much exaggeration, as Geemood was truly a good hunter. He had Adik *Medicine*

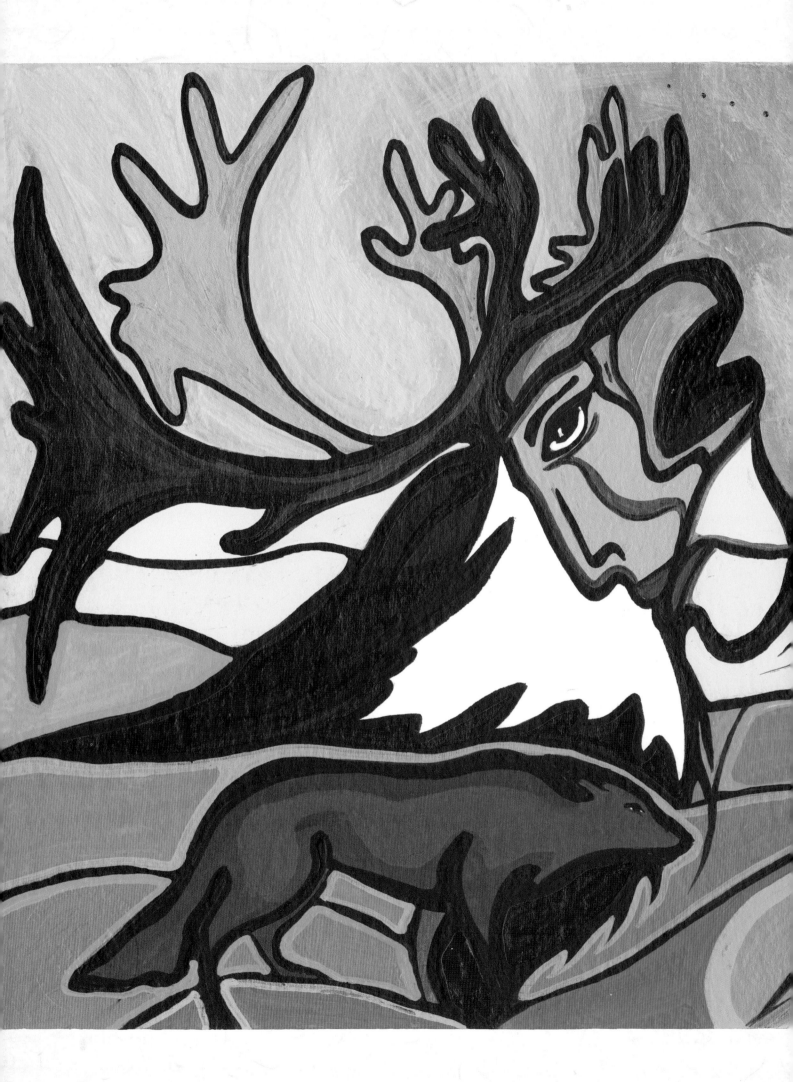

Moses Amik s.L.B. 05

and was the eldest, most experienced hunter of the *clan*. Providing consistently for his People, he would be sure to help feed and clothe those in need.

"I'll make a *Petition Pouch* for Uncle out of this lush pelt from the white Wabooz I snared last White Season," decided Dewe'ig. He empowered the pouch by decorating it with Adik teeth, because it's with their power that Adik turns bitter Lichen into sweet meat and warm fur. He attached several of Adik's sun-dried scat, as this was Adik's gift of nourishment to The Earth-Mother which enabled Her to continue feeding Her Wabooz, Bine, and Adik Children. Lastly, he made a latch from a piece of Adik rib that had been used as a hide-tanning tool.

When Dewe'ig held the pouch, he could close his eyes and feel the power. He couldn't wait to present it, so he immediately went out to look for the Elder hunter.

Geemood had wandered out alone on the Tundra, which he often did just before going on a Hunt. When Adik called him, a farseeing look would come to his eyes, and his People would know that he wished to be alone to prepare himself for the Hunt. This time Dewe'ig felt the same calling, so he thought it would be alright to go join his Uncle.

"I've been waiting for you, Dewe'ig," said Geemood when he heard the Boy approaching from behind.

"How ever did you know someone was coming to see you?" asked Dewe'ig.

"It is not me who knows," replied Geemood, "it is me who listens to those who do know."

"Uncle, I don't understand."

"Perhaps your mind does not, and yet your heart does. Come and sit with me."

The Boy-Man sat beside the aged hunter on a mossy rise overlooking a vast sweep of Moss, Heather, and Pondlets that make up the Green Season Tundra.

"Honored Uncle," began Dewe'ig, "*this Boy*

who strives to be a Man believes that he's been given his Lifedream. He respectfully comes to you for guidance."

As he spoke, he reverently—and with a bit of shyness—handed his Uncle the Petition Pouch. "This Person was told that Adik wishes him to help keep her kind strong," he continued, "and he feels the passion to bring Adik Medicine to his People. Nothing would please him more than to dedicate his life to Adik and Adikanesi. He is so filled with this dream that he feels about to burst, because he doesn't have the skills to serve in the way he is called. Now he sits humbly before you, asking if you would accept him as an apprentice."

"This Man hears the words of your heart," replied Geemood. "How might he serve in the walking of your *Lifepath*?"

A thoughtful look came over Dewe'ig's face, and then he spoke:

Uncle, ever since I could first walk, I've followed in your footsteps. When you took your Man-Bow out on the Tundra to hunt Adik, I would take my Child-Bow and stalk the Adik that my fanciful eyes saw lurking around the camp. When you came home with the gifts of Adik, I felt both the joy of the camp and the joy in your heart. I'd bring in berries and greens, or perhaps a Wabooz. They were my Adik, so like you I also felt the joy of providing for our People.

As I grew older, I came to notice the faraway look that danced in your eyes when you prepared for the Hunt. It caused me to realize that there was far more to hunting than knowing how to stalk and shoot a Bow. Uncle, this is what I wish to learn."

Geemood listened with quiet pride, as few Children were so perceptive. He looked off over the low-rolling Hills as he

recalled bringing his own petition to a great hunter in the time of his youth.

After a while, he spoke; however, the voice was not his. The words came from a hunter whose bones did long lie on the Tundra with those of his Sister Adik.

This Silverhair who sits beside you is honored as a skilled and cunning hunter; however, you must know that it is Adik Spirit who deserves the honor, for it's she who presents those of her kind before me. And it's *Ma'eengan* (Wolf) who should have the credit for skill and cunning. I am merely a clever imitator: a shadow of Ma'eengan, the real hunter. You've brought your petition to me because you've seen me hunt. It has not yet been possible for you to

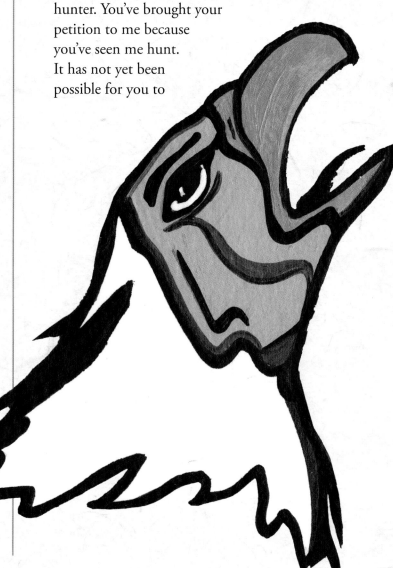

see the hunter within me: the hunter whose spirit guides mine.

I will fast on your petition, my Brother's Child, and if I'm given the sign that I am intended to accept it, I will do so with honor, on behalf of Adik and our People. And then I'll guide you to Ma'eengan, as he was the first hunter for our People, and it was he who has taught us—and continues teaching us—the ways of the Hunt. This has been so ever since the long-ago time of the first Adikanesi hunter. This is as was done for me and for all those of our calling who have walked before us.

"My heart embraces your words, which touch me deeply," responded Dewe'ig. "At the same time, there were other voices distracting me, and still they echoed your exact words. Soon I realized that I was hearing your Uncle, and all the wise hunters before him, going all the way back to when the first Boy-Man petitioned the first Adikanesi hunter."

Geemood smiled, knowing that when his bones lie mingled with the bones of Adik and Ma'eengan out on the Mother Tundra, Adik would remain strong and his People would be provided for.

ORIGIN

WHEN I FIRST LEFT HOME, I hitchhiked back and forth across the continent in search of Native teachers. I found those I was intended to be with, and I am deeply grateful for the new world they opened to me. I was also guided to Elders who left me anything but thankful. They frustrated me because they would not teach me, and I was full of questions and impatient to learn.

I could not appreciate how patient and respectful they were with me, especially considering that I often could not extend the same to them. Neither that nor my expectations seemed to matter much to them, as they lived in a time frame of their own, with their own sense of priority. What I asked of them they seldom gave. They would tell me it was not theirs to give—it was mine to find. I would leave, sometimes hurt, sometimes confused, and usually disappointed.

One afternoon back in that era, Bill Hurrle, a '60s counterculture friend who recently *Passed-over*, told me the story of "How a Boy Learned to Hunt." Immediately it caused me to realize that the Elders who irritated me where doing the same as Geemood in the story: taking my thirst and directing it beyond themselves to their sources of wisdom. I am profoundly grateful to Bill, the Elders, and the storytellers, for their serendipitous roles in bringing me a way of knowing that has changed the way I learn.

I would also like to express my appreciation for people such as Faith Gemmill, a Gwich'in Athabascan from Arctic Village, Alaska, for educating outsiders on the point that "the health of our people is the health of the herd."[100] This is the heart of "How a Boy Learned to Hunt," and in sharing the heart, Faith is helping to assure that both Adik and the way of the traditional Hunt will remain sound and sacred. I see how hard it can be for many who do not live close to the Earth to appreciate just how intimately Adik and the Adik People are related. Andrei Golovnev, a Nenet Reindeer (semi-domestic Adik) herder from Siberia's Yamal Peninsula, helps by eloquently portraying this relationship: "The first thing a newborn baby touches outside the womb is the deerskin in which it is wrapped by the midwife. A dead man is also wrapped in deerskins. And between these first and last encounters, a person lives with the deer and gives thanks to the deer."[101]

Sisters of the Moon

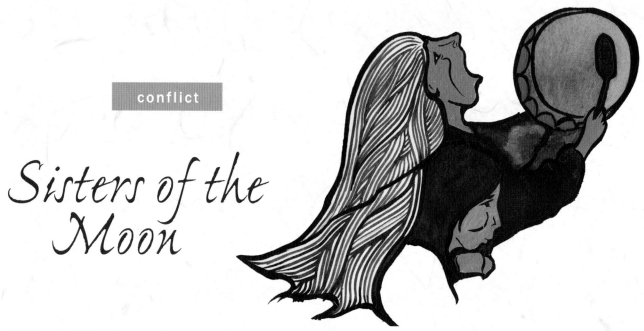

THE AIR HUNG MOIST and still, as it often does on a late Green Season night. Wise Sister-Moon shone brightly on the Meadow, which looked as though it were bathed in a milky haze. *Oshkeequay* (Young-Keewaydinoquay) stayed just out of sight, in the dense shadow of the thick Cedar Forest surrounding the Meadow. Earlier that evening Oshkeequay's Mother, *Makoons* (Little-Bear), tucked her and *Nishime* (Younger-Brother) into bed, giving them a smile that both of them suspected was to reassure them that everything was alright.

They had just come from playing along the beach and knew they were late for bedtime. The Sun had already slipped below the Water and the shadows had merged into one black sheet. On the way up from the beach, they walked by the camp's central Hearth, where People would often gather in the evening to share their stories of the *Sun* and make plans for the next.

"Why are there only Men gathered around *Shkode* (Fire)?" asked Oshkeequay.

"And they're using harsh, angry words," added Nishime.

"It is not our way, as we are all *clan*!" said Oshkeequay. Nervous as she was, she grabbed her little Brother's hand and they walked quickly by, not saying a word until they got home.

What they did not know was that, earlier in the Sun, several of the Men paddled out on the Lake to pull up their *Geegoon* (Fish) nets,

only to find them empty. This was unusual, as Geegoon were plentiful and Geegoon Spirit had always been generous in giving of her kind. The *Balance* of *Bimadiziwen* (*Circle of Life*) was maintained in this way, as the Human People were nourished and the Geegoon *People* were kept healthy by not becoming overpopulated.

"Have we been too greedy?" asked *Majipon* (It-Starts-to-Snow) that morning when they were lowering the net back into the Water.

"Did we forget to lay down an *Offering* and Give Thanks, or did we do it only to help fill our nets?" wondered *Nikimo* (Dog-Growling).

"Maybe someone already came for the catch," suggested *Dakwa* (The-Short-One).

"That makes sense," stated Nikimo, "I bet that's what happened."

Everyone nodded in agreement, and they paddled back to shore.

That evening at mealtime, the Men checked with each other and came to realize that no one had gone earlier to empty the nets, and that it had been many turns of the seasons since the nets had come up without a single Geegoon. They also remembered *Gibakwa* (He-Who-Holds-Back) reverently sprinkling an Offering of *Kinnikinick* (an aromatic herbal blend) over the Water before they pushed off in their *Jeeman* (Canoe).

"I smell a *Gweengwa'age* (Wolverine)," said one of the younger Men.

"Those ornery creatures don't smell like *Zhigag* (Skunk) and have strength like *Makwa* (Bear) for nothing," added another. "They're detestable trap robbers."

"You're right," said someone else, "I wouldn't be surprised if someone went out there before dawn and cleaned out our nets."

"Of course!" a brash voice chimed in. "Why else would they be empty?"

"But who?" asked another. "It doesn't make sense for one of us to steal Geegoon from our own nets."

"Who said it was one of us?" posed someone in an ominous voice.

"My Brothers," said *Mashkanodin* (Grass-in-the-Wind), one of the older Men, "I suggest that we remember the words of our Elders, who have cautioned us about jumping to conclusions. They have suggested that we always 'be as a question' and go directly to the Person so that he has the opportunity to speak his truth."

Out of respect, the young Men listened to Mashkanodin. And yet before long, their talk again took on a suspicious, blaming bite. Even the older Men began to join in.

"It could be someone from the camp at the other end of the Lake."

"I bet it was. Just a couple of Suns ago, I heard that their nets were getting old and ratty. Knowing them, they still haven't gotten around to making new ones."

The pitch grew louder until everyone in the camp could hear what was going on. Others went down to the Hearth to join in. The talk grew more heated and calls for revenge rose up among them.

"We must do something," said the Women who had gathered in a group in front of the Lodges. For many generations they had taken it upon themselves to soothe the rage of their Men. It was a time of turbulent change for the People, for the missionaries had come to seduce them away from their sacred ways and the traders kept returning to entice them into trapping many more furs than they could possibly use. Although all lives were disrupted, the Men felt the most pressure to change. The burden was too much for many of them to bear, and in desperation they would turn to alcohol. Then aggression.

And so it was that night. The more the Men talked, the more fearful grew the Women. In twos and threes they walked over to the Hearth to talk with the Men; however, they were ignored. "For the sake of our families, we *have* to do something *now*," stated the Women.

It was then that Nishime and Oshkeequay came up the Hill. "We are afraid," they said to their Mother as they cuddled close to her.

"I will be home shortly," said Makoons as she gave her Children a hug. "Go ahead and I'll see you there."

When Makoons got home, she got her Children ready for bed and tucked them in.

"Do not worry," she said, "I'm going to meet with the other Women in the Meadow just above the camp; so if you awake, you'll know that I'm not far away."

Makoon's words brought her Daughter no comfort; she could not sleep. "Why are the Women gathering on the Hilltop?" she asked herself. "I must know what they're going up there to do." She lay quietly in bed, listening intently to her Mother's movements.

After a short while, Makoons checked in to see if the Children were sleeping. Oshkeequay lay still with her eyes closed. "They're asleep," said Makoons to herself as she reached up for the Hoop Drum hanging on the wall and quietly tiptoed out into the night.

"Now it's safe for me to get up," thought Oshkeequay. She slipped into her clothes, carefully so as not to disturb her Brother, and followed her Mother's footsteps to the hilltop.

Like an old Wind moaning in the Pines, the wail of the Women drifted down through the

shadows to meet the young Girl as she made
her way up the trail. The power of that pleading
chant hit her as though it was coming from
deep within some immense, mournful creature.

Oshkeequay peered cautiously over the
crest of the Hill. "Every Woman in the camp
must be here!" she exclaimed. They stood in
a great Circle in the middle of the Meadow
with Drums held high and feet thumping. The
Women, with moonlight reflecting off of their
vibrating Drums, looked like a Circle of giant
Fireflies flashing to the rhythm of the chant. "I
will never forget this," whispered Oshkeequay to
herself.

The throbbing wail rolled down the Hill
and pounded its way through the commotion
surrounding the Hearth. One by one the Men
came to sober attention. "What is that?" said the
younger ones to one another. "I *have never* heard
anything like this!" The older Men grew quiet
and lost themselves in memories.

The eldest, one at a time, turned from the
Hearth and walked slowly back to their Lodges.
Eventually, and without a word, the younger
followed suit. By the time Shkode had burned
down to embers, there was not a single Man
remaining.

The Women came down from the Meadow
to find their Men asleep in their beds. Young
Oshkeequay snuck in after the Lodge was dark
and quiet, so she could be certain her Mother
was asleep.

"I'll say nothing," thought Makoons to
herself as she lay in her bedroll listening to her
Daughter trying to be quiet. "When I was her
age," she remembered, "I too stole out into
the night to watch the adults." In the *Old Way*
this was accepted, because observation and
experience were considered the best ways to
learn. And yet it was *quietly* accepted, because to
say anything would ruin the drama and intrigue
for the Children.

The next Sun, not a word was spoken about

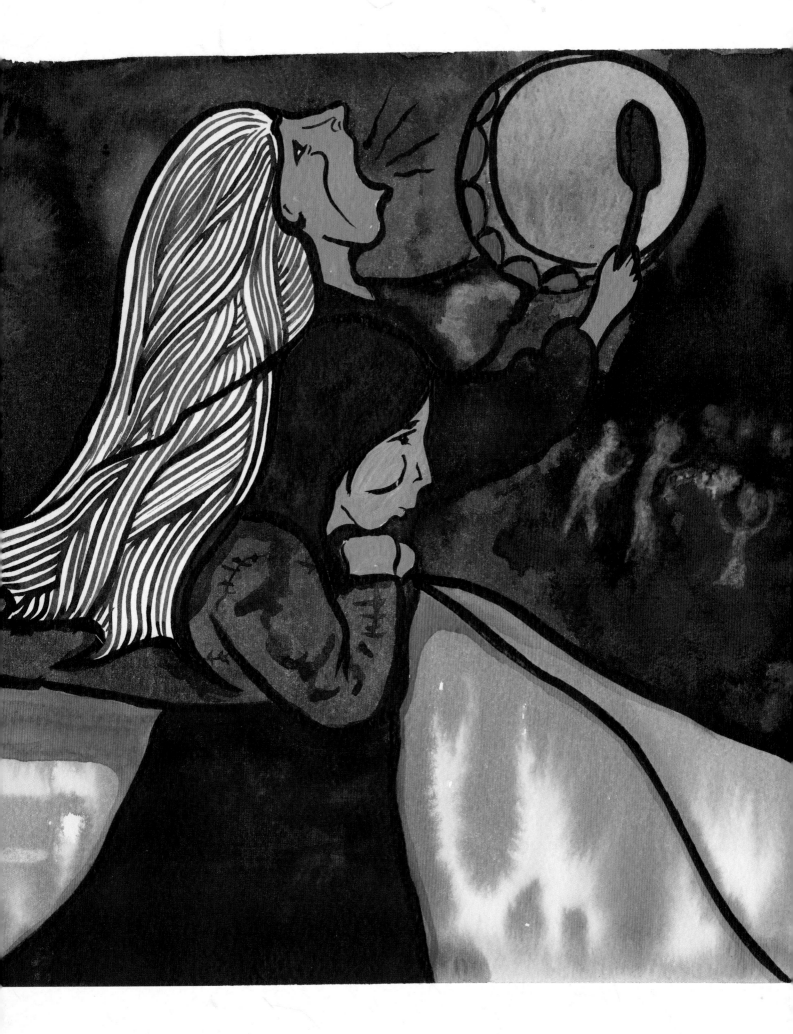

the events of the night before, nor was there another angry or vengeful word from the Men about the empty nets. "Look how fast we sunk into gossip and blaming," they said. "Perhaps our hearts were not clear enough to carry our *Song* of Honor and need to Geegoon Spirit, so she chose not to gift us."

That Sun marked the beginning of healing for the entire camp. No longer did the People see themselves as victims of a cruel, overriding power. Their renewed belief in who they were reflected in everything they said and did, and their sense of clan touched the hearts of many— even their former oppressors. In this nurturing environment, the young Oshkeequay grew up to become the wise and respected *Mashkikeekwe* (Healer) known as Keewaydinoquay (Woman-of-the-Northwest-Wind). She embraced the suffering of those who came to her from many different communities, and helped them find the beauty and *Medicine* within their own souls.

ORIGIN

ONE NIGHT AFTER AN EVENING meal at her wilderness camp, our dear Elder, Keewaydinoquay, shared some of her childhood memories with several of us who lingered around the Fire. In her version of "Sisters of the Moon," it was her Grandmother rather than her Mother who asked her to stay behind and go to sleep while the Women came together on the Hill. I made other changes as well while developing this story for telling.

After she finished the story, I remember her voice trailing off, and she had very little else to say. She seemed to have lost herself in memories of a far-off time, just like the older Men in the story after they heard the chanting. We each respectfully excused ourselves and left her with the spirit of her Grandmother and the vision of those noble Men and courageous Women who lived on in her memories.

The Scream That Stilled the Forest

THERE ONCE LIVED A WOMAN called *Nozhekwabkwe* (What She-Bear Sees), who was known by her *clan* mates as Nozhek. Like her Mother, who was a *Makwa dodem Mashkikeekwe* (Bear clan herbalist), Nozhek had a natural affinity for the Plant *People*. They gift food and healing herbs to the Humans, who learn the Plants' uses by watching what Makwa (Bear) eats. Besides similar diets, Makwa and Human both stand on their hind legs, climb Trees, and raise their young in a caring way. Nozhek's People considered Makwa to be their closest Animal *Relation*.

Nozhek felt deep love for a Man known as *Akwab* (Looks-Far), who was of *Ashageshin dodem* (Crayfish clan) and spent much time by the Water. Sometimes in the evening, Akwab would take his leave of the *Shkode* (Fire) Circle, and a short time later a plaintive song would come drifting down from the Hillside above the camp. If you didn't know it was Akwab playing his *Bibigwan* (Flute), you could easily think it was the sonata of an inspired Bird.

Nozhek and Akwab's love grew stronger, and one *Sun* in the season of the unfurling leaves, they were joined in ceremony. "Let us build our Lodge beside the upriver rapids," suggested Nozhek.

"It's a beautiful place," added Akwab, "and from there we could serve our People by catching *Geegoon* (Fish)."

In a short while, the pair was blessed with the Birth of a Daughter, who was given the child-name of *Inakakee* (Sees-Like-Frog). (When Inakakee came of age, she would assume an adult name.) "What a great name the Elder chose for her," commented Nozhek to her Mate. "Look at how she sits perfectly still with her eyes wide open, catching everything that goes on."

One Sun while checking their Geegoon traps, Nozhek and Akwab heard a series of frantic yelps coming from far up the rapids. The cries were so intense and piercing that not even the thrashing Water could drown them out. The pair dropped everything and listened intently, trying to figure out the source of the yelps, only they grew fainter and fainter and then stopped completely.

"I don't remember ever hearing anything quite like it," said Nozhek.

"If it weren't so far upstream, we might've been able to run and see. I fear that now we may never know," responded her Mate.

They looked at each other, shrugged their shoulders, and went back to pulling up traps.

145

Whispers of the Ancients

"Wha . . . " exclaimed Nozhek as she jumped with a start. She was in knee-deep Water and bent over a trap when something bumped her leg from behind. Dropping the Geegoon she had just grabbed, she spun around to see drifting beside her a *Ma'eengan* (Wolf) Pup, face down in the Water.

"Come quick, Akwab!" Nozhek shouted. "Those cries from upriver, I think I know where they came from."

She instinctively picked up the Pup and began to rub him. After a while, Akwab said, "Did you see that? His mouth quivered a little."

"He's not dead!" whispered Nozhek. She rubbed him more vigorously and pressed down on his chest to help him breathe. In no time he was coughing and wheezing, trying to catch his breath.

"Let me dry him with some soft Grasses," said Akwab. He did so and then handed the Pup back to Nozhek, who warmed him in the folds of her body. Soon he was whimpering as contentedly as though nothing had happened.

"Now what do we do?" asked Akwab.

"He's much too young to be on his own," replied Nozhek, "His eyes are barely open. Do you think his Mother will come for him?"

After some thought, Akwab responded, "Perhaps she was reluctant to leave the rest of her Pups to rescue this one, or I think we'd have seen her by now."

"What do you think happened?"

"I'm not sure," replied Akwab. "Mother Ma'eengan might've been moving her Pups across the Stream and slipped on a Rock. If she dropped this one, the current may have pulled him away faster than she could grab him."

"It may be that he has come to us because we're intended to caretake him," suggested Nozhek. "If that be so, let us raise him as one of our own, and I will nurse him. He's too young to eat and I have milk enough to share with both Inakakee and him."

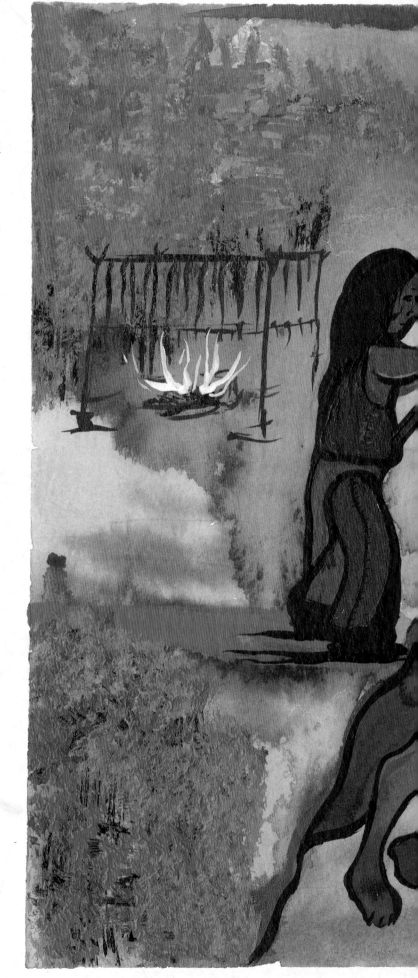

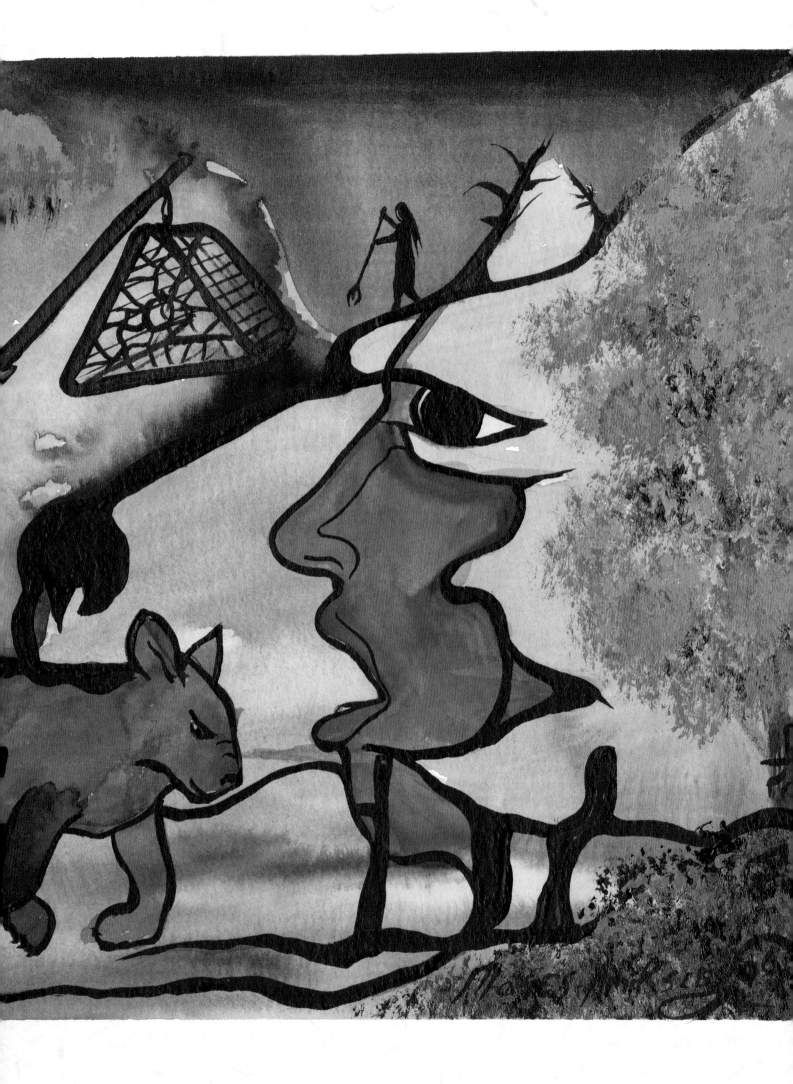

"Let us call him *Neemabik* (Rock-Dancer)," suggested Akwab, "in honor of his Mother and of the way he came to us."

The next turn of the seasons went peacefully, with both Pup and Babe growing robust and yearning to explore their expanding world. Much to Inakakee's delight, it was time for her to leave the *Dikinagan* (Cradleboard) and take her first steps.

"Look at how they play together, just like Sister and Brother," said Akwab to Nozhek early one Sun as they watched the young pair tumbling around in the Grass.

"They *are* Sister and Brother," replied Nozhek with a warm smile.

It was a bright morning in the Geegoon-Trapping *Moon* and Nozhek was just leaving to gather Nettle in the upstream Meadow. "I'll go down to check the trap in the rapids just below the Lodge," Akwab said. "Inakakee is sleeping in the furs at the back of the Lodge and Neemabik is standing guard outside the door, so they should be fine."

"Yes, they should," agreed Nozhek, and she and Akwab each went their separate ways.

Skirting the rapids, Akwab waded out to the trap and reached to open it. Just as he touched the hatch, an anguished scream shattered the morning calm. He froze in place, acutely alert, and a surge of hot energy flashed through his body.

"What could that possibly be?" he asked himself. His mind raced through a list of possibilities.

"No . . . No—it couldn't be!"

He raced up the bank and burst into the Lodge. Standing before him was Neemabik, with blood dripping from his mouth. Pushing past him, Akwab scrambled to the back of the Lodge, where he found his beloved Inakakee in front of a jumbled pile of furs. Her twisted body was gashed open and lying stone-still in a pool of blood.

148

Moses Amik S.1.B

Akwab spun around, grabbed his hunting club, and sent it crushing into the skull of Neemabik. Over and over he beat the Animal until his wrath was spent. The dazed Man then sunk to his knees, let the club fall from his hands, and numbly crawled over to face the horror before him.

As he reached to touch the Babe, he caught sight of two sets of bloodied tracks, one Neemabik's and the other much larger. "It's the great yellow *Mshibishi* (Cougar) who's been lurking around our camp," said Akwab to himself. Ragged looking and crippled with age, Mshibishi was no longer able to hunt. Feeling pity for him, the couple had allowed him to scavenge what meager meals he could from discarded bones and Geegoon scraps.

Akwab's eyes followed the Cat's bloody paw prints to the back of the Lodge, where they exited through a hole torn in the wall.

"Noooo," moaned Akwab, and his world went black. All he could see, over and over, was the story the tracks told him: a fierce but short battle, with Neemabik savagely tearing at the much larger Mshibishi, who was forced to drop the Babe's lifeless body and escape through the hole he made in the back wall.

The shattered Man stumbled outside, threw his fists to the Sky, and let out a wail that

shocked everything to mute stillness. Even the River was hushed.

Upriver, Nozhek heard the scream—it slammed through her like a peal of deafening thunder after a blinding lightning strike. She dropped her Basket and bolted for home. What shook her even more than the wail was the silence—the way all life froze and let her hear the voice of Death.

The fear that only a Mother could know roiled in her breast like the fiery core of a Volcano. Images flashed before her: a sleeping Babe swaddled in furs; a starving, yellow beast with swollen joints and broken teeth. "Not that!" she cried between panting breaths.

She reached the Lodge gasping so violently that she could hardly stand. There to meet her at the doorway was Neemabik, his body contorted and his head smashed to a bloody gruel.

Turning away from the piteous sight, she caught sight of someone sitting in the shadows beside the Lodge. "It can't be him," she exclaimed as she stared, transfixed. His hair was hacked off, his face was smeared with charcoal, and his chest bore two long slashes from which streams of blood ran to the ground. Staring out of an expressionless face were hollow eyes that could see only a pair of hands dripping blood from the self-inflicted gashes covering them.

"My dear Mate!" Nozhek cried out. She touched his cheek. He barely acknowledged her. "I must be strong!" she thought, "I *will* be strong—my family needs me."

She stepped over the slain Ma'eengan to enter the Lodge, her pounding heart throbbing like a Drum. For the second time that awful morning, a soul-rending wail rose like a tidal wave and crashed through the Forest, freezing all life in its tracks.

Precious Inakakee was laid to rest on soft furs in the *Passing-over* Lodge, and noble Neemabik was placed at her feet, just as they had been in life. Shkode was then touched

to the Lodge, and the flames carried the two siblings over to their Spirit Lodge, where they continued to dwell in the bliss of their sharing.

"Let us return to our People," said Akwab to Nozhek after the flames died to embers. "There we can retreat into mourning and perhaps find reason to live."

Their kin clothed them in old skins and fed them while they dwelled in sorrow for a full turn of the seasons.

In the final Suns of their grieving, Nozhek suggested, "Let us seek the counsel of the Elders. They say the *Gifting Way* is everywhere, in everything; maybe they can help us find some small blessing to walk with. Through a mindless act, we've heaped tragedy upon tragedy, which has left us with no children. Perhaps through our blindness we can find sight."

The Elders helped them see how jumping to conclusions closes us off from the truth, and how being ever questioning is the only path to truth.

Soon thereafter, Nozhek became heavy with Child, and a joy filled their lives that was even richer than when she and Akwab first came together. With their newly opened eyes and "Be as a question" as their motto, their family flourished, and their example inspired many to choose the way of truth.

ORIGIN

STORIES WITH THE TRUSTED-animal-kills-baby theme are found in many cultures, with a Norse version probably being the best known one involving a Wolf. Minnesota storyteller Kevin Strauss told me a medieval Welsh version, complete with knight and castle, where the falsely accused was a trusted old hunting Dog and the actual culprit was a Wolf.

I first heard a story with this theme from Nick Hockings, a cultural emissary for the Ojibwe People, who is from the Lac du Flambeau band of Wisconsin. He told the story in his *Ginoondawan* (Teaching Lodge) at *Waswagoning* (Place-to-Spear-Fish-by-Torchlight), a traditional camp that he and his wife Charlotte have re-created as a place for People to learn about the old ways of living. I am honored to have Nick and Char as friends, as they are People of clear spirit.

We in Western cultures are taught that in order to be successful, one needs to be definitive: make a decision, find a solution, choose a career, embrace a belief system. Our natural inclinations run contrary to this: they would have us remain ever open to new possibilities. "The Scream That Stilled the Forest" offers a doorway to exploring this dichotomy, which is why this legend is so cherished by me as a storyteller.

The legend opens with reference to the re-vered relationship we Humans have with Makwa (Bear), a kinship I have found with nearly all traditional People, past and present, who have been privileged to share domains with Makwa. "In many ways he is so much like a human that he is interesting to watch," said Ota K'te (Chief Luther Standing Bear), an Oglala Lakota from the 1800s. One of the reasons he offers is that "In the matter of food the bear eats everything that the Indian eats."[102] My Elders have told me that because we are so like Makwa, he can teach us which Plants to use for food and healing.

How to Put Nuts in a Basket

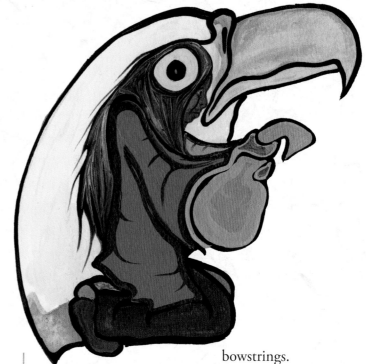

MESHKWADOONKWE (SHE-TRADES-for-Things) was a wise Elderwoman who People of all ages came to for guidance. They affectionately called her Meshkwad, and they would often stop by her Lodge and offer to help her with whatever they could, just to be in her presence. It seemed as though wisdom simply radiated from her, and her example inspired others even when she was involved in the most menial of tasks.

"*Biendigain! Biendigain!*" ("Come in! Come in!") she said to the young Man who stood outside her *Wigwam* (Lodge). Meshkwad could only see his legs, as Northcountry Wigwam doors are typically small and low to hold the heat. Still she knew, by the way he walked to the door and the style of his moccasins, who stood there. It was *Agawate* (He-Casts-a-Shadow), a young Man of *Nigig dodem* (Otter *clan*), to which they both belonged.

Agawate sat down beside the Elderwoman, laid a *Petition Pouch* before her, and joined her in making cordage from Milkweed fibers. They stripped the tough silken strands from the length of the stems, cleaned off the chaff, and braided the strands into a tough, durable twine. It would be used when the very best cordage was needed, which would be for traps, nets, and bowstrings.

They worked together for quite a while before Agawate said anything. This didn't surprise Meshkwad; she knew he'd need some time to gather his thoughts. He had only recently completed his *DreamQuest* and become an adult, so he was finding the world to be a different place than he had known in his younger years.

At length he spoke, "Wise Woman, *this Person* who is known as Agawate requests permission to ask a question which confuses him so much that he has trouble finding the right words for it."

"*Daga* (Please)," she responded. "I would be honored to receive your question, though I don't know that I'd have anything to offer in return."

"Meegwetch (Thank you)," said Agawate. "I thought I'd feel grown-up and know something more when I came to be an adult, and still I find myself so immature and confused. In fact, I sometimes think that I knew more as a Child. My life then was like the familiar colors of yellow, blue, and red. Now there are so many more shades and hues, and I do not understand them."

"I understand your confusion," replied Meshkwad. "It's not so strange to me because

I experienced it myself when I came into womanhood; however, before we talk any further, may I ask a favor of you?"

"Of course, Honored Elder," said Agawate.

"I'd like to pour some Walnuts from that big bag into this small *Makak* (Basket) so I can take them outside and husk them. As I pour, will you watch and tell me when the Makak is filled?"

Agawate signaled when the Makak was full, and Meshkwad set the bag down.

"Are you sure the Makak is full?" she asked.

"What?" thought Agawate. "Of course it's full, and yet one so wise must have good reason for asking the obvious." Rather than speak his confusion, he answered with a tentative "*Eya* (Yes), it is full."

"I wish to husk some Hazelnuts also," said Meshkwad. "I'll pour them from this other bag into the Makak; will you again tell me when it's full?"

Agawate watched the Elder gave the Makak a shake to help the Hazelnuts trickle into the spaces between the larger Walnuts. Before long, Hazelnuts were spilling over the brimming Makak onto the ground.

"My Grandson, you did not tell me when the Makak was full."

"I was confused . . . I . . . I wasn't paying attention," replied Agawate. "I was sure the Makak was already full, and then you filled it once more."

While picking up the spilled Hazelnuts, Agawate stated, "Now I'm quite certain the Makak is full, because even the spaces between the Walnuts are filled in. And look at the overflowed nuts lying all around the Makak— it has to be full!"

"I see," said the Woman. "Perhaps then I shouldn't add these Pine nuts; however, they've gotten damp and I'd very much like to spread them out in the Sun to dry so they'll not mold."

"I don't see how you could add them," responded Agawate.

The Makak ended up taking quite a few of the little nuts—they sifted down easily between the others.

"Aaaahhh!" exclaimed Agawate, "What magic! You've made full, empty; and empty, full! What I *thought* I saw, became an illusion right before my eyes. You have reminded me that looking is not necessarily seeing. Even though I was raised to say 'perhaps' or 'possibly not' instead of 'yes' or 'no,' I still sometimes forget."

"If you're like me, you'll likely forget again and again," responded Meshkwad. "This is intended, as each rite of passage: into youth, adolescence, adulthood, and Elderhood, opens a new door, giving us a vision of life different from what we knew."

"A wise Person you are," said Agawate. "And clever. I never learned so much from a pile of nuts! Why then, do I still sit in confusion? You are a magician: you made everything in the Makak work so smoothly. My life is not so simple, and I am not so clever as you."

"I don't think it's cleverness you lack," replied Meshkwad. "Let's look through the doorway . . . Imagine what would've happened if I had poured the Hazelnuts first into the Makak."

"There would be no room for the Walnuts."

"And if the Pine nuts went in first?"

"There would be no space for any other nuts."

"What if I didn't set the Makak in front of me before pouring?"

"There would be nuts all over the floor," responded Agawate.

"I do not understand why nothing would work as it had before," said Meshkwad with feigned seriousness. "Everything would be there just as it was the first time."

"Except for the proper sequence, Honored Elder. The nuts need to be in right relationship with each other, and with the Makak."

"Ha, I thought you said you weren't clever,

153

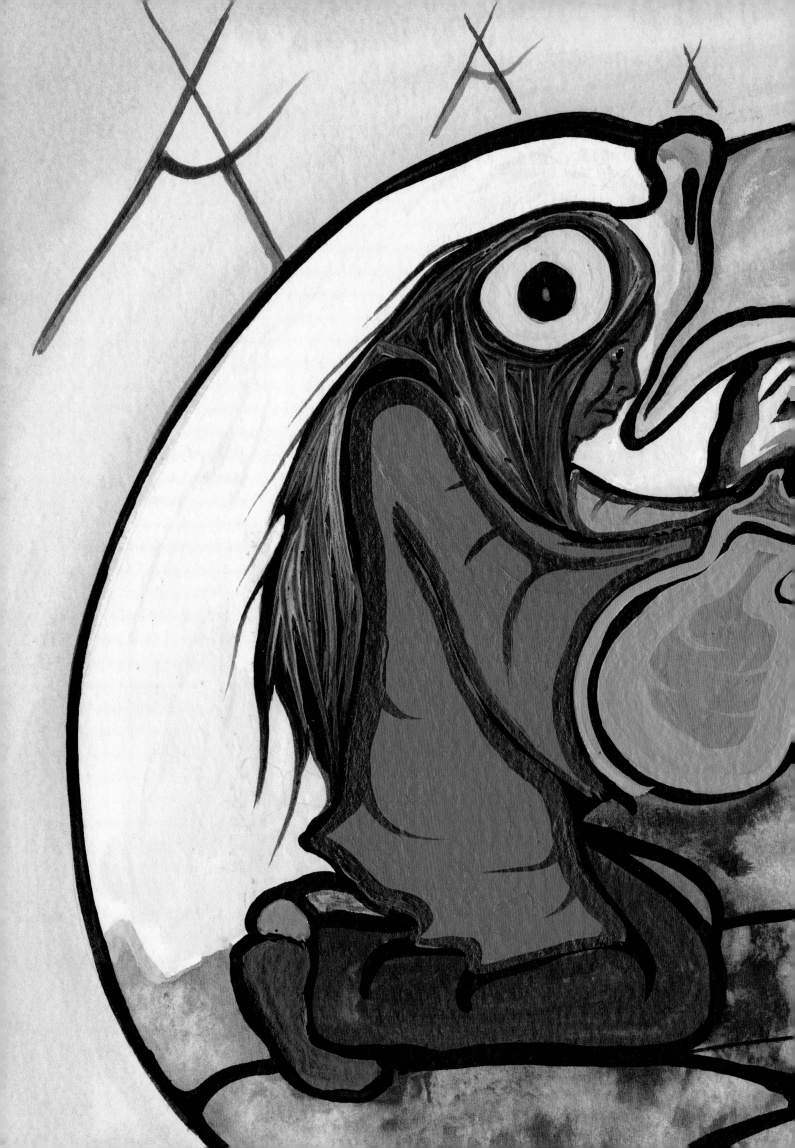

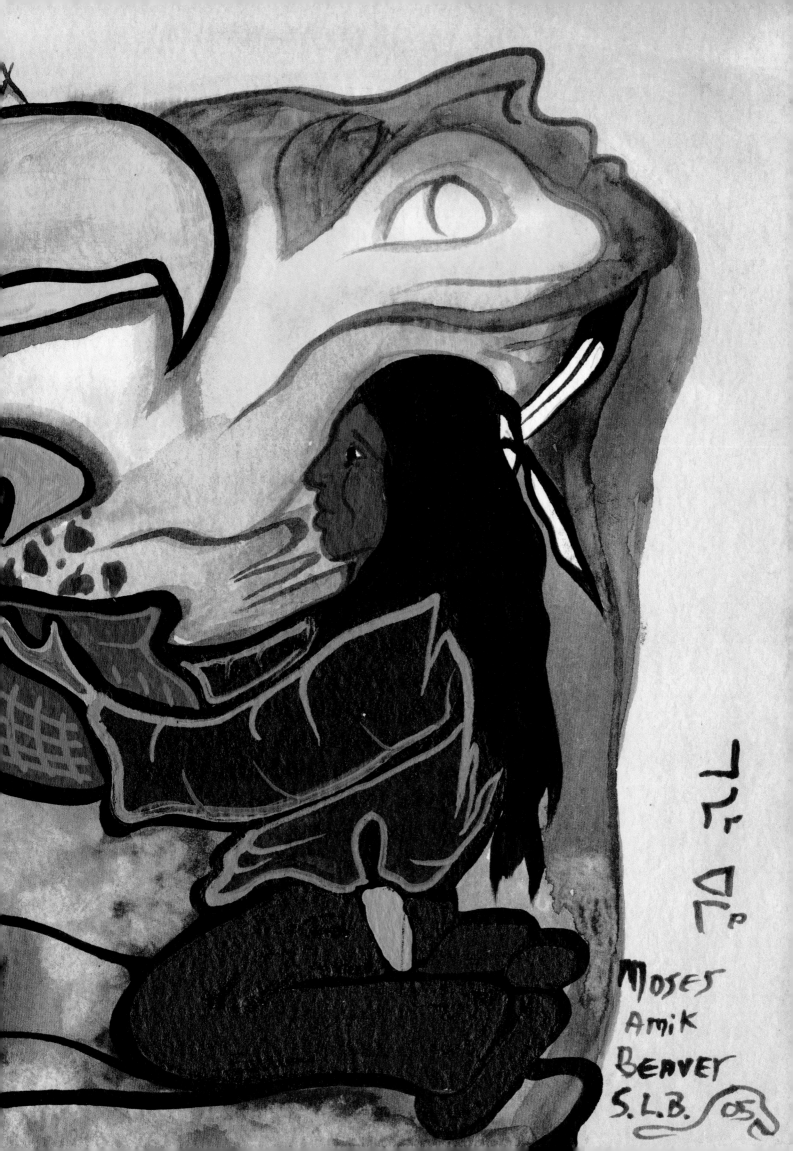

Moses
Amik
Beaver
S.L.B. 05

and here you know my magic! As with the nuts, what you need in order to simplify your life and have it go smoothly is to know and honor the sequence of relationship."

"Perhaps this is so," stated Agawate. "However, I'd still have to find, as with the nuts, the proper sequence of my relationships."

"I would suggest being as a question," replied Meshkwad, "because when we seek answers, we're only looking; however, when we question, we begin to see. We then go from pouring nuts to being aware of how nuts pour. Let us imagine that the Makak is you. Now who in your life would be the Walnuts: who would be your first, most essential, *Relation*?"

"That would be *Omakakee* (Frog), my *dodem* (Animal guide)."

"How about your second Relation: the Hazelnuts?"

"My sweet companion, *Dabazikwe* (Dodging-Woman)."

"And the Pine nuts?"

"My parents, I would think, along with my Sisters and Brothers . . . Aha, I see it clearly now: I need to honor my closest Relation first in order to be in *Balance* with my second Relation,

and so on, just like honoring the proper sequence of nuts!"

Brimming with self-satisfaction, the fledgling Man gave a grateful nod to the aged Woman who sat before him.

"Go now and walk your magic," she said, with a benevolent smile gracing her countenance. "This Woman is filled with joy to know that after she has *Passed-over*, there will be clansfolk like you to guide our Children's Children in the ways of relationship."

ORIGIN

AFTER I LEFT HOME, I struggled in virtually all of my personal relationships, whether they were with friends, siblings, People I met traveling, or even my Mate. It seemed that the less supportive a role my parents played in my life, the more complex and frustrating became my involvements with others. I needed help, and did not have anyone to turn to, so I went to the storyline and was given a guide in "How to Put Nuts in a Basket."

Immediately I connected with the universal metaphor of the wise Elder, because he had been personified in my life by my Father. He would guide me through the confusing times of my youth in much the same way that Meshkwadoonkwe did with Agawate.

This story exists in many versions, both contemporary and traditional. In fact, it may be the universal story with the most variants.

The Woman and the Talking Feathers

SOUTH OF HERE, on the banks of the great River that is born in the Mountains, stood a handsome *Bizhiki* (Buffalo)-robe Lodge. It was nestled in a grove of Cottonwoods and had a tiny sweetwater Stream flowing beside it. *Sagasige-Geezis* (Sun-Chaser), known to his People as Saga, and his Mate *Aneebeesh-Anamagon* (Snow-on-the-Leaves) dwelled there, along with their first Babe, whose name had not yet come.

On this particular *Sun*, Saga was at the riverside making a dugout *Jeeman* (Canoe) from a great Elder Cottonwood. He looked up from the *Shkode* (Fire) he was using to hollow out the log and noticed a Jeeman in the distance. He knew it came from the *Zhashagi* (Heron) *clan*, whose camp was about a half Sun's paddle upriver, because their Jeeman had a unique extended bow and stern platform on which you could stand while were spearing or pulling in nets. Like their clan guardian, Zhashagi, they ate many *Geegoon* (Fish).

Seeing Jeeman on the River was not uncommon, and yet something troubled Saga about this one. It was coming faster than usual, and as it got closer, he could see that the paddlers were pushing hard.

"*Aneen* (Greetings) Brothers!" hailed Saga as he waded out to get their attention. "Is there something I can help with?"

Realizing that they were already headed in his direction, he called for Aneebeesh, who was in the clearing beside the Lodge, cleaning Sunflower seeds.

The first one to step out of the Jeeman held a *Message Stick*, which told the couple that there was a serious matter at hand. In silence, they all walked up to the Lodge and sat around the outside Hearth, the place of social gathering. The Messenger was given the place of honor on the sunset side of the Hearth Circle.

After food was served, as was the custom with visitors, the Messenger spoke, "Aneebeesh, *this Person* respectfully asks that you listen with your heart to these words. Your blood Sister, *Neeganabi* (Sits-High), who we call Neega, is without Mate. *Babagine* (Cricket-Who-Runs) journeyed out on the Prairie four *Moons* ago to scout the whereabouts of Bizhiki, and we haven't seen him since. Not even our best hunters could follow his trail in the dry Grasses trampled by so many hooves. The only sign they found was his *Opwagan* (Pipe). We are afraid that he has gone on to another destiny."

"My heart goes out to your People," said Aneebeesh, "for Babagine was a good Man:

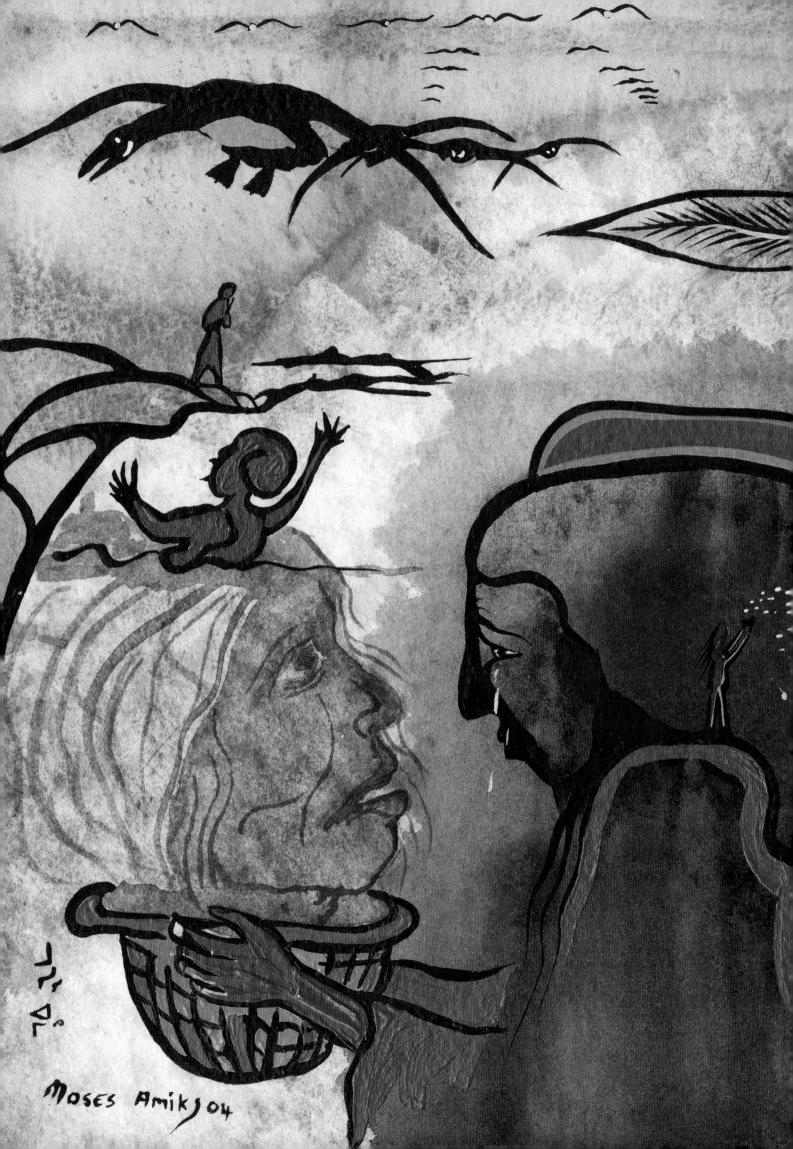

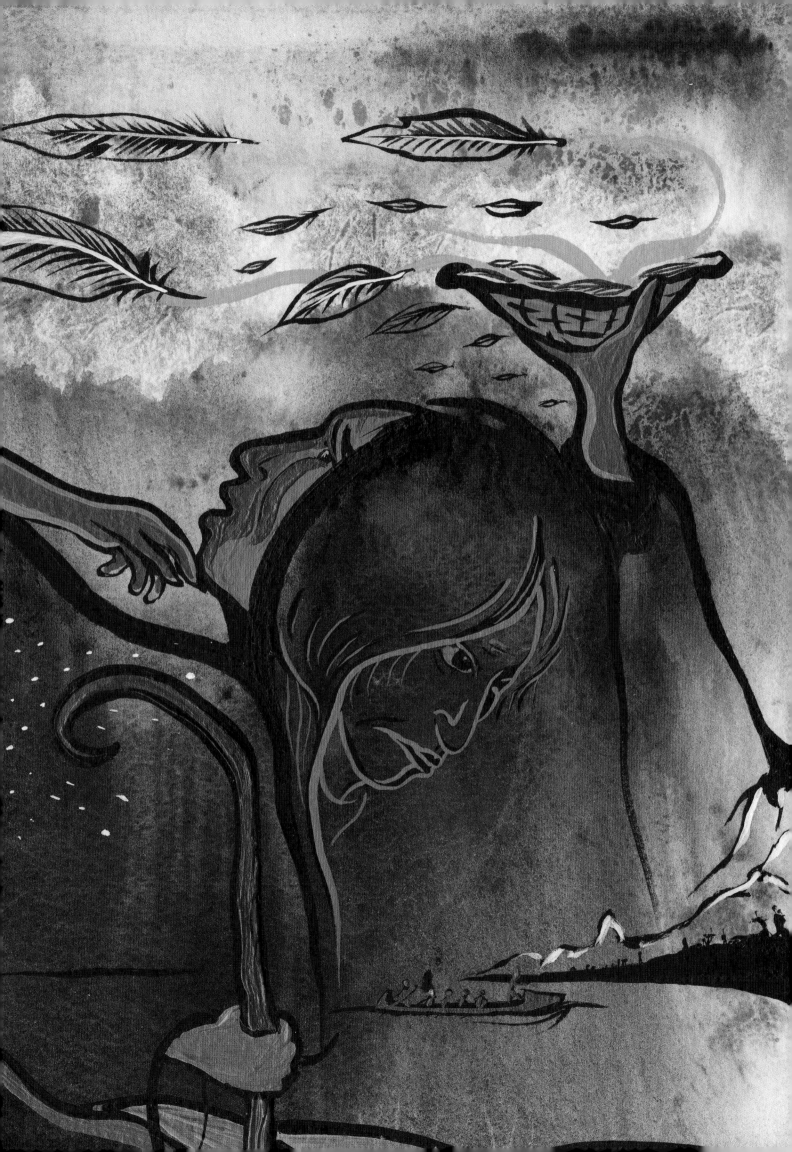

he served your clan well. And he cared for my Sister, Neega, as did she for him."

Aneebesh then turned to her Mate, Saga, and said, "Beloved Man, your eyes have smiled kindly upon me and our Child, and your hands are strong and giving. The Great Mother has provided well for us, and The Great Father has shone warmly upon us. I respectfully ask if you would take my Sister, Neega, as you have taken me. I would be honored if you would shelter her and bathe her in the beauty of your *Song*."

By asking Saga to bring her Sister, Neega, into their Lodge, Aneebeesh gave Saga great honor. To receive such a request means that you're viewed as being able to provide for others. And Saga surely was, as he was already helping clan mates who were either Elder or injured. For a *Native*, the clan is everything, and the well-being of each individual is the health of the clan. Thus it is common to take in the family members of one's Mate if they are in need.

And so, after Neega's time of mourning, the two Sisters and the Man came together as one Lodge. Life was good for them as they prepared for the coming of the Snows. Throughout the Moon of the Falling Leaves, they dried Geegoon, and in the Freezing-Over Moon that followed, they gathered wood and readied their Lodge and clothing for the gifting white blanket that was soon to come. The shared blood of the Sisters drew them all together, and the Babe grew plump in spirit on the nourishment of two Mothers.

"I'm looking forward to the White Season," said Neega. "All of our kin gather from afar, so it's a beautiful time of feasting and reconnection. I haven't seen many of them since last White Season, and it'll be great to again visit each other's camps and share stories around the warm *Wigwam* (Lodge) Shkode."

This was also a time of reflection and guidance. In the evening, the ancient teaching legends would be retold by the Elders. They

would recount the history of the People, in order that it remain alive in the *clan memory* and be passed down to the coming generations. The past turn of the seasons would be reflected upon, and stories of Hunts and Journeys would provide entertainment. This was also a fun way for the young to gain knowledge and learn about new places.

It was during that White Season that Neega started thinking to herself, "When other People are around, I am not always first with Saga, as I was with my Mate, Babagine. I don't feel this way when we're at our Lodge on the River, because there we are a Circle; however, when we're with other People, my face grows hot when someone says that Aneebeesh is Saga's Mate, or when Saga would smile at Aneebeesh rather than me."

There were a couple of others in the clan who were also struggling with their self-measure. A bitterness would catch in their throats, and they would not know how to get rid of it, so they would try to find others to pass it on to.

When no one else was around, they would go to Neega and whisper things like, "Do you know what Aneebeesh said about you to your Mother?" or "What do you think Aneebeesh would do if she knew all that Saga did on his Journey, before he came back to mate with her?"

Neega did not like tasting this bitterness and wanted to get rid of it. When her Sister, Aneebeesh, was gone, Neega would say to Saga things like, "I thought that Sister of mine was supposed to grind some Sunflower seed; where is it now when we need it?" and "I know all the Men who my Sister spent the night with while you were gone on your Journey."

In similar manner, Neega spread, up and down the River, rumors and tidbits of Saga and Aneebeesh's private life.

As the White Season lingered on, Aneebeesh would say to herself more and more, "Why are

People looking at me so strangely, and why do they not talk as kindly with me as they once did? And my Mate isn't as warm and trusting as usual. Why . . . ?"

A wall grew between Aneebesh and Saga, which transformed their formerly blissful life into no more than a numb existence. Aneebeesh grew withdrawn and despondent, her Child becoming the only reason she got out of bed.

One Sun when the Waters were high from the melting of the Snows, Saga and the Sisters decided to take some extra Geegoon to their kin down River. It was a warm, bright afternoon, the buds of the Cottonwoods were exploding, and the Geegoon were moving into the shallows to spawn, making them easy to catch. "I'm not needed to paddle," said Neega, "Why don't you two go, and I'll stay here. The Child can stay with me, and we will enjoy the Sun together." Neega was looking forward to the break, as the air was charged with tension when the three of them were together.

After Saga and Aneebesh left, Neega and the Child, who was now out of his *Dikinagan* (Cradleboard) and learning to walk, went down to the River to watch the returning Geese. Before she knew it, the Babe slipped on a wet Rock, tumbled into the Water, and was being whisked down the River.

"Let him go," Neega mumbled under her breath. "Wha . . . what did I just say?" she stammered as she quickly came to realize what was happening. Her cheeks were afire as she rushed into the Water to grab the Babe, but her delay—just for that vengeful instant—was too long. The Child was gone.

Neega stood there in the shallows, as stone-still as a Cottonwood stump. The Water chilled her to the bone, and yet she could do nothing but stare blankly out over the River. The only signs of life left in the Woman were the warm tears finding their way down her face.

As the damp darkness came in to lie over the Water, Neega's numbness lifted enough that she could drag herself up the bank and start a small Shkode. With no further show of emotion, she hacked off her hair with a sharp Rock, burned it along with her clothing, and rubbed the ashes into her skin. Clothed only in ash, she walked through the frigid night to reach the Lodge of the revered Elder, *Miskwadesi Beejimag* (Fragrant-Turtle), who lived with a Sister clan down the River.

"My intolerance and ungratefulness have caused great tragedy," she blurted out upon greeting the Elder. "I was too full of myself to realize that I am my Circle, and that everything within my Circle is also a part of me."

In a bleak, monotone voice, Neega went on to describe all that had happened since her Mate, Babagine, had disappeared.

When she finished, she and Beejimag sat together in quiet reflection.

After a while, Beejimag turned to Neega and looked straight through her. She squirmed with discomfort, and yet she was so transfixed by his gaze that she gave him her full attention.

"Tomorrow," spoke the Elder, "go ask the

River for one of her *Zheesheeb* (Ducks). Pluck all the Feathers, put them into a Basket, and take them to the top of the high Bluff overlooking the Prairie. When a gust of Wind comes along, empty the Basket and let the Wind carry the Feathers wherever she will. After a while, go and gather each Feather back up into the Basket, and come back to me only after you've recovered every last one."

A full Moon passed, and then another. Finally, Neega appeared before the Lodge of Beejimag. With cheeks sunken and eyes glazed over like those of a dead Geegoon, she held out the Basket. It contained some Feathers, but not nearly all of them. Here are her words to Beejimag:

Honored *Mishomis* (Grandfather), I have searched until my feet left tracks of blood, and still I couldn't find all the Feathers. My constant misery became my mirror, haunting me, forcing me to face my wretched self. I realized that the Zheesheeb I snared was actually me. I got caught in my own noose of envy, and the Feathers that I plucked from myself were gossip, which I scattered on the Wind of my intolerance. They had traveled farther than I could ever have imagined—I couldn't begin to find them all!

And yet each Feather that I did find, spoke to me, telling me what harm it had done. Their stories were all the same. 'We drifted deep into the recesses of People's souls,' they would say, 'where we made them strike out with stinging words on bitter breath. Then we rode the next foul breeze to another, and then another . . . '

My deepest sadness, Mishomis, is that some of the Feathers were so bent on causing misery that no matter what I did, I could not tear them from the souls they had possessed. Even if all the hurt could have been retrieved, I couldn't have carried it back. The burden would've been more than any ten Women could bear.

Now here I stand, gaunt and naked like a plucked Zheesheeb, holding my shame before me in this Basket. Why could I not have spoken my truth—the simple pain in my heart—rather than spitting venom like a mad Snake?

ORIGIN

THIS LEGEND WAS GIFTED to me by my Mate, Lety, who remembers hearing it as a child from the Elderwomen of her family. They are Maya–Olmec–Mixtec–Popoluca Indians from the Mexican state of Veracruz, and they believe the story's origin to be Mayan.

In the family version of the story, the Person is instructed to go to a hilltop on a windy day and tear open a feather pillow. I recast the story in a traditional setting, so that it might more resemble its original form (most teaching stories embrace universal themes and have ancient roots). I also developed the personality of gossip in the story so that it could serve as a potent example in my truthspeaking workshops.

Chapter Twelve

The Journey Called Life

IN WALKING OUR GIVEN *LIFEPATHS*, we pass through major transitions as we enter states of life such as puberty, marriage, and Death. The ritualized commemorations of these times are generally referred to as rites of passage. Along with celebrating the milestones reached, these rites act as gateways to our future. Stories, ritual enactments, and visionary experiences paint a picture of what life is intended to be like after the transition. They also provide the guidance and support to help manifest it.

Stories like these in this section help people of traditional societies prepare for rites of passage. Some stories instill courage in facing the coming life changes; others complement the rites by acting as metaphors to help individuals become more intimately involved in the transition.

Many civilized cultures give rites of passage only token attention, with some rites not being observed at all. (Relevant puberty rites, for example, are conspicuously missing from most Western cultures.) The consequence is that the majority of us go through life without feeling fully involved in it. Additionally, we often feel victimized by our own life changes. We might end up struggling with issues of self-esteem and life purpose. This chapter's stories are intended to awaken us to the need for self-awareness and change. The characters and situations are designed to strike sympathetic chords that can help us see ourselves differently. These stories can also offer encouragement to those of us resisting the life transitions we are approaching.

Whether or not the particular life transition in a story is the one we are approaching does not matter: fear is fear, no matter when, where, or how we meet it; and disconnectedness is disconnectedness, whatever the cause. These imposing walls will crumble before stories of the type found in this chapter, because their clear symbols and gripping metaphors have the power to reach the vibrant life lurking behind mere existence.

The Grandfather and the Stone Canoe

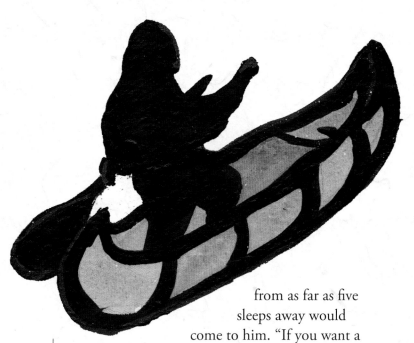

MANY TURNS OF THE SEASONS ago, and long before the People of the Northern Lakes knew the *Wabishkeewed* (European) traders and missionaries, there was a camp of the *Ginoozhe dodem* (Pike *clan*) People located along the sunrise shore of an amber-colored Lake known as *Migizigami* (Eagle Lake). The clan chose the east shore because the westerly breezes kept it cool and free of Mosquitoes.

In the camp lived an Elder who had seen so many Winters that no one alive could remember his Birth, or even his childhood. He was revered by all and especially loved by the Children. Having no offspring of his own, he was yet called *Mishomis* (Grandfather), because it was the way of the People to collectively parent and grandparent all of the Children. *Wawashkeshi* (Deer) was Mishomis's personal dodem, which was one reason he was so cherished. Those of Wawashkeshi dodem were known to be gentle and peace loving.

Back in the time of those *Suns*, a *Jeeman* (Canoe) was highly valued, as it was the main mode of transportation on the easy-to-travel Water trails that spanned the countless interconnected Lakes and Rivers. Mishomis was such a renowned craftsman that People

from as far as five sleeps away would come to him. "If you want a quality Jeeman," they would say, "see the Elder craftsman on Migizigami."

However, it was a time of change for Mishomis. "We've noticed," some of his clan mates were saying, "that with each new turn of the seasons, he seems less connected with life. He has lived well, so he's still vibrant and in good health, and yet it looks as though his time of *Passing-over* grows near."

At the same time, Mishomis was saying to himself, "I would like to prepare for this, my last rite of passage. The trouble is I've been given no sign, no message, so I don't know where to begin."

One night in a dream, the Seven Ancestors who dwell as Stars in the Sky Realm came to Mishomis. "This is impossible!" he said to himself in his dream, and yet there they sat, in a Circle around his *Shkode* (Fire). He caught his breath, rose from his sleeping furs, and greeted them with these words:

"*This Person* is deeply honored that you have chosen his Hearth for warmth on this frosty night. He does not know why his *Wigwam* (Lodge) would be blessed with such a grand visit, and yet he graciously welcomes the Wise Ones from the Long-ago who are the keepers of our heritage."

Mishomis reached for his sacred *Opwagan*

(Pipe), which he kept in a *Nigig* (Otter) fur pouch hanging above his sleeping area. Carefully slipping Bowl and Stem out of the pouch, he set them down on a special fur and sprinkled them with *Kinnikinick* (an aromatic herbal blend) in preparation for the Opwagan Ceremony. Reverently inserting the Stem (the phallus) into the Bowl (the womb), he consummated the union of the two primary forces of creation that gave Opwagan its power to heal and bring *Balance*.

He handed Opwagan to the Ancestor on his left, who placed a pinch of his own Kinnikinick into the Bowl. Each Ancestor did the same until Opwagan came back around to Mishomis. He added a pinch of his own Kinnikinick, tamped down the contents of the Bowl, and again handed Opwagan to the Ancient One on his left.

In order to light Opwagan, a flame was needed from a sacred Shkode started just for this purpose. Mishomis pulled out his Shkode-making kit and quickly had a burning stick, which he held before the Bowl. The Ancestor who held Opwagan drew in his breath to pull the spark of life into the fertile Kinnikinick nestled in the Bowl.

Each Ancestor took one puff, sent the smoke Skyward, and passed Opwagan on to the next. When Opwagan went completely around, all in the Circle were joined as one in spirit and purpose. Their smoke, which came from the same life-spark drawn through their combined Kinnikinick, rose above them as their united voice to *Bimadiziwen* (*Circle of Life*).

In gratefulness for the gifts the Seven Directions so generously bestowed upon the People, Mishomis blew fragrant smoke first to *Wabanong* (East), and then to *Zhawanong* (South), followed by *Ningabee'an* (West), *Geewaedinong* (North), *Wegimind-Aki* (Mother-Earth), *Ishpiming* (Sky), and finally *Anishinabeg* (Direction Within).

He held Opwagan before him, with the Bowl cupped in his hand. Its warmth penetrated his being, bringing him a flood of memories from a lifetime of gifts granted by the Directions. Quiet tears were given stories by his smile as they tracked down the lines of his face.

Kneeling beside Shkode, he cleaned the Bowl and cast the ash into the flames. Just as ceremoniously as he had assembled Opwagan, he separated Stem from Bowl and returned them to their pouch. He then resumed his place in the Circle with the Ancestors, and everyone in unison said, "*Aho* (It is finished)" to conclude the ceremony and break the sacred silence.

"Revered Ancestors," said Mishomis, "this Person would be deeply honored if you would join him in a Feast of Thanks-giving for the blessings we've been given." Such a Feast after a ceremony was the tradition of Mishomis's People. He offered his guests boiled Wawashkeshi *weeyas* (meat), roasted *Zhigagawanzh* (Onions), and dried *Miskomin* (Raspberries).

Just as they finished eating, Mishomis heard a voice that seemed to come out of nowhere. "It must be one of the Ancestors," he thought. He studied their faces, but still he couldn't tell if one of them was speaking are not. "I'm quite certain it's coming from inside the Lodge," he mused, "and yet it seems to be echoing from far away . . . " The eeriness of the situation sent a chill up his spine, and at the same time he found himself mesmerized by the majestic tone of the voice. He could do nothing but listen in rapt attention.

"Mishomis, you have served well," the voice began. "In sharing your *Medicine* with your People, you've given to *all* the People. Soon you will be *Passing-over* from the realm of the living to a place of honor where even those who come long after the *Seventh Generation* will know your *Gifting Ways* and learn from them."

"This makes no sense to me," thought Mishomis, and yet he respectfully listened.

The voice continued, "We have come to instruct you in how to make a special Jeeman to

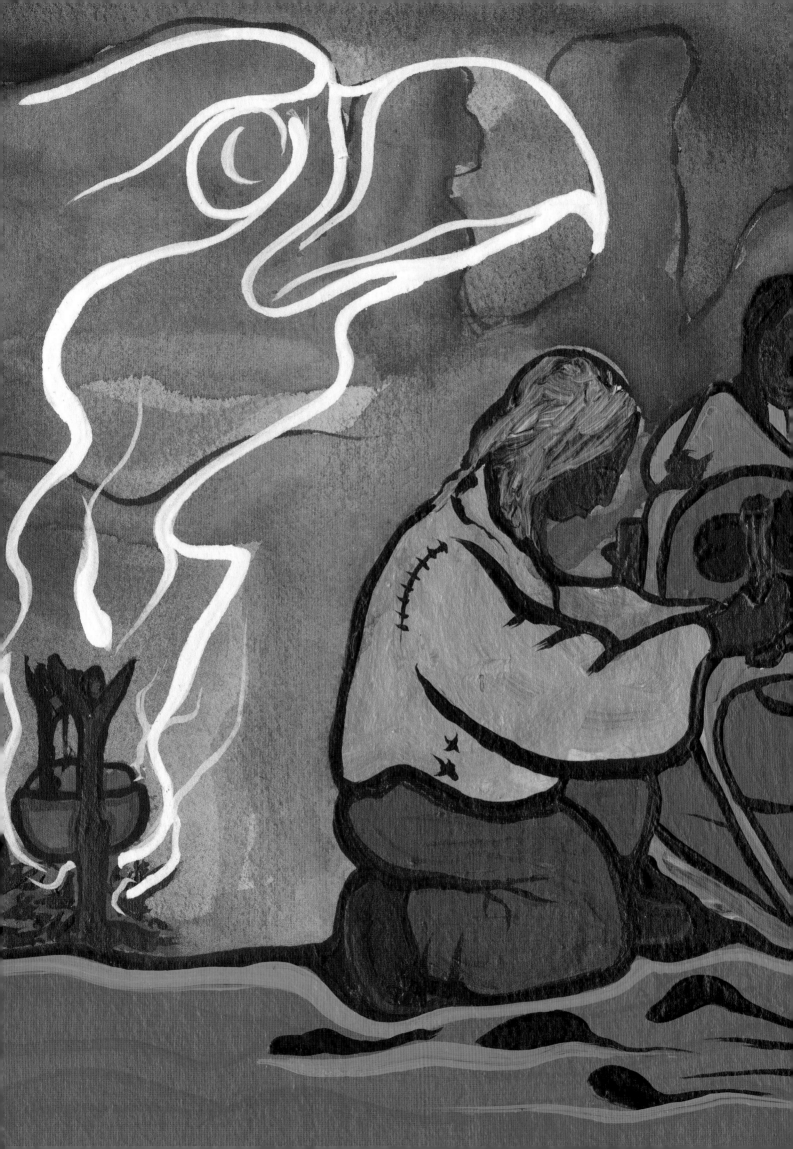

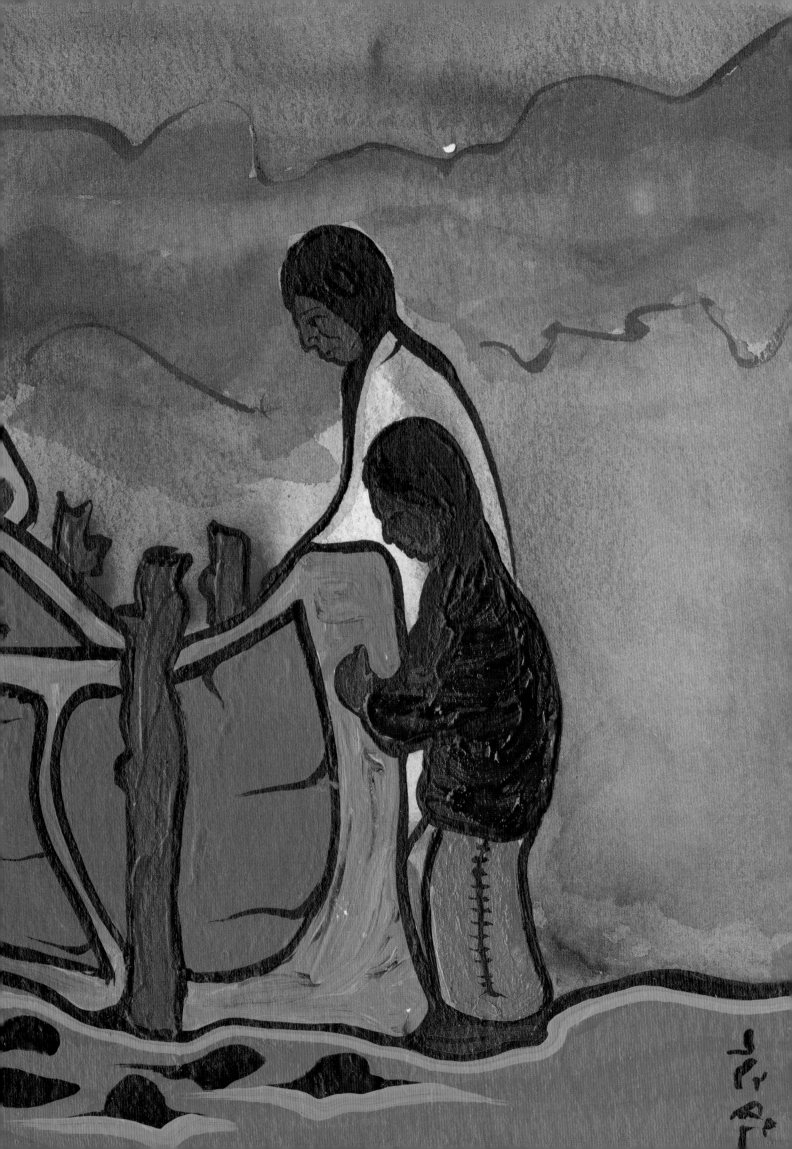

carry you on this, the last step of your life Journey. Carve it out of the great granite Boulder that you'll find at the base of the Cliff along the Lake. A nearby Ash Tree who has been cut down by *Amik* (Beaver) will gift you wood for your Paddle. On the handle, carve the symbols you find etched on this piece of *Weegwas* (Birch bark) we lay here before you."

"Wha . . . Where are . . . ?" blurted Mishomis as his eyes darted around the Lodge. "The Ancient Ones, they're gone! But . . . but . . . they were just here! Or was it all just a dream?"

"Wait, what is this?" he exclaimed as he turned over the small panel of Weegwas lying before the cold Hearth. "They *were* here; it *did* happen!" He ran his fingers over the etchings to assure himself that they weren't just an illusion, and then he jumped up to check his food stores. The Miskomin, Zhigagawanzh, and Wawashkeshi weeyas were gone.

The Elder craftsman immediately set to work. "I barely have the strength to carve the Stone," he sighed, "and my tools quickly wear down." Even though progress was slow, he was able to keep on, as he was yet strong of body. And most importantly, he was inspired.

Usually his kinfolk would pay him little heed, as they were used to him being absorbed in his craft. This time was different: he was hacking away at a big Stone, of all things, *and* he claimed to be making a Jeeman out of it!

"Is that for someone with Rocks in his head?" snickered one young Man.

"I bet it's for someone with a heart of Stone," wisecracked his friend as they both walked away laughing.

The old craftsman felt terribly alone. He had not told anyone about his visit from the Seven Ancestors of the Sky Realm. It would not have been appropriate, because to share a *Lifedream* risks giving away its power. And yet, the support and understanding of one's People would normally be there. In the *Old Way*, someone's personal path is honored, whether or not it's understood or agreed with.

"They are young," Mishomis thought of his ridiculers. "They have much time yet to learn the ways of honor and respect. And yet I wonder . . . they might be bringing me guidance! Perhaps it is intended that I have time alone to prepare, as my time here is soon over. Yes, it would be good for me to be in the company of my feelings and memories. When I am ridiculed a fourth time, I will leave the camp and stay alone with my Jeeman."

Already the next Sun, Mishomis was jeered for the fourth time, so he collected his few possessions and left the camp under cover of darkness. As he built himself a small Lean-to at the base of the Cliff, he told himself, "Now that I am with my sacred project, I'll be in good company."

Little did he realize what "good company" would mean. The Children, his constant companions, continued coming to visit their beloved Mishomis. They believed in him because they knew his kind of magic. Like Mishomis, they had not lost their natural sense of wonder or their ability to see beyond the visible. "We can look out on the Water and already see you paddling your Jeeman," they would say. "Will you give us a ride?"

While Mishomis worked, he would paint word-pictures for the Children, who were easily mesmerized by this sparkly eyed man. He'd describe to them the ways of the Animals and recount the great Hunts of old, and they never ceased to be enthralled. Sometimes he'd tell them stories of his youthful adventures, and even a few about when their own parents and

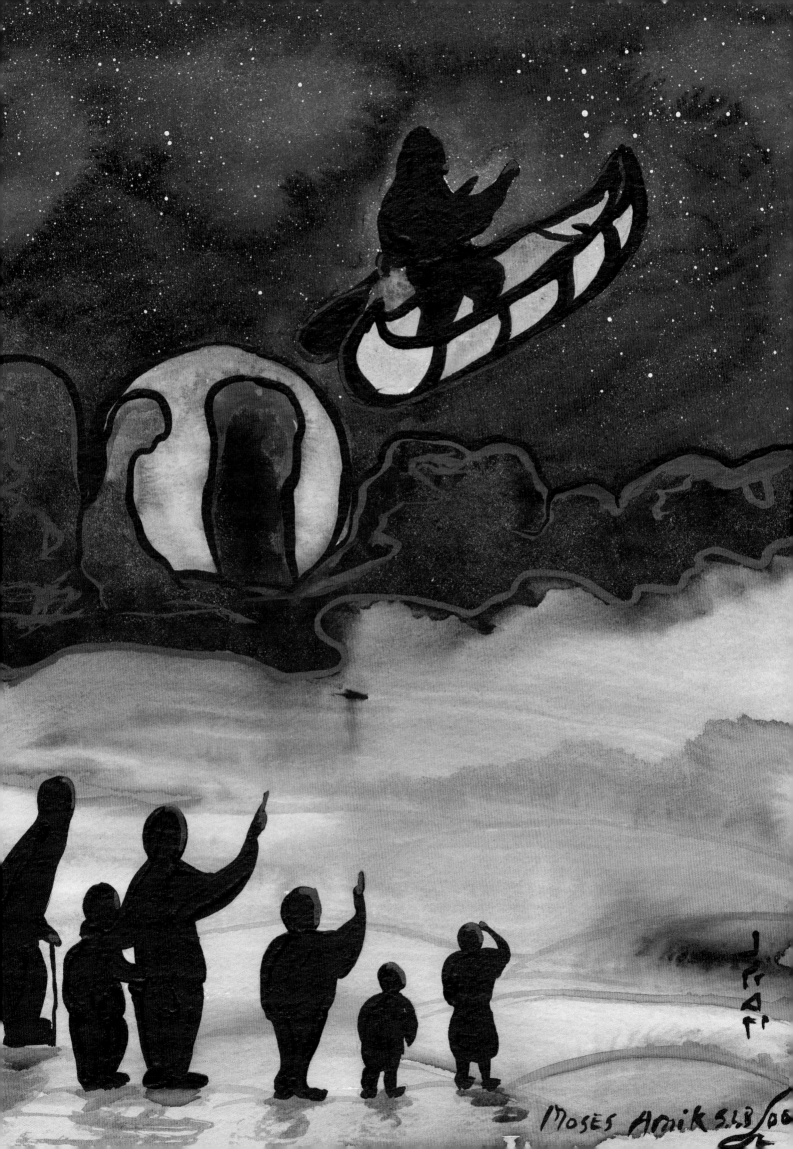

Moses Amik S.L.B '06

grandparents were young. These were the ones the Children liked the most.

The Green Season came and went and it was now the *Moon* of the Falling Leaves, which heralded the start of the White Season. Mishomis had worked diligently and happily nearly every Sun since his visit from the Ancestors, and the Jeeman was finally completed. "Tonight when Moon breaks over the top of the Cliff," he told the Children as they left for the evening meal, "it will be time for me to leave on my final Journey."

Right after the Little Ones finished eating, they raced down to the Cliff to bid their kind storyteller farewell. The adults snuck down one-by-one, staying in the shadows to hide their curiosity.

As the full Moon crested the Cliff, the tired yet serene Elder stepped slowly and purposefully into his Jeeman, who sparkled in the moonlight as though she was bedecked in jewels. The splendor of the sight made it obvious to everyone that all along something special had been unfolding before their blinded eyes.

"Follow your heartsong," were the last words the loving Elder had for the dear Young Ones gathered around him. He then looked up and saw his kin, who had come out of the shadows, and he gave them a smile that embraced their hearts.

Without delay, he picked up the *Medicine* Paddle, dug it into the rich evening air, and sailed off into the night Sky. The whole camp watched in awe as he paddled higher and higher, until all that could be seen was a sparkle among the evening Stars.

Warmhearted Mishomis of Wawashkeshi dodem can still be seen up there in the night Sky where he dwells with the Ancestors. They honored him and his gracious ways by having him become the constellation known to the People of the Northern Lakes as *Mishomis ig Asini-Jeeman* (The Grandfather-and-the-Stone-Canoe). Some swear they can see the kindly twinkle in his eyes. He is there to ever remind us that Elders speak from a place of wisdom that rests in the bosom of the Ancestors.

Ever since Mishomis went to dwell in the Sky Realm, the People have striven to follow the example of considerate, respectful relationship that he and his Grandchildren practiced. Everyone returned to listening diligently to the counsel of their Elders. At Feasts, Elders were again honored by being served first, and they were given the place of honor in Lodges, Circles, and ceremonies.

ORIGIN

LATE ONE NIGHT in the sticky heat of the Blackberry Moon (late Summer, when the Blackberries ripen), a small group of Seekers stood under the Stars with Keewaydinoquay on her wilderness Island retreat. As she told the story of "The Grandfather and the Stone Canoe," I closed my eyes and became one of the Ancestors in Mishomis's Lodge, and then one of the Children watching Mishomis work, and then one of the criticizing adults. I was then the Elder himself, crafting my last Canoe, and finally paddling up to my new home with the Stars. When the story ended, I looked up, and there I—or rather he—was with his boat and paddle, just as glittering as in the story. I think I might even have seen his twinkling eyes.

If I had to choose a legend that had the most impact on who I am and how I walk my life's Journey, this would be the one. Nokomis (Grandmother) Keewaydinoquay, esteemed guide and inspiration, you will live on in my heart as long as I am alive to embrace this story.

Raccoon Helps Fox Find His Hunger

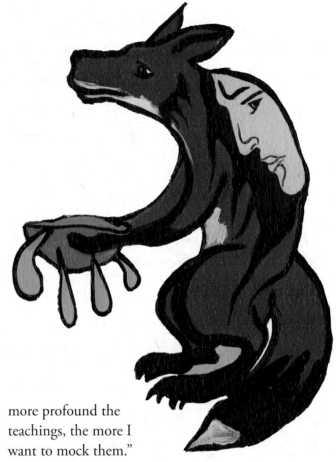

WAGOSH (FOX) WAS YOUNG and full of vigor, though he was not content. "Even though I am now tall as an adult," he said to himself, "I do not feel like one, because I do not know the world. Perhaps I should go on a *Journey of Discovery*, so that I can take the teachings from my youth and test them out. I'm anxious to meet other People and learn new ways, and then I can gift my *clan* when I return."

Wagosh set out the next *Sun*, wandering up Hills, through Swamps, and down Rivers. Over nearly every ridge and around nearly every bend, he'd meet another of his *Relations*. One afternoon he lay in the Sun with *Asabikeshin* (Spider), who was patiently watching for *Oojeeg* (Flies) to pounce upon. Another time he waited out the Rain under a Rock overhang with *Gag* (Porcupine). During a storm he climbed high in a *Mitig* (Tree) to be with the Wind and Rain.

"My Journey has taken me far," said Wagosh one Sun, "and I have seen many wonders, yet I feel empty inside, as though life is running out of me faster than I can drink it in. What is the use of going on?" he said to himself. "The more I live, the less I feel alive; the more beauty before me, the more numb I become to it; the more profound the teachings, the more I want to mock them."

Just then a familiar odor tickled his nose, which he realized was coming from the direction of a huge Willow growing on the bank of a nearby Stream. Curious, he walked up to the Tree and caught sight of some familiar-looking scat on top of a large fallen limb. "Ah," he exclaimed, "my elder Sister, *Esiban* (Raccoon), dwells in the hollow of this Tree. She is both wise and clever; I will ask if she could help me to be alive."

Wagosh knew that *Ashageshin* (Crayfish) was one of Esiban's favorite foods, so he waded into the Stream and caught one as a *Petition Offering*.

"Honored Sister," he began, "*this Person* before you is on his Journey of Discovery. He comes from a far place and has experienced much between there and here. Still, he feels that he has learned very little. He humbly asks if you would guide him in the ways of appeasing the hunger of one who has grown up and yet is so small inside."

"This Person would consider it an honor to feed you, for you are my younger Brother,"

171

responded Esiban as she stirred the steaming pot of stew before her. She motioned for Wagosh to hold out his Bowl so she could serve him.

"Does my masked Sister not understand me?" wondered Wagosh. "The hunger I speak of is not in my belly." However, the weary journeyer had belly hunger as well, so he kept his confusion to himself and held out his Bowl, grateful for the opportunity to partake of such savory fare.

Esiban filled the Bowl, and then added another scoop, and yet another, until scalding stew overflowed onto Wagosh's hands, dribbled down the fur of his belly, and splattered over the ground.

"*What* is going on?" a wide-eyed Wagosh almost blurted out. He was thankful that he caught himself, for after all, he was a guest and it would be disrespectful to say something contrary to his host's customs, no matter how odd they might seem.

Nevertheless, after another spill burned his hands, he had to speak: "Kind Esiban, you are a most generous host and this Person is grateful for your desire to serve him more. Only it seems that his Bowl is full and the extra you give him spills out on the ground. He respectfully asks why you keep serving him."

The elder Sister set down her serving spoon, looked into the young Man's eyes, and softly spoke these words:

So you might come to realize that you held out a Bowl already full. And it appears it has been full for a while. Neither I nor another can give a Person anything when they are so full of themselves.

Through the quiet that comes with practicing honor and respect, one might draw nearer to knowing the hunger of an empty self. You came finally to me not because I was the only one with food, but because you did not have the vision that true hunger brings,

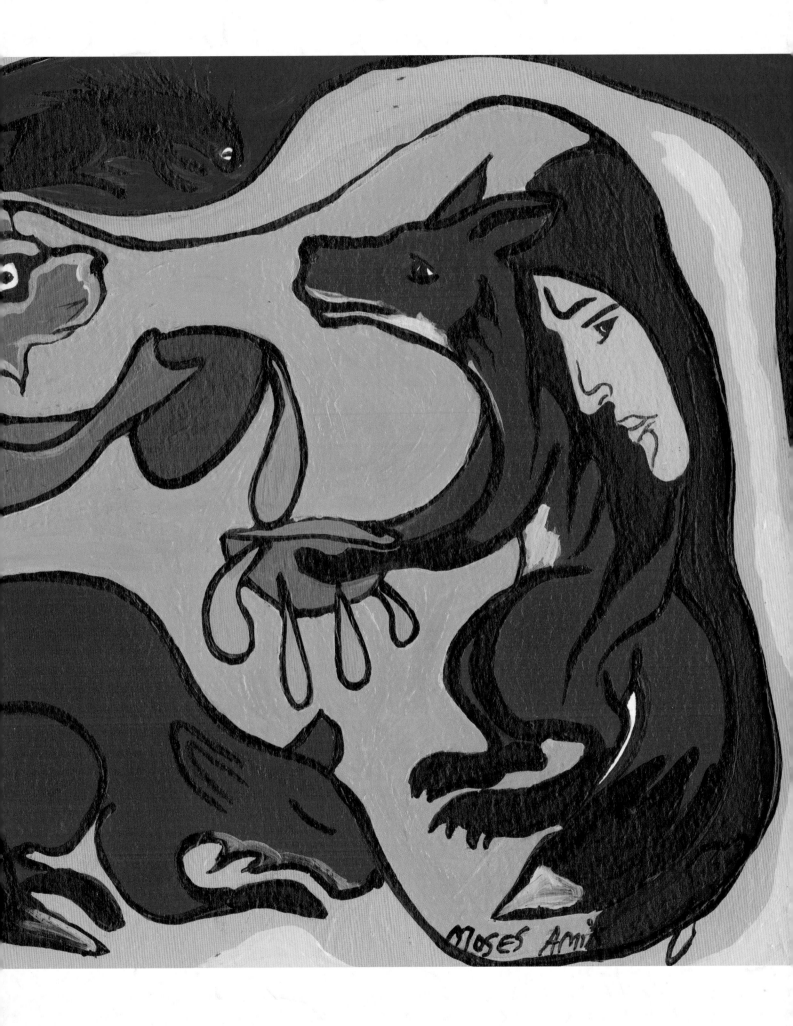

or you would've recognized the brimming pot that sits ever before you.

"Truly, I have never known this hunger," responded the reflective Seeker.

"Now go, my wandering Brother," continued Esiban, "and I humbly suggest that you Journey until you feel light and free as a leaf in the Wind.

Let yourself be swayed by the branch, washed by the Rain, and chewed upon by the bugs. You may then find ears to listen, and you'll likely cherish the sap and the sunshine that sustain you. If after that you come back to me with your Bowl, I would truly serve you from my pot. And at the same time, I would respectfully ask that you serve me from yours."

ORIGIN

I AM BLESSED with the opportunity to meet many young Seekers like Wagosh. They remind me of myself when I was their age, and they bring to mind the Saami (Laplander) tradition of taking a year off to find the fullness of life, which they call "pitää välivuosi."[103] Like the Seekers, I was often either too numb to recognize the lessons laid before me or too headstrong to listen. Still, I stumbled along on my Journey, because if I didn't trip over things I could not see, they would have gone unnoticed and it would not have been a Journey of Discovery.

It is usually easier to stumble when one realizes there might be some redeeming value to the scrapes and bruises. And one feels more like getting back up when there is some encouragement. Stories provide this support, and this is the reason young People need to have stories accompany them on their Journeys. I wonder how different my Journey of Discovery

would have been had I more of the metaphorical perspective of story.

Recently I have come to realize that I might be able to help others by sharing some of the perspective gained from my Journey. Even those with full Bowls need guidance, as the English proverb, "A full Bowl must be carried steadily"[104] states. However, I had no story that fit the bill as closely as I would have liked. It was not that I found stories of this type to be rare, as I knew that Buddhist, Hindu, and Arabic traditions were particularly rich in them, and I knew a few from my own culture. I liked the Ojibwe stories for their directness, and those from the East appealed to me for their clarity, so I combined the two approaches to craft "Raccoon Helps Fox Find His Hunger."

This telling of the story is in honor of the Seekers who have the courage to set out on their Journeys, whether or not they have stories to walk with.

Night of the Windigo

WINDIGO, WINDIGO, please don't steal my soul. When we were Children, we'd say this over and over when we were afraid of going out in the dark. Even now I'll catch myself doing it once in awhile. And that's good, because you don't want to forget it when it's bone-chilling cold in the dead of the White Season, because that's when Windigos are the hungriest. They come from out of the deep Forest and lurk in the shadows around camp.

"Why?" you ask.

They eat People, you know.

Sometimes in the middle of the night you can hear their awful moaning. Some say it's the Wind; however, if you had ever come face-to-face with a Windigo, as I had, you'd know the difference. And you would never forget.

When the Snow lies deep and it gets so cold that Trees freeze and crack open, starvation drives Windigos to claw at *Wigwams* (Lodges) in a grim effort to get at the People inside.

"Windigos don't have bodies like ours," our parents used to say, "so they usually can't tear through a Wigwam wall." *Usually* wasn't much comfort to a spooked Child on a dark and blizzardy night, nor was being told that they did not have normal bodies.

"Then what *did* they have?" I would wonder.

At first I thought my parents were just trying to scare us more than we already were, so that we'd quiet down and go to sleep. I'd shrink down under my sleeping furs and not show myself until daylight. One night, however, I learned just how serious my parents were.

But before that story, you must know more about Windigos. Most of what I've learned about them is from our Elders—except for a few things I came across the hard way. When I was your age, we Children would sit around the Wigwam *Shkode* (Fire) on a howling cold-as-Death night, just like this one, and the Elders would tell us "why" things, like why Windigos didn't have normal bodies and why they became so famished.

"Back in the *Suns* of old," they would say, "our People lived together in *clans* in the Forest. There were no policemen or prisons then, because we lived by honor and respect, and the occasional violation was taken care of by the clan.

"Guess what the most extreme punishment was?" they would ask.

We'd come up with things like torture and Death.

"No," they would say, "it was banishment. Our kin meant everything to us, so imagine being barred from ever living with them again and having to wander the rest of your days alone in

175

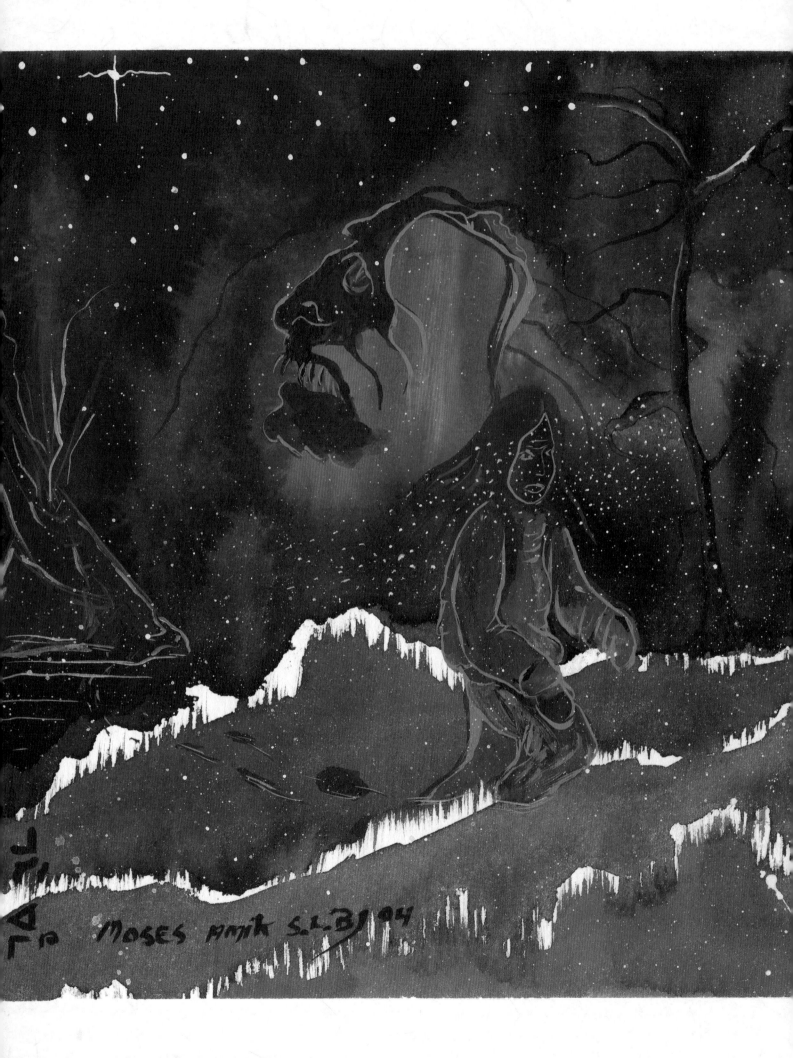

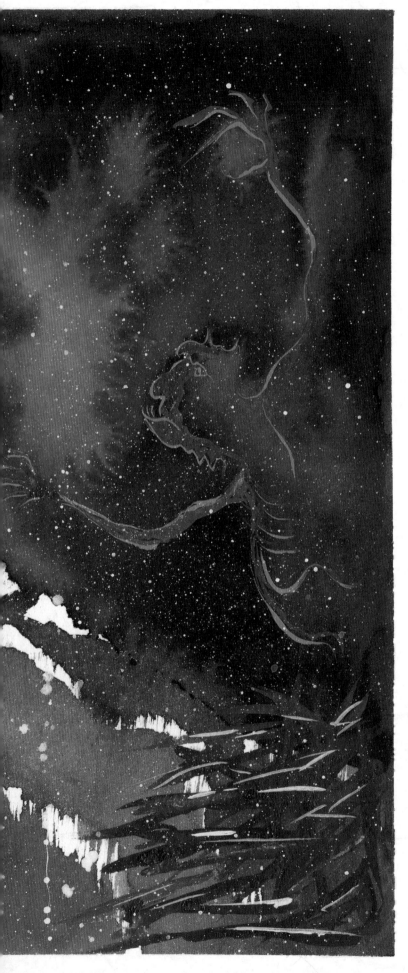

the wilderness. It was a fate worse than Death."

"Ooooh," we'd exclaim as we tried to imagine what it must be like.

"It was sometimes far worse, particularly when a banished one got so desperate and driven by madness then he'd come back to camp. However, he would not—no, could not—allow himself to be seen. Even the most wretched of castouts still held the ways of their People in utmost respect."

"What did they look like?" we'd ask.

"You wouldn't want to lay your eyes on one—nor would he let you—because he knew his loved ones would shriek in terror."

"Tell us what he would look like," we'd beg.

"Imagine—just imagine—being desperately lonely, Sun after Sun, season after season, with barely the will to live. It would twist your body and distort your features, turning you into something so grotesque that you could no longer be called Human. In fact, you wouldn't be anything familiar to us, because you'd no longer be fully connected to this world. You'd be neither all flesh nor all spirit, not completely alive nor completely dead."

"But what would we . . . I mean *he*, look like?" we would plead.

"Nobody really knows," they would reply, "because you only catch a glimpse of one if you're lucky. Or we should say, unlucky. Those few who have actually come face-to-face with one are so jolted they can no longer speak."

"Oooooh . . . We heard they were cannibals; are they?"

"If you ran into one, you'd wish he was, because being eaten would be the easy way out. Would you like to hear what could happen if you came face-to-face with one?"

"Yes, yes!" we'd shout.

The Elders would wait for us to quiet, and then in a hushed, mysterious voice, one of them would speak:

This happened not long ago, just before your parents were born. A young Girl wandered alone out into the woods. Night fell and a blizzard set in, with a screeching wind that blew right through your parka. Not even our best tracker could follow the Girl's trail through the fast-drifting snow.

Somehow she found her way back. But she was not the same Person: her face was blank and she showed no feeling. She could no longer speak, and after dark she did nothing but curl up in a corner with her eyes shut tight in her arms locked over her head. If you touched her unawares, she would thrash around like a Fish trying to throw off a hook. That Windigo sucked the life right out of her. One Sun she just disappeared, and we never saw her again.

* * *

Well, that's what I learned from the Elders when I was young. Now I will tell you my own story. To this Sun, I still scream myself awake from nightmares—I jump up out of bed and grab my shoulder that throbs all over again from the pain of that death grip. There are some who doubt that Windigos even exist. Please honor me by listening to my story, and then you can decide for yourself. I'll take you back to that terrible night . . .

It was bitterly cold and the Wind wailed like a Woman at the grave of her only Child. The turn in the weather caught the whole camp by surprise, as we were all out enjoying what we call Little Summer: the warm period that often follows the falling of the leaves. At about mid-afternoon, a breeze came in that was so faint it barely rustled a branch, and yet it brought a chill that pierced right to the heart.

"Strange . . . there aren't any Clouds," commented someone. "With this cold, they always come, along with the smell of Snow.

What's going on?" We all anxiously looked up and saw only clear blue from horizon to horizon. Like a choking, black Fog rolling over a cheery Meadow, an ominous feeling pressed upon our chests and made it hard to breathe.

Soon enough, however, the Clouds came. And then the Snow. It wasn't the typical first Snow of the season: big, fluffy flakes floating down, the kind Children like catching on their tongues. No, this was hard, driven little pellets that stung our faces as we scrambled for cover.

The weather put me in a melancholy mood. I felt like an overgrown Child: fourteen Winters of age and not yet knowing my *Lifedream*. My kin were concerned for me, and yet they said nothing, as they knew I had to be ready before I could receive anything.

"What's the hurry?" I would tell myself. "Life is good—I don't see any reason to go out alone in the wilderness and fast for Suns, just to find out how I'm supposed to serve my People. I have plenty of time for that."

The Snow ended by nightfall, but not the raw North Wind. Anything, anyone, that stood exposed, got blasted by a barrage of stinging ice crystals. Even the full Moon's bright glow got beaten down to an eerie, ashen haze.

That evening, we ate our meal in silence as we listened to the Wind howling around the Wigwam and clacking the Tree branches in a chaotic rhythm.

In a valiant effort to keep us warm, our Shkode ate up wood almost as fast as we could feed him. "There's plenty of wood out on the woodpile," said Mother, "and I believe it's your turn to go and get more." Normally I'd have jumped at the opportunity. I liked the feel of the cool night air after sitting by a hot Shkode, and I could listen to the calls of the Animals. That night, however, I shuddered at the thought. It wasn't just the Wind or the creepy moonlight or the biting cold. No, there was something else—something that turned my heart to ice at

the mere thought of taking a step outside.

I bundled up, took a couple deep breaths, and glanced longingly back at my family as I pushed the door flap aside.

A few steps out, I stopped and glanced at my feet. "Wha . . . Where are they?" I stammered. The lower half of my body was gone, engulfed in a raging torrent of Wind-whipped Snow. It looked mushy and unstable, like fast-flowing quicksand. The more I look at it, the more my head swirled. "I'm going to pass out," I remember saying to myself. I closed my eyes and leaned against a tree until my head cleared.

The Wigwam . . . I looked back and its lower half had disappeared, as though it was being devoured by a raging River. A nervous laugh was my only reaction. A couple more steps away from the Wigwam . . . a couple more . . .

I glanced back and the Wigwam was gone! My home, my family, swallowed up by this demon screaming down from the Tundra! "Windigo, Windigo, please don't steal my soul."

Several more steps toward the woodpile. Maybe it's more over this way. No, it must be the other way. If I can only find it, I'll be able to get my bearings and find my way back.

No woodpile. Nothing. The whole world had disappeared, vanished into hissing Snow, washed out by milky moonlight.

"Aaaahhh!" I screamed, but I couldn't hear my own voice—the Wind swallowed everything. An unearthly chill burrowed into my bones.

Again I called out. And again. And once again. Wretched Wind!

Or *was* it the Wind? I couldn't see my feet, I couldn't hear, I couldn't find anything around me. Am I the only thing alive . . . suspended in a Sea of haze . . . no past, no future . . . only the obscure, eternal now?

"Grab a hold of yourself," I barked. "Move! You *have* to get back to the Wigwam!"

But did it even exist anymore?

Every time I raised a foot, the Wind would

tear at it, knocking me off balance. My stomach knotted, my eyes burned from straining to see. "Windigo, Windigo, please don't steal my soul," I pleaded over and over. If I were to stop the chant, I feared I'd go screaming off like a blind Coyote with his tail on fire.

The chant was just helping me regain composure when something clenched my shoulder. Long, bony fingers, just like the Elders described!

They gripped my flesh right through my clothing, as though I was wearing nothing, and it burned like fiery coals. I tried to scream but couldn't open my mouth. My joints locked, my eyes froze open, and my heart pounded so hard I could hear it above the deafening Wind.

That . . . that hissing and groaning . . . it can't be the Wind. It's much colder than the Wind, and it sounds like it's being forced through clenched teeth. And that smell, like a stinking carcass! I struggled for air, then coughed so hard that it felt like a jagged Rock tearing at my throat. My heart slammed against my ribs like a caged madman trying to escape from a nightmare.

All I could see were shadows projected by the ghostly moonlight: silhouettes of shriveled arms and a head dripping rotten flesh. I retched.

Another gaunt hand whacked the back of my head, pushing me forward while a foot shot out to trip me.

By sheer willpower I broke the spell, and like lightning I tumbled forward and rolled away. Yet it wasn't fast enough—something grabbed at my ankle. Kicking furiously, I rolled

again and shot away faster than I had ever moved in my life.

I didn't get far. Out of nowhere a black, branch-like arm, dripping with frozen drool, caught me across the chest. The impact threw me backward into the Snow, and yet I only missed a step. Sheer instinct propelled me off in another direction before I realized what I was doing.

The chant returned: "Windigo, Windigo . . . " Had it ever stopped? My lungs pumped as hard as my feet hit the ground. My throat burned; my eyes stung from the icy windblown grit. Branches poked me and I tripped on logs and boulders and still I ran, rasping "Windigo, Windigo, please don't steal my soul; Windigo, Windigo, please don't steal . . .

" . . . My soul? What *is* my soul? Windigo, Windigo, please . . . Yes, *please* . . . What is my Lifedream . . . Why do I not serve my People? Windigo, Windigo, please don't . . . *Please don't!*

I want to be with my People!"

That was the last thing I remembered before . . . Smack! I ran face-first into something and crumbled down into the Snow. I lay there awhile to catch my breath, and then slowly got up to see what I crashed into. It was the Wigwam—my home, my People!

"Your face is paler than the moonlight," gasped the young Children as they took in my haggard appearance. "Ha, we knew all along it was no Windigo," the older Children sneered. "It was just you making that racket out there to scare us! Then you rolled in the Snow to make it *look* like you were attacked! You'd be dead or crazy if it really was a Windigo."

Little did they know. I gave a weak smile and turned to the Elders. They knew. "Are you now ready to become an adult and serve the People?" they asked.

I nodded.

ORIGIN

BEFORE I MET coauthor Moses (Amik) Beaver, I saw his Windigo paintings. Of all his works, I had to know what inspired those renditions of creatures that words could hardly begin to describe. The first time we got together, he talked about the origin and character of Windigos and their role in his People's culture, and he told me about the Windigos who haunted him during a troubled time in his life. "Night of the Windigo" is based on his stories.

Even though this story's roots lie deep in the traditions of the North, the Windigo spirit seems to dwell everywhere. People of nearly every culture I have studied or been exposed to have their creatures who stalk the night. For example, the Hawai'ian Windigo is *Hio*, an *akua* (ghost) who wanders about peering into the doors of Lodges and biting off the noses of those who annoy him. *Moku ka ihu ia Hio*

(literal translation: Bitten off is the nose by Hio, or Hio will bite off your nose) is used to frighten Children into staying close to home at night.[105]

While my Mate, Lety, was transcribing "Night of the Windigo," she remembered that the night before I recorded it, I received a dream message encouraging me to explore my dark, suppressed side. I had conveniently forgotten that guidance. Were it not for Lety's reminder, I may not have made the connection between dream and story. I might not have recognized the creature I was describing as part of me, and I doubt I would have seen my own story in my recounting.

It is my hope that wherever there are People, of whatever age, facing the daunting (and yet alluring) specter of finding themselves and embracing their fears, there be Windigos to help.

Afterword

THE OLD ONES HAVE SPOKEN; it is time for these two storytellers to echo their Hawai'ian counterparts and say "*Amama ua noa*[106]—It is finished." These tellers see many Little Ones snugly asleep in many laps, so let us follow their example and go prepare for our dreams. The tellers are honored for your help this evening, because without an audience a story is only a memory. Were it not for each of you, the stories would have had no characters, no flavor. You were the story; the narrators merely gave it voice.

They will not say "Goodbye" to you because in the way of our Native kin around the world, there are no goodbyes. The Gaelic *Beannachd*[107] *leat*[108] means "Blessings go with you" and *Doe vizhdanae*[109] is "Until I see you again" in Bulgarian. The Zulu would say "*Ukubusisa*"[110] ("Bless you") and "*Salam alaikum*"[111] ("Peace be on you") would be heard among the Iraqi Tigris–Euphrates marsh dwellers. In Java it would be "*Slamat djalan, mas*" ("May your Journey be blessed, Brother").[112] These parting words, in keeping with the spirit of the stories just shared, show that we are and will ever remain connected. In keeping with this spirit, the tellers would like to leave you with the following Ojibwe parting, which means, "We are related and will remain so until we meet again."

Geegawabamin to each and all of you.

Glossary

Balance The natural state of harmony with self and surroundings that occurs when one lives by the principles of honor, respect, and self-knowing.

Circle of Life All that dwells within one's physical realm, both animate (Trees, Flowers, Birds, Insects, Humans, and so on) and inanimate (Rocks, Clouds, Rivers, and so on). Natives consider all members of the Circle of Life to be living entities, on a plane with Humans. Also known simply as *Life*. See **Bimadiziwen** in the Glossary of Ojibwe terms.

clan An extended family group within a larger culture group, often under the guardianship of a principal dodem. See **dodem** in the "Glossary of Ojibwe Terms."

clan memory A particular group's traditions, adventures, and accumulated knowledge, which are remembered by the group's individuals and passed down in story. See **clan**.

Contrary A Person, Animal, or event who acts in an atypical and often confusing or contradictory manner, for the purpose of raising awareness, encouraging questioning, or teaching a lesson. Also known as *trickster*.

dreamtime The state of sleep, during which one's superconscience, or dream–self, offers guidance in the form of dreams. Considered by many Natives to be a parallel reality to awaketime.

DreamQuest A solo fast in the wilderness for the purpose of seeking one's **Lifedream**, which usually manifests as a revelatory experience. Duration is typically from a few to ten or more days. Also known as *Vision Quest*.

Gifting Way The state of abundance and personal fulfillment that comes, often seemingly without effort, from living the natural law that giving is receiving. Also known as *Blessing Way* and *Beauty Way*.

Giveaway Ceremonial practice of gifting surplus to maintain a non-material life and help provide for others. Fosters strong social bonds and encourages group consciousness.

Guardian-Warrior A Person, male or female, who devotes his or her life to the service of his or her People as provider, protector, emissary, scout, and guide to the Young.

Honor Dance/Song A special dance or song dedicated to an individual or group, often in recognition of a particular deed or achievement.

Hoop of Relations A means of categorizing Human relationship, with one's **dodem** dwelling in the first or most intimate hoop, Mate and parents in the second, Children and Grandparents in the third, and so on.

Journey of Discovery A time of travel to break convention and discover new surroundings and People with different outlooks and ways of doing things. Usually undertaken by a young adult. Also known simply as *Journey*.

Life See **Circle of Life**.

Lifedream One's special gift or talent, unique to the individual, which is developed and gifted back to one's People. Often revealed by way of a revelatory experience during a **DreamQuest**. Also known as *Vision*.

Lifepath The central and purposeful lifelong Journey one walks in the development and fulfillment of his or her **Lifedream**. Also known as *Path of Life*.

Medicine Energy that can be employed for various pursuits, such as crafting, hunting, Warrior actions, prophesying, and healing. Often appears as the skill and insight that comes from walking the **Gifting Way** and manifesting one's **Lifedream**. Also referred to as *personal power*.

Medicine Bundle A pouch or parcel containing sacred items. May be personal or **clan**, in which case it might be handed down to successive keepers.

Medicine Woman One who is fully attuned to her **Lifedream** and uses it for the benefit of the People. Distinct from a shaman, who serves by traveling to other realms to retrieve knowledge. There are also Medicine Men. See **Mashkikeekwe** in "Glossary of Ojibwe Terms."

Message Stick A specially inscribed or decorated baton that identifies a messenger as legitimate.

Moon The period of time between one new Moon and the next or one full Moon and the next. A means of reckoning time, e.g., Moon of the Falling Leaves (roughly October).

Native A Person of any race or origin who either follows or adopts the regional indigenous way of life.

Offering A ritual of symbolic giving before expecting to receive, or of Giving Thanks for what has already been received. In North America, commonly enacted by the gifting of a pouch or handful of a sacred Herb such as **Asema** or **Kinnikinick**. See **Asema** or **Kinnikinick** in "Glossary of Ojibwe Terms."

Old Way The clan-based gathering–hunting lifeway common to Native Peoples of all ethnicities and geographical locations. Also known as *Traditional Way, Native Way, Aboriginal Way, Ancestral Way, Primitive Lifeway*. See **clan.**

Passing-over Death. Signifies that Death is a transition rather than an ending.

People Any and all beings, whether Human, Animal, Plant, or Mineral; e.g., Tree People, Snail People, Rock People. A way of honoring all life as being of equal value to Human life.

Personal Power See **Medicine.**

Petition Pouch A small sack, sometimes decorated, usually containing **Asema** (see in "Glossary of Ojibwe Terms") or **Kinnikinick** (see in "Glossary of Ojibwe Terms"). Used to accompany a formal request for a service or teaching, or given as an expression of thankfulness.

Petition Stick A specially inscribed or decorated stave that serves as an invitation to a function.

Red Pipestone People The Native inhabitants of southwestern Minnesota, who are the keepers of the area's deposits of red catlinite: a soft stone held sacred because it is used to craft Pipes. The deposits are respected as neutral ground, which allows individuals of other Native cultures to procure Pipe material.

Relations Relatives. Includes all Animals, Plants, Minerals, and so on, who are commonly referred to as Sisters and Brothers.

Seventh Generation Future generations. Usually used in reference to the fact that decisions are made with consideration for their effect upon the unborn.

Shapeshift To assume another life form, that often being one's **dodem.**

Slow-Shell Clam, Oyster, Snail.

Smudge A cleansing ceremony during which one is infused with the aromatic smoke of **Kinnikinick** (see in "Glossary of Ojibwe Terms"), Sweetgrass, Cedar, Sage or other sacred cleansing Herb.

Smudging Ceremony See **Smudge.**

Song The intrinsic rhythm, personality and beauty of a place or being; its essence or spirit.

Spirit Wind An empowering breath that comes independently of breathing. Usually experienced in long-distance running when the endurance threshold is crossed and a new surge of energy is felt.

Sun A day.

sunwise The direction in which the Sun travels; clockwise. Also the direction of one's **Lifepath** and the changing seasons.

Sweat Lodge Ceremony A cleansing and rebirthing ritual held in a small, tightly enclosed Lodge where sweating is encouraged in various ways, the most common being the generation of steam by pouring Water over Fire-heated Rocks. Related to the pre-Christian Finnish sauna.

Talking Circle A method of collective expression and consensus decision making whereby participants gather in a circle and each speaks in turn, usually in **sunwise** order.

Talking Stick A baton, Feather, or other object, sometimes symbolically decorated, which is held by the speaker in a **Talking Circle**. Symbolizes the center, or focal point, of the Circle, with the bearer being afforded complete attention.

this person/woman/boy/one A form of humility in reference to self. Used in formal speech by one who wishes to keep the focus off of self and on the topic at hand.

trickster See **Contrary.**

Two-Legged Human

walk in Balance See **Balance.**

Warrior See **Guardian–Warrior.**

who Used in place of "that" or "which" when referring to Animals and sacred items who are considered animate.

Glossary of Ojibwe Terms

Rarely were there written versions of Native languages, so multiple adaptations to modern writing systems would often surface. Such has been the case with the Ojibwe language, so for that reason, and to allow you to easily experience the sound of the language, I have chosen to use phonetic spellings for all Ojibwe words throughout the text. Find a more extensive explanation of language usage, along with titles of recommended Ojibwe dictionaries, in *The Doorway to These Stories* at the front of the book.

Abinozhee Child; Little One.

Adik Caribou.

Adikanesi Caribou People.

Agongos Chipmunk.

Agwadashi Sunfish.

aho I have spoken; it is said; it is finished.

Ajidamo Squirrel.

Aki Earth.

Amik Beaver.

Amoo Bee; Wasp.

Anaganashk Fern.

Anakwad dodem Cloud clan.

Andeg Crow.

aneen Greetings; hello.

Animikee Thunderbird; Thunder Being.

Anishinabe Human.

Anit Fish spear.

Asabikeshin Spider.

Asema Tobacco.

Ashageshin Crayfish.

Ashageshin dodem Crayfish clan.

Askik Seal.

Bapakine Grasshopper.

Bapase Woodpecker.

Bibigwan Flute.

biendigain Come in.

Bimadiziwen Circle of Life. See in Glossary of English terms.

Bine Grouse.

Bizhiki Buffalo.

Bizhiw Lynx.

chi meegwetch Much gratitude; I am deeply grateful.

daga Please.

debwewin Personal truth.

Deendeesi Blue Jay.

Dibik-Geezis Lit. Night Sun; Moon.

Dikinagan Cradleboard. A portable baby crib, usually carried backpack-style by means of a tumpline passed around the forehead. Most of a baby's first year is spent in a cradleboard.

dodem A non-Human guide, usually Animal, yet may be Plant, Mineral, or other. Human–dodem is the most intimate of relationships, and lifelong, which is reflected in the literal translation of dodem: my heart. Also means *clan*. See **clan** in Glossary of English terms.

Enigoons Ant.

Eshkibod Raw Meat Eater; Inuit.

Esiban Raccoon.

eya Yes.

Gag Porcupine.

Gagagi Raven.

geegawabamin We are related and will remain so until we meet again; farewell.

Geegoon Fish.

Geeshkimansi Kingfisher.

Geewaedin North.

Geewaedinong Cold-Wind-Blower.

Geewaedinoni People-of-the-North.

Gekek Hawk.

gichi meegwetch We are very grateful.

Gichi-Anit Medicine Spear.

Gichigami Lake Superior.

Gijiganaeshi Chickadee.

Ginoondawan Teaching Lodge.

Ginoozhe dodem Pike clan.

Gizhik Cedar.

Gookookoo ween dodem Owl is his clan.

Gookookoo Owl.

Goon Snow.

Gweengwa'age Wolverine: a rare, stocky, Bearlike Animal of the Weasel family, the size of an average Dog. Lives in remote northern Mountains and boreal Forests. Noted for cantankerous disposition and gluttony.

Ishpiming Sky.

Jeeman Canoe.

Kinnikinick A blend of aromatic Herbs, often gathered and prepared according to tradition. Used as incense, a Thanks-giving Offering for being gifted, a gathering/hunting preparatory Offering, and in accompaniment of prayers and petitions. See **Petition Pouch** in Glossary of English terms.

Ma'eengan Wolf.

Madodiswan Sweat Lodge.

Makade Gekek Black-Hawk.

Makak Basket.

Makwa dodem Mashkikeekwe Female Bear clan herbalist.

Makwa Bear.

Mang Loon.

Manidoogami Mystery Lake.

Mashkikeekwe Medicine Woman; female healer/herbalist. See **Medicine Woman** in Glossary of English terms.

Meegwan Feather.

meegwetch My gratitude; thank you.

Meenan Blueberry.

Memengwa Butterfly.

Menominee Wild Rice People. A tribe of Algonquian-speaking People in east-central Wisconsin.

Michigeegwane Osprey.

Migizi Eagle.

Migizigami Eagle Lake.

Mikinak Snapping Turtle.

Minensagawanzh Thornapple Tree.

Minisino Warrior; Guardian-Warrior. See **Guardian-Warrior** in Glossary of English terms.

Misabe Giant.

Mishomis Grandfather.

Miskomin Raspberry.

Miskwadesi Turtle; Painted Turtle.

Mitig Tree.

Moasay Woodgrub.

Mooz Moose.

Mshibishi Cougar.

Nagan Bowl.

Nakana My Relations. See **Relations** in Glossary of English terms.

Namay Sturgeon.

Nanabozho First-Man. Culture hero of many of the Western Algonquin Peoples, including the Ojibwe, Ottawa, Potawatomi, and others. Variants: Manabosho; Wenabozho; Nanabush.

Nenookasi Hummingbird.

Nesewin Air.

Nibi Water.

Nigig Otter.

Ningabee'an West.

Nodin Wind.

Nokomis Grandmother.

nongom The moment; now.

Obodashkwanishee Dragonfly.

Ode'imin Geezis Heartberry (or Strawberry) Moon.

Ode'imin Strawberry.

Omakakee Frog.

Oojeeg Fly.

Opitchee Thrush.

Opwagan Pipe.

Shkode Fire.

Wabanong Morning light; in the East.

Wabishkeewed White Person; European.

Wabizi Swan.

Wabooz Hare.

Waboosons Bunny.

Wagosh Fox.

Wagosh dodem Fox clan.

Waswagoning A place to spear Fish by torchlight.

Wawashkaeshi Deer.

Wawashkaeshi weeyas Deer meat.

Weegwas Birch Tree; Birch bark.

Wegimind-Aki Earth-Mother.

Wigwam Lodge.

Windigo Cannibalistic Winter Demon.

Zagime Mosquito.

Zesab Nettle.

Zhashagi Heron.

Zhawan South.

Zhawanoni People of the South.

Zhawanong Greening-Mother-Wind; Warm-Breeze-Bringer; South.

Zheengibis Grebe.

Zheesheeb Duck.

Zheesheegwan Rattle.

Zheesheegwe Rattlesnake.

Zhigag Skunk.

Zhigag Makwa Lit. Skunk-Bear; Wolverine. See also **Gweengwa'age** in this Glossary.

Zhigagawanzh Onion.

Zhingwak Pine; White Pine.

Endnotes

Epigraph

1. Wandjuk Marika and Jennifer Isaacs, *Wandjuk Marika: Life Story* (St. Lucia: University of Queensland Press, 1995), 125.

Acknowledgments

2. Joseph Rael, *House of Shattering Light* (Tulsa: Council Oak Books, 2003), 96.

Dedication: In Honor of Keewaydinoquay

3. Robert Wolff, *Original Wisdom: Stories of an Ancient Way of Knowing* (Rochester: Inner Traditions International, 2001), 7.

4. Mary Kawena Pukui and Samuel H. Elbert, *Hawaiian Dictionary* (Honolulu: University of Hawaii Press, 1971), 257.

The Doorway to These Stories

5. Pali Lee and Koko Willis, *Tales from the Night Rainbow* (Honolulu: Night Rainbow, 1988), 17.

6. Mary Kawena Pukui and Samuel H. Elbert, *Hawaiian Dictionary* (Honolulu: University of Hawaii Press, 1971), 257.

7. James MacLaren, *Beginner's Gaelic* (NY: Hippocrene Books, 1999), 183.

8. Baraga, Frederic, *A Dictionary of the Ojibway Language*, 2nd ed. (First published as *A Dictionary of the Otchipwe Language*, Montreal: Beauchemin & Valois, 1878; repr., St. Louis: Minnesota Historical Society Press, 1992). Citations are to the Minnesota Historical Society Press edition.

9. Johnston, Basil, *Ojibway Language Course Outline* (Ottawa: Indian and Inuit Affairs Program, 1978).

10. John D. Nichols and Earl Nyholm, *A Concise Dictionary of Minnesota Ojibwe* (St. Louis: University of Minnesota Press, 1995).

11. Edith Kanaka`ole, "Ka Uluwehi O Ke Kai (The Plants of the Sea)," on *Hi'ipoi I Ka 'Âina Aloha (Cherish the Beloved Land)*, compact disc, Aiea: Hula Records 1979, CDHS-568. Line 13.

Introduction: A Story to Invoke All Stories

12. Billy Graham, "A Second Chance" in *More Stories for the Heart,* comp. Alice Gray (Sisters, ID: Multnomah Publishers, 1997), 105.

13. Dr. Laura Schlessinger and Rabbi Stewart Vogel, *The 10 Commandments: The Significance of God's Laws in Everyday Life* (New York: HarperCollins, 1998), 197.

14. Joseph Campbell, *Primitive Mythology*, Vol. 1, *The Masks of God* (Harmondsworth, UK: Penguin Books, 1987), 3.

15. Carl G. Jung, *The Portable Jung*, ed. Joseph Campbell (NY: Penguin Books, 1976), 525.

16. Jennifer Isaacs, comp. and ed., *Australian Dreaming: 40,000 Years of Aboriginal History* (Willoughby, NSW: Ure Smith Press, 1991), 33.

17. Charles F. Haanel, *The New Psychology: The Universal Mind, The Conscious Mind, The Creative Process V2* (Whitefish, MT: Kessinger Publishing, 2006), 112.

PART I: THE POWER OF STORY

Introduction: Story Is Life

18. Muriel Rukeyser, *The Speed of Darkness* (NY: Random House, 1971), 111.

19. Shirley Ann Jones, ed., *Simply Living: The Spirit of the Indigenous People* (Novato, Canada: New World Library, 1999), 89.

20. Laurens Van Der Post, *A Story Like the Wind* (NY: William Morrow, 1972), iix.

21. Shirley Ann Jones, ed., *Simply Living: The Spirit of the Indigenous People* (Novato, Canada: New World Library, 1999), 36.

Chapter 1: The Role of Stories

22. Marjorie Shostak, *Nisa, The Life and Words of a !Kung Woman* (NY: Random House, 1983), ix.

23. James MacLaren, *Beginner's Gaelic* (NY: Hippocrene Books, 1999), 35.

24. D.F. Bleek, *Bushman Grammar in Zeitschrift fur Eingeborenen-Sprachen Band XIX* (1929), 162.

25. Joe Adamson, *Bugs Bunny: 50 Years and Only One Grey Hare* (New York: Henry Holt & Co., 1990), 50.

26. Luther Standing Bear, *My Indian Boyhood* (Lincoln: University of Nebraska Press, 1988), 174–175.

27. Charles A. Eastman, *Indian Scout Craft and Lore* (NY: Dover, 1974), 175.

28. Shirley Ann Jones, ed., *Simply Living: The Spirit of the Indigenous People* (Novato, Canada: New World Library, 1999), 151.

29. Michael Patterson, *Seeds of Old Wisdom: Proverbs from Many Countries* (Unpublished, 2005).

30. Michael Patterson, *Seeds of Old Wisdom: Proverbs from Many Countries* (Unpublished, 2005).

31. Michael Patterson, *Seeds of Old Wisdom: Proverbs from Many Countries* (Unpublished, 2005).

32. Michael Patterson, *Seeds of Old Wisdom: Proverbs from Many Countries* (Unpublished, 2005).

33. Michael Patterson, *Seeds of Old Wisdom: Proverbs from Many Countries* (Unpublished, 2005).

34. The Education of Finland: Sanasto Dictionary (accessed 30 Sept. 2005), http://www.edu.fi/oppimateriaalit/ymmarrasuomea/sanasto.htm.

35. Michael Patterson, *Seeds of Old Wisdom: Proverbs from Many Countries* (Unpublished, 2005).

36. Credo Mutwa, *African Proverbs* (Cape Town: Struik Publishers, 1997), 8.

37. Michael Patterson, *Seeds of Old Wisdom: Proverbs from Many Countries* (Unpublished, 2005).

38. Michael Patterson, *Seeds of Old Wisdom: Proverbs from Many Countries* (Unpublished, 2005).

Chapter 2: The Soul of a Story

39. The Education of Finland: Sanasto Dictionary (accessed 30 Sept. 2005), http://www.edu.fi/oppimateriaalit/ymmarrasuomea/sanasto.htm.

40. Shirley Ann Jones, ed., *Simply Living: The Spirit of the Indigenous People* (Novato, Canada: New World Library, 1999), 99.

41. Wandjuk Marika and Jennifer Isaacs, *Wandjuk Marika: Life Story* (St. Lucia: University of Queensland Press, 1995), 130.

42. Peter Austin, *A Reference Dictionary of Gamilaraay, Northern New South Wales* (Melbourne: La Trobe University, Dept. of Linguistics, 1993).

Chapter 3: The Body of a Story

43. The Education of Finland: Sanasto Dictionary (accessed 30 Sept. 2005), http://www.edu.fi/oppimateriaalit/ymmarrasuomea/sanasto.htm.

44. Peter Austin, *A Reference Dictionary of Gamilaraay, Northern New South Wales* (Melbourne: La Trobe University, Dept. of Linguistics, 1993).

45. Mary K. Pukui, coll., trans. and ed., *'Olelo No'Eau: Hawaiian Proverbs and Poetical Sayings,* (Honolulu: Bishop Museum Press, 1983), 291.

46. Mary K. Pukui and Alfons L. Korn, trans. and ed., *The Echo of Our Song, Chants and Poems of the Hawaiians* (Honolulu: The University Press of Hawaii, 1973), 1.

Chapter 4: Where Stories Come From

47. Shirley Ann Jones, ed., *Simply Living: The Spirit of the Indigenous People* (Novato, Canada: New World Library, 1999), 30.

48. Marjorie Shostak, *Nisa, The Life and Words of a !Kung Woman* (NY: Random House,1983), 4.

49. Chief William Red Fox, *The Memoirs of Chief Red Fox* (Greenwich, CN: Fawcett Publications, 1971), 19.

50. Shirley Ann Jones, ed., *Simply Living: The Spirit of the Indigenous People* (Novato, Canada: New World Library, 1999), 106.

51. Wandjuk Marika and Jennifer Isaacs, *Wandjuk Marika: Life Story* (St. Lucia: University of Queensland Press, 1995), 37.

52. Kent Nerburn and Louise Mengelkoch, eds., *Native American Wisdom* (San Rafael: New World Library, 1991), 10.

53. Annette Rosenstiel, *Red and White: Indian Views of the White Man 1492–1982* (New York: Universe Books, 1983), 78.

54. Michael Patterson, *Seeds of Old Wisdom: Proverbs from Many Countries* (Unpublished, 2005).

55. Wandjuk Marika and Jennifer Isaacs, *Wandjuk Marika: Life Story* (St. Lucia: University of Queensland Press, 1995), 36.

56. Wandjuk Marika and Jennifer Isaacs, *Wandjuk Marika: Life Story* (St. Lucia: University of Queensland Press, 1995), 173.

57. Michael Patterson, *Seeds of Old Wisdom: Proverbs from Many Countries* (Unpublished, 2005).

58. Kent Nerburn, ed., *The Soul of an Indian and Other Writings from Ohiyesa (Charles Alexander Eastman)* (Novato: New World Library, 1993), 25–26.

59. The Education of Finland: Sanasto Dictionary (accessed 30 Sept. 2005), http://www.edu.fi/oppimateriaalit/ymmarrasuomea/sanasto.htm.

60. Patrick V. Kirch, *Feathered Gods and Fishhooks: An Introduction to Hawaiian Archaeology and Prehistory* (Honolulu: University of Hawaii Press, 1985), 61.

61. Pali Lee and Koko Willis, *Tales from the Night Rainbow* (Honolulu: Night Rainbow, 1988), 17.

62. Pali Lee and Koko Willis, *Tales from the Night Rainbow* (Honolulu: Night Rainbow, 1988), 23.

63. Pali Lee and Koko Willis, *Tales from the Night Rainbow* (Honolulu: Night Rainbow, 1988), 23.

64. Pali Lee and Koko Willis, *Tales from the Night Rainbow* (Honolulu: Night Rainbow, 1988), 24.

65. Pali Lee and Koko Willis, *Tales from the Night Rainbow* (Honolulu: Night Rainbow, 1988), 24.

66. Pali Lee and Koko Willis, *Tales from the Night Rainbow* (Honolulu: Night Rainbow, 1988), 24.

Chapter 5: The Role of the Storyteller

67. Kent Nerburn, ed., *The Soul of an Indian and Other Writings from Ohiyesa (Charles Alexander Eastman)* (Novato: New World Library, 1993), 25–26.

68. Charles A. Eastman, *Indian Scout Craft and Lore* (NY: Dover, 1974), 176.

69. Masoyoshi Shibatani, *The Languages of Japan* (Cambridge: Cambridge University Press, 1990), 34.

70. Chief William Red Fox, *The Memoirs of Chief Red Fox* (Greenwich, CN: Fawcett Publications, 1971), 17.

71. Pali Lee and Koko Willis, *Tales from the Night Rainbow* (Honolulu: Night Rainbow, 1988), 19.

72. Michael Patterson, *Seeds of Old Wisdom: Proverbs from Many Countries* (Unpublished, 2005).

73. Alvin C. Currier, *Karelia: The Song Singer's Land and the Land of Mary's Song* (published by the author, 1991).

74. Louise Erdrich, *Books and Islands in Ojibwe Country* (Washington: National Geographic Society, 2003), 39.

75. Luther Standing Bear, *My Indian Boyhood* (Lincoln: University of Nebraska Press, 1988), 52.

76. Mary and Herbert Knapp, *One Potato, Two Potato...The Secret Education of American Children* (New York: WW Norton & Co., 1976).

77. Francelia Butler, *Skipping around the World: The Ritual Nature of Folk Rhymes* (Hamden: Library Professional Publications, 1989).

78. Shirley Ann Jones, ed., *Simply Living: The Spirit of the Indigenous People* (Novato, Canada: New World Library, 1999), 88.

79. Shirley Ann Jones, ed., *Simply Living: The Spirit of the Indigenous People* (Novato, Canada: New World Library, 1999), 36.

Chapter 6: Learning through Stories

80. Michael Patterson, *Seeds of Old Wisdom: Proverbs from Many Countries* (Unpublished, 2005).

81. Shirley Ann Jones, ed., *Simply Living: The Spirit of the Indigenous People* (Novato, Canada: New World Library, 1999), 166.

82. Shirley Ann Jones, ed., *Simply Living: The Spirit of the Indigenous People* (Novato, Canada: New World Library, 1999), 162.

83. Shirley Ann Jones, ed., *Simply Living: The Spirit of the Indigenous People* (Novato, Canada: New World Library, 1999), 171.

84. Luther Standing Bear, *My Indian Boyhood* (Lincoln: University of Nebraska Press, 1988), 52.

85. Pali Lee and Koko Willis, *Tales from the Night Rainbow* (Honolulu: Night Rainbow, 1988), 19.

86. Charles A. Eastman, *Indian Scout Craft and Lore* (NY: Dover, 1974), 176.

PART II: THE STORIES
Chapter 8: Self-Discovery

87. Colin M. Turnbull, *The Forest People: A Study of the Pygmies of the Congo* (NY: Simon & Schuster, 1961), 260.

88. Masoyoshi Shibatani, *The Languages of Japan* (Cambridge: Cambridge University Press, 1990), 68.

89. Wandjuk Marika and Jennifer Isaacs, *Wandjuk Marika: Life Story* (St. Lucia: University of Queensland Press, 1995), 36.

90. Paul Pearsall, *Miracle in Maui* (Makawao, HI: Inner Ocean, 2001), xiii.

91. Pali Lee and Koko Willis, *Tales from the Night Rainbow* (Honolulu: Night Rainbow, 1988), 25.

92. Roger A. Caras, *North American Mammals* (NY: Galahad Books, 1967), 185.

Chapter 9: Winter Stories

93. Charles A. Eastman, *Indian Scout Craft and Lore* (NY: Dover, 1974), 176.

94. Kent Nerburn, ed., *The Soul of an Indian and Other Writings from Ohiyesa (Charles Alexander Eastman)* (Novato: New World Library, 1993), 25–26.

95. Luther Standing Bear, *My Indian Boyhood* (Lincoln: University of Nebraska Press, 1988), 52.

96. David and Emerson Coatsworth, comps., *The Adventures of Nanabush: Ojibway Indian Stories* (New York: Atheneum, 1980).

Chapter 10: The Guardian–Warrior Path

97. Joseph Marshall III, *On Behalf of the Wolf and the First Peoples* (Santa Fe: Red Crane Books, 1995).

98. Luther Standing Bear, *My Indian Boyhood* (Lincoln: University of Nebraska Press, 1988), 52.

99. James Mooney, "The Sacred Formulas of the Cherokee" (Smithsonian Institution. 7th Annual Report of the Bureau of American Ethnology, 1891), 322.

Chapter 11: Seeing through Different Eyes

100. Shirley Ann Jones, ed., *Simply Living: The Spirit of the Indigenous People* (Novato, Canada: New World Library, 1999), 113.

101. Kent Nerburn and Louise Mengelkoch, eds., *Native American Wisdom* (San Rafael: New World Library, 1991), 10.

102. Luther Standing Bear, *My Indian Boyhood* (Lincoln: University of Nebraska Press, 1988), 52.

Chapter 12: The Journey Called Life

103. The Education of Finland: Sanasto Dictionary (accessed 30 Sept. 2005), http://www.edu.fi/oppimateriaalit/ymmarrasuomea/sanasto.htm.

104. Michael Patterson, *Seeds of Old Wisdom: Proverbs from Many Countries* (Unpublished, 2005).

105. Mary Kawena, *'Ilelo No'eau, Hawaiian Proverbs and Poetical Sayings* (Honolulu: Bishop Museum Press, 1983), 238.

Afterword

106. Pali Lee and Koko Willis, *Tales from the Night Rainbow* (Honolulu: Night Rainbow, 1988), v.

107. Malcolm Maclennan, *Gaelic Dictionary* (Great Britain: Aberdeen University Press, 1989), 33.

108. Malcolm Maclennan, *Gaelic Dictionary* (Great Britain: Aberdeen University Press, 1989), 207.

109. Shirley Ann Jones, ed., *Simply Living: The Spirit of the Indigenous People* (Novato, Canada: New World Library, 1999), 182.

110. Shirley Ann Jones, ed., *Simply Living: The Spirit of the Indigenous People* (Novato, Canada: New World Library, 1999), 183.

111. Shirley Ann Jones, ed., *Simply Living: The Spirit of the Indigenous People* (Novato, Canada: New World Library, 1999), 183.

112. Shirley Ann Jones, ed., *Simply Living: The Spirit of the Indigenous People* (Novato, Canada: New World Library, 1999), 183.

For Further Reading

Along with the following recommendations, the authors encourage you to avail yourself of any references listed in "Endnotes" that interest you.

Stories and Collections–Worldwide

Abrahams, Roger D. *African Folktales*. New York: Pantheon Books, 1983.

Bierhorst, John. *The Mythology of South America*. New York: William Morrow, 1988.

Bulfinch, Thomas. *Bulfinch's Mythology*. New York: Random House, 2003.

Chase, Richard. *The Jack Tales: Folk Tales from the Southern Appalachians*. New York: Houghton Mifflin, 1943.

Coomaraswamy, Ananda K., and Nivedita, Sister. *Myths of the Hindus and Buddhists*. New York: Dover, 1967.

DasGupta, Sayantani, and Das Dasgupta, Shamita. *The Demon Slayers and Other Stories: Bengali Folk Tales*. New York: Interlink Books, 1995.

Galdone, Paul. *The Elves and the Shoemaker*. New York: Houghton Mifflin, Clarion Books, 1984.

Geisel, Theodor Seuss. *Green Eggs and Ham*. New York: Random House, 1960.

Grimm, Jacob and Wilhelm, Manheim, Ralph, Trans. *Grimm's Tales for Young and Old: The Complete Stories*. New York: Doubleday, 1977.

Muhawi, Ibrahim, and Kanaana, Sharif. *Speak Bird, Speak Again: Palestinian Arab Folktales*. Berkeley: University of California Press, 1989.

O'Faolain, Eileen. *Irish Sagas and Folk Tales*. New York: Avenal Books, 1982.

Pyle, Howard. *The Story of King Arthur and His Knights*. New York: Dover, 1965.

Pyle, Howard. *The Merry Adventures of Robin Hood*. New York: Dover, 1968.

Shirane, Mitsuo. *Folk Tales of Old Japan*. Japan: The Japan Times, 1975.

Smith, Philip, ed. *Japanese Fairy Tales*. New York: Dover, 1992.

Tashjian, Virginia A., comp. *Once There Was and Was Not: Armenian Tales Retold*. Boston: Little, Brown, 1966.

Van Over, Raymond, ed. *Sun Songs: Creation Myths from Around the World*. New York: New American Library, 1980.

Stories and Collections–Native American

Bruchac, Joseph. *Iroquois Stories: Heroes and Heroines, Monsters and Magic*. Trumansburg, New York: The Crossing Press, 1985.

Bruchac, Joseph. *Return of the Sun: Native American Tales from the Northeast Woodlands*. Freedom, CA: The Crossing Press, 1990.

Dove, Mourning, Guie, Heister Dean, ed. *Coyote Stories*. Lincoln: University of Nebraska Press, 1990.

Erdoes, Richard, and Ortiz, Alfonso, eds. *American Indian Myths and Legends*. New York: Pantheon Books, 1984.

Grinnell, George Bird. *Pawnee Hero Stories and Folk-Tales: With Notes on the Origin, Customs and Character of the Pawnee People*. Lincoln: University of Nebraska Press, 1961.

Johnston, Basil. *Honour Earth Mother*. Lincoln: University of Nebraska Press, 2004.

Jones, William, Truman Michelson, ed. *Ojibwa Texts, Part I*. Salinas, CA: Coyote Press. Facsimile 1974 reprint of American Ethnological Society Publication No. 7(1), 1917.

Jones, William, Truman Michelson, ed. *Ojibwa Texts, Part II*. Salinas, CA: Coyote Press. Facsimile 1974 reprint of American Ethnological Society Publication No. 7(1), 1919.

La Pena, Frank, comp., Medley, Steven P. and Bates, Craig D., eds. *Legends of the Yosemite Miwok*. Yosemite National Park: Yosemite Association, 1993.

Lopez, Barry H. *Giving Birth to Thunder, Sleeping with His Daughter: Coyote Builds North America*. New York: Avon, 1981.

Metayer, Maurice, ed. *Tales from the Igloo*. New York: St. Martin's Press, 1977.

Peyton, John. *Stone Canoe and Other Stories*. Blacksburg: McDonald & Woodward, 1989.

Schoolcraft, Henry Rowe. *The Hiawatha Legends and Other Oral Legends, Mythologic and Allegoric, of the North American Indians*. AuTrain: Avery Color Studios, 1984.

Thompson, Stith, ed. *Tales of the North American Indians*. Bloomington: Indiana University Press, 1996.

Wallis, Velma. *Two Old Women: An Alaska Legend of Betrayal, Courage and Survival*. Seattle: Epicenter Press, 1993.

Understanding Stories

Campbell, Joseph. *The Hero With a Thousand Faces*. New York: HarperCollins, 1993.

Campbell, Joseph. *The Masks of God: Vol. I Primitive Mythology.* New York: Penguin Books, 1959.

Campbell, Joseph. *The Masks of God: Vol. II Oriental Mythology*. New York: Penguin Books, 1962.

Campbell, Joseph. *The Masks of God: Vol. III Occidental Mythology*. New York: Penguin Books, 1964.

Campbell, Joseph. *The Masks of God: Vol. IV Creative Mythology*. New York: Penguin Books, 1968.

Christie, Anthony. *Chinese Mythology*. Middlesex: Hamlyn Publishing, 1968.

Estes, Clarissa Pinkola. *Women Who Run with the Wolves: Myths and Stories of the Wild Woman Archetype*. New York: Ballantine, 1992.

Estes, Clarissa Pinkola. *The Gift of Story: A Wise Tale about What Is Enough*. New York: Ballantine, 1993.

Livo, Norma. *Who's Afraid...? Facing Children's Fears with Folktales*. Englewood: Teacher Ideas Press, 1994.

MacDonald, Margaret Read. *Traditional Storytelling Today: An International Sourcebook*. Chicago: Fitzroy Dearborn, 1999.

Nicholson, Irene. *Mexican and Central American Mythology.* London: Hamlyn Publishing, 1967.

Pearson, Carol S. *The Hero Within: Six Archetypes We Live By*. New York: Harper and Row, 1986.

Von Franz, Marie-Louise. *Interpretation of Fairytales*. Dallas: Spring Publications, 1970.

Storytelling Guilds and Publications

Northlands Storytelling Network, P.O. Box 1055, McHenry, IL 60051-1055. Available at http://www.northlands.net.

Creation Company, P.O. Box 392, Tolleson, AZ 85323. Available at http://www.storyteller.net.

National Storytelling Network, 132 Boone Street, Suite 5, Jonesborough, TN 37659. Available at http://www.storynet.org.

Index

Index